Robert and Lisa Sainsbury Collection

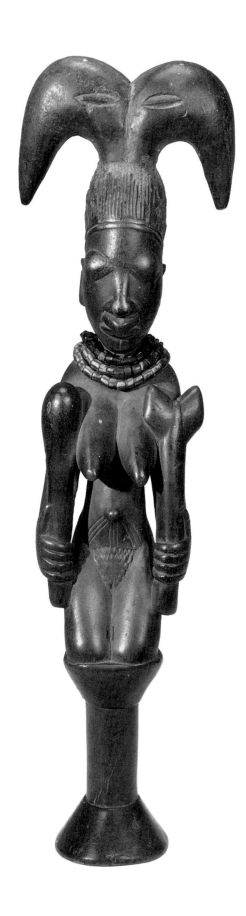

Catalogue in Three Volumes

Robert and Lisa Sainsbury Collection

Edited by STEVEN HOOPER

VOLUME II
Pacific, African and Native
North American Art

Yale University Press
New Haven and London
in association with
University of East Anglia
Norwich

© University of East Anglia, 1997

Photography by James Austin

Designed by Humphrey Stone

Hot-metal typeset and reproduced by Susan Shaw at The Merrion
Press, London, in 11 on 13 point Monotype Dante (vols. 1 and 11).
Film typeset and reproduced by Martino Mardersteig at
Stamperia Valdonega, Verona (vol. 111)

Origination and printing by John Parfitt at The Westerham Press,
Kent, on acid-free Mohawk Superfine paper

ISBN 0 - 300 - 03952 - 2 (set)
Library of Congress catalogue card no. 89 52206

FRONTISPIECE: Nigeria: Yoruba, *Shango staff*
(catalogue no. 112)

Contents

Contributors

A number of specialists have prepared entries for this catalogue. Their details are listed below, together with the section to which they have contributed.

VOLUME I European 19th and 20th Century Paintings, Drawings and Sculpture

MR GRAHAM BEAL *Director, Los Angeles County Museum of Art, Los Angeles; formerly Keeper, Sainsbury Centre for Visual Arts, University of East Anglia*

VOLUME II Pacific, African and Native North American Art

MRS MARGRET CAREY *Formerly Assistant Keeper, Museum of Mankind, British Museum, London (Africa)*

MR WILLIAM FAGG *Formerly Keeper, Museum of Mankind, British Museum, London (Nigeria)*

DR STEVEN HOOPER *Director, Sainsbury Research Unit for the Arts of Africa, Oceania & the Americas, University of East Anglia (The Pacific, North America)*

VOLUME III Precolumbian, Asian, Egyptian and European Antiquities

MR CYRIL ALDRED *Formerly Keeper, Department of Art & Archaeology, Royal Scottish Museum, Edinburgh (Egypt)*

DR CHARLES AVERY *Formerly Deputy Keeper, Department of Architecture & Sculpture, Victoria & Albert Museum, London (Europe)*

PROFESSOR WARWICK BRAY *Professor of Latin American Archaeology, Institute of Archaeology, University College London (South America)*

DR DOMINIQUE COLLON *Assistant Keeper, Department of Western Asiatic Antiquities, British Museum, London (Western Asia)*

DR IAN GLOVER *Reader in Southeast Asian Archaeology, Institute of Archaeology, University College London (Southeast Asia)*

MR VICTOR HARRIS *Assistant Keeper, Department of Japanese Antiquities, British Museum, London (Korea)*

MR REYNOLD HIGGINS *Formerly Deputy Keeper, Department of Greek & Roman Antiquities, British Museum, London (Mediterranean)*

PROFESSOR PETER LASKO *Formerly Director, Courtauld Institute of Art, University of London (Europe)*

DR TED J.J. LEYENAAR *Curator of American Antiquities, Rijksmuseum voor Volkenkunde, Leiden (Mesoamerica)*

PROFESSOR GEOFFREY T. MARTIN *Emeritus Professor of Egyptology, University College London (Egypt)*

DR YUTAKA MINO *Director, Osaka Municipal Museum of Art, Osaka (Early Japan)*

DR JOANNE PILLSBURY *Lecturer, Sainsbury Research Unit for the Arts of Africa, Oceania & the Americas, University of East Anglia (Mesoamerica)*

DR JESSICA RAWSON *Warden, Merton College, Oxford; formerly Keeper, Department of Oriental Antiquities, British Museum, London (China)*

DR LOUISE SCHOFIELD *Curator, Department of Greek & Roman Antiquities, British Museum, London (Mediterranean)*

MR ROBERT SKELTON *Formerly Keeper, Indian Department, Victoria & Albert Museum, London (Southern Asia)*

MR LAWRENCE SMITH *Keeper, Department of Japanese Antiquities, British Museum, London (Japan)*

PROFESSOR JURGEN THIMME *Formerly Director, Department of Antiquities, Badisches Landesmuseum, Karlsruhe (Cyclades)*

The production of this catalogue has involved the close collaboration of the following people.

Photographer JAMES AUSTIN

Designer HUMPHREY STONE

Typesetter SUSAN SHAW

Printer JOHN PARFITT

Editor STEVEN HOOPER

The entire catalogue has been prepared under the general direction of Sir Robert and Lady Sainsbury.

Editor's Note

The material in volume II of the catalogue has been divided into three main geographical sections – the Pacific, Africa and North America (Mesoamerica and South America are included in volume III). There is no satisfactory general term for the type of material included here, which is popularly referred to as 'tribal art'.

Within each section, works are presented in a regional, cultural, chronological or typological order – whichever is most appropriate. The precise sequence of objects within any subgrouping has been determined by considerations of scale and clarity of layout. Editorial policy concerning the presentation of the catalogue is discussed in more detail in the *Preface* in volume I.

Each object has a short caption, together with an explanatory text and one or more illustrations. The texts are not extensively descriptive, given the illustrations; they aim to provide contextual and historical information on the particular piece, or its type. Attributions are based on the current state of scholarship. Uncertainties as to attribution or date are made clear in the caption. On the few occasions where authenticity is uncertain, this is discussed in the text. The last line of the caption gives the date of acquisition by Robert and Lisa Sainsbury, followed by the object's registration number (UEA or RLS).

Collection data, if known, is given in a *Provenance* entry at the end of the text. Unless relevant to text discussion or provenance, details of previous publication or exhibition are not given. Enquiries concerning works in the collection may be made to the Director, Sainsbury Centre for Visual Arts, University of East Anglia, Norwich NR4 7TJ.

The *Robert & Lisa Sainsbury Collection* is owned by the University of East Anglia at Norwich, except for certain items with RLS registration numbers, which, for the time being, remain the private property of Sir Robert and Lady Sainsbury. The Collection is on permanent display in the Sainsbury Centre for Visual Arts at the University.

The Pacific

The Pacific

by Steven Hooper

The Pacific section of the Sainsbury Collection, though not extensive, is notable for the presence of pieces of great rarity and ethnohistorical importance. This is especially the case with the Polynesian material, much of which ceased to be made over a century and a half ago. The familiar categories 'Polynesia' and 'Melanesia' have been used here for convenient presentation, though these terms are not entirely satisfactory from a cultural point of view, particularly with respect to the position of Fiji within such a classification.

The six New Ireland sculptures from the George Brown Collection have been included in an appendix (pp. 305-17). They were acquired after the catalogue sequence had been finalised, but in view of their artistic and academic interest, it was thought that they should not be omitted.

The nineteenth and twentieth century sculptures from Indonesia, an area not always included within the Pacific region, were considered more appropriate to this section than that of Southeast Asia in Volume III Indonesia is used here as a geographical, not a political, term.

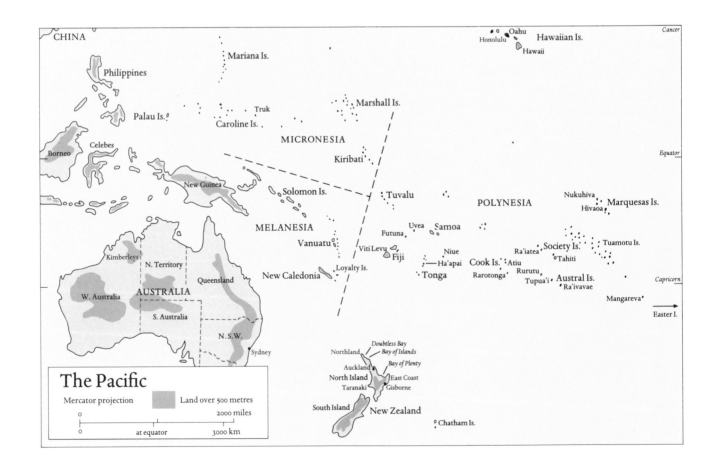

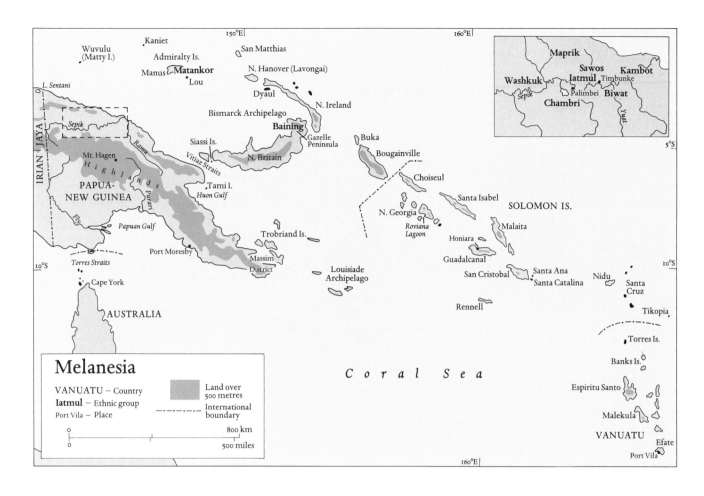

Melanesia

VANUATU – Country
Iatmul – Ethnic group
Port Vila – Place

Land over 500 metres

International boundary

0 800 km
0 500 miles

Labels on map (upper):
Wuvulu (Matty I.), Kaniet, Admiralty Is., San Matthias, Manus, **Matankor**, Lou, N. Hanover (Lavongai), L. Sentani, Dyaul, N. Ireland, IRIAN JAYA, Sepik, Bismarck Archipelago, Baining, Gazelle Peninsula, Buka, Ramu, Mt. Hagen, Highlands, Siassi Is., N. Britain, Bougainville, PAPUA-NEW GUINEA, Purari, Vitiaz Straits, Tami I., Huon Gulf, Choiseul, Santa Isabel, SOLOMON IS., Fly, Papuan Gulf, N. Georgia, Roviana Lagoon, Malaita, Port Moresby, Massim District, Trobriand Is., Honiara, Guadalcanal, Torres Straits, Cape York, Louisiade Archipelago, San Cristobal, Santa Ana, Santa Catalina, Nidu, Santa Cruz, AUSTRALIA, Rennell, Tikopia, Torres Is., Coral Sea, Banks Is., Espiritu Santo, Malekula, VANUATU, Efate, Port Vila

Inset labels:
Maprik, **Sawos**, **Kambot**, **Washkuk**, **Iatmul**, Timbunke, Sepik, Palimbei, **Biwat**, **Chambri**, Yuat

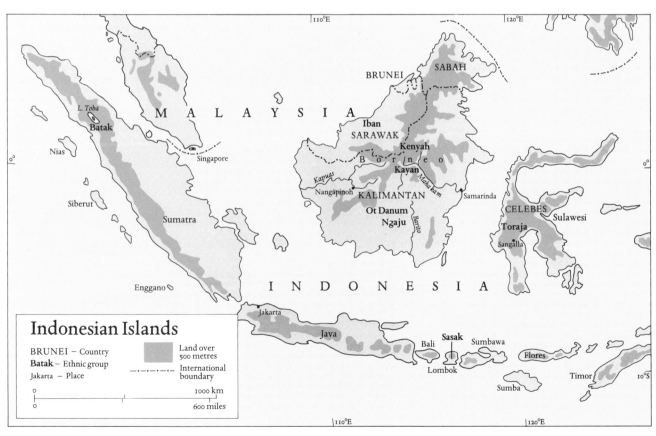

Indonesian Islands

BRUNEI – Country
Batak – Ethnic group
Jakarta – Place

Land over 500 metres

International boundary

0 1000 km
0 600 miles

Labels on map (lower):
L. Toba, **Batak**, MALAYSIA, BRUNEI, SABAH, Nias, Singapore, Iban, SARAWAK, Kenyah, Borneo, Siberut, Kapuas, Kayan, Maha kam, Nangapinoh, KALIMANTAN, Samarinda, Sumatra, Ot Danum Ngaju, Barito, CELEBES, Sulawesi, Toraja, Sangalla, Enggano, INDONESIA, Jakarta, Java, Bali, **Sasak**, Sumbawa, Flores, Lombok, Timor, Sumba

Polynesia

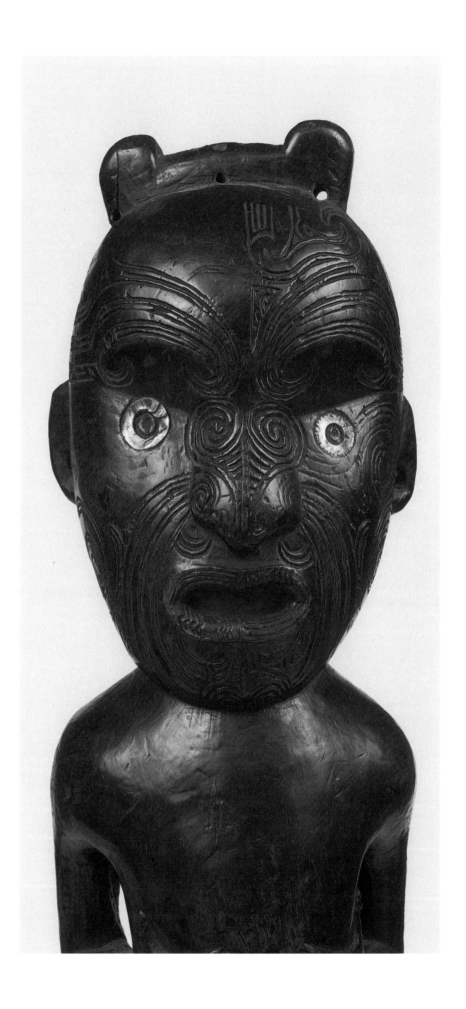

New Zealand, North Island, East Coast

Free-standing male figure
Late 18th/early 19th century
Wood, *Haliotis iris* shell
h. 15¼ in (38.7 cm)
Acquired 1963 UEA 178

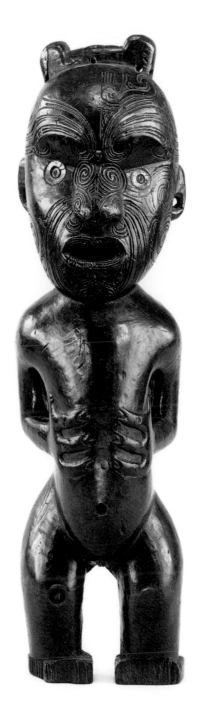

This figure belongs to a small corpus of Maori images which were apparently made to be free-standing and were not part of a gable ornament or other architectural structure. Five, including the present fine sculpture, were reported and discussed by Barrow (1959), and a further example has since appeared in London (Sotheby's, 1983: 68–71). All are characterised by the presence of male tattoo designs on the face and – in two figures – on the buttocks; also by the attachment, or means for attachment, of human hair to the top of the head.

None of these images has a reliable collection history, although one now in the Hunterian Museum was apparently in Glasgow by 1831 (Scott, 1961: 15). Their traditional function is also not clear, for there are few references to such figures in the early literature. Crozet, however, made an interesting observation in the Bay of Islands area of North Island in 1772 when he noted that '. . . in the middle of every village there is a carved figure which appears to represent the tutelary god of the village. In their private houses are to be found similar figures like little idols placed in positions of honour' (Roth, 1891: 45). Also, the Reverend Richard Taylor reproduced an engraving of a chief with a small free-standing figure, clothed in a miniature cloak, which he refers to as a 'memorial idol' (Taylor, 1855: 62).

From the limited evidence available it seems likely that these images represent deified ancestors, and that they date to the period prior to missionary activity. The Maori had been in regular contact with Europeans since Captain Cook's first visit in 1769, and as a result had acquired metal tools and other exotic goods, but these early encounters with Europeans had only a limited effect on indigenous Maori beliefs and rituals. Missionary influence, however, increased steadily during the decades following their arrival in 1814, and whereas ancestor images appear to have been acceptable to Christians when incorporated as architectural 'ornament' in elaborately carved Maori houses, they were not acceptable when they took the form of individual 'idols'. This may account for the rarity of the type.

This particular image is in general well preserved, though unfortunately it has been emasculated and the feet are damaged at the front and back. The hair, which formerly would have covered the back of the head, is also missing, though this reveals the topknot projection and holes for lashing. The ears are pierced for pendants and the right knee and possibly the navel are carved to receive *Haliotis* shell inlay, now lost; the

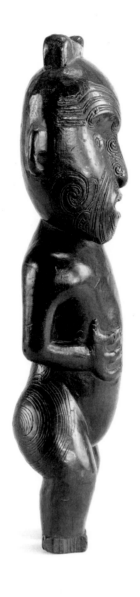
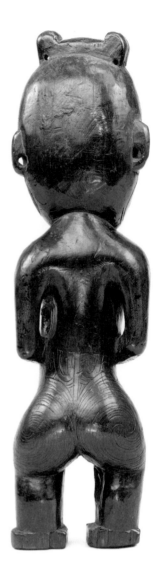

eyes are inlaid with *Haliotis* shell rings, the right probably an ancient replacement, since the rim is not serrated. The eye inlay is not composed of two rings, as reported by Barrow (1959: 113).

A notable aspect of this sculpture is that the tattoo patterns on both face and buttocks are remarkably similar to those on the equally fine free-standing image in the National Museum, Wellington, which was formerly in the Oldman collection (Oldman, 1938: pl. 73; Barrow, 1959: 111–12; Mead, 1984: 124, 213). Although the Oldman image is clearly by another hand, the similarity of the tattoo patterns may indicate that both images were carved to represent the same deified ancestor, whose distinctive tattoo (with the right cheek and forehead left plain) was known and recorded within his tribe, most probably one of those inhabiting the Gisborne area on the East Coast of North Island.

Free-standing images of ancestral deities were a feature of ritual systems in other areas of Polynesia, and a close parallel with Maori images can be seen in the *'aumakua* images of pre-Christian Hawaii (Cox and Davenport, 1974: 94–103), which are described as 'family or personal gods'. These are also relatively naturalistic in form, often having human hair. Such images acted as a channel for communication with ancestral spirits, who entered the images during ritual, and it is likely that New Zealand Maori images fulfilled a similar function.

Provenance: Formerly in the collection of Kenneth Webster.

2

New Zealand, North Island, Gisborne

Head from a male figure
Early/mid 19th century
Wood, flax
h. 5⅛ in (13.0 cm)
Acquired 1973 UEA 518

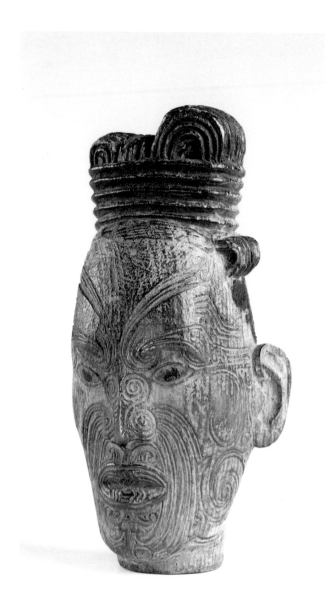

This small tattooed head is a fine example of the Gisborne or Turanga school of carving, which continued to flourish during the middle of the nineteenth century on the East Coast, notably at Manutuke, some time after carving had declined in other areas. The Rongowhakaata and Ngati Kaipoho were the principal tribes involved and the master carver Raharuhi Rukupo was particularly influential in maintaining this vigorous carving tradition. Work by him and Timote Tuhi, which is comparable to the head shown here, is illustrated in Barrow (1969: 36, 79).

Full facial tattooing (*moko*) was undergone by men of high status during the course of their adult lives and although the full significance of this painful ordeal is not now known it was in part a process of ritual sanctification of chiefs, who were living representatives of deified ancestors and possessed powers derived from them. Women's facial tattoo was restricted to the lips and chin. (For a discussion of *moko* see Simmons, 1983.) The tattoo on this small head is finely executed and exhibits an unusual feature in the truncated bands of engraved lines which arch above the eyebrows. The hair is shown tied up in a topknot, characteristic of the East Coast region, and the head has clearly been sawn off at the neck. The right ear is missing and a cord of twisted flax is tied to a ring screwed into the back of the head, suggesting that it may be from a *karetao* puppet figure, for which cords would have been necessary to operate the arms (*cf.* Barrow, 1969: 148, 151; Mead, 1984: 210). Puppets were used to dramatise myths and were not merely children's toys.

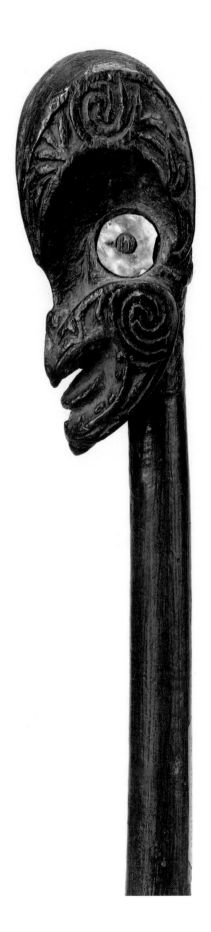

New Zealand, North Island, S.Taranaki

Image of a god – 'godstick'
Late 18th/early 19th century
Wood, *Haliotis iris* shell
h. 15 in (38.1 cm); head h. 5½ in (14.0 cm)
Acquired 1967 UEA 179

Maori images of this rare form (*whakapakoko atua*) are generally known as 'godsticks', since there is reliable evidence (discussed by Barrow, 1959a, 1961 and Simmons, 1983a) that they represent particular named gods. The Reverend Richard Taylor, who collected a number of these images in the South Taranaki/Wanganui area towards the middle of the nineteenth century, provides some detailed information concerning them, including an illustration, in his book *Te Ika a Maui* (1855: 82). In the second, fuller, edition of this work he writes (albeit in awkward prose) that these images '... were little more than wooden pegs with a distorted figure of the human head carved on the top ... [They] were only thought to possess virtue or peculiar sanctity from the presence of the god they represented when dressed up for worship ... This dressing consisted in the first place of the pahau, or beard, which was made by a fringe of the bright red feathers of the *kaka*, parrot, – next of the peculiar cincture of sacred cord with which

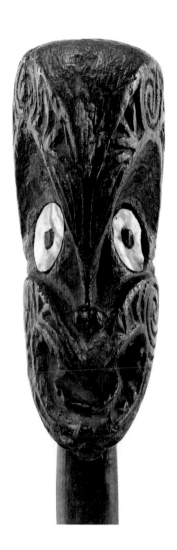
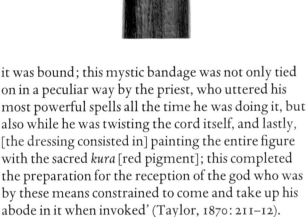

it was bound; this mystic bandage was not only tied on in a peculiar way by the priest, who uttered his most powerful spells all the time he was doing it, but also while he was twisting the cord itself, and lastly, [the dressing consisted in] painting the entire figure with the sacred *kura* [red pigment]; this completed the preparation for the reception of the god who was by these means constrained to come and take up his abode in it when invoked' (Taylor, 1870: 211–12).

Various names are recorded for these gods, but this example most probably represents Maru, one of the gods closely associated with the great mythical Aotea migration and an important deity in the South Taranaki/Wanganui area. Simmons (*ibid.*) discusses the ritual use of these godsticks in sets of three, conducted according to the purpose for which divine favour was to be invoked. The elaborate binding, lost here, was clearly an important part of the ritual invocation and corresponds to related practices and images in other regions of Polynesia, notably in the Cook Islands, the Society Islands and Hawaii.

Comparison with other examples places this image, in sculptural terms, among the finest of all godsticks. The bold arching brow crests complement the curving beak-like mouth, and the carving is well smoothed yet also well preserved. The appearance of the worked surfaces suggests stone tool work, though certainty is not possible since this technical aspect of carving is difficult to assess. The back of the head has a distinctive raised medial ridge which divides to extend to the sides of the head just behind the eyes, a feature also present on examples in Auckland (Z1894.3, Mead, 1984: 221) and Salem (E19,166, Barrow, 1961: 216). The *Haliotis* shell eyes are probably old replacements for ancient originals.

Provenance: This image, which lacks any historical data, was formerly in the collection of Harry Beasley (no. 4335), who acquired it in 1937 in Weston-super-Mare, Somerset.

4

New Zealand, North Island, Northland

Flute/whistle
Early/mid 19th century
Wood, *Haliotis iris* shell
l. 6⅝ in (16.8 cm), aperture diam. ⅝ in (1.6 cm)
Acquired 1971 UEA 181

The Maori developed several forms of musical instrument (see Anderson, 1934), and this type, with a curving terminal, has often been erroneously identified as a 'nose flute', because it was formerly thought that it was nose-blown through the small aperture at the curved end. However, it is now clear that it was mouth-blown at the larger aperture in a similar manner to the tubular *koauau* flute, which has been discussed in detail by McLean (1968). Both instruments were apparently used to accompany *waiata*, sung poems.

This fine, boldly carved example has four stops, two towards the mouthpiece and two at the curved end, one of which is encircled by a *Haliotis* shell ring. A further stop close to the mouthpiece has been carefully plugged and the mouth of the main figure carved on the opposite side is recessed behind the tongue to form a lug for a suspension cord. An unusual feature of the flute is that the curving terminal is joined to the main body of the instrument. The straight-bored interior and crisply finished carving suggest metal tool work of the first part of the nineteenth century, and the flute most probably originates from the Bay of Islands area of Northland, for it exhibits two carving styles distinctive to that region, firstly meandering raised parallel lines enclosing notches and secondly the *unaunahi* 'rolling spiral' design on the limbs of the main figure (see Mead, 1984: 186).

Provenance: Formerly in the Pitt Rivers Museum at Farnham, Dorset.

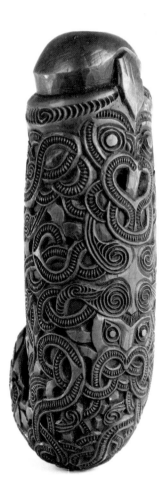
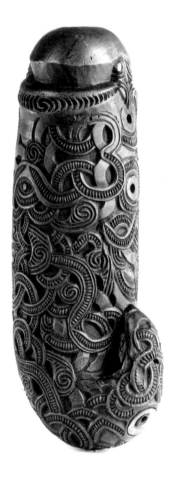

5

New Zealand, North Island, Gisborne

Step for digging stick
Early/mid 19th century
Wood, pearl shell, nails
l. 7 in (17.8 cm)
Acquired 1967 UEA 183

Special carved steps (*teka*), often incorporating a figure, were attached to long digging sticks (*ko*) and used during important stages in the agricultural cycle – breaking the soil and planting sweet potato and other crops (Best, 1925: 32–42). The Maori, like most Pacific peoples, were predominantly agriculturalists, root crops being the staple, while hunting, fishing and gathering provided supplementary foods. Gardening was thus not a menial activity but one essential to survival, involving important ritual procedures under the direction of priests (*tohunga*),

to propitiate ancestral deities, secure divine favour, and thus ensure the fruitfulness of the land.

This bold openwork carving represents a contorted figure, positioned as a support to the foot when the digging stick was in use. Three-fingered hands reach down to grasp the legs, which thrust forwards to join the chin, while the narrow body loops below. A low crest extends from the forehead and divides at the back of the head in the form of a T. There is an aperture running along the centre of the footrest. The eyes are pearl shell and nail replacements for the *Haliotis* shell originals.

This example is very similar in treatment to *teka* in the Auckland Institute and Museum (Best, 1925: fig. 23, 3rd from left) and the National Museum of New Zealand (*ibid.*: fig. 30, top), indeed they could well be by the same hand, though documentation is lacking to support this. It is also comparable to another example in Auckland, from the Rongowhakaata tribe of the Gisborne area (see Mead, 1984: 212).

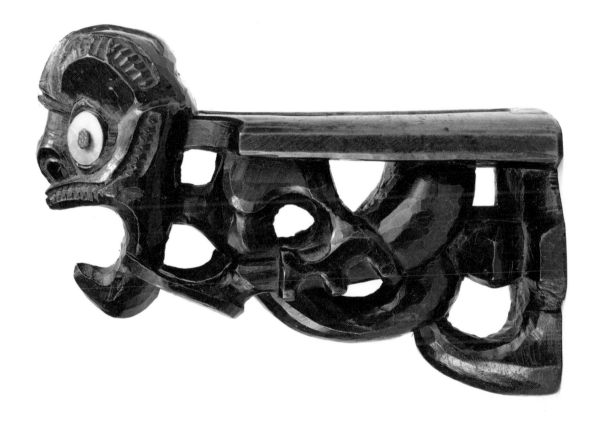

6

New Zealand, North Island, Northland

Club, *wahaika* form
18th century
Wood
l. 14¾ in (37.5 cm)
Acquired 1972 UEA 186

In traditional times the Maori warrior carried two basic weapons, one a short club, the other a longer two-handed weapon of the quarter-staff type. Several varieties of each type were developed, together with skilful techniques in close combat, much as formerly applied in European sword and knife fighting. There were also honourable conventions respecting combat and the proper method of despatching an enemy, which with short weaponry involved a thrusting blow to the opponent's temple with the distal end of the weapon. All varieties of short club, whether of wood, stone or bone, have a sharp spatulate blade for this purpose. The handle of these clubs is invariably pierced for a flax wrist cord, which prevented the weapon's loss during combat.

The present fine example is of the *wahaika* 'billhook' form, which usually has a small figure carved above the grip, and also a head as the butt terminal, typically with gaping mouth and tongue extended in the Maori gesture of defiance and challenge. In many areas of Polynesia clubs were carved as a modified human image, and thus besides being shaped for technical efficiency were also designed to enshrine the productive and destructive powers of deified ancestors.

Provenance: This particular club is of special interest because it was most probably collected during the course of one of Captain Cook's three voyages, between 1768 and 1780. Documentary proof for this is currently lacking, but the club was part of a collection of evidently eighteenth-century Polynesian items which were owned by the Greville family at Warwick Castle. These were apparently obtained from Sir Joseph Banks, who accompanied Cook on his first voyage (1768–71) and also acquired material brought home on the two subsequent voyages. On morphological grounds the club certainly appears to date from this eighteenth-century contact period, and is similar to an example in Stockholm which was probably collected during Cook's first voyage (Kaeppler, 1978; 185–6). Just visible on both sides of the blade near the figure is a *u* or *n* in faded ink.

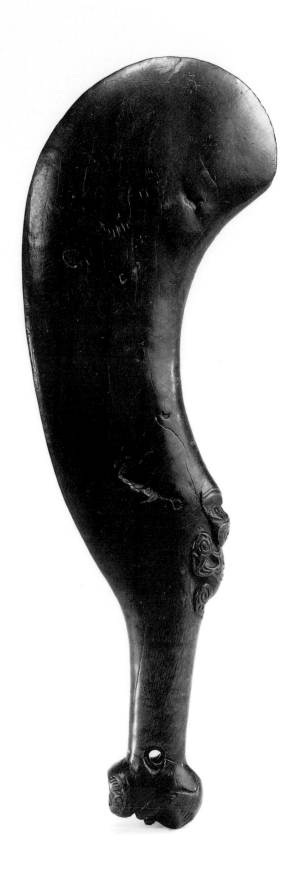

7

New Zealand, North Island, East Coast

Club, *wahaika* form
Early 19th century
Whalebone
l. 17 in (43.2 cm)
Acquired 1949 UEA 185

This is a whalebone variant of the *wahaika* 'billhook'
form of club, differing from UEA 186 in its broader
blade, 'sinus' indent and straight butt terminal.
The treatment of the lateral figure is notable for the
regular three-toed feet and the triple projections
which extend from the forearms.

Whales were not hunted by the New Zealand
Maori, but bones and teeth from stranded specimens
were used for making weapons and ornaments. These
materials became increasingly available after the
arrival of European whalers and traders towards the
end of the eighteenth century. This club is compara-
tively thin and appears to have been carved from a
whale's jaw bone or shoulder blade.

Despite the acquisition of firearms by the Maori in
the early nineteenth century, indigenous short and
long weapons continued to be used in inter-tribal and
anti-colonial combat until the 1860s. Thereafter,
clubs were made for sale or exhibition purposes and
tended to be clumsy and elaborately carved over the
entire surface of the blade (see Hamilton, 1896: pl.
XXXIII for several examples).

Provenance: This club was formerly in the collections
of Alphonse Kahn and Pierre Loeb. It bears a number
in black ink beneath the figure (obscured by wear:
two letters followed by three digits).

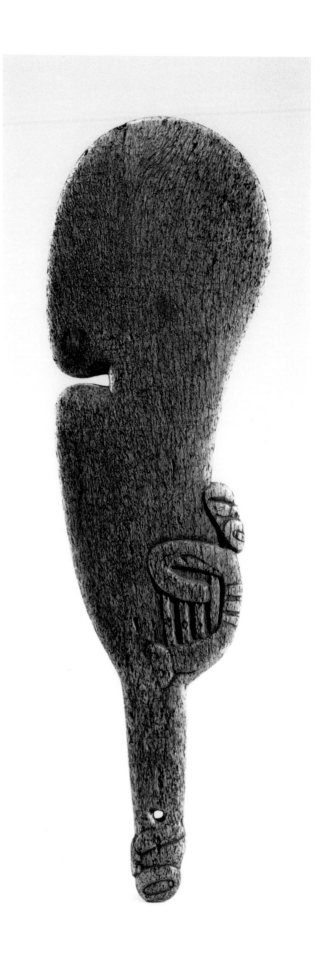

8

New Zealand, North Island, East Coast

Club, *kotiate* form
Early/mid 19th century
Whalebone
l. 12½ in (31.8 cm)
Acquired 1973 UEA 519

Several wooden examples of the *kotiate* 'fiddle-shaped'
club date to the eighteenth century, but only around
the turn of the nineteenth century do they appear to
have been made in whalebone, perhaps because of the
increasing availability of this material as a result of the
visits of European whalers, though other types of
club had previously been made in whalebone. The
general form of the *kotiate* resembles a highly stylised
human figure and the butt terminal usually takes the
form of a head in full profile, with a curving tongue
extending from the mouth. In examples made for
exhibition and sale purposes during the last quarter
of the nineteenth century this profile head becomes
highly ornate and exaggerated and the body of these
clubs is also often engraved with large eyes and gaping
mouths. This example, of more coarse bone than
UEA 185, appears to have been polished or varnished.

Provenance: Formerly in the Pitt Rivers Museum at
Farnham, Dorset.

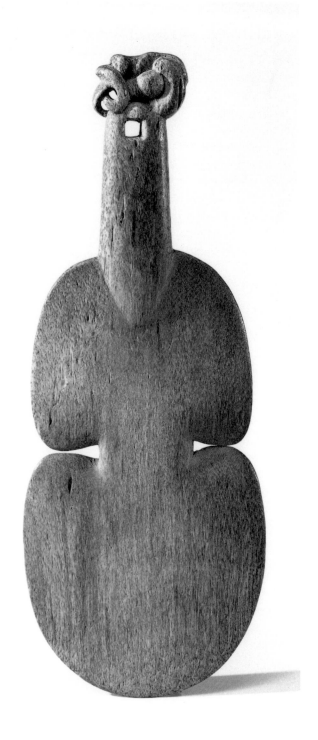

9

New Zealand, North Island, Northland

Neck pendant
18th century
Nephrite
h. 2⅞ in (7.3 cm)
Acquired 1971 UEA 184

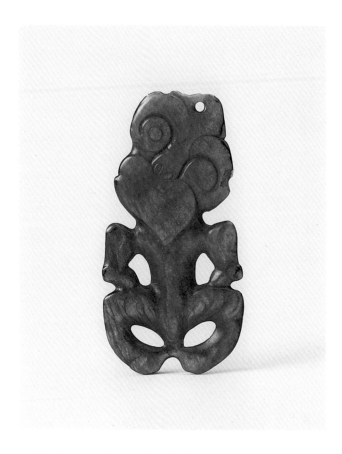

Neck pendants of this type (*heitiki, hei* = necklace, *tiki* = figure) are the most famous of all Maori ornaments and this example is among the most beautiful known. Its extreme thinness (4 mm max.) and the pale green nephrite (*pounamu*) from which it is made give it an exceptional light, translucent delicacy. The condition is remarkable, considering its fragility: only the details of the lower face have been lost through wear, while other features, like the three slender, curving fingers which grasp each thigh, are still clearly discernible. An unusual feature is the form of the shoulders, for in most *heitiki* both shoulder and upper arm appear as a continuous crescent between chest and elbow. The original hole above the right eye for a plaited flax suspension cord has worn away and been repositioned through the forehead. It has been suggested that *heitiki* represent ancestors or, given the frequent presence of a vulva, that they are 'fertility charms'. It is not possible to give a specific explanation, but most Maori 'art' was to some extent connected with ancestors and their role in promoting fertility and abundance.

In the eighteenth century a variety of ornaments in nephrite, whale ivory and bone were worn by both men and women, but during the nineteenth century only the *heitiki* remained popular. Indeed, after the introduction of metal tools, many were made from redundant nephrite adze blades and their previous use is discernible in their form. During this period European settlement led to the dislocation of traditional Maori society, and as a result many *heitiki* passed, by one means or another, into European hands.

Nephrite, a type of jade, occurs naturally on the west coast of South Island and was highly prized by the Maori, who worked it by a laborious process of chipping, grinding and polishing with sand and water. It is extremely hard, though brittle, registering 9 on Moh's scale of hardness. Nephrite formerly circulated widely throughout New Zealand as a result of inter-tribal exchanges or as the spoils of war.

Provenance: This piece was formerly in the Armytage Collection, published as no. 64 with the annotation: 'From Wirinauhoia, a chief of Taipa (Manganui) in 1900' (Webster, 1948: 47). Taipa is on the coast near Mangonui, Doubtless Bay, which is Ngati Kahu territory (information courtesy of David Simmons, who also suggests that Wirinauhoia denotes a title, since this name is not known locally). This *heitiki* almost certainly dates from the eighteenth century or earlier and is likely to have passed through many generations before 1900, since *heitiki* were, and are, highly-valued family heirlooms.

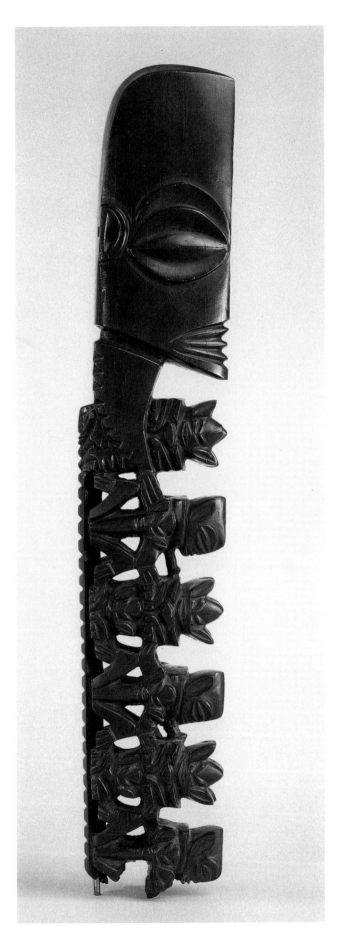

Cook Islands, Rarotonga

Head of a 'staff god'
Late 18th/early 19th century
Wood
h. 31¼ in (79.4 cm)
Acquired 1953 UEA 188

'... we observed a large concourse of people coming towards us, bearing heavy burdens. They walked in procession, and dropped at our feet fourteen immense idols, the smallest of which was about five yards in length. Each of these was composed of a piece of aito, or iron-wood, about four inches in diameter, carved with rude imitations of the human head at one end, and with an obscene figure at the other, wrapped round with native cloth, until it became two or three yards in circumference. Near the wood were red feathers, and a string of small pieces of polished pearl shells, which were said to be the manava, or soul of the god. Some of these idols were torn to pieces before our eyes; others were reserved to decorate the rafters of the chapel we proposed to erect; and one was kept to be sent to England, which is now in the Missionary Museum' (Williams, 1837: 115–16).

Thus Reverend John Williams describes the surrender in 1827 of what he refers to as the 'national idols' of Rarotonga. No historical information exists for the present superb sculpture, but it may well have been one of those 'torn apart' and is one of twelve large 'staff god' heads so far documented in collections (see below), all of which have been broken near the point where the long shaft formerly entered the large roll of bark cloth. The complete example which was sent to the Missionary Museum measures about thirteen feet in length and is now in the Museum of Mankind, London (see Buck, 1944: 310; Barrow, 1979: 85). Two further complete but smaller 'staff gods', measuring c. 8 ft and 10 ft respectively, are in the Otago Museum (Oldman, 1943: pl. 2) and the Royal Scottish Museum, Edinburgh (Idiens, 1982: pl. 17). These and other fragments which survive show that what Williams termed an 'obscene figure' is a naturalistic phallus terminal (Buck, 1944: 323–5; Oldman, 1943: pl. 3).

These images belong to the pre-European period of Rarotongan culture, prior to Williams' first missionary visit in 1823 and the subsequent swift conversion of the population. From a sculptural viewpoint this image reveals a masterly skill in the carving of the very hard 'ironwood' (*Casuarina*

equisetifolia), using stone, shell and tooth tools, and possibly rudimentary metal tools obtained from European ships which visited the area before the arrival of the missionaries.

Reliable information concerning the identity of these 'staff gods' and their role in Rarotongan religious practices is lacking, but their general form, considered in the light of knowledge of other Polynesian cultures, suggests the following possible interpretation. Polynesian gods and hereditary chiefs (who were their earthly descendants) possessed a special efficacious quality, usually termed *mana*, which was capable of bringing about abundance and success in important activities. However, the ability of chiefly *mana* to produce these results was dependent on the maintenance of an appropriate relationship between gods/chiefs and the people, notably through the proper observance of ritual procedures, the details of which differed in the various Polynesian societies. Manufactured objects, like 'staff gods', served as a focus for these rituals and often symbolised in material form the most important philosophical tenets of the society. With respect to these 'staff gods' it can be said that certain hardwoods, including ironwood, were conceptually associated with gods/chiefs and their productive powers and were carved by men into images, canoes and weapons. Correspondingly, bark cloth was associated with the people generally and in particular with women, who manufactured it.

It is therefore suggested that these 'staff gods' represented in symbolic terms, and at two levels, an ideal relationship between two different yet complementary elements, a combination considered to be essential to life and prosperity. At one level the association of the phallic wood image with the bark cloth binding was a reference to male and female sexuality and to procreation. At another level these 'staff gods' symbolised the productive potential of the partnership between gods/chiefs (hardwood) and the people (bark cloth), a partnership which in everyday life was manifested in mutual offerings and co-operation, the polygamy of chiefs, and their role in co-ordinating all important activities.

Provenance: Formerly in the collection of Kenneth Webster.

Location of eleven other known 'staff god' heads:
Five in Otago Museum (Oldman, 1943: pls. 1–2); one each in the Museum of Mankind, London (Buck, 1944: 320–21), Cambridge University Museum of Archaeology and Anthropology (Barrow, 1979: 86), Peabody Museum, Harvard (*ibid.*: 84), Staatliche Museum für Völkerkunde, Munich (Müller, 1980: no. 32), De Menil Collection (De Menil, 1984: 359), and formerly Hooper Collection (Phelps, 1976: 133).

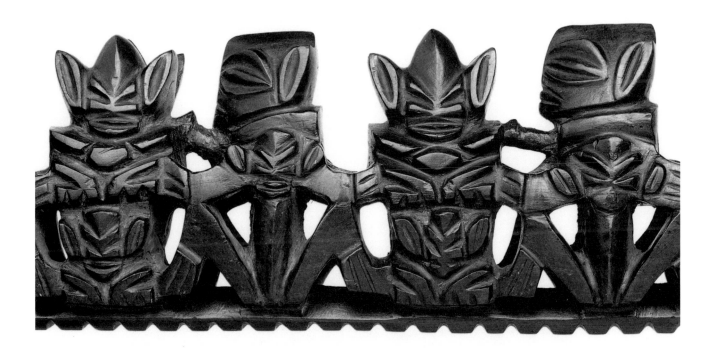

11

Cook Islands, Rarotonga

Male figure – 'Fishermen's god'
Late 18th/early 19th century
Wood
h. 16 in (40.7 cm)
Acquired 1949 UEA 189

Among the masterpieces of Polynesian sculpture, this rare image is one of only seven of its type known to have survived from the early nineteenth century. They are generally referred to as 'fishermen's gods', an attribution which derives from the missionary John Williams, who spent over a year on Rarotonga during the 1820s and who provides us with the only first-hand reference to the type in the literature. In his *Missionary Enterprises* (1837: 116–17) he illustrates an example (almost certainly the London Missionary Society image in the Museum of Mankind, LMS 123) and states that this type of 'idol . . . was placed upon the fore part of every fishing canoe; and when the natives were going on a fishing excursion, prior to setting off, they invariably presented offerings to the god, and invoked him to grant them success.' Williams then goes on to pay a barbed compliment to Rarotongan piety with the exhortation, 'Surely professing Christians may learn a lesson from this practice. Here we see pagans of the lowest order imploring the blessing of their gods upon their ordinary occupations. Christians, go and do likewise.'

Although unconfirmed from other independent sources, this 'fishermen's god' attribution is quite plausible, since in many areas of Polynesia carved images were mounted on the bow and stern of important canoes. Such images were not in themselves regarded as gods, but when carved in an appropriate way and from an appropriate material they functioned as representations of gods and as a suitable medium through which the god could manifest itself. During ritual, such as formal invocations for fishing success, the god was invited by the priest to occupy its material image. Morsels of food or flowers were offered as tokens of respect, a procedure which constituted a kind of exchange in return for divine blessings on the fishing expedition. A number of gods were recognised in Polynesian societies, many of them ancestral, and frequent ritual supplication and offerings were considered necessary in order to obtain divine favour and ensure success.

The form of this image, with massive head and abdomen, flexed legs and straight shoulder line, relates it to central Polynesian sculpture from the Society and Austral Islands, but its Rarotongan origin is clear from the distinctive eye and mouth form. It is unique among the known 'fishermen's gods' in that it has a fully carved nose, stylistically similar to that on the famous tall Rarotongan image in the Museum of Mankind (LMS 169). It is also a particularly powerful example of the way in which Polynesian sculptors were not constrained in their work by considerations of naturalism. Representative portraiture was not the intention, but rather the evocation and realisation in material form of partic-ular qualities – in this case fecundity, potency, solidity and permanence – conveyed in the emphasis on the head, abdomen and genitals, and in the phallic form of the sculpture as a whole.

The condition of the image is good, although the feet are damaged and the large pendent phallus, present on three other examples, has unfortunately been sawn off. This is probably a result of having originally been collected by London Missionary Society missionaries, who retained as souvenirs those 'idols' which were not destroyed in the early fervour of conversion. Two of the seven surviving examples (one in the Museum of Mankind, the other in the Peabody Museum, Harvard) have designs painted in black on the head and body, probably representing tattoos. This image may once have been so decorated, but no traces remain.

Location of six other known 'fishermen's gods': Two in Museum of Mankind, London (Buck, 1944: 312–13; Barrow, 1979: 75–7); one each in Royal Scottish Museum, Edinburgh (Idiens, 1982: 26), Rautenstrauch-Joest Museum, Cologne (Anton, 1979: 496), Peabody Museum, Harvard (Buck, 1944: 314; Barrow, 1979: 70), Museum für Völkerkunde, Munich (Buck, 1944: pl. 13).

Further illustrations overleaf

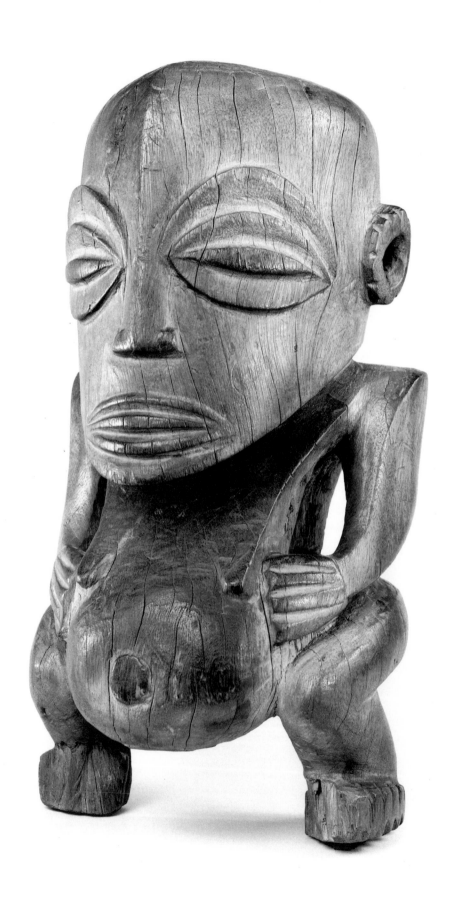

12

Cook Islands, Atiu

Stool
19th century
Wood
l. 16½ in (42.0 cm)
Acquired 1968 UEA 190

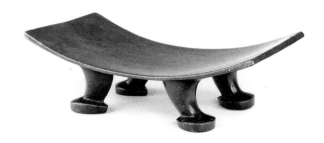

Polynesian houses were simply furnished, usually with layers of soft pandanus-leaf matting covering the floor, bark cloth bedding and perhaps a wood or bamboo pillow for the use of senior members of the household. In central Polynesia (Society Is., Austral Is., Cook Is.) low stools of various types were used by chiefs and others of high status.

On Atiu Island the stool form achieved an elegant simplicity. Carved from a solid block of *tamanu* (*Callophyllum inophyllum*), the slightly flaring rectangular seat is supported on four curving legs with heart-shaped feet. The speciality of Atiu craftsmen (Buck, 1944: 48), these stools circulated by exchange to other islands in the group.

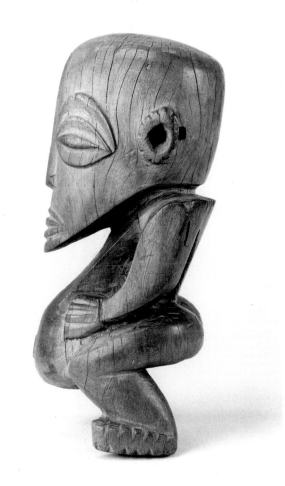

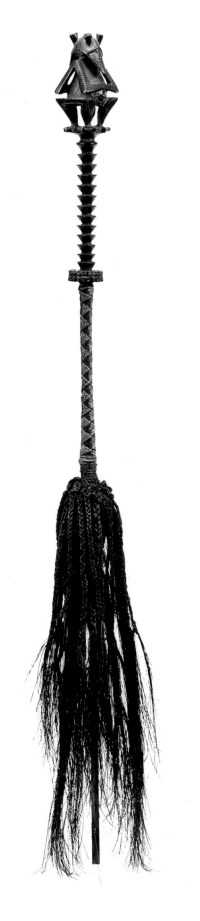

13

Austral Islands, Tupua'i or Rurutu

Chief's fly whisk
Late 18th/early 19th century
Wood, human hair, coir
l. 28½ in (72.4 cm); figure h. 3¼ in (8.3 cm)
Acquired 1984 UEA 895

Until comparatively recently much of the fine early
wood sculpture brought back by Europeans from the
central Pacific was generally attributed to 'Tahiti',
which for a long period had been used as a catch-all
term not only for the Society Islands (of which Tahiti
is the largest island), but also for the whole of central
Polynesia. It is now clear that many of these carvings
originated from the Austral and Cook Groups, and
this elegant type of fly whisk is a case in point. For long
known as 'Tahitian' fly whisks, ethnohistorical analysis
by Rose (1979) and others has shown that they were
almost certainly made in Tupua'i or Rurutu in the
Austral Islands. However, it is probable that many
examples were collected in the Society Islands, since
it appears that drums, whisks and other ritual items
were supplied to chiefs on Tahiti and other islands by
craftsmen on the Australs.

This attribution to the Austral Islands is further
strengthened by evidence from an unpublished
example in the Peabody Museum, Yale (no. 7154.
209919), which was collected on Tupua'i in June 1826
by Lieutenant Hiram Paulding of the United States
Schooner *Dolphin* (information courtesy of David
Kiphuth). Paulding wrote a lively account of his
voyage, in which he describes his visit to Tupua'i, his
friendship with 'King Dick', and their exchange of
presents. He also makes direct reference to this type
of fly whisk. He wrote: 'At Toubouai, we added
considerably to our collection of curiosities. The most
ingeniously wrought article, was a lash, used by the
natives for brushing the flies off their backs. The
handles were carved to represent a man's face, or
some animal familiar to them. The lash itself, was,
in several strands, finely braided from twine of the
cocoa-nut husk' (Paulding, 1831: 249).

There are two basic varieties of double-figure fly
whisk, large and small, both of which have a similar
general form: twin figures sit atop a columnar grip,
which is separated from the decoratively bound shaft
and coir whisk by a raised disc, the rim of which is
engraved with tiny heads. Rose (1979) describes these
whisks in detail and designates three types (A–C),
dividing the smaller variety according to the form

11 PACIFIC: POLYNESIA

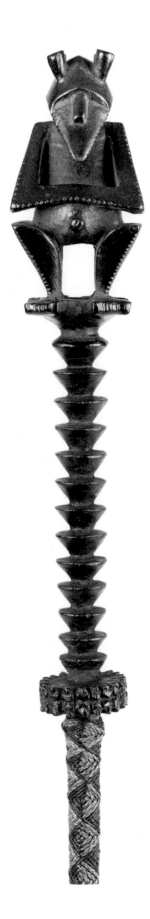

of the hand grip. The figures on the larger variety (represented here: Rose type A) are more angular and crisply carved and they lack the lateral perforation through the body which occurs on most of the smaller whisks. It is possible that these larger ones are a local post-contact development of the late eighteenth century, since only smaller examples were collected during Cook's voyages (Kaeppler, 1978: 39, 162) and the availability of metal tools would have facilitated greater precision in carving. Nonetheless, in creating both varieties of whisk the Austral craftsmen achieved a particularly elegant solution to the sculptural problem of representing twin figures addossé; the bodies are fused and the thighs are linked to repeat an inverted version of the arm arrangement on the front of each figure. The significance of this twin figure motif is not clear, but variations on this theme occur in the iconography of other Polynesian groups, notably the Marquesas and Cook Islands.

Besides performing a practical function, these whisks also served as batons denoting the high status of their owner. Some examples have small sections of pearl shell bound into the whisk, which would have flashed and rattled dramatically when in use. This example is virtually undamaged except for the whisk, which is a comparatively recent coir replacement, inexpertly attached. The patterned binding of plaited coir and human hair on the shaft is original.

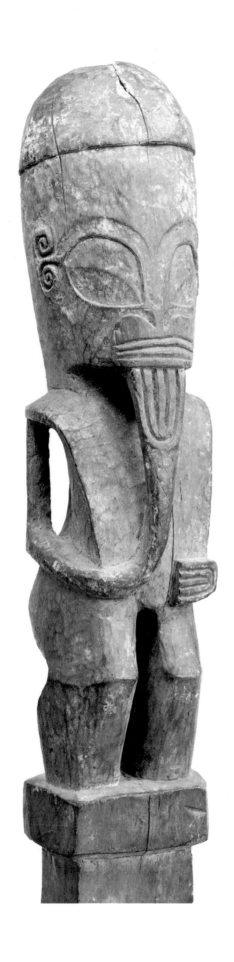

Marquesas Islands, Nukuhiva

Figure on post
Early 19th century
Wood
h. 19¾ in (50.2 cm); figure h. 12¼ in (31.1 cm)
Acquired 1952 UEA 192

In many areas of Polynesia wood or stone images
were set up in sacred enclosures, or 'temples' (called
me'ae in the Marquesas), which were reserved for
important rituals connected with the welfare of the
community. Handy reported that in the Marquesas
Islands, prior to Christian conversion, figures were
erected at the back of the *me'ae* and that they
'represented deified tribal ancestors – chiefs and
inspirational or ceremonial priests who had been
famous in their time and whose spirits had become the
tutelary deities of the tribe' (Handy, 1923: 236). It is
probable that this male figure is a portable image of
this type, for the rectangular-section post upon which
it stands appears to have been designed to fit into a
supporting framework, either on the prow of a canoe
or possibly on a *me'ae*.

In over-all form this piece (which is illustrated in
Edge-Partington, 1896: 24) appears to be unique, the
only comparable example being a roughly carved
figure on a long stake from Puamau, Hivaoa Island,
in the Berlin Museum (reproduced in von den Steinen,
1928: III: BD, 14). The present figure is sculpturally
interesting in that the symmetrical treatment of the
body is offset by the long right arm which extends to
the mouth, a gesture which occurs in figure sculpture
from other parts of Polynesia.

The wood is pale and heavy and there are splits
down the back of both figure and post. It is possibly
breadfruit, for Porter (1822: 110–15) noted in 1813–14
that there were 'wooden gods' on Nukuhiva and that
this species was used for images.

Provenance: This piece may be localised to Nukuhiva
Island in the northern Marquesas because 'Nukahiva,
Marquefas Island' is written in ink on the back of the
head. This attribution is also recorded in the Report
of the Leeds Philosophical and Literary Society for
1881–2, when this and other items were acquired from
the widow of H. W. Eyres, who had collected them
'during a voyage round the world'. Unfortunately
further collection data is lacking (information cour-
tesy of Barbara Woroncow, City of Leeds Museum
and Art Gallery).

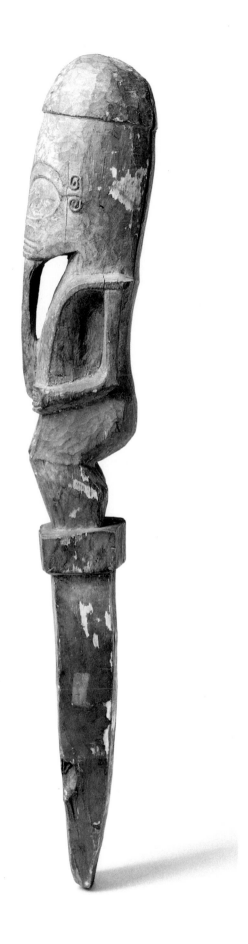

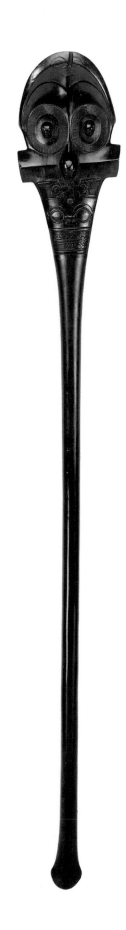

Marquesas Islands

Club
Early 19th century
Wood
l. 58¼ in (148.0 cm); head w. 7½ in (19.0 cm)
Acquired 1963 UEA 193

This distinctive form of club (*'u'u*), which was recorded by Cook and other early visitors to the Marquesas Islands, continued to be made until about the middle of the nineteenth century, by which time European influences and diseases had considerably disrupted the local culture. Later in the century smaller, lighter, more elaborate and less well finished versions were made for sale.

 Traditionally most able-bodied men possessed a club, for inter-tribal disputes occurred frequently, both within and between islands. These clubs were probably produced by specialist craftsmen working in the service of tribal chiefs, then distributed beyond the tribe via exchanges or as the spoils of war. They exhibit a remarkable consistency in their general appearance (see von den Steinen, 1928: vols. II, III; Oldman, 1943: pls. 91–6; Phelps, 1976: pls. 53–6), though the details are seldom identical. This example is representative and very finely finished. A plain shaft with flaring butt expands into a bifacial club head, the 'foreheads' of which incline outwards and form a saddle-shaped link between. It is carved from 'ironwood' (*Casuarina equisetifolia*), and the dark glossy patina was produced by immersion in a local black mud followed by polishing with coconut oil. Formerly the lower part of the shaft may have been bound with coir cordage and tufts of dog hair.

 Although interpretation of the detailed design is not possible, given the paucity of information available, the general form of these clubs is clearly anthropomorphic. They were a kind of god/ancestor image for direct practical use and their symbolic importance is evidenced by the considerable care expended on their manufacture and decoration, for their potency and effectiveness ultimately derived as much from ancestral favour as from their purely technical qualities. This anthropomorphism is a characteristic of clubs from many parts of Polynesia, where specifically bifacial examples occurred in the Marquesas Islands, New Zealand and Easter Island.

Provenance: Formerly in the collection of Kenneth Webster.

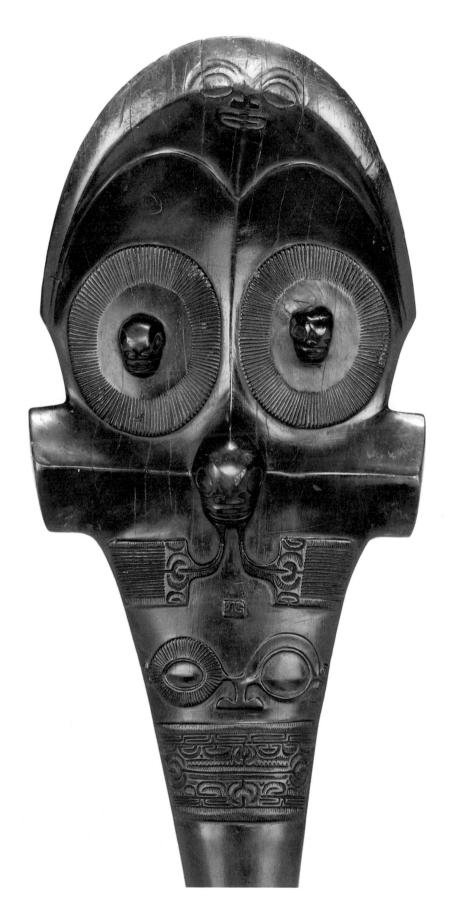

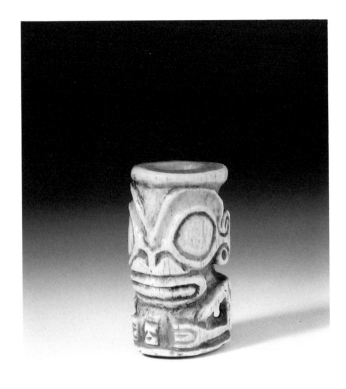

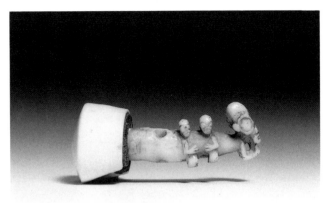

16

Marquesas Islands

Toggle
Early/mid 19th century
Bone
h. 2 in (5.1 cm)
Acquired 1961 UEA 194

Small toggles of this type, called *ivi po'o*, were used to
secure the human hair or fibre bindings on slings,
calabashes, shell trumpets and other ritual objects.
They are carved in human limb bone in the form of
the head and upper body of a stylised figure. This
example may be regarded as representative, having
neatly carved features, pierced arms and a small
raised square panel on the back of the head, engraved
with either two or three curving lines enclosing each
corner. The characteristic Marquesan 'spectacle' eye
form and inverted T nose are clearly rendered. No
attempt has been made to achieve proportion, the
head, as is usual in most tribal sculpture, being
strongly emphasised.

Provenance: Formerly in the collection of Kenneth
Webster.

17

Marquesas Islands

Woman's ear ornament
Early/mid 19th century
Whale ivory, *Conus* shell, wood
l. 2 in (5.1 cm)
Acquired 1964 UEA 195

Small ear ornaments (*taiana*), often carved with tiny
figures, were worn by women in each earlobe with the
Conus shell cap facing forwards. This example is for
the left ear, and the whale ivory section is pierced
vertically near the cap for a peg to hold it firmly in
place when being worn (see von den Steinen, 1928:
III: BP, BR). The feet of the two figures on the shaft
are chipped. Marquesan men and women wore a
variety of ornaments made from wood, shell, bone,
whale ivory, seeds and feathers and the men were
renowned for their full body tattoo.

Provenance: Formerly in the collection of Harry
Beasley.

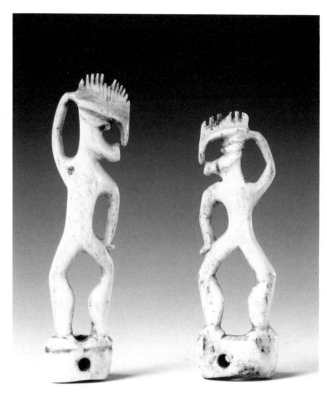

18

Hawaiian Islands

Wrist ornament
Late 18th century
Bone, turtle shell, human hair
l. 1⅝ in (4.1 cm)
Acquired 1964 UEA 196

Captain Cook's visits to Hawaii in 1778 and 1779
during his third voyage were the first made by
European ships to the group, although trading vessels
had been crossing the north Pacific between the
Americas and the Orient since the sixteenth century.
David Samwell, surgeon aboard Cook's ship the
Discovery, observed that Hawaiian women he saw
wore 'little Images of turtle made of bone on their
Fingers like we do Seals, and some wear them on
their wrists' (Beaglehole, 1967: 1180). Several turtle
ornaments were collected at this time (Force and
Force, 1968: 95; Kaeppler, 1978: 97) and although no
collection history exists for the present example, it is
closely comparable to documented turtles and
certainly dates from this contact period.

The turtle, an animal of ritual significance in many
Polynesian cultures, is beautifully rendered here in
bone (probably human), with features clearly defined
and eyes inlaid with tiny pieces of turtle shell. The
underside is pierced three times for bracelet cords of
8-ply braided human hair, a highly valued material,
which may have been provided by the locks which
were cut off during mourning for an eminent person
or after a woman's marriage or first childbirth.

Provenance: Formerly in the collection of Kenneth
Webster.

19

Hawaiian Islands

Two dancing figures
Early 19th century (?)
Bone
h. 3⅜ in (8.6 cm); 3¾ in (9.5 cm)
Acquired 1962 UEA 197

These figures are an enigma, for their function is
unclear and no other examples are known. They are,
nevertheless, stylistically of interest in that the head
form, with arching crest and chin, corresponds to
certain old Hawaiian wood images (see Cox and
Davenport, 1974: 135, 141, 166–7) and the posture,
though unusual, can be seen in an early illustration of
female dancers (Choris, 1822: pl. XVI). They may be
the 'one-off' creation of an artist in the early decades
of the nineteenth century, or possibly a result of the
traditionalist revival which took place in Hawaii in the
1880s during King David Kalakaua's reign (see Rose,
1980: 215). The hollow bases are each pierced twice,
presumably for attachment, though whether to a
staff or *kahili* handle is not certain. However, probable
saw marks can be detected on the base of the larger
figure and the possibility that they are not authentic
Hawaiian objects cannot be discounted.

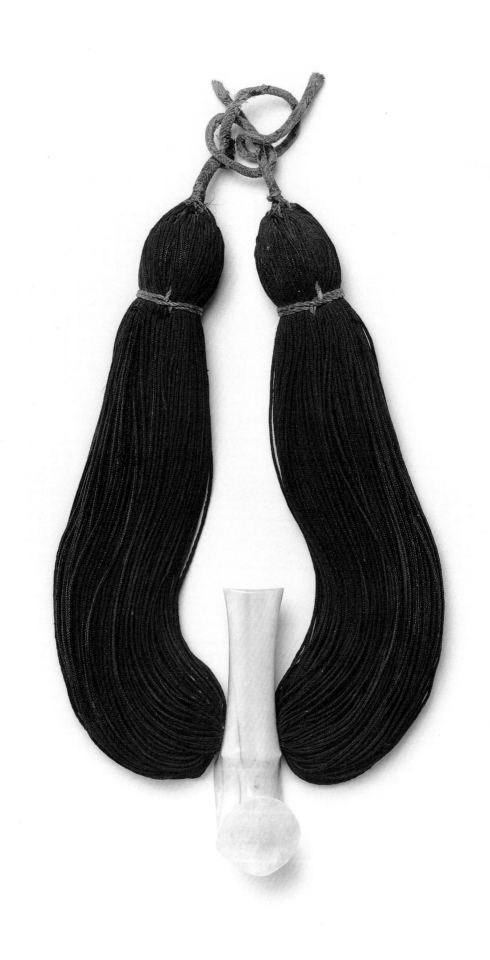

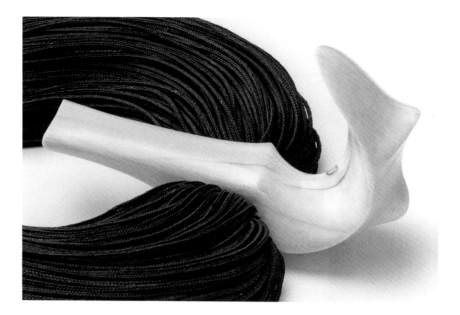

Hawaiian Islands

Neck ornament
Late 18th/early 19th century
Whale ivory, human hair, fibre
l. 11½ in (29.2 cm);
Pendant l. 4⅝ in (11.8 cm)
Acquired 1984 UEA 876

A number of traditional Hawaiian art forms underwent an increase in scale and technical refinement during the period following initial European contact in 1778 and prior to the dramatic religious and political changes of 1819. This was in part a response to the political and ritual centralisation which was taking place in Hawaii at the time and was also facilitated by the increasing availability of metal tools. This trend is noticeable in wood temple images and also in hook-shaped ornaments of the type shown here (*lei niho palaoa*), for only smaller examples in whale ivory, wood or shell were collected during Captain Cook's visits (see Kaeppler, 1978: 91–3).

The Hawaiians did not hunt whales, but relied on stranded sperm whales as their source for ivory. However, in the last years of the eighteenth century, European traders began to supply large whale teeth and even walrus tusks to Hawaiian craftsmen, thus allowing the development of the larger form. Choris (1822: 19) made an interesting observation on the type during his visit to Hawaii in 1816. He wrote: 'Les femmes portent souvent au cou des tresses de cheveux d'hommes, auxquelles est suspendu par devant un morceau d'os taillé en forme de langue; c'est ordinairement de la dent de cachalot que les Américains vendent très-cher aux insulaires.'

Of these larger necklaces this example is unique, for the artist has refined the basic form by adding two ridges at right angles to one another on the underside of the hook pendant. It is suspended between thick looping bunches of 8-ply braided hair, which are joined by a fibre cord passing through a hole in the pendant. Walrus ivory pendants can normally be distinguished from whale ivory ones by the crystalline core which runs down the centre of the tusk.

The hook shape is an ancient Polynesian design form. An example of a hook neck pendant, possibly dating to AD 1000, has been excavated on Hawaii Island (Rose, 1980: 126,197), and related objects were also made by the early Maori (Mead, 1984: 179; Duff, 1950: 110–22). The significance of the form is not clear, though Choris's reference to the tongue is quite feasible, since the tongue was also important in New Zealand Maori iconography.

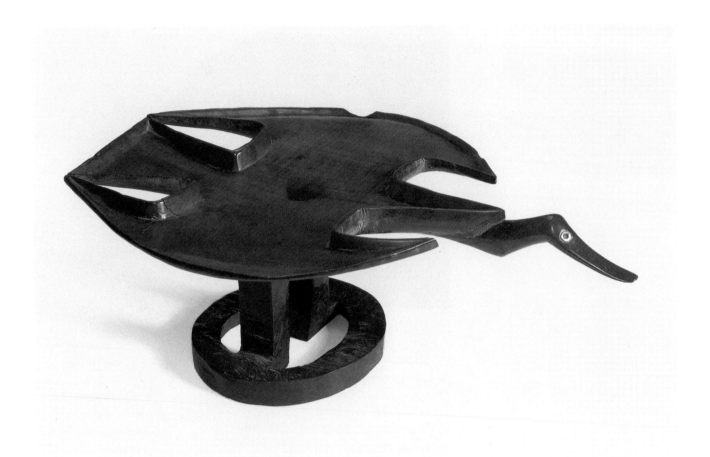

21

Fiji

Priest's *yaqona* dish in duck form
Early 19th century
Wood, shell
l. 18¼ in (46.3 cm); h. 5¾ in (14.6 cm)
Acquired 1985 UEA 912

Fijian pedestal *yaqona* dishes in any form are rare, and this is one of
only four examples known in the shape of a duck. The flat body and
outstretched wings are carved as an elegant shallow dish, which is
supported by two square-section legs on a circular base. The head
is clearly that of a duck, with the upper bill slightly overlapping the
lower, as can be seen in the detail. The inner surface of the dish and the
head are beautifully smooth, whereas the underside and the base are
unpolished, with adze marks still evident. The whole sculpture is carved
from a single piece of *vesi* (*Intsia bijuga*), a Fijian hardwood which was
favoured for items of ritual importance. The shell ring for the left eye
is missing.

 Special *yaqona* dishes (*ibuburau ni bete*), carved with elaborate stands,
were an important part of a priest's ritual equipment in pre-Christian
Fiji, notably on Viti Levu, where most examples have been found (see
Roth and Hooper, 1989, for several collected in the 1870s by Baron von
Hügel). The significance of the duck form of this dish is unclear.

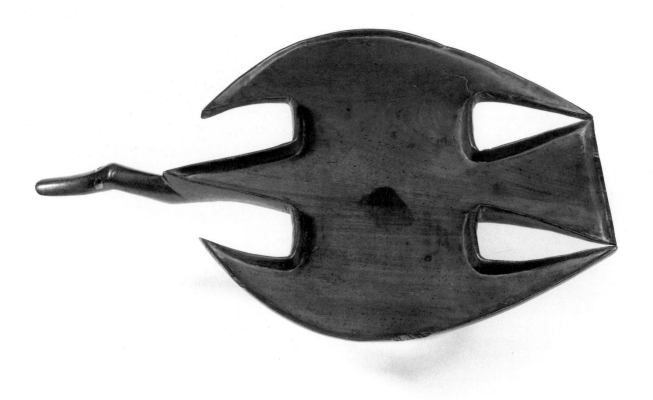

Although indigenous to Fiji, the duck does not appear to have been a creature of general ritual importance, though it may have had some specific totemic associations with particular groups.

Yaqona, more generally known by the Tongan name *kava*, was, and is, a drink of great ritual significance in Fiji. It is prepared from the roots of a species of pepper plant (*Piper methysticum*), mixed with water. Clunie (1986: 168-75) has discussed at length the two basic *yaqona* drinking methods employed in Fiji – the indigenous priestly *burau* rites, for which this dish was used, and the Tongan-influenced 'kava circle' ceremony, for which a plain circular bowl (*tanoa*) on four or more legs was used. The *burau* method, by which priests entered a trance state, virtually ceased with conversion to Christianity during the third quarter of the nineteenth century, whereas the *kava* circle method has developed to become one of the most important of Fijian state ceremonials.

The principal role of the pre-Christian priest was to act as a channel for communication with gods and spirits. After drinking an infusion of *yaqona* through a wood or straw tube, the priest entered a trance and became possessed by the god. The god would speak through him and could be addressed by supplicants for the purpose of asking favours, seeking medical cures or for discovering the origin of sorcery.

The precise history of this dish is not known, but examination of historical sources, and of the three other extant duck dishes, allows us to suggest that it may be the example given to John Erskine during his visit to Fiji in 1849, and also the one illustrated by Williams in his *Fiji*

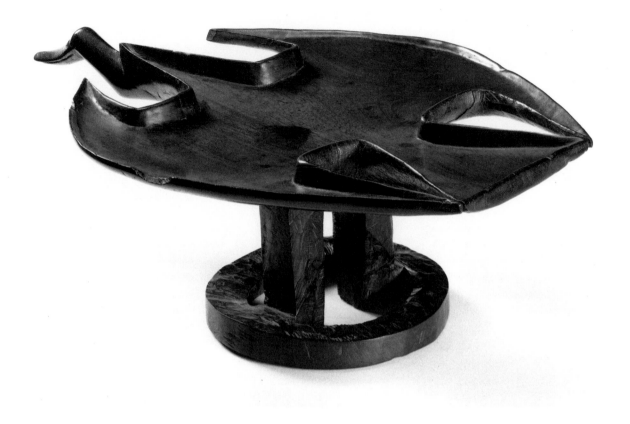

and the Fijians (1858: 77). Beasley noted this possibility in his short article on this dish (1922: 133), but took the matter no further.

In the earliest known published reference to this type of dish, John Erskine wrote that at Viwa on 15 August 1849 the missionary James Calvert gave him 'a rare specimen of a priest's sacred kava-bowl, carved in rude imitation of a duck, acquired from some recently Christianized community' (Erskine, 1853: 200). The Reverend Thomas Williams, who collaborated with Calvert on *Fiji and the Fijians*, also refers to such a dish. In a general summary he wrote, 'Fancy oil dishes and yaqona bowls, chiefly for the priests, are cut . . . out of very hard wood, and the former in a great variety of forms. I have seen one carved like a duck, another like a turtle' (Williams, 1858: 77).

Fortunately, Williams provided a drawing of a duck dish (shown opposite) which is very similar to the present example, despite some distortion in scale and perspective, particularly of the base. The dish in the drawing has a circular base, square-section legs, and – a feature which is clearly emphasised – the central part of the dish extends along the neck of the bird, beyond the wing tips.

Of the three other known duck dishes, none corresponds so closely to the Williams drawing as the present example. One in the Fiji Museum is known to have been collected by Williams, but it has cylindrical legs and the neck part barely extends beyond the wings. The other example in the Fiji Museum was collected in the late 1850s and has a conical stand (Clunie, 1986: 86). The fourth dish, in Tasmania, has no history, and although similar in general form to this dish, its legs are cylindrical,

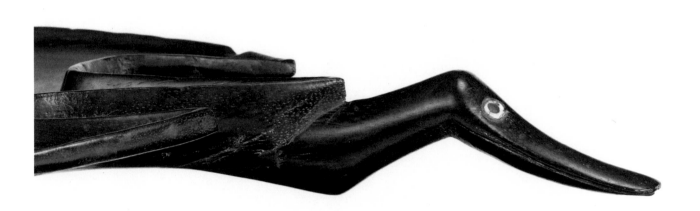

while the central part of the dish does not extend beyond the wing tips (Ewins, 1982: 60). There is a further small bird dish in Auckland (Oldman, 1943: pl. 70), but it differs markedly from the duck dishes in the form of the wings and the angle of the head.

Until further evidence comes to light, this little ethnohistorical puzzle will remain unresolved, though it is safe to say that all such dishes date to the period before Christian conversion (1840s to 1870s) and the cessation of formal *burau* rites.

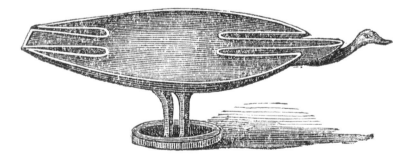

Drawing from Williams (1858: 77)

Provenance: Formerly in the collection of Harry Beasley, no. 354, purchased in Canterbury, Kent, in 1908 from A. E. Hobday (information courtesy of John Hewett). Possibly collected in Fiji in 1849 by John Erskine (see discussion above).

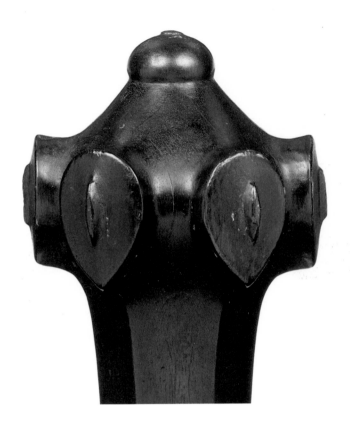

22

Fiji

Club
18th/early 19th century
Wood
l. $41\frac{1}{2}$ in (105.4 cm); head w. $3\frac{3}{4}$ in (9.5 cm)
Acquired 1984 UEA 894

Although clubs from the Fiji-Tonga area are numerous, this particular
type is rare and examples are found mainly in collections of early
material. Two examples in the Peabody Museum, Salem (nos. E4800,
E4840) were acquired in 1823. It is not possible to be certain that this type
originates from Fiji, for although the bulbous club head, grip carving
and butt form are characteristic of Fijian clubs (see Clunie, 1977), the six
oval faces around the club head correspond more closely to faces on
Tongan images than to Fijian forms (see Oldman, 1943: pl. 45–6; Larsson,
1960). Tongan images are thought to have been produced in Ha'apai, the
central of the three groups of islands which compose Tonga, and since it
is clear that there was considerable communication between Fiji and
Tonga it is possible that these clubs were made by Tongan craftsmen
resident in Fiji.

 This example is made from a heavy hardwood, probably *vesi* (*Intsia
bijuga*), a material from which many items of ritual importance were
carved. This, combined with the anthropomorphic imagery, makes it
a kind of god/ancestor image, a conception consistent with club forms
from other parts of Polynesia (see no. 15, Marquesas club UEA 193).

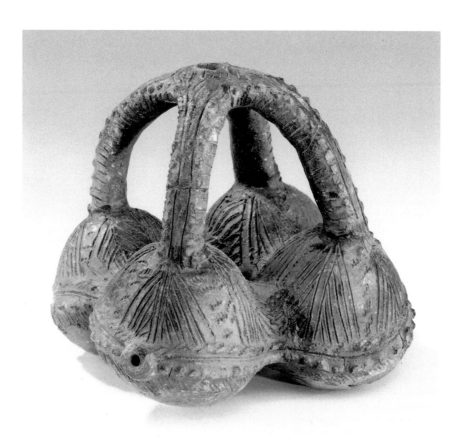

23

Fiji, south-east Viti Levu

Water vessel
Mid 19th century
Pottery
h. 6½ in (16.5 cm)
Acquired 1982 UEA 811

This water vessel (*saqa moli*) is composed of four linked chambers, modelled to represent citrus fruits (*moli*). One chamber has an access hole and its opposite partner a spout positioned on the outer rim. The handle is pierced at the top for a suspension cord.

Pottery manufacture was the work of women and there were a number of centres of production in Fiji. This example probably comes from the Rewa delta area of south-east Viti Levu. Completed pots, made from local clay and a temper of river sand, were open-fired and a glaze, or more accurately a varnish, of local kauri gum (*makadre*) was applied immediately to help resist leakage (see Ewins, 1982: 70–3 for a similar example and details). Such elaborate works as these were easily damaged and this one has been broken and repaired.

Pottery appears to have been made in Fiji without interruption since earliest human settlement (before 1300 BC on current evidence, Bellwood, 1978: 250), though production is now mainly directed at the commercial market. Formerly a wide variety was used for cooking and storage, but in the late nineteenth century both production and use declined as European containers became increasingly available.

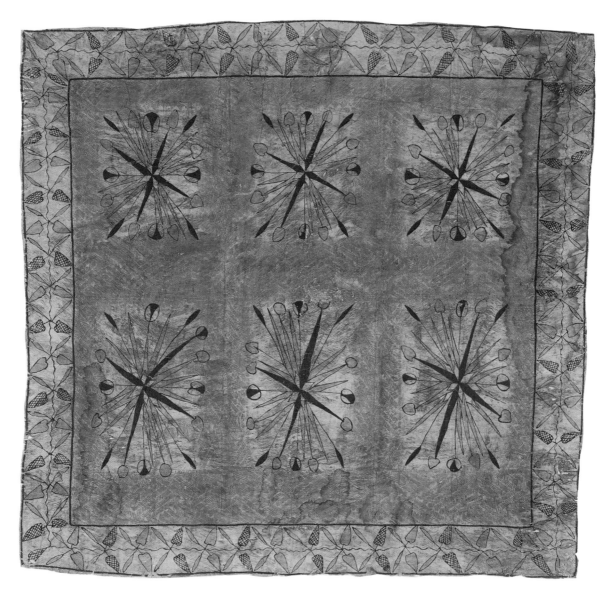

24

Western Polynesia

Tapa cloth
Early/mid 19th century
Bark
$55\frac{1}{2}$ in (141.0 cm) × 60 in (152.4 cm)
Acquired 1984 UEA 896

In tropical Polynesia the loom was not used and the
principal material for clothing and bedding was bark
cloth, generally known by the Tahitian term *tapa*.
This was, and in many parts of Western Polynesia still
is, made by women from strips of the inner bark of
the paper mulberry (*Broussonetia papyrifera*), which
were soaked, beaten with wood mallets and then
felted or gummed together to form large sheets of
varying texture.

Decorated *tapa* was used as special 'seats', 'beds',
clothing, wrappings and shrouds for ceremonies
connected with birth, marriage and death and for
other important rituals. The designs were applied by
a variety of methods and are often distinctive and
attributable to particular island groups (see Kooijman,
1972). However, the precise origin of this fragile and
fine-textured example is not easy to identify, though
the star designs, foliate border and reddish chevron
background (produced by rubbing on a design tablet)
point to a Western Polynesian origin, possibly Futuna,
Uvea, Samoa or Niue (*cf.* Brigham, 1911: pl. 17). This
cloth has suffered some damp staining and a previous
owner has restored damaged areas with bark cloth
patches, coloured appropriately.

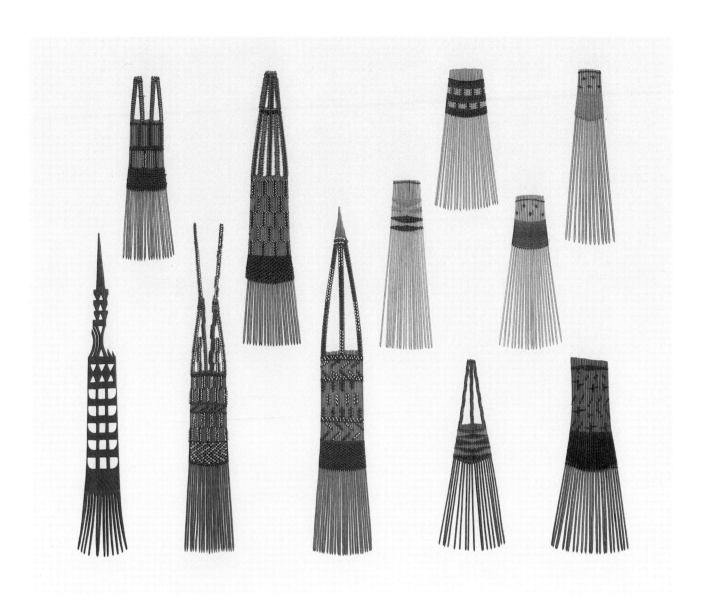

25

Samoa and Tonga

Eleven combs
19th century
Coconut leaflet midribs, coir, wood, beads
l. (see below); longest 13½ in (34.9 cm)
Acquired 1979/1983 UEA 424 A–K

Decorative combs or, more properly, hair ornaments
were worn by both men and women in Samoa and
Tonga. In Tonga they were usually made entirely
from coconut materials. The dried midribs of coconut
leaflets were bound with single fibres of coir (coconut
husk fibre) in red and black patterns, resembling
those used in house beam bindings and basketry.
The browny-red colour is natural, while the black is
produced by steeping the fibres in a local black mud.

In Samoa a larger variety of this type was made,
having European glass beads threaded on to the coir
fibres in decorative patterns. Wood forms with long
carved handles were also worn. Combs circulated
widely through inter-island exchanges and thus were
also used in neighbouring Fiji.

Details: left to right. SAMOA: (a) 12¾ in (32.4 cm);
(b) 7½ in (19.0 cm), ex Beasley collection, 3349, acquired
1931; (c) 13 in (33.0 cm); (d) 11 in (27.9 cm); (e) 13½ in
(34.9 cm). TONGA: (f) 6¾ in (17.2 cm); (g) 5⅝ in (14.3 cm);
(h) 6⅛ in (15.5 cm); (i) 7 in (17.8 cm); (f) to (i), top four,
formerly owned by Sir Ralph Darling, *c*. 1830; (j) 7½ in
(19.0 cm); (k) 7⅝ in (19.4 cm).

Melanesia

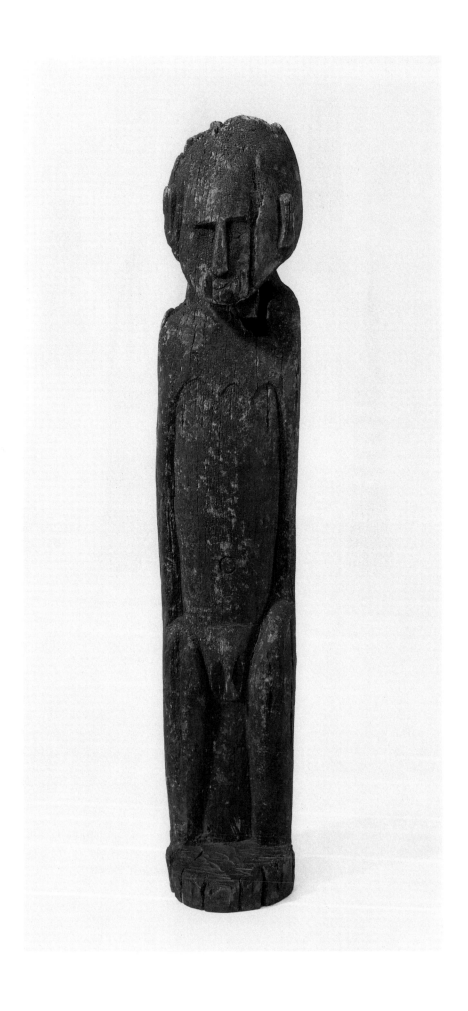

26

New Guinea, Lake Sentani

Housepost figure
19th/early 20th century
Wood
h. 39½ in (100.3 cm)
Acquired 1939 UEA 156

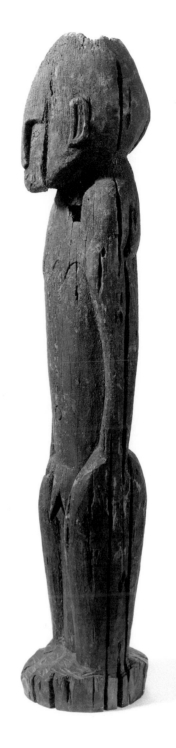

Prior to missionary activity in the Lake Sentani area during the first decades of the twentieth century, the villagers living around the shores of the lake built large ceremonial houses which were constructed on piles over the water. These houses also served as the residences of the village leaders (*ondoforo*), who presided over rituals and other matters affecting the general welfare of the community. The main posts which supported the ceremonial house were carved with images of ancestral and mythic importance, and the present sculpture is a fine example of this type. It has been cut from the top of a post which originally projected up through the floor.

A range of human images of this kind survive (see Kooijman, 1959), some male, some female, others with breasts and prominent sexual parts which make their sex ambiguous, as in this case. There are also a number of mother and child images – an iconographic association between housepost figures and sexual fertility which is also apparent in the general phallic appearance of this particular example.

Sentani sculptures are widely admired as 'powerful' works of art by western critics, and in an essay on western approaches to non-western art Edmund Leach suggests why this type of reaction may occur. He writes that one reason for our strong response lies to some extent in an image's partially disguised sexual ambiguity, which 'makes us aware, in a barely conscious way, that here is something quite out of the ordinary' (Leach, 1973: 234). This comment seems particularly valid for this figure, as indeed it is for several other 'powerful' sculptures in the Sainsbury Collection, notably the 'fishermen's god' from Rarotonga (UEA 189, see above).

Lake Sentani figures were carved from very heavy hardwood, which no doubt helps explain the survival of this example. It was probably made towards the end of the nineteenth century, possibly with stone-bladed tools, and has weathered as a result of mistreatment and long exposure to the elements. Much of the surface has a charred appearance, which obscures details of the eyes, breasts and shoulder blades, and it seems likely that during the early period of missionary influence this image was burned before being cast into the lake (see Kooijman, 1959: 7).

Provenance: Collected in 1929 by Dr Jacques Viot from beneath a derelict ceremonial house on Lake Sentani (Kooijman, 1959: figs. 39, 42). Formerly in the collection of Pierre Loeb, sponsor of Viot's expedition.

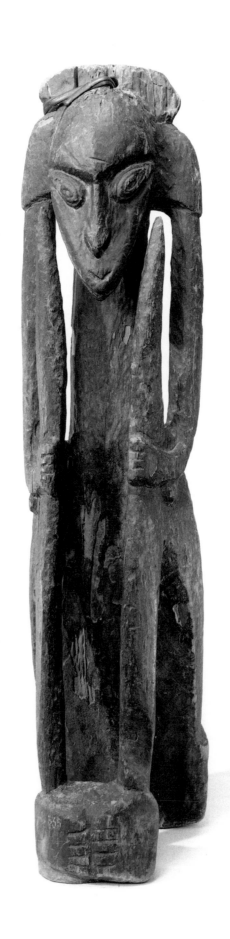

27

New Guinea, Lower Sepik River

Seated figure
19th century
Wood, cane
h. 37¼ in (94.6 cm)
Acquired 1954 UEA 157

No collection data exists for this large image and
only one comparable example has been found in the
literature – a sculpture formerly in the De Miré
collection which is similar in form, though clearly the
work of a different hand (Dr O., 1929: fig. 24). The
De Miré image is attributed to Irian Jaya, though on
what evidence is uncertain, whereas the head, eyes
and feet of the present piece suggest a Lower Sepik
origin. It has previously been ascribed to the
Anggoram/Kambot groups (Wardwell, 1967: 40).

Given the lack of information about its origin, little
can be said about the function of this piece, except
that it is almost certainly an image of an ancestor or
spirit. Technically it is unrefined, except for the head,
yet it is remarkable in over-all concept. The
positioning of the projections which extend upwards
from the knees, combined with the anatomical
distortion, creates a particular balance in which the
spaces between the carved elements contribute
crucially to the image's success as a sculpture. It is
unlikely that the impact would be so great if the knee
projections were absent.

The appearance of the surface carving, especially on
the lower part of the back, where grooves indicate the
passage of a curved adze blade, suggests that stone
tools were used. On this evidence the image may well
date back to the mid nineteenth century. At some
time in the past it has suffered severe insect infes-
tation, while a potentially disastrous split down
the body has been prevented by a local repair with
cane binding. Steadying supports have been added
beneath the right foot and buttock.

Provenance: Formerly in the collections of Walter
Bondy and Pierre Loeb. It bears the numbers 9 (in
red) and 335 (in white) and appears in a photo taken
in Pierre Loeb's apartment, Paris, in 1929 (Rubin,
1984: I: III, far corner of shelf). This is one of three
fine Sepik sculptures in the Sainsbury Collection
which were once owned by Walter Bondy (see
following two items). An auction of Bondy material
was held in 1928 at Hotel Drouot, Paris, but none of
these sculptures appeared in that sale.

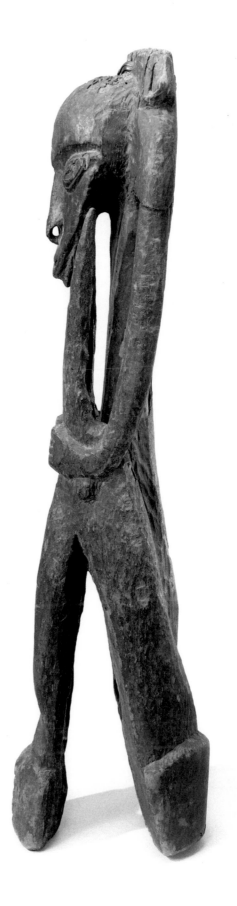

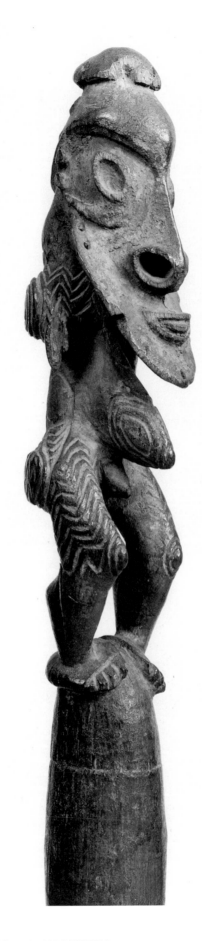

New Guinea, Yuat River, Biwat

Male figure
19th century
Wood
h. 14 in (35.5 cm); figure h. 10 in (25.4 cm)
Acquired 1954 UEA 159

Although weathered and damaged this figure retains great sculptural vigour. The arms, now broken, would have reached forwards with the palms of the hands held inwards, a position which in profile would have enhanced the existing rhythm achieved by the chin, projecting abdomen and knees. Fraser (1955: 20) noted 'a high degree of assertiveness' and an 'emphasis on aggressive qualities' in Biwat sculpture, and these characteristics are certainly in evidence here. The Biwat (formerly known as Mundugumor) were highly appreciative of fine wood sculpture, for sculptures were important as exchange valuables, and their possession conferred high status on the owner.

The original function of this piece is not clear. The base seems too large for use as a flute or lime tube finial, yet there is no apparent grip for use as a taro or sago beater. The groove around the base suggests that it was fixed to something, and its most probable use was as a flute finial. It has previously been attributed to the Iatmul (Wardwell, 1967: 74), but it undoubtedly originated from the Biwat people of the Yuat river, a tributary of the Lower Sepik. It resembles other known Biwat pieces, in particular a flute finial which was collected by Margaret Mead in 1933/4 and is now in the American Museum of Natural History, New York (Wardwell, 1967: 52). Eichhorn (1929: 75) has referred to this image as 'la figure du mort', but upon what grounds is not clear.

From the appearance of other Biwat figures the perforations around the chin would formerly have held a beard of human hair, while numerous feather and shell ornaments would have been attached to the neck, body, cap and ears. The eyes were inlaid with shell. There are traces of paint over most of the figure, white, red and black all being discernible. Early photographs show that previously there was more white paint on the face (see Eichhorn, 1929: 74; Basler, 1929: 68). The surface engraving is carefully done, notably on the back.

Provenance: Formerly in the collections of Walter Bondy, Madeleine Rousseau, Stephen Chauvet and Pierre Loeb.

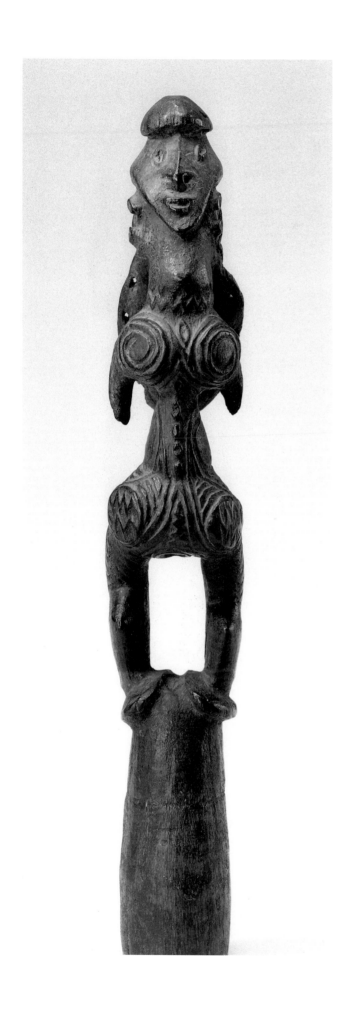

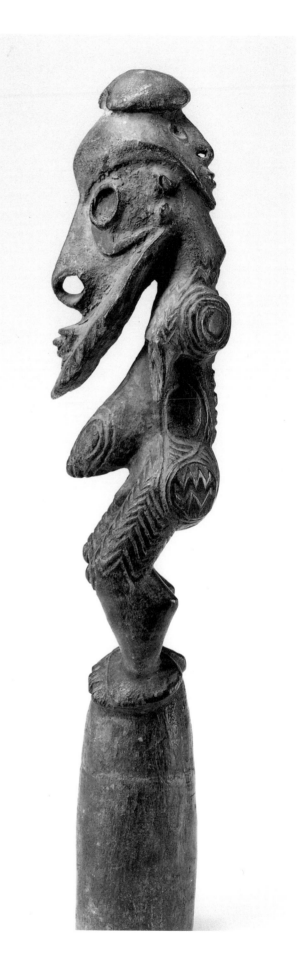

New Guinea, Yuat River, Biwat

Flute finial
19th century
Wood, cane
h. 19 in (48.3 cm)
Acquired 1954 UEA 158

This is a fine old Sepik sculpture, which was already
in Europe by the 1920s and was probably collected
long before. There appears to be nothing comparable
in the Berlin or Basle museums (see Kelm, 1966, 1968;
Kaufmann, 1980), which have extensive New Guinea
material collected during the early part of this
century. A similar image is in the Mission Museum at
Steyl in Holland (illustrated in Muensterburger, 1955:
pl. 82), which was acquired by them prior to 1916.

Sacred flutes were, and in some places continue to
be, an important part of men's cult activities in many
parts of New Guinea. They are composed of bamboo
tubes between three and eight feet long and are in
some cases fitted with carved finials such as the
present example. Their precise use varies, but they
are usually revealed as part of the initiation rituals by
which boys are introduced to the secrets of the men's
cult. Some flutes are for display only, but others are
played and the sounds produced by flutes, drums
and bullroarers are said to be the 'voice' of the spirit
patron (generally called *tamberan* or *tambaran*) of
the men's cult.

An informative account of the complexities of
initiation rituals and the central role of the men's
cult in a Sepik society has been written by Tuzin
about the Arapesh, entitled *The Voice of the Tambaran*
(1980). Practices vary, but in general terms it can be
said that, through the rituals of their cult, men
communicate with spirits and ancestors and claim
exclusive knowledge of the mysteries of life, death
and fertility. The possession of such important secret
knowledge places men in a position of power with
respect to women and the uninitiated.

Among the Biwat (formerly known as the
Mundugumor) there were no great men's cult houses.
Individual ownership of sacred objects, like flutes,
conferred prestige, and they could only be viewed by
initiates who had made appropriate presentations
of feasts and valuables. Fraser (1955: 17) illustrates a
complete flute and refers to flute carvings as the
'most important objects made by the Mundugamor'.

Margaret Mead, who visited the Biwat in the early
1930s, has written vividly of the significance of flutes:

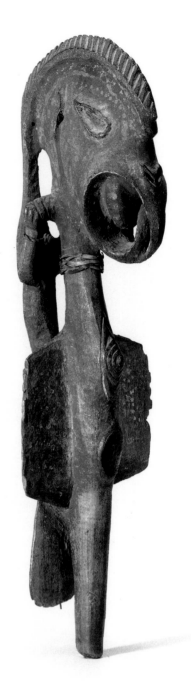

'. . . to enter and see the sacred flutes with their
tall, thin, shell-encrusted standards surmounted
by a manikin figure with a huge head, wearing a
diadem of shell and hundreds of graceful and
valuable decorations from the midst of which its
mother-of-pearl eyes gleam – this is an experience of
importance. About these sacred flutes, the hereditary
possession of a rope [a term used to refer to a res-
idence group], the almost equivalent of a woman,
these flutes upon which all the artistic skill of the best
carvers and the cherished valuables of a whole group

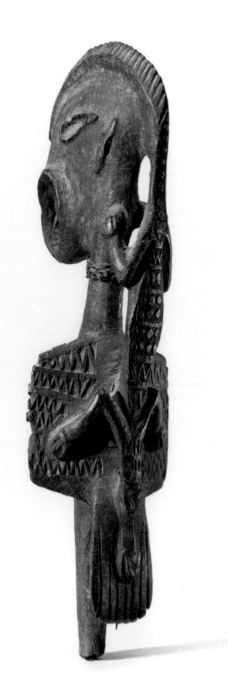
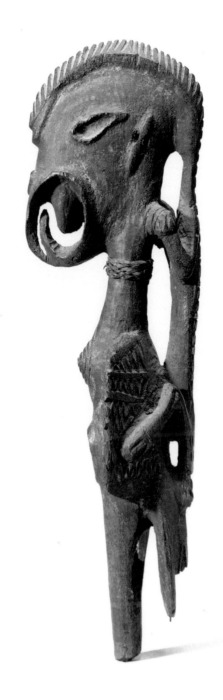

of men have been lavished; is centred the pride of the Mundugumor [Biwat] . . . of their flutes they are inordinately proud; they call them by kinship terms, they offer them food' (Mead, 1935: 213).

Mead also states that flutes represent both bush and water spirits, and the present example would appear to refer to both categories. It has lost the numerous pendants which formerly hung from the wings, ears and neck, but nevertheless this allows us to appreciate the bold form of the bird, probably a variety of parrot, and the pleasing lack of symmetry

in the carving of the crocodile-like creature down the back. The wood is heavy and was no doubt hard to work in the pre-metal era from which this image probably dates. The shell eyes have also been lost and only traces of paint remain, mainly white on the underside of the wings and above the eyes.

Provenance: Formerly in the collections of Walter Bondy and Pierre Loeb. It appears in a photograph taken in the Pierre Matisse Gallery, New York, in 1934 (Rubin, 1984: I: 115; right side of shelf).

30

New Guinea, Lower Sepik River

Mask
19th/early 20th century
Wood
h. 13⅛ in (33.3 cm)
Acquired 1969 UEA 165

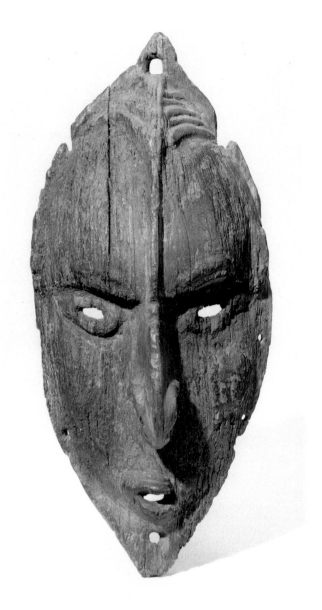

Despite erosion and damage the finely sculpted
features of this mask remain impressive. Its tribal
attribution is uncertain, but characteristic elements
like the eye, nose and mouth form indicate an origin
in the Lower Sepik or adjacent regions.

The mask was formerly part of a complete dance
costume which covered the body of the wearer and
was attached through the holes around the rim, many
of which are now broken. Feathers and shell pendants
may also have been attached. Danced masquerades
were performed throughout the Sepik area as an
integral part of a range of rituals conducted to secure
ancestral favour, promote abundance and initiate
young men into the closely guarded secrets of the
men's cult. Masquerades often celebrated the activ-
ities of the primary ancestors and were also ritual
re-enactments of important myths concerned with
fertility and the origins of society.

The mask is thin and fragile, with a dished inner
surface. The hooked nose is pierced, the cheeks are
slightly raised, and there are traces of red pigment
over the whole surface.

31

New Guinea, Middle Sepik River, Iatmul

Canoe shield mask
19th/early 20th century
Wood
h. 15¾ in (40.0 cm)
Acquired 1951 UEA 161

Not all Sepik masks were worn in danced mas-
querades. Other types, made from basketry as
well as wood, were incorporated into the facades
of men's ceremonial houses or, as in this case, were
attached behind canoe prows.

The Iatmul built long canoes for river transport
and for trading and war expeditions. Success in trade
and exchanges or in war was dependent as much on
supernatural favour as on mortal efficiency, and
canoes, the principal vehicle for such important
activities, were fitted with elaborate prow pieces
depicting crocodiles and other predatory creatures.
Behind the prow was slotted a bark or palm spathe
shield, generally having three upper extensions and
a wood mask fixed to the front. A similar mask is in
Basle (Kaufmann, 1980: no. 81, collected by Speiser
in 1930) and complete examples are illustrated in
Wardwell (1967: no. 115) and Kelm (1966: I: 496).

Although providing some physical protection from
arrows, the shield acts as a mount for the mask,
which represents the spirit associated with the canoe.
This spirit protects its occupants and threatens their
opponents. In many areas of the Pacific canoes were
associated with respected ancestors and in some cases
were built as a kind of memorial image of a particular
ancestor, who acted as its tutelary spirit.

This mask has a lug at the back by which it was
secured to the shield. The nose septum and ears, now
broken, were pierced for fibre pendants. The recessed
areas are applied with white pigment, while the
raised lines and surfaces all have traces of red.

Provenance: Formerly in the collections of Madeleine
Rousseau and Stephen Chauvet.

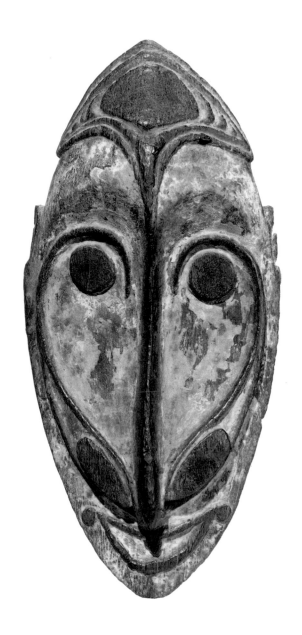

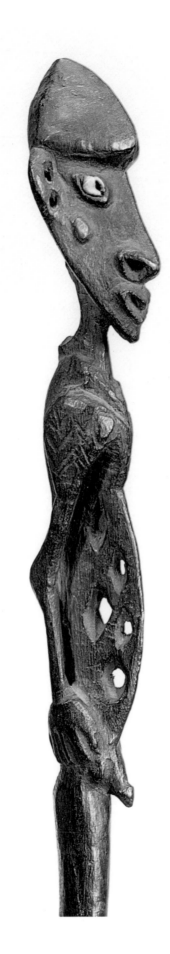

New Guinea, Middle Sepik River, Iatmul/Sawos

Flute finial
19th/early 20th century
Wood, shell
h. 16 in (40.6 cm); figure h. 9 in (22.9 cm)
Acquired 1939 UEA 160

This is most probably the finial from a sacred flute, a highly valued item used during the rituals by which young men were initiated into the secrets of the men's cult (see no. 29, UEA 158). The stick would have been bound into the end of the bamboo flute, and the male half-figure would formerly have had many shell, feather and fibre pendants attached through the apertures in the ears and nose, and also through the openwork panel on the abdomen.

This piece most probably comes from the Iatmul or Sawos peoples of the Middle Sepik, but it is not possible to give a specific tribal attribution because not only were objects traded and exchanged between groups, but carving styles were also copied. It is similar in some respects to a Iatmul example in Wardwell (1967 : 64). A single shell remains in the right eye and the neck has been broken and repaired.

Provenance : Formerly in the collection of Pierre Loeb.

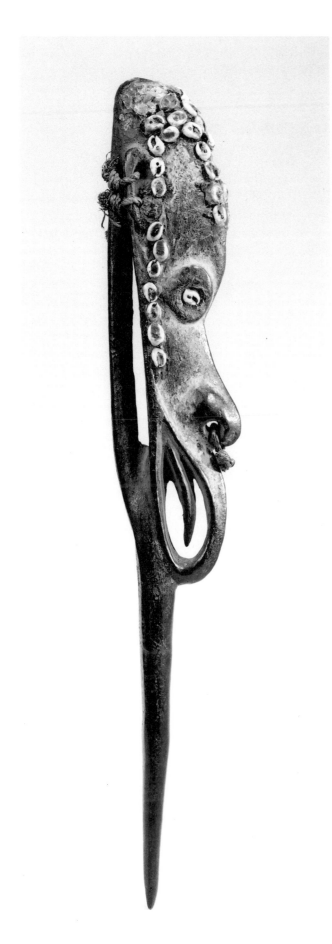

33

New Guinea, Middle Sepik River, Iatmul

Arm band ornament
19th/early 20th century
Wood, shell, fibre, gum
h. 12⅛ in (30.8 cm)
Acquired 1951 UEA 162

Arm bands and small masks were part of the finery
worn by men on important ritual occasions, together
with shell and fur ornaments, leaves, flowers and
body paint. This narrow, finely-modelled head was
probably worn on the upper arm, attached through
the vertical aperture at the back to a man's arm band.
The carving has traces of white and red pigmentation
and retains most of its shell decoration.

 It resembles in composition, especially in the form
of the mouth and the presence of shells, the wood
masks used in *mai* rituals discussed recently by
Hauser-Schaublin (1976/77, 1981; see also an example
from Niyaura in the Wielgus Collection, Newton *et al.*,
1979: 318). It is similar in form to a carving in Berlin
(Kelm, 1966: I: no. 64), but no specific function is
ascribed to that example.

Provenance: Formerly in the collections of Madeleine
Rousseau and Stephen Chauvet.

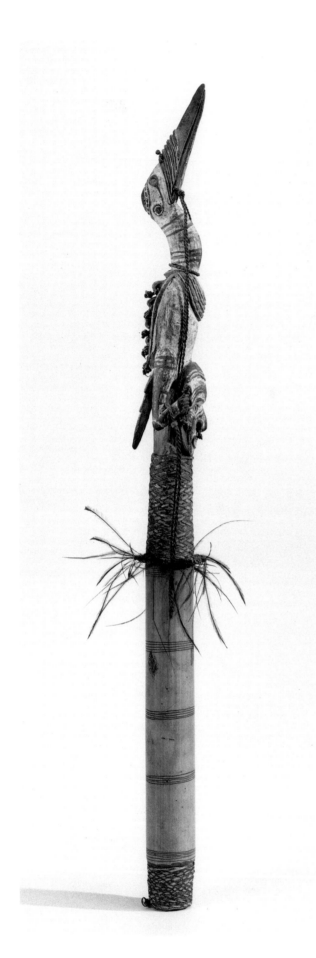

New Guinea, Middle Sepik River, Iatmul/Sawos

Lime container
20th century
Wood, bamboo, cane, fibre, feathers
l. 28¾ in (73.9 cm)
Acquired 1954 UEA 163

'Betel chewing' was, and continues to be, a custom
practised widely in Melanesia, in both ritual and
recreational contexts. The leaves of the *Piper betel*
bush are chewed with areca nuts and lime, which act
together as a mild narcotic. In the Sepik region lime
for 'betel chewing' was kept in a bamboo tube, which
was sometimes mounted at one end with a wood
carving secured with cane binding, as in this example.
The other end has an aperture for extracting the lime
with a limestick, though in this case it has been
sealed off for fitting on to a European mount.

Most initiated men possessed lime tubes, which
were flourished on public occasions. Aggressive and
assertive behaviour was expected of men, and the
rattling and scraping of the limestick in the tube was
regarded as flamboyant manly behaviour, notably
during oratory. The theme of aggression is echoed in
the lime tube finials, which usually depict a bird
clutching a crocodile or human head in its talons (see
Kelm, 1966: I: 421–37 for examples). The human head
on this example closely resembles the painted
ancestor and trophy skulls of the Sepik area.

Cassowary feathers and red, white, black and blue
paints have been used, the last not a local pigment
but acquired after the arrival of Europeans. Blue
appears predominantly on the mask and the back of
the bird's wings. The cane binding is painted red.

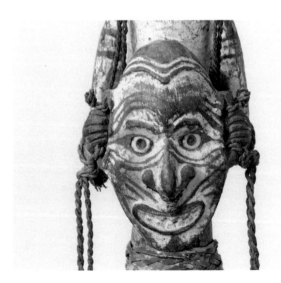

New Guinea, Middle Sepik River, Iatmul

Paint dish
Early 20th century
Wood, fibre
l. 13 in (33.0 cm)
Acquired 1974 UEA 574

Among the Iatmul hardly any artefact was left
uncarved or undecorated. This paint dish, resembling
a miniature canoe with boar/crocodile prow piece, is
carved with a humanoid face on the chest and has a
further mask as the tail, through the back of which is
looped a suspension cord. The recessed areas are filled
with grey-white pigment, which dramatically sets off
the surface patterns. Stylistically it closely resembles
a wood mallet in Berlin, which was collected at
Timbunke in 1912/13 (Kelm, 1966: I: 443).

'Paint', made from mineral and vegetable pigments,
is an important substance in New Guinea societies,
and therefore it is not unexpected that dishes for
mixing paints should be carefully made. Forge (1962)
has stressed the magical potency of certain types of
paint used in sorcery, and also noted that the painting
and repainting of house fronts, sculptures and trophy
heads was a sacred and dangerous activity.

Provenance: Formerly in the collection of Harry
Beasley, no. 2124. The Beasley catalogue has the
following entry (information courtesy John Hewett):
'A shallow pigment bowl of wood, the handle as the
head of a crocodile, the underside carved as a face.
13 inches long. Collected in 1927 by the Reverend
F. B. Bishop of the Melanesian Mission, chaplain to
the Territory, Rabaul. Purchased 18th January 1928.'

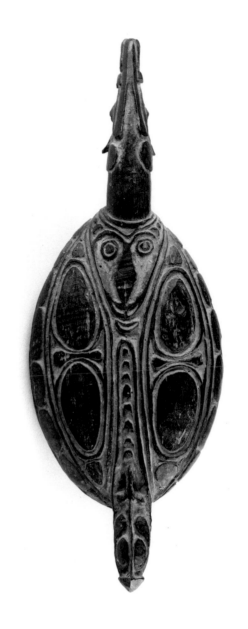

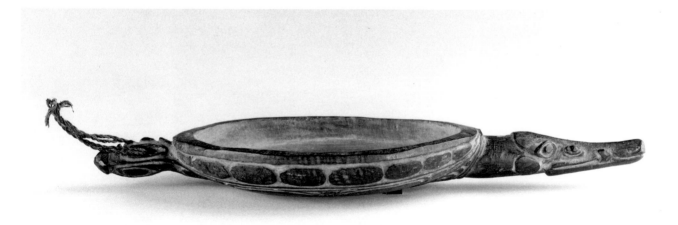

36

New Guinea, Middle Sepik River, Washkuk

Dagger
19th/20th century
Human bone, quill
l. 13¾ in (34.9 cm)
Acquired 1972 UEA 169

This dagger closely resembles an example collected
among the Washkuk in 1971 (Güell and Rusiñol,
1976: 55), and two others collected in Palimbei, Iatmul
territory, in 1913 and 1927 (Kelm, 1966: I: 460-61).
However, Anthony Forge has confirmed (personal
communication) a Washkuk origin for this example.

 In the Middle Sepik area certain bones, enshrining
the potency and spiritual power of the deceased,
were preserved after death; skulls were embellished
with painted clay features and hair, while the shin
bone (tibia) was sometimes made into a dagger, as
here. Although this example has lost its decorative
pendants of feathers and shells, which were once
attached to the quill which passes through the two
holes in the top, it has acquired a beautiful dark
honey-coloured patina, enhancing the designs
which extend all round the surface of the handle.

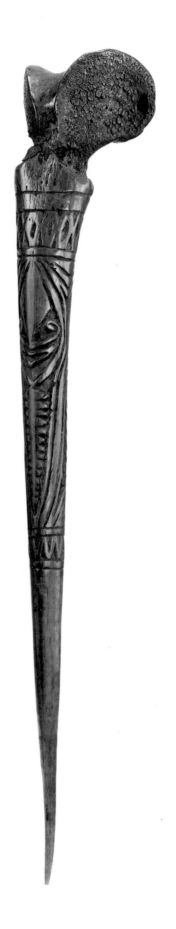

37

New Guinea, Middle Sepik River, Chambri

Suspension hook
20th century
Wood
h. 18⅛ in (46.0 cm)
Acquired 1969 UEA 166

Suspension hooks were used widely in the Middle
Sepik region for hanging valuable property away from
vermin and the danger of accidental damage. In some
cases they represent a whole figure, in others a head,
as here, both motifs no doubt signifying the presence
of a protective spirit. In the same region larger and
more elaborate versions were used to support and
display trophy skulls.

This example is probably from the Chambri, who
live south-west of the Iatmul, and is comparable to a
Chambri example collected by Margaret Mead in
1934/35 (Wardwell, 1967: no. 186). The designs are
painted rather than engraved and, although faded,
red, white and black can be seen. The head has a hole
for a suspension cord at the top and the ears are
pierced twice for pendants, now lost. The nose is
elongated and extends to the chin.

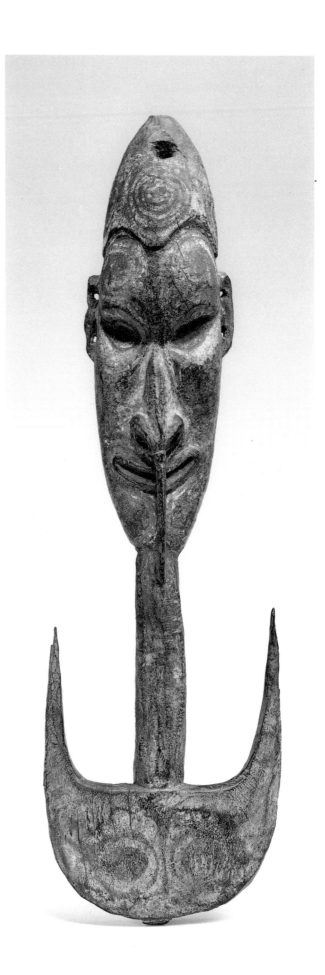

New Guinea, Papuan Gulf

Substitute trophy head
19th/early 20th century
Wood, cowrie shells
h. 13 in (33.0 cm)
Acquired 1949 UEA 153

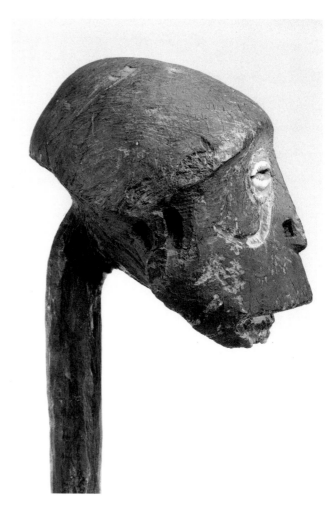

Wood substitute trophy heads were either incorporated into images constructed of cane and bark cloth or were paraded as dance clubs, with fibre pendants hanging from the nose and ears (see Wirz, 1950: figs. 2-3, for comparable examples). They were made in the central areas of the Papuan Gulf, and this example most probably comes from the Wapo Creek/Era River region of the Purari delta.

Numerous masks and images were used during the complex ceremonial cycles conducted by the people of this region to promote abundance and renewal, both societal and agricultural (see Newton, 1961, and Williams, 1940, for a vivid account of the Elema ritual cycle). Associated with these rituals was the practice of head-hunting, since sacrificial victims were required at certain stages in the cycle, such as the completion of a ceremonial house. Accordingly, a pattern of revenge raiding existed, killing expeditions rather than open warfare, in which men strove to secure a head as a mark of manhood and as a trophy to be displayed in the ceremonial house. Williams (1936: 286) noted that 'a man-slayer was . . . the object of general admiration and some envy', and also

that 'the head is regarded as the individual property of the slayer; he carries it in his arms in the dance; and he may leave it hanging under his own roof-tree. It is as much a record of his prowess in the raid as the pig and crocodile jaws are of his prowess in the chase.' Wood substitute trophy heads performed a similar function.

The head-hunting complex and its role in social life is unfamiliar to Europeans, yet this head conveys a certain grim, cadaverous quality which is instantly impressive. Although damaged about the chin and ears, the sculpture remains compelling, with an almost poignant twist to the head. There is a band of cross-hatching across the brows and a deep cavity in the centre of the mouth.

Provenance: Formerly in the collection of Pierre Loeb. A drawing of a head closely resembling this sculpture, though lacking the shell eyes and spike, appears in an article by Paul Wirz (1950: fig. 11). If the two are the same, as seems very probable, then this head was collected by Paul Wirz in 1930 in the Delta Division of the Papuan Gulf.

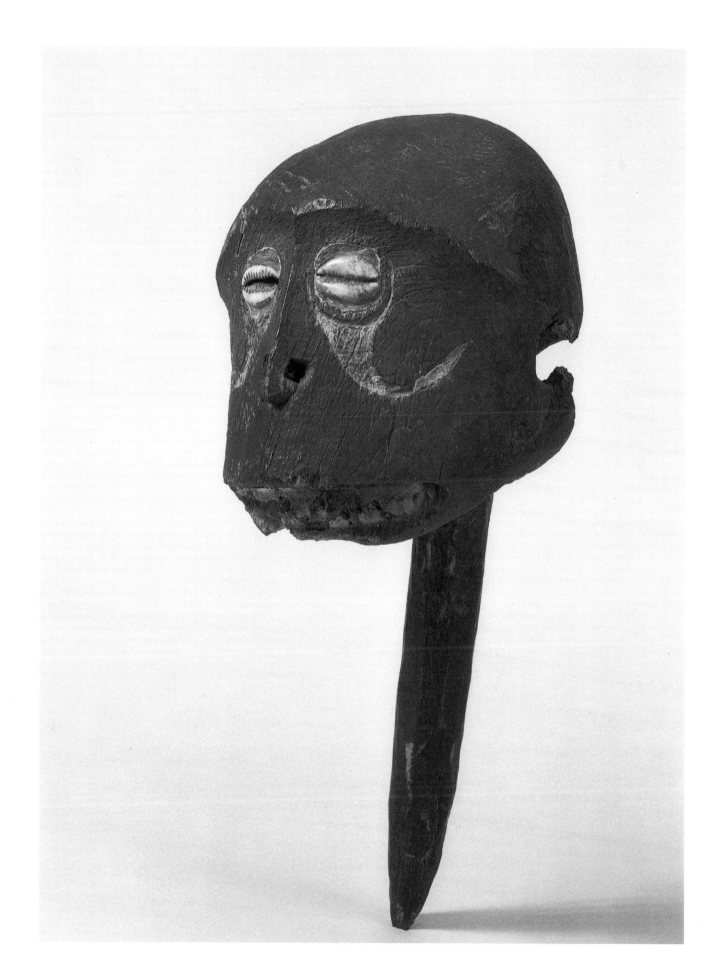

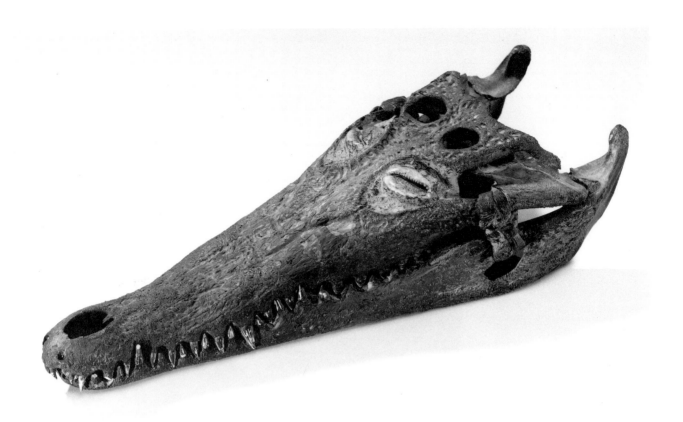

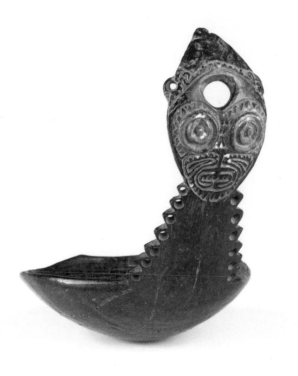

39

New Guinea, Papuan Gulf, Purari Delta

Spoon
19th/early 20th century
Coconut shell
l. 5 in (12.7 cm)
Acquired 1975 UEA 612

This delicate little spoon, carved from a section of
coconut shell, illustrates in miniature the charac-
teristic art style of the Namau and neighbouring
peoples of the Purari delta area. The circular eye and
complex mouth form may be seen more dramatically
on masks and *kwoi* boards (*cf.* Newton, 1961: 80 ff).
The central hole, probably for a suspension cord, is
formed by the natural aperture in the coconut shell.
Most of the lime inlay has been lost.

40

New Guinea, Papuan Gulf

Crocodile skull trophy
19th/early 20th century
Bone, shell, cane, fibre
l. 12 in (30.5 cm)
Acquired 1968 UEA 164

In addition to human skulls, the skulls of crocodiles
and pigs were also preserved as hunting trophies by
the people of the Papuan Gulf. Wirz (1950: pls. 5-7)
illustrates several examples which were displayed in
the ceremonial house, arranged in rows with pig
skulls or hung from specially carved skull racks.
Williams refers to them as evidence of the hunter's
prowess in the chase (1936: 286).

 The treatment of the eyes, which are cowrie shells
set into a reddened fibre pad, suggests that this skull
originates from the same area as the wood trophy
head described on page 56 (UEA 153), the Wapo/Era
region of the Purari delta. It has a smoke-blackened
appearance, no doubt the result of long exposure in
the ceremonial house.

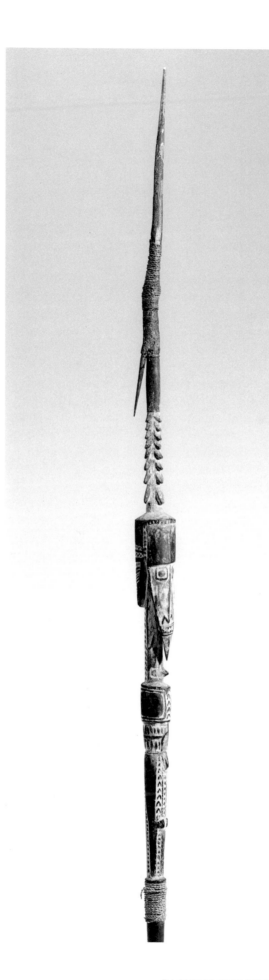

41

New Guinea, South Coast, Daudai

Arrow head
19th/early 20th century
Wood, bone, fibre
h. 26¾ in (68.0 cm); figure h. 9¼ in (23.5 cm)
Acquired 1957 UEA 154

Although generally attributed to the Torres Straits,
these arrows were made on the adjacent New Guinea
mainland and were acquired by the Torres Straits
islanders through inter-tribal exchanges (Haddon,
1912: 175). A note on this example by Douglas Fraser
states that they were made in the Daudai area and
were traded to the islands via Mowatta.

 The arrow head itself represents a stylised male
figure – the head is prominent, the body condensed
and the legs elongated. All details are highlighted by
lime, which fills the carved recesses. When complete
with cane shaft the arrow was over six feet long.

New Guinea, Trobriand Islands

Dance shield
19th/early 20th century
Wood
h. 25⅝ in (65.0 cm)
Acquired pre-1939 UEA 168

Dancing features prominently in the feasts and
presentations associated with the yam harvest in the
Trobriand Islands. Malinowski (1922: 56-7) recorded
that dancing was done 'only at one time in the year,
in connection with the harvest festivities, called
milamila, at which season also the spirits of the dead
return from Tuma, the nether-world, to the villages
from which they hail. Sometimes the dancing season
lasts only for a few weeks or even days, sometimes
it is extended into a special dancing period called
usigola . . . A performance consists always of a dance
executed in a ring to the accompaniment of singing
and drum-beating, both of which are done by a group
of people standing in the middle. Some dances are
done with the carved dancing shield.' Malinowski
also illustrated men using dance shields of this type
(*kaydebu*; *ibid.*: pls. XIII, XIV).

The elaborate curvilinear designs are distinctive
to the Trobriands and neighbouring islands in the
Massim area of south-east New Guinea. They appear
on many important items, like canoe prows, and in
certain respects are said to refer to the frigate bird,
which has a hooked beak and is a successful fisher.
The carved panels are painted red and black and
the recessed areas are filled with lime.

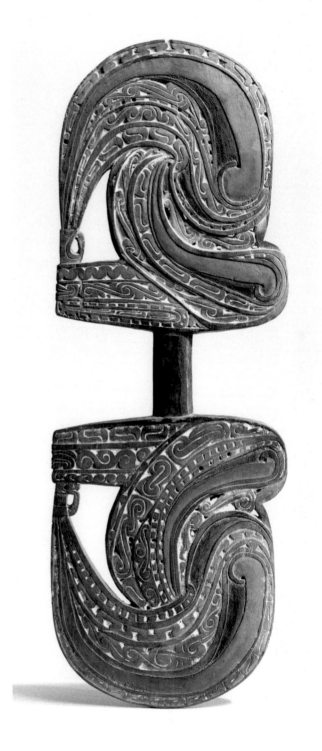

43

New Guinea, Huon Gulf, Tami Island

Food bowl
19th/early 20th century
Wood
l. 26¾ in (67.0 cm); w. 11 in (28.0 cm)
Acquired 1974 UEA 558

This distinctive form of navette-shaped bowl, used
for preparing and presenting food, was made by the
Tami islanders of the Huon Gulf. This region has
varying natural resources, and food and manu-
factured goods, including bowls, circulated by
exchange among the inhabitants of the mainland
and the adjacent islands of the Vitiaz Straits. This
exchange network was studied by Harding, who
noted that in the 1930s the Siassi islanders also began
to make bowls, though of inferior quality (1967: 38).

This example, shown base upwards to reveal
the full design, is similar to bowls in Dresden and
Leipzig, illustrated by Reichard in her extensive
museum-based study (1933: pls. XXXII, LXIX). The
brown wood has been blackened with a manganate
graphite compound and then highly polished. The
main design, of which a detail is shown, is stated by
Bamler (1911: 490–507) to represent *buwun*, a spirit
with human and fish attributes. One side of the rim
has a figure with outstretched arms, the other a
schematic design resembling a double fish. The best
survey of the art of this region is by Bodrogi (1961).

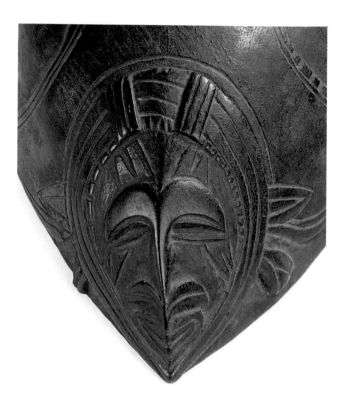

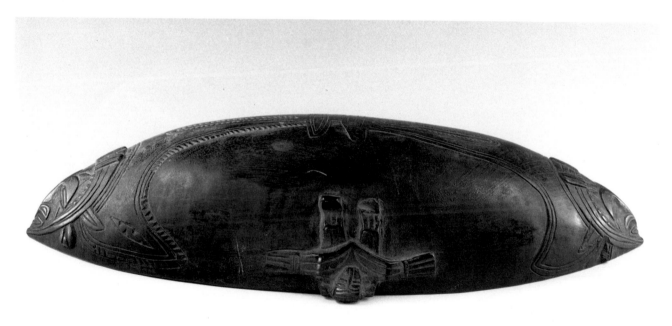

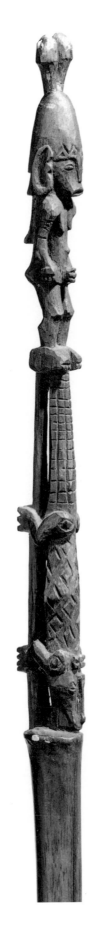

Admiralty Islands, Matankor

Lime spatula
19th century
Wood
l. 21⅞ in (55.5 cm); figure h. 3¾ in (9.5 cm)
Acquired 1966 UEA 170

Lime spatulae were part of the equipment used for 'betel chewing', when powdered lime was chewed with a mixture of crushed areca nuts and the leaves of the *Piper betel* bush. In the Admiralty Islands lime was kept in gourds decorated with curvilinear designs, and a long spatula was used to extract the powder. This example, of which the finial is shown, terminates in a narrow blade for the purpose.

The finial carving resembles a miniature version of the 'ancestor' figures from this region, which can be up to six feet high and are often incorporated into house architecture (see Badner, 1979). Such figures are often carved in association with crocodiles, as here, where the crocodile appears as though trussed by the legs to a stake, which may be a reference to hunting prowess (see also Nevermann, 1934: fig. 132). The figure has a projection down the centre of the back, flaring at the lower end, which possibly represents a warrior's pendant of the type shown opposite (UEA 511). The twin projections on top of the head represent men's elaborate wigs.

Provenance: Collected before 1898, when it was offered for sale by W. D. Webster. It bears the label '2038 Admiralty Is. WBSTR 1898.14'.

45

Admiralty Islands, Matankor

Warrior's pendant
19th/early 20th century
Wood, feathers, gum, cloth
h. 20¼ in (51.1 cm)
Acquired 1973 UEA 511

An early photograph of a Matankor warrior,
published by Nevermann (1934: pl. 3), shows a
pendant of this type being worn at the nape of the
neck, the feathers spreading downwards and
outwards. Information on their precise significance is
limited, but it has been suggested that these pendants
are a kind of war charm and protective amulet.
Human bones and hair pendants were also worn in
a similar way, and it is likely that this object is a kind
of substitute trophy head of a slain enemy, worn to
proclaim the man-slayer status of the wearer.

The back of the head is hollowed, and the long
feathers are bound and gummed to the base of the
neck. Nevermann (1934: 138-9), who illustrated
several examples, noted that the feathers are from
the frigate bird or sea eagle. These are both large
and effective fishers, embodying aggressive and
predatory qualities which are much admired in
a warrior. Traces of red, black and white pigment
remain on the head, and a cotton cloth strip secures
the feathers near the tips. Cloth was a highly valued
material in early trading with Europeans.

Three main groups inhabit the Admiralty Islands,
the Manus, Matankor and Usiai (Badner, 1979). Most
sculpture was produced by the Matankor.

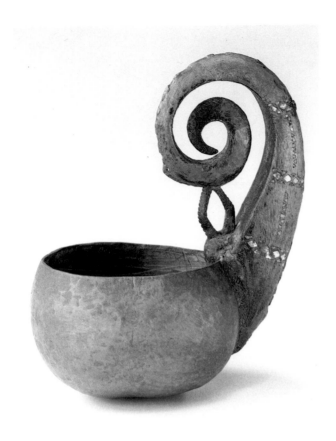

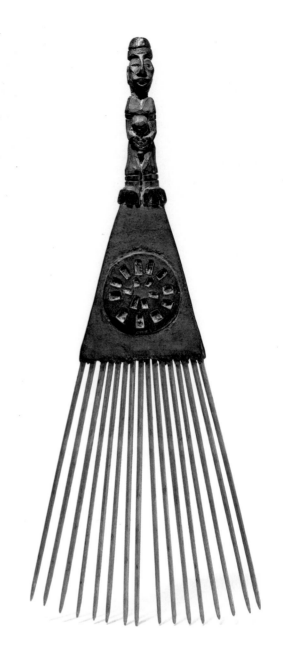

46

Admiralty Islands, Matankor

Ladle
Gourd, wood, gum
19th century
h. 9 in (22.8 cm)
Acquired 1971 UEA 171

The Admiralty Islands are renowned for the large
double-handled bowls which were made by the
Matankor people of Lou Island, south-east of Manus
(Buhler, 1935: 20). However, smaller ladles were also
made in the same region. In this example the wood
handle is gummed securely to the gourd bowl, and
although elegant in its present form, it is likely
that at one time there was a low openwork frieze
of carving around the outer curve of the handle.

Provenance: Formerly in the Linden Museum,
Stuttgart, no. 63588. Acquired by them in 1910 from
H. Hornung.

47

Admiralty Islands

Comb
20th century
Wood, gum
l. 12½ in (31.7 cm)
Acquired 1983 UEA 425

This large comb is not only unusual in having a human
figure as a finial for the handle, but also for the fact
that the figure is modelled in gum and painted red,
black and white. A second rosette appears on the
reverse of the handle, with a different design.

48

New Ireland

Kapkap ornament
20th century
Clam shell, turtle shell
diam. 4 in (10.2 cm)
Acquired 1974 UEA 513

49

New Ireland

Kapkap ornament
20th century
Clam shell, turtle shell
diam. 2 in (5.1 cm)
Acquired 1974 UEA 514

50

New Ireland

Kapkap ornament with beads
20th century
Clam shell, turtle shell, beads, fibre, hair, metal
diam. 2⅛ in (5.3 cm)
Acquired 1974 UEA 512

This type of ornament is generally called 'kapkap',
a term deriving from a New Ireland language which
is now used widely by Europeans for Melanesian
ornaments of this kind. They are usually worn as
neck pendants on ceremonial occasions, but also
function as valuables in local exchanges.

The white disc is ground from clam shell, while
the filigree overlay is made from a thin piece of turtle
shell. Both are pierced through the centre for sus-
pension or attachment. Reichard (1933) illustrates
a large selection of museum specimens.

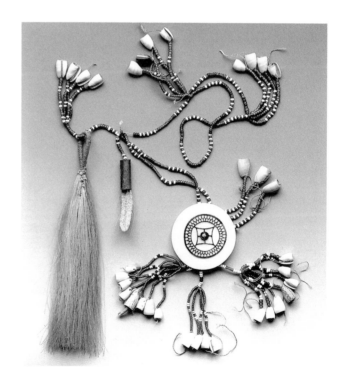

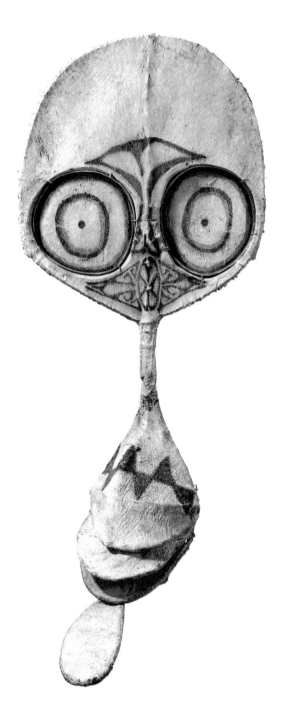

51

New Britain, Central Baining

Helmet mask
20th century
Bark cloth, cane
h. 47 in (119.5 cm)
Acquired 1970 UEA 175

The Baining of the Gazelle Peninsula are famous for their large and
dramatic masks, worn during day and night dancing ceremonies (see
Rubin, 1984: I: 116, for a colossal example from the north-west Baining,
which is over twenty-three feet high). The present example comes from
the central Baining and is a type of helmet mask called *kavat*, which
are distinguished by large eyes and a tongue-like projection at the
mouth. These were worn for night dances, and Corbin (1979) states that
the designs refer to a variety of natural and manufactured forms. They
are painted in black and red, and the back of the upper disc has a
lateral band of zig-zag designs in the same colours.

52

Solomon Islands

Seven combs
19th/20th century
Wood, fibre, gum, shell
l. (see below)
Acquired 1979/1980 UEA 426 A–G

Combs from the Solomon Islands are notable for their variety and colourful appearance. They were worn as hair ornaments by both men and women, and are in most cases made from slivers of wood which are shaped, bound and gummed together. Those decorated on one side with pearl shell segments set into *Parinarium* 'putty nut' gum (see no. 53) were made on San Cristobal or one of the smaller neighbouring islands. The coloured examples, bound in natural yellow and dyed red fibres, are from the interior of Malaita, whence they circulated by exchange to other parts of the group.

The three-pronged comb comes from Rennell, a 'Polynesian outlier', so called because, although it is administratively part of the Solomon Islands, it (along with several other islands in the western Pacific) is inhabited by Polynesian peoples who are more closely related to the Samoans (see Birket-Smith, 1956).

Details: left to right. SAN CRISTOBAL: (a) 11¾ in (29.8 cm); (b) 9¼ in (23.5 cm). RENNELL: (c) 5½ in (14.0 cm). MALAITA: (d) 7 in (17.8 cm); (e) 9 in (22.8 cm); (f) 7⅛ in (18.1 cm); (g) 8¾ in (22.2 cm), ex Hooper collection, no. 1174.

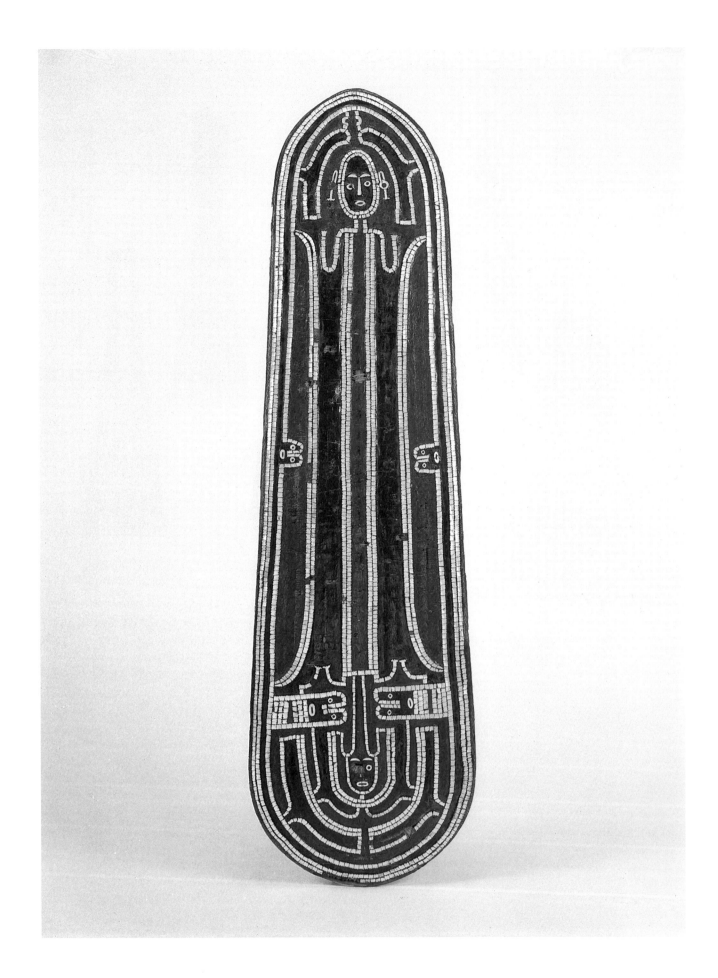

53

Solomon Islands, central region

Ceremonial shield
Early/mid 19th century
Cane, wood, gum, shell
h. 34½ in (87.5 cm)
Acquired 1975 UEA 632

These rare shields are among the most outstanding achievements of Solomon Islands art, yet little is known of their use or significance. Twenty-one examples are currently known (Waite, 1983b: 120-1), and all have the same general appearance, though they differ in details of decoration. Few have any associated historical information and none of the late nineteenth or early twentieth century writers in the field makes direct reference to them. The earliest reliable information relates to an inlaid shield in the Brooklyn Museum (*ibid.*: 119-23), which had been acquired by the Montrose Museum in 1852 and was probably collected in the Solomon Islands during the 1840s. The present shield also came to light in Scotland, in an antique shop in 1975, though without documentation. It seems that decorated shields ceased to be made after the mid nineteenth century, by which time only a few had been acquired by Europeans.

This example consists of a basic central Solomon Islands wickerwork shield, to the front of which has been applied a layer of gum made from the kernel of the 'putty nut' (*Parinarium laurinum*), which is pale when fresh, but black and hard once dry (see Ivens, 1927: 151 for details). Some areas of the gum are painted red and tiny segments of nautilus shell have been applied to make up the main designs. These give a beautiful opalescent turquoise effect when the shield is moved in the light. While the front of the shield is remarkably well preserved, the back (also illustrated here) is missing the vertical hand grip and three of the seven original cross-struts. Black designs are painted at the top and bottom.

Interpretation of the designs on the shield is problematic, given the lack of historical or local information. However, bearing in mind the usual protective function of a shield, it is possible that the figures represented are tutelary spirits or deities, although Sillitoe (1980: 497) has suggested, on the basis of an analysis of Wola shields from the New Guinea Highlands, that anthropomorphic designs are connected with the practice of revenge killing, for which a human victim was required.

The precise place of manufacture of this type of shield is also uncertain. Wickerwork shields were made in New Georgia, Santa Isabel and Guadalcanal, but Waite's review of the evidence shows that even on this point there is no firm information (Waite, 1983b: 115-16). Shields were also used as valuables in exchanges, for Woodford (1926: 485) noted that plain shields (and probably formerly also the inlaid type) were 'articles of barter amongst the natives of the islands where they are in use', thus suggesting that the place of collection need not necessarily correspond to the place of manufacture.

54

Solomon Islands, Roviana region

Kneeling male figure
Late 19th century
Wood, pearl shell, fibre, gum
h. 7 in (17.8 cm)
Acquired 1971 UEA 172

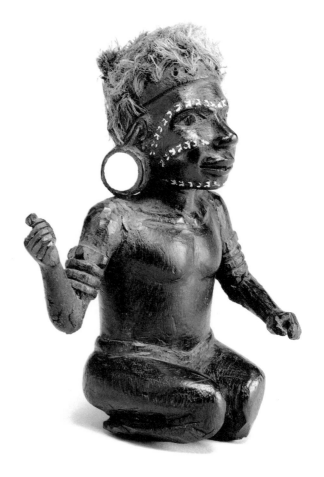

This finely modelled sculpture is an example of the naturalistic
carving style which developed in the Roviana (New Georgia) area of
the western Solomon Islands during the second half of the nineteenth
century. This is possibly a comparatively early example, since it
appears that by the beginning of the twentieth century images made
in this style were larger and, although still technically proficient, had
become sculpturally stiff (see McCarthy, 1951; Waite, 1983a: 119).

 The emergence of this naturalistic style of carving was probably a
local response to contact with European representational art, and it
developed alongside the more familiar indigenous non-naturalistic
style (see the canoe figurehead opposite). After visiting the Roviana
area in the early 1890s, Lieutenant Somerville (1897: 378) reported
that two types of sculpture existed there – that of spirits and that
of 'men' – and that the latter, naturalistic type was made for trade
rather than for ritual purposes (see examples in Brown, 1910: 248, 251).

 This kneeling figure is almost certainly one of a set representing
warriors (with white face paint and limed hair) paddling a canoe,
and he formerly would have held a paddle in both hands (inform-
ation courtesy of Lawrence Foanaota, Director of the Solomon Islands
Museum; see also an early canoe illustration in Waite, 1983a: 36).
The arms are carved separately and are pegged at the shoulders and
elbows. The rings on the upper arms represent shell armlets.

55

Solomon Islands, Roviana region

Canoe figurehead
19th century
Wood, pearl shell
h. 6½ in (16.5 cm)
Acquired 1967 UEA 173

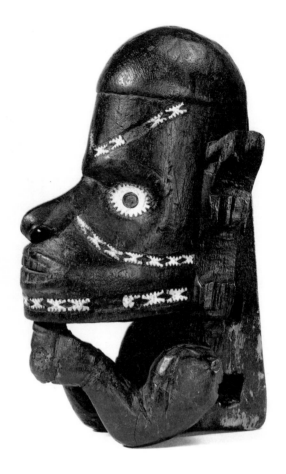

Canoes in the Pacific region were often decorated and elaborated far beyond the basic requirements of technical efficiency, for they were great ritual vehicles, used for important enterprises like ceremonial exchanges, fishing and war expeditions. The success of any enterprise was dependent upon divine favour, and many of the carvings on canoes, like this figurehead, referred to tutelary spirits, who protected the occupants and acted malevolently towards an enemy.

In the Roviana (New Georgia) area the local plank-built canoes were elaborately decorated with carvings and shell inlay (see Starzecka and Cranstone, 1974: 29, 41). Close to the waterline, beneath the prow, was attached a figurehead of this type, which Somerville (1897: 371) stated was 'to keep off the *kesoko* or water fiends which might otherwise cause the winds and waves to upset the canoe'.

These images, known as *musumusu* or *nguzunguzu*, usually have prognathous features and arms which reach forwards, in some cases holding a small head, as here, which may refer to a head-hunting trophy. Waite (1984) has suggested that figureheads with a pointed head date from the 1880s, while those with a rounded head, as is the case here, may be earlier. The large-lobed ears are damaged and some shell inlay is missing from the main face and the eyes of the small head; the nasal septum is pierced and there are three square holes at the back of the head for attachment to the canoe hull.

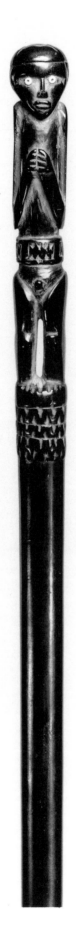
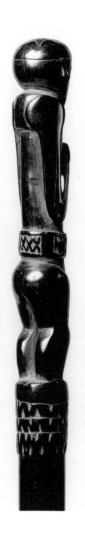
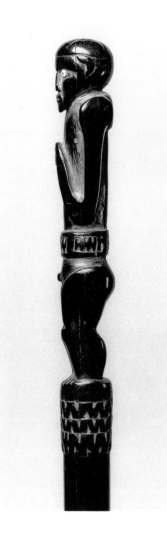

56

Solomon Islands, eastern region

Limestick
19th century
Wood, shell
h. 27½ in (69.8 cm); figure h. 4¾ in (12.1 cm)
Acquired 1967 UEA 167

The custom of 'betel chewing' was practised widely in the Solomon Islands, and special limesticks were used for the powdered lime which was chewed with crushed areca nut and betel leaves. This example, in glossy black hardwood, has an unusually long shaft which narrows to a fine point; the finial is carved as a male figure with shell ring eyes and a distinctive quatrefoil design on top of its head. Its precise origin is not known. Waite (1983a: 128-9) discusses a comparable example and tentatively attributes it to the San Cristobal or Guadalcanal area, from where this piece also probably originates.

Provenance: Formerly in the collection of Lord Lonsdale, Lowther Castle.

57

Solomon Islands, south-east region

Neck pendant
19th/20th century
Pearl shell
w. 3 in (7.6 cm)
Acquired 1982 UEA 833

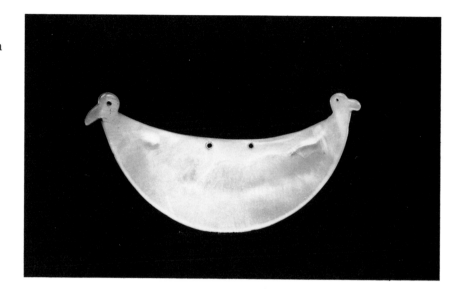

58

Solomon Islands, south-east region

Neck pendant
20th century
Pearl shell, turtle shell, fibre
w. 8⅝ in (21.9 cm)
Acquired 1980 UEA 755

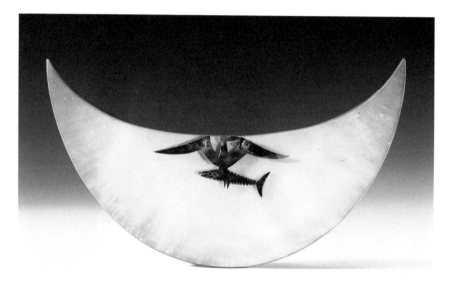

Crescent-shaped neck pendants of this type were made in the Malaita and San Cristobal area and were worn by men. Bird imagery occurs on both pendants illustrated here, and the turtle shell overlay on no. 58 depicts a frigate bird clutching a fish, probably a bonito. Both these species feature prominently in local iconography, for the frigate bird is associated with protective spirits and is often seen at sea above shoals of bonito, acting as a guide to fishermen. Special fishing expeditions for bonito were formerly an important part of male initiation rites (see Fox, 1925; Davenport, 1981).

Ivens (1927: 393-5) noted that whereas small pendants like no. 57 were made from local black-lip pearl shell, large examples like no. 58 had been made since the late nineteenth century from gold-lip pearl shell obtained from European traders.

Provenance: No. 57 (UEA 833); formerly in the collections of Harry Beasley (no. 3681, acquired 9.10.1935 and attributed to Santa Ana or Santa Catalina) and George Ortiz (Sotheby's, 1978: lot 68).

59

Santa Cruz, Nidu

Standing figure
Late 19th/early 20th century
Wood, shell
h. 11½ in (29.2 cm)
Acquired 1974 UEA 557

Davenport, in a recent paper on the subject (1985), observes that carved figures from Santa Cruz 'are representations of men's tutelary deities and are called *munge-dukna* ("image-deity")'. He also states that they were 'permanently installed on household altars and were the focal objects for domestic rituals' – which were generally offerings of food.

When in use, images of this type were painted and ornamented with fibre clothing and shell pendants, but on this example only the shell eyes and traces of the original painting remain, mostly black linear designs on the forehead, abdomen and legs; those on the sides of the knees resemble frigate birds with outstretched wings. There are also traces of yellow turmeric colouring. The projection at the back of the head represents the *abe* or *ombe* head-dress, formerly worn on ceremonial occasions by men, who were said to be 'impersonating the deities' (*ibid.*).

Carved figures are thought to have been made only on Nidu Island (also known as Ndende or Santa Cruz Island), the largest island in the group. This example closely resembles two figures in Berlin and Cologne which were collected by Wilhelm Joest in 1897 (see Koch, 1971: 177, and Graebner, 1909: 152).

Provenance: Formerly in the Pitt Rivers Museum at Farnham, Dorset.

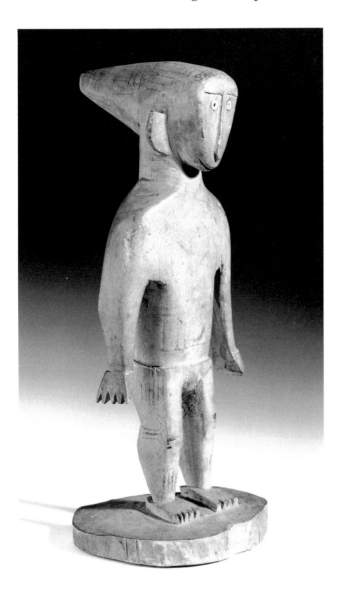
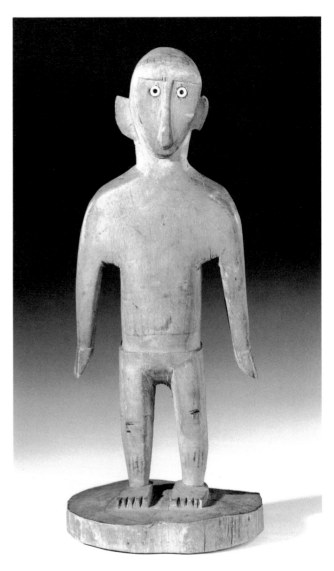

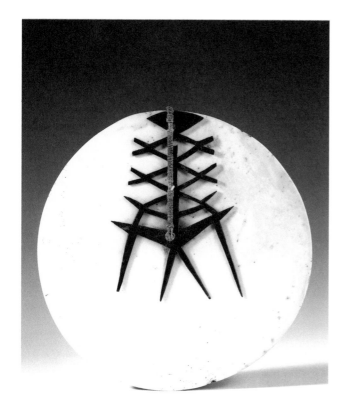

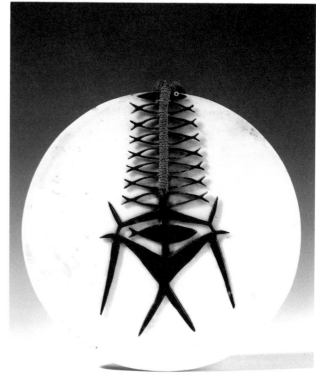

60

Santa Cruz

Breast ornament
19th/20th century
Clam shell, turtle shell, cloth
diam. 6½ in (16.5 cm)
Acquired 1980 UEA 745

This distinctive form of breast ornament, locally
called *tema*, was worn by men and was suspended
round the neck on a cord, which in this case is
made of twisted cloth (see Koch, 1971: pls. 15-16 for
photographs of men in full ceremonial costume).

The pendant is composed of two main parts: a
white disc ground from the hinge section of a large
clam shell (*Tridacna gigas*) and pierced through the
centre, to which is fitted a filigree overlay carved
in turtle shell obtained from the hawksbill turtle
(*Eretmochelys imbricata*). The turtle shell designs
on *tema* usually show the silhouette of a frigate bird
with angled wings and forked tail, above which are a
series of triangular elements, generally interpreted
as fish (see Beasley, 1939, for a variety of designs).
As in the neighbouring Solomon Islands (see nos. 57
and 58), the frigate bird is associated with fishing
prowess, strength and endurance.

61

Santa Cruz

Breast ornament
19th/20th century
Clam shell, turtle shell, fibre
diam. 6 in (15.2 cm)
Acquired 1983 UEA 871

In this example of the *tema* breast ornament the
head of the frigate bird takes the form of a fish, with
seven further double fish-like elements above.

Many *tema* are localised to the Graciosa Bay area
of Nidu Island (also known as Ndende or Santa Cruz
Island), but it is not clear where they were made,
since red feathers, canoes and other valuables circu-
lated throughout the group as part of an extensive
exchange network (see Davenport, 1962: 96-7). Both
examples illustrated here most probably date to the
first part of the twentieth century, though the clam
shell discs may be older, and make an interesting
comparison in technique; the craftsman who carved
the turtle shell on this example having a much more
fluent style.

Provenance: Collected in 1983 from Ebol Japusa,
Lwepe village, Graciosa Bay, Nidu Island.

62

Vanuatu, Malekula

Head
20th century
Wood, fibre, cloth
h. 21¼ in (54.0 cm); head h. 5½ in (14.0 cm)
Acquired 1967 UEA 177

Heads of this type were used in the extensive rituals
of the men's grade societies of Malekula in Vanuatu,
formerly known as the New Hebrides. The principal
grade society was the *nimangki* (or variations of this
name), and by successfully amassing and distributing
wealth, usually in the form of pigs, men were able
to progress through a series of named grades and
thereby increase their status. The role of such heads
in the rituals of *nimangki* and other secret societies,
such as *nevinbur*, is not clear, but a comparable head
is illustrated in Deacon (1934: pl. XVI), which is
referred to as a 'dancing stick', held aloft by men
when dancing so as to be just visible to women and
children outside the special men's enclosure.

 This hollow head is modelled in a vegetable fibre
compound (see Deacon, 1934: 545 for the full recipe),
and the hardwood stick which passes through the
centre is fixed with pieces of shredded cotton cloth.
The face is painted red, white and black – colours
which were adopted by men who had achieved
particular grades in the *nimangki* hierarchy (Deacon,
1934: 282-4). The red forms triangular areas around
the eyes and also appears in V-shaped designs on the
back. A ridge encircles the face, and others delineate
the brows, cheeks, nose and mouth.

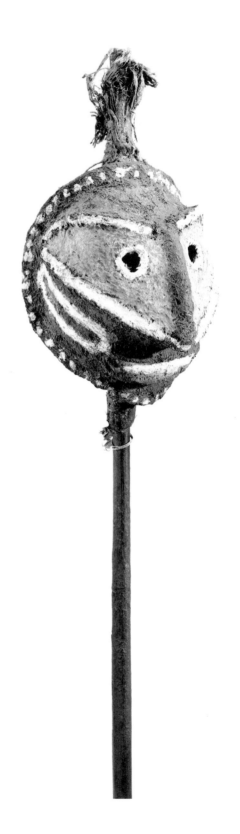

63

Vanuatu, Malekula

Spear head
19th/20th century
Wood, bamboo, coir
h. 22¾ in (57.8 cm); head h. 6¼ in (15.9 cm)
Acquired 1973 UEA 517

These wood spear heads with stylised janus faces,
initially reminiscent of New Caledonian sculpture,
originate from the north-west area of Malekula in
Vanuatu (see Speiser, 1923: pls. 49-50). The wood
section is fixed into the end of a bamboo shaft, only a
short length of which remains, and is bound with coir
cordage. A human bone point was formerly fixed into
the tip and the whole spear would originally have
been over ten feet long. It is not clear if such spears
were used for fighting or for ritual purposes, such as
the spearing of sacrificial pigs.

 Given that similar sculptures were in European
collections and museums by the late nineteenth
century, it is possible that the striking treatment
of the face in these spear heads inspired *avant garde*
European artists of the early twentieth century.

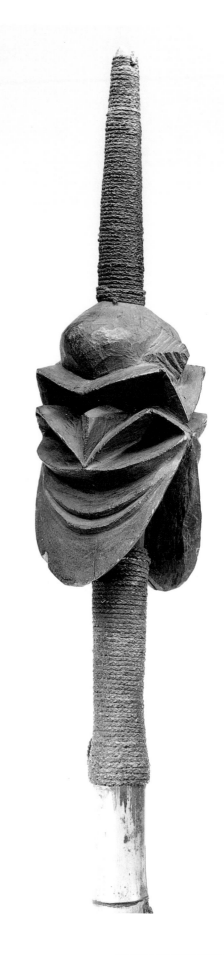

64

New Caledonia

'Bird-headed' club
19th century
Wood
l. 29¼ in (74.3 cm)
Acquired 1984 UEA 897

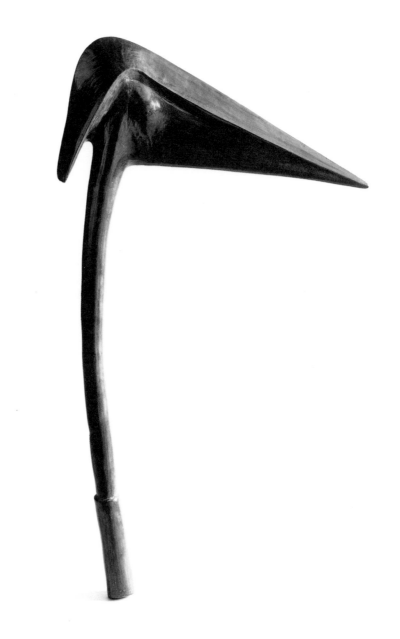

A variety of clubs were made in New Caledonia, and several examples were collected in 1774 during Cook's second voyage (see Kaeppler, 1978: 245). Perhaps the most distinctive form is the 'bird-headed' type represented here (see Sarasin, 1929: pls. 52-5 for examples). The name derives from the resemblance to a profile bird's head, though the symbolic significance of the form is not clear.

This is a particularly elegant example, having a long beak and curving handle. It also has an expanded section at the end of the handle, characteristic of New Caledonian clubs. As in other Pacific societies, most able-bodied men carried weapons, though contrary to European popular notions they were not in constant use.

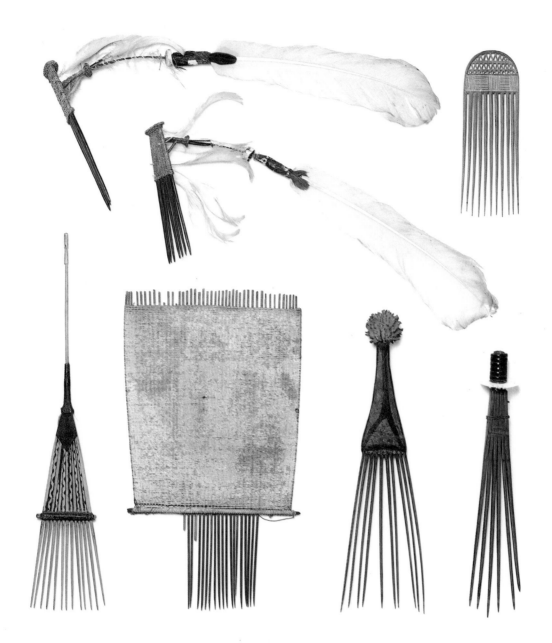

65

Melanesia and Micronesia

Seven combs
19th/20th century
Wood, gum, nut, fibre, feathers
l. (see below)
Acquired 1979/1981 UEA 427 A–G

Some decorative combs must have been very impressive when worn, notably the large man's comb from Wuvulu (Matty I.) and the Maprik feathered examples. The feathers, fixed to a flexible arm, would have swung gracefully with the wearer's movements. The single Micronesian example, bottom right, is a rare type from Truk.

Details: left to right, top to bottom. NEW GUINEA, MAPRIK: (a) 16 in (40.6 cm); (b) 15 in (38.1 cm). KANIET: (c) 6½ in (16.5 cm). BANKS IS., GAUA (*cf.* Speiser, 1923: pl. 34): (d) 14½ in (36.8 cm). WUVULU: (e) 12¼ in (31.1 cm). ADMIRALTY IS.: (f) 11½ in (29.2 cm). TRUK: (g) 10¼ in (26.0 cm).

Australia

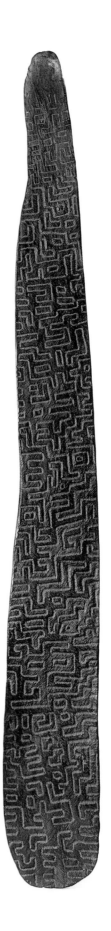

66

Western Australia, Kimberleys region

Sacred board
19th century
Wood
l. 78½ in (199.4 cm); max w. 9½ in (24.1 cm)
Acquired 1985 UEA 913

This large and finely engraved sacred board from
the Kimberleys region displays a virtuoso rendering
of what Davidson has termed the 'angular meander'
pattern (1937: 100, 128-30; figs. 24, 57), a design
specific to the Kimberleys which can also be found
on shields, bullroarers and spear throwers from this
northern area of Western Australia (see a shield from
Balgo in Berndt and Stanton, 1980: 18). The impact
of this design is enhanced by the juxtaposition of
parallel bands of engraving, which are composed of
diagonal grooves set at right angles to those on the
adjacent band.

 Decorated boards and stone tablets from central
and western Australia are known popularly as
tjurunga or *churinga*, a term which derives from
the Arunta (Aranda) language, though local names
vary from tribe to tribe. Campbell (1904: 104), who
referred to this type as 'dancing boards', stated that
they could be up to fifteen feet long and were carved
from the hard wood shell of a decayed gum tree. This
example probably dates from the nineteenth century,
though its particular history is not known. The plain
back shows the furrowed marks of stone tool adzing,
while the designs on the front may have been
engraved with fine stone or glass tools, the latter
obtained from European bottles which, since at least
the sixteenth century have drifted on to the north
Australian coast.

 The function and the precise 'sacredness' of these
boards is difficult for non-Aborigines to comprehend.
In societies with few material possessions, yet with
complex religious and social institutions, such objects
as these boards acted as a focus for ritual activities.
They were stored in secret places and brought out to
be laid on the ground and meditated upon by male

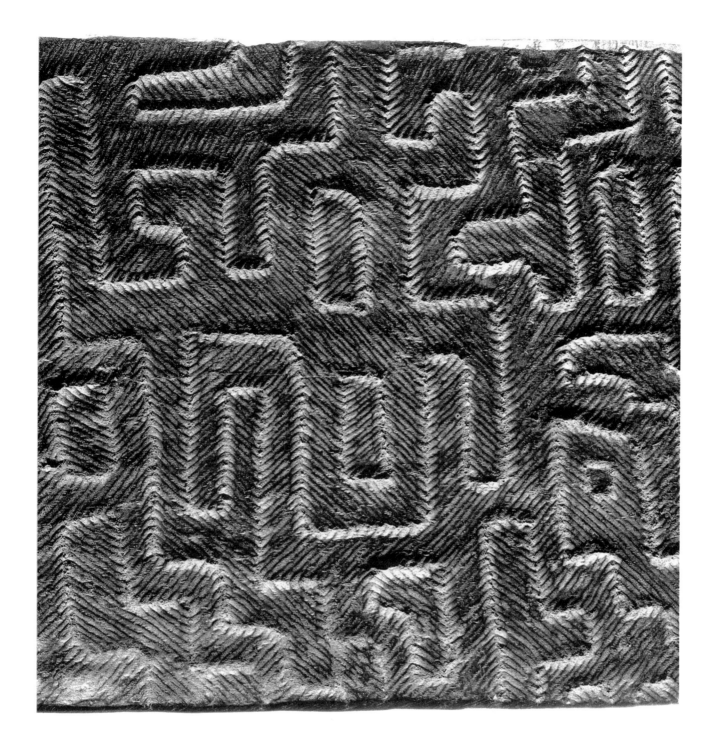

elders (see Berndt, 1974: pls. 52-4); they were also important in male initiation rites, as 'holy' (in the sense of set apart or restricted) objects which at a particular juncture were revealed to the young initiates. In general terms they were a material link with the ancestors, the designs inspired by events and locations belonging to what is called the 'dreamtime', the mythic/historical period when the ancestors and all important features of the landscape were created. Berndt and Berndt (1964: 368) state more specifically that long sacred boards from this area 'represent, symbolically, the bodies of the great ancestral and mythical beings'.

However, despite an inability to understand fully the significance of the boards or to interpret their designs, the non-Aborigine can still derive inspiration and aesthetic pleasure from the dramatic designs on this exceptional example. Such virtuosity has been attempted but seldom achieved by Western artists, even Paul Klee.

Indonesia

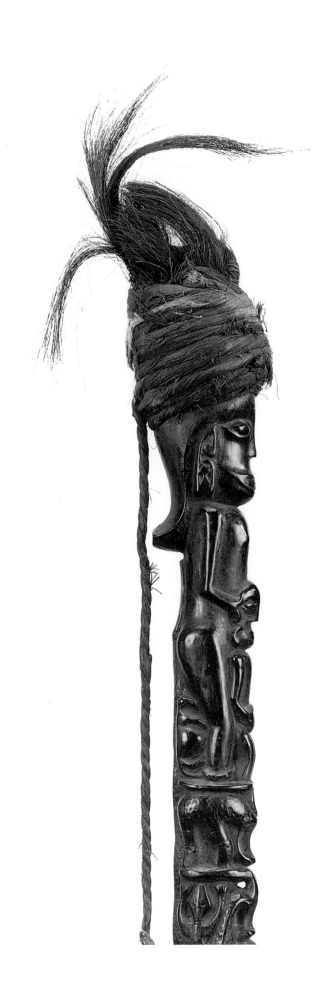

Sumatra: Batak, Toba

Priest's staff
19th/early 20th century
Wood, hair, fibre, feathers, metal
l. 66½ in (168.9 cm); top figure h. 7 in (17.8 cm)
Acquired 1985 UEA 914

Long staffs (*tunggal panaluan*), elaborately carved for
most of their length, were an important part of the
Toba Batak priest's ritual equipment. The priest (*datu*
in the Toba language) presided at seasonal rituals,
like the harvest festival, and was the agent through
whom ancestral spirits and deities could be contacted
for purposes of divination or healing or for assistance
in matters affecting the welfare of the community.
Tobing (1963: 170-89) discusses *tunggal panaluan*,
calling them representations of the 'tree of life',
but his illustrations of their use were apparently at
'rituals' he himself choreographed (see Barbier, 1983:
161-7), thus calling into question the validity of his
observations.

This staff is a fine example of the type, the hard
thorn-tree wood from which it is made having
acquired a glossy black patina. The principal figure
retains the original head-dress of coarse black hair
bound with red, blue-black and white fibre threads.
Beneath this were placed magical substances (*pupuk*)
which assisted the *datu* in his sacerdotal work. The
shaft above the handgrip is completely carved with
human and animal images, variously contorted and
integrated into the cylindrical design space. Humans
and water buffalo face the front, while snakes,
lizards, dogs and tiny humans are arranged on the
sides and back. The shaft below the handgrip is
carved with a figure above a snake which bites the
tail of a lizard. Cameron (1985) refers to a myth
associated with this complex iconography, which
concerns five *datu*, two children and various creatures
which were 'swallowed' by a thorn tree. Eventually
a *datu* cut down the tree and carved from it a staff of
this kind, thereby gaining the assistance of the spirits
of those who had been swallowed.

Although the provenance of this example is not
known it most probably dates to the late nineteenth
century and is almost certainly of Toba origin (see
Barbier, 1984: pl. 14a, Schoffel, 1981: 40-51 and
Cameron, 1985: 93, for comparable examples).

Further illustrations overleaf

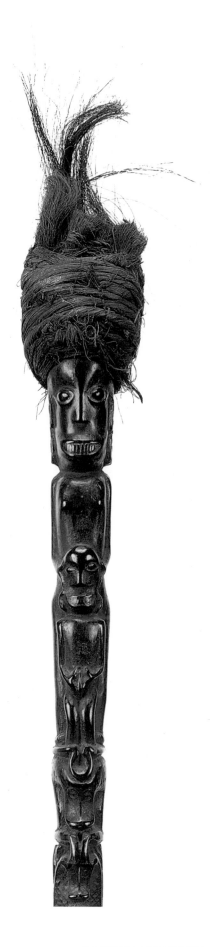

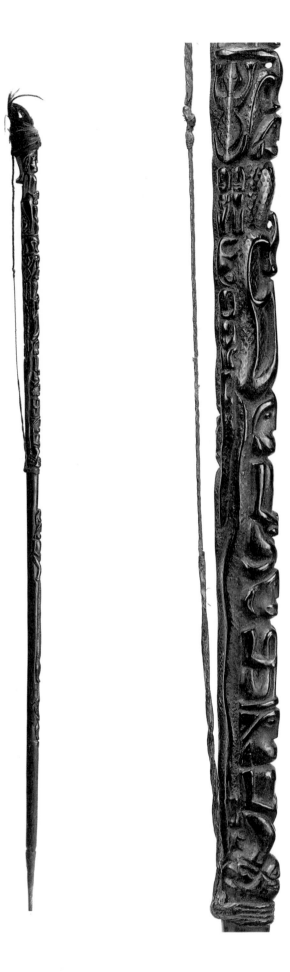
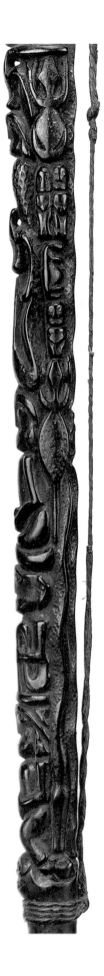

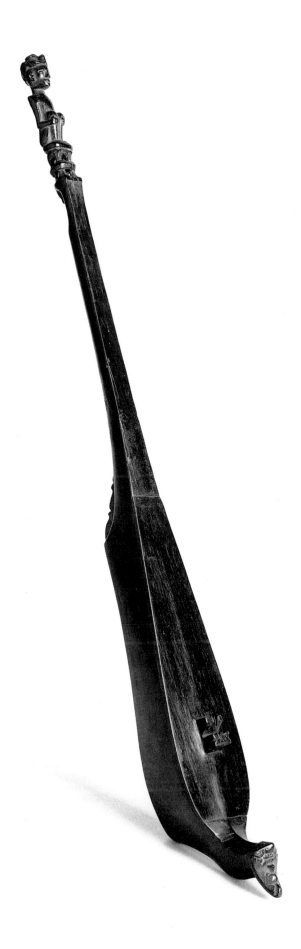

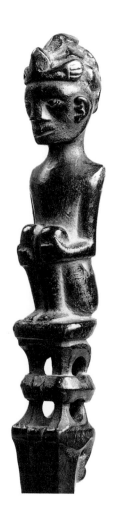

68

Sumatra: Batak, Toba

Musical instrument
19th/early 20th century
Wood
l. 27 in (68.6 cm); figure h. 3⅜ in (8.5 cm)
Acquired 1981 UEA 798

The Batak developed a distinctive two-stringed musical instrument (*hasapi*), generally referred to as a lute. *Hasapi* usually have a seated figure as a terminal, here wearing an elaborate turban, and also a projection beneath the resonating chamber, which in this case takes the form of an inverted face. The instrument is carved from a single piece of wood except for the sound board, which is a replacement for the original. The back of the resonating chamber has an oval aperture and both ends of the neck have pierced scrolls which were formerly linked by a chain or cord. The two holes beneath the figure are for string-tightening pegs.

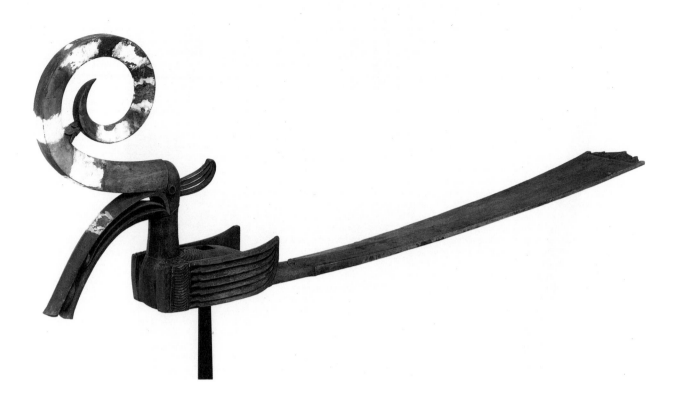

69

Borneo, Kalimantan: Ngaju or Ot Danum

Hornbill image
19th/20th century
Wood
l. 64 in (162.5 cm); h. 19 in (48.3 cm)
Acquired 1983 UEA 868

Birds feature prominently in the cosmology and iconography of many
Borneo peoples (see Harrisson, 1960, 1965), notably the rhinoceros
hornbill (*Buceros rhinoceros*), which this sculpture represents. The
rhinoceros hornbill is smaller than the helmeted hornbill (the casques
of which were carved into ornaments), but its long black and white tail
feathers, emphasised here, were highly prized for warriors' war cloaks
and head-dresses.

Hornbill images were made in several areas of Borneo, the best
known being the large and elaborate polychrome carvings of the Iban,
which were the centrepiece of *gawai kenyalang* rituals (see Freeman, 1960;
Feldman, 1985: pl. 9). This image, however, differs stylistically from
those of the Iban and appears to be a very rare type, only one other
comparable example being known from the literature (Schoffel,
1981: 134), though regrettably this has an unsubstantiated and unlikely
attribution to Samarinda, on the east coast. Victor King (personal
communication) suggests an origin for this carving from among the
Ngaju or Ot Danum of central Kalimantan. Among the Ngaju, hornbill

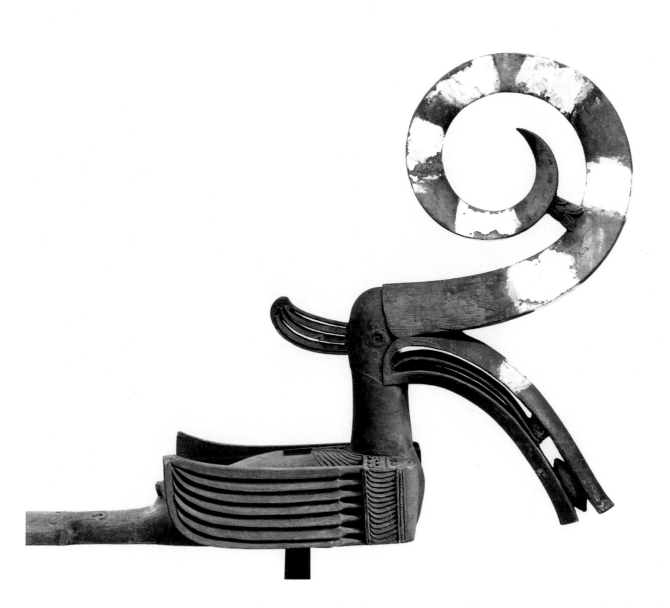

images were fixed atop posts erected during mortuary rituals, when the myth of creation was re-enacted. The hornbill represented the deity of the upper world, while the watersnake carved at the base of the post represented the deity of the lower world (see Avé and King, 1986: 36, 60; Schärer, 1963). Similar posts were also used among the Ot Danum (see Juynboll, 1909: pl. XIII). The square hole through the body suggests that this hornbill was formerly fixed to a post, and as the piece was reportedly collected at Nangapinoh, in interior Kalimantan, a Ngaju or Ot Danum provenance seems likely.

In sculptural terms, this image, carved from a single piece of wood, has exceptional qualities. The long, slightly upswept tail acts as a perfect counterpoint to the accentuated spiral casque and curving beak. The uropygial gland above the base of the tail, carved with a rosette, is carefully rendered, while the beak holds two fruits, a reference to the hornbill being a voracious fructivore. The casque has six bands of white mineral paint, the remainder traces of black encrustation, apparently cleaned off by a previous owner.

70

Borneo: Kenyah or Kayan

Baby carrier
19th/20th century
Wood, shell
w. 17½ in (44.5 cm); h. 14 in (35.6 cm)
Acquired 1981 UEA 797

This is one of several wooden baby carriers (*hawat*), some of them virtuoso pieces of sculpture, which have been published in recent years (see Richman, 1980: 132; Avé, 1981: 105; Barbier, 1984: pl. 26; Feldman, 1985: pl. 7), though none appear to have any collection data associated with them. Their age and precise provenance therefore remain uncertain, although on stylistic grounds they can be attributed to the Kenyah or Kayan of the central highlands. Roth (1896: I: 100), however, illustrates a shell-inlaid example, confirming the antiquity of the type, which is much rarer than rattan-backed examples or those with beadwork decoration. This is a form of baby carrier used widely by the Dayak of Borneo, Dayak being a term used to describe the indigenous people of Borneo, as distinct from the Malays, Chinese and others who now live in the coastal areas.

There are few signs of wear, though these heavy examples would not have been for daily use, and Nieuwenhuis (1904: pl. 14) shows how cloth padding was used on the inside of the curved backboard.

Three pegs secure the backboard where it is slotted into the semicircular base; four carved lugs along the top and two holes in the base were for shoulder straps, now missing. A number of the conus shell discs have been replaced by a previous owner.

The two lugs at each side are in the form of 'dog-dragons' (*aso*) with gaping jaws, while further *aso* motifs appear beneath the three main figures. The *aso* profile is frequently found on carvings associated with high-ranking Kenyah and Kayan, as are frontal anthropomorphic figures. These are widely explained as having protective functions (see Sumnik-Dekovich, 1985: 103, 109; Avé and King, 1986: 62), and since baby carriers have a shield-like quality, such tutelary carvings are not inappropriate.

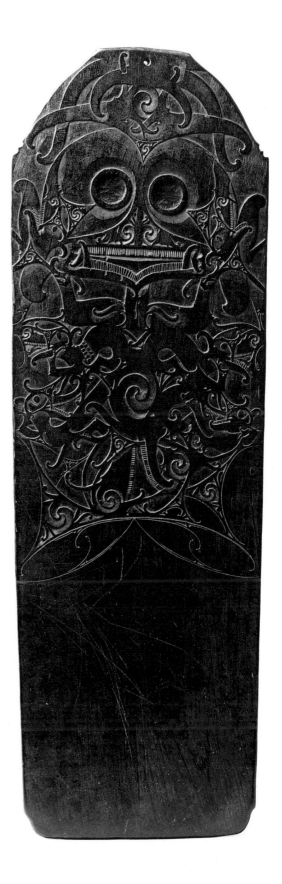

71

Borneo: Kenyah or Kayan

Work board
19th/early 20th century
Wood
h. 22½ in (57.2 cm)
Acquired 1981 UEA 803

This is another undocumented piece which on stylistic grounds can be attributed to the Kenyah or Kayan of the Sarawak/East Kalimantan border area of central Borneo. It rivals in virtuosity a comparable board, possibly by the same hand, which is illustrated by Barbier (1984: pl. 24). The upper two-thirds is carved as a large guardian spirit figure with circular eyes (formerly inlaid with Dutch coins or shell or bone discs), whose limbs and body dissolve into a complex of scrolls and seven *aso* motifs (see previous entry). It is very thin and light and the back is plain.

Work boards were used by women when making clothing and beadwork panels, or for other household tasks, such as preparing tobacco. This example shows signs of use and would have belonged to an eminent family, since elaborately carved objects such as this and the baby carrier opposite were reserved for those of chiefly status (Sumnik-Dekovich, 1985: 103).

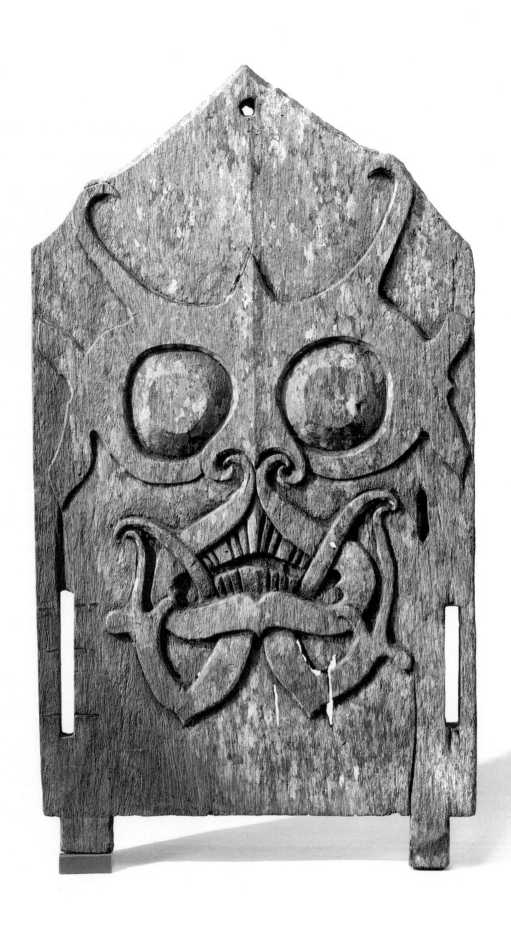

72

Borneo: Kenyah or Kayan

Panel from a vault
19th/20th century
Wood
h. 42 in (106.7 cm)
Acquired 1983 UEA 852

The Kenyah and Kayan of the Kalimantan and
Sarawak border area of interior Borneo placed their
dead in timber-panelled funerary vaults (*salong*),
raised on top of one or more large pillars (Hose and
McDougall, 1912: II: pl. 156). *Salong* made for people
of high status were carved or painted with faces and
images of guardian spirits, who protected the corpse
and soul of the deceased from evil influences (Avé
and King, 1986: 58).

This pale hardwood panel is almost certainly from
the end of such a vault, having two projections for
slotting into the floor and two vertical apertures to
accommodate the side wall panels. The hole at the
top is probably for a ridgepole to support the roof. Its
age is uncertain, but it is considerably eroded at the
lower part of the back, probably indicating that it
had been in contact with a funerary bundle for some
time. White encrustations and lichen have been
cleaned off by a previous owner.

The face is of comparatively simple form, with few
tendril-like embellishments; the diminutive hands
appear to take the form of two plain *aso* dog-dragon
heads in profile.

Provenance: Stated by a former owner to have been
collected at Long Apari on the Mahakam river, the
upper reaches of which are in Kenyah/Kayan
territory.

73

Borneo, Sarawak: Iban

Pig trap stick
19th/20th century
Wood
l. 21¼ in (54.0 cm); figure h. 3⅜ in (8.6 cm)
Acquired 1981 UEA 804

These familiar seated stick figures (*tuntun*) are
reported to have functioned both as charms, set up
close to wild pig traps to assist their effectiveness
(Sumnik-Dekovich, 1985: 121, 127), and also as rods
to measure the appropriate height of the horizontal
bamboo spear which was triggered by the animal
(Hose and McDougall, 1912: I: 145). A piece of cloth
wedged between the knees and elbows of this
example is almost certainly connected with the first
function, while five transverse grooves on the shaft,
above the carefully tapered point, are likely to be
measuring marks. Traps were set up in the forest
and near rice cultivations, where wild pigs could do
serious damage.

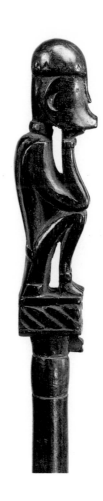

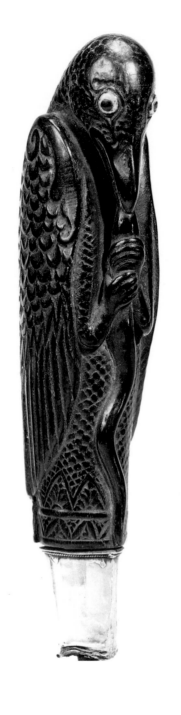

74

Lombok : Sasak

Handle in the form of a bird and snake
19th/20th century
Wood, silver, bone
h. 6½ in (16.5 cm)
Acquired 1983 UEA 872

The Sasak people of the island of Lombok, just east
of Bali, have been subject to considerable Hindu and
Muslim influences, as well as to Balinese invasion (De
Hoog, 1981 : 123 ; Barbier, 1984 : 114). The sculpture
shown here, the silver-mounted handle of a weapon
or, possibly, of a betel spatula, demonstrates this
Asiatic/Balinese influence in the art of the indigenous
Sasak, in both the subject matter and the decorative
style.

The bird and serpent motif, symbolising the upper
and lower world, or heaven and earth, is widespread
throughout southern and south-east Asia (Zimmer,
1960 : I : 48 ; see also the Borneo hornbill, no. 69,
UEA 868), and is here rendered in a particularly
harmonious composition : the bird clasps the snake
to its breast, while gripping the head in its beak.
Frequent handling has given the outer surfaces a
smooth dark patina. A split down the back has been
filled by a previous owner ; the wood pupil is missing
from the left eye.

75

Celebes, Sulawesi: Toraja

Memorial figure
19th/20th century
Wood
h. 37½ in (95.2 cm)
Acquired 1981 UEA 805

These distinctive wood images (*tau tau*) represent
particular eminent individuals for whom full
funerary rites, feasts and sacrifices have been carried
out. Mortuary rituals still play a very prominent part
in the life of the Toraja of south-central Sulawesi.
Those conducted for high-ranking people involve
lengthy preparations – the mobilisation of large
amounts of food, goods and livestock, notably water
buffalo for sacrifice, and the assembly of hundreds of
people for the seven days of a full funeral sequence
(see Crystal, 1985, for a detailed account). By such
complex rituals the deceased is appropriately
honoured, while the living relatives demonstrate
and celebrate their wealth and resources, and thus,
indirectly, the favour of the ancestors.

A *tau tau* image, normally of jackfruit wood, is
commissioned from a carver after the death and is
paraded, wearing fine clothing, during the funeral
procession of the body. When the body itself is
placed in a cliff vault, the clothed image is set up in
a recess in the cliff, or, more recently, on a balcony
structure where it can be seen from below. The age
of this *tau tau* is not known, though it is unlikely to
be recent; severe erosion at the back and base, and a
weathered appearance, indicate prolonged exposure.
It has the remains of squared sockets for articulated
arms, now missing, and, unusually, a square cavity
in the back of the head, possibly for the insertion of
moveable eyes in the hollow sockets. Pegged holes
in the head will have been for attachable hair. There
are two further pegged holes in each earlobe and a
shallow groove across the top of the head. The ears
and features, notably the eyebrows, are finely and
sensitively rendered, a combination of the skill of
the sculptor and natural weathering.

Provenance: Acquired in 1976 at Sangalla, Toraja
territory, Sulawesi.

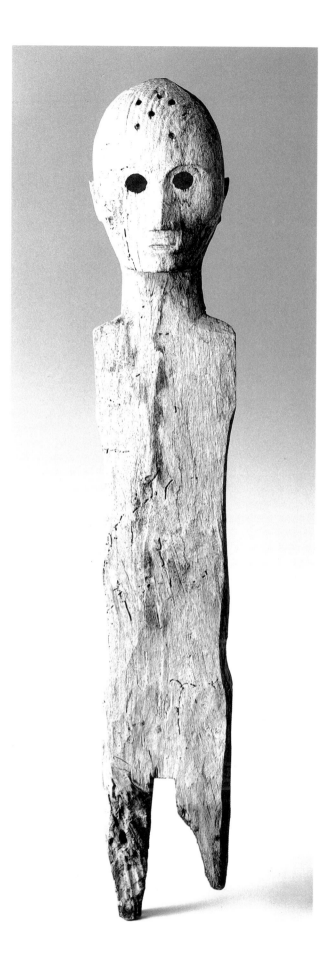

Africa

Africa

by Margret Carey

The African material in the Sainsbury Collection makes no claims to
comprehensiveness, either in terms of style areas represented, or in
terms of categories of item within a style area. The Sainsburys never
intended to make an African 'collection', with examples of art from
all ethnic groups, even though the first piece was acquired as long
ago as 1935 (the Fang head, no. 130). Pieces were acquired which were
considered exciting, in a formal sense, and choice was limited to what
they were able to acquire in London, Paris or, in a few cases, New York.
Thus some areas are well represented, such as Nigeria and Zaire, and
others are not. Nevertheless, the pieces shown here do provide a good
cross-section of sub-Saharan art styles, and it is intended that the texts
will act as a general introduction to African art, and direct attention
to publications where further information may be found.

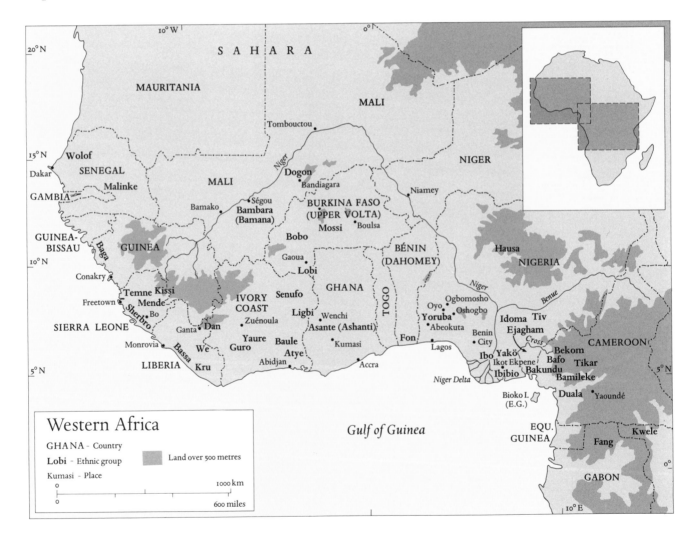

The texts have been prepared by Margret Carey, formerly Assistant Keeper at the Museum of Mankind (British Museum). The entries for Nigeria (nos. 110-122) were written in collaboration with William Fagg, formerly Keeper of the Museum of Mankind, who made valued comments on other West African pieces, and who also prepared the captions for the African items in the previous catalogue (Sainsbury, 1978). John Mack, Assistant Keeper at the Museum of Mankind, has given valuable advice on several Central African pieces. Comments by other specialists are acknowledged in the appropriate text.

The maps have been prepared by the editor; information on the nineteenth and early twentieth century locations of ethnic groups has been drawn from the survey by G. P. Murdock, *Africa: Its People and their Cultural History* (1959).

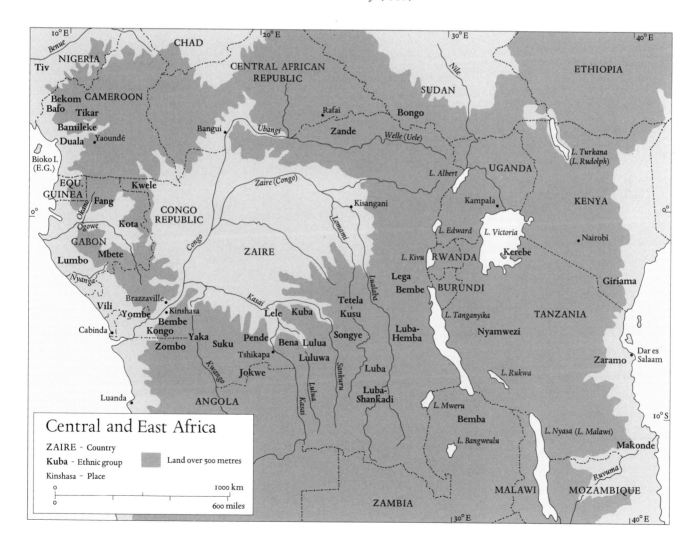

Central and East Africa

ZAIRE - Country
Kuba - Ethnic group
Kinshasa - Place

Western Africa

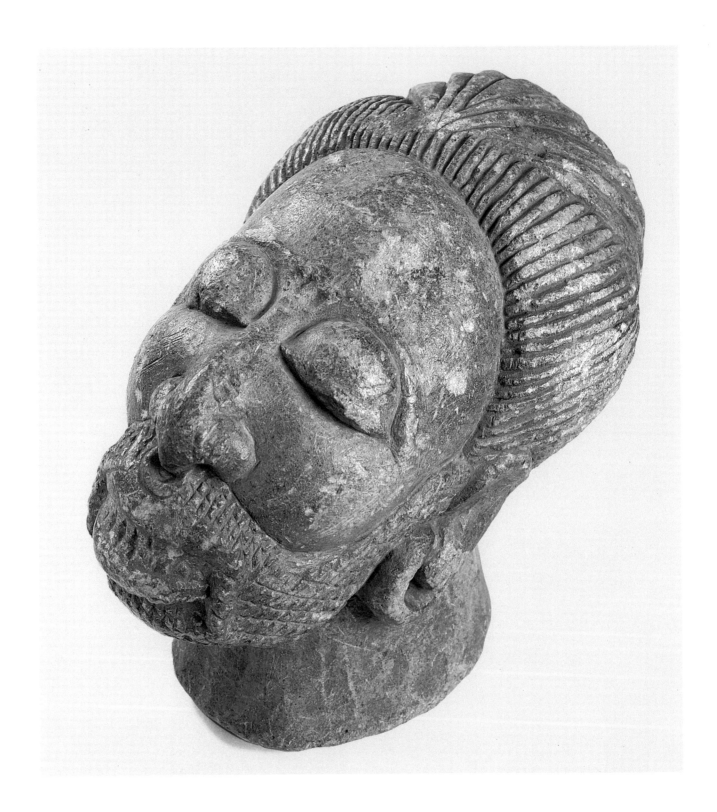

76

Sierra Leone: Sherbro

Male head
15th/16th century
Steatite
h. $11\frac{1}{8}$ in (28.0 cm)
Acquired 1959 UEA 205

The most striking feature of this majestic head is its pronounced horizontality. The neck is a centred pedestal with cranium and jaw projecting laterally on opposite sides. As can be seen from the two illustrations, the distortion of angles and surfaces, so noticeable when the head is seen at shoulder level, virtually disappears if it is viewed at ground level from a standing position, and the face becomes a seemingly naturalistic portrait. The sculptor can thus be credited with a sophisticated handling of form and mass to achieve the desired effect.

Steatite heads of this sort are not *nomoli* (see no. 77, UEA 204), though the earliest group of *nomoli* as classified by Tagliaferri and Hammacher (1974) have similarly hooded eyes. They are locally called *mahen yafe* (the chief's devil), are rarer than *nomoli*, and when owned by local chiefs or the Poro Society they are much venerated and kept hidden. Originally they may have been effigy heads, even portraits, set on the ground or on low altars to commemorate deceased chiefs of the Sapi confederacy (the early Sherbro and Temne people of southern Sierra Leone), since the details of coiffure, beard, filed teeth and ornaments illuminate the descriptions of contemporary writers. The Portuguese d'Almada wrote in 1594 of how the dead nobility were buried, 'with the gold ornaments they used to carry in their ears, around their arms [see no. 77, UEA 204] and through the nose'. Finch in 1607 described coiffures, 'cut into allyes and crosse patches . . . [and other] foolish formes' (both quoted in Tagliaferri and Hammacher, 1974: 18-19).

The more recent role of these heads has been somewhat different from that of the *nomoli*, in that the village 'medicine man' would appeal to the spirit in the head to bring about good fortune or avert disaster, to grant wishes or work revenge. Smaller heads may also be called *mahen yafe*, but the neck may show that some of these have broken off from *nomoli* figures.

Provenance: Reported to have been excavated at Bo, southern Sierra Leone.

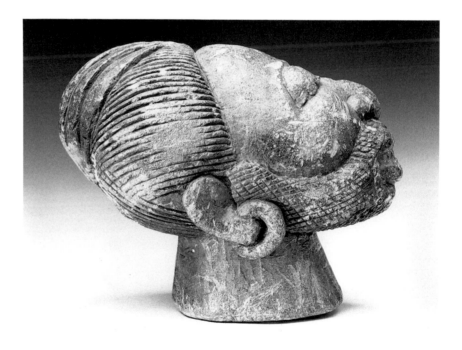

Sierra Leone: Sherbro

Seated figure
16th/17th century
Steatite
h. 8¼ in (21.0 cm)
Acquired 1945 UEA 204

Some of the finest African carvings in stone and
ivory come from the area inhabited by the ancestors
of the present-day Sherbro of Sierra Leone. Their
work in ivory was praised by early Portuguese
travellers; indeed, many of the 'Afro-Portuguese'
ivories (Fagg, 1959), such as salt-cellars, spoons,
forks and oliphants, were made by Sherbro artists.
These can be dated to between AD 1462, when the
Portuguese reached Sierra Leone, and some hundred
years later, when invaders from the south-east broke
up the old Sapi confederacy of the Sherbro and the
Temne, who had occupied the greater part of
southern Sierra Leone (see Ajayi and Crowder, 1971:
chapter 4). Taking into account the differences in
material, the stone carvings (*nomoli*) dug up over
most of southern Sierra Leone are often sufficiently
similar in style to certain Afro-Portuguese ivories
to allow them to be attributed to the Sherbro.

About two thirds of *nomoli* are carved in steatite
(soapstone, a form of talc); the rest are in other
stones, even hard ones. Steatite is no harder than
ivory or hardwood (Moh's hardness 1), but it chips
easily as the blade changes direction, and carving
it requires skill. The African carver's preferred
medium is wood, yet steatite has been used in Sierra
Leone, Esie in Nigeria, around the mouth of the Zaire
and in parts of Kenya.

Nomoli generally represent human figures, mostly
male, and are dug up on river banks, in fields or on
the sites of former villages. Most have forward-
thrust heads, prominent eyes and broad noses with
flaring nostrils. The main axes are horizontal, unlike
the steatite *pomdo* figures of the neighbouring Kissi
of eastern Sierra Leone, which are rather more like
pole figures, with a vertical axis.

Tagliaferri and Hammacher (1974: 15-28) divide
nomoli into four groups, beginning with those akin
to the large heads (see no. 76, UEA 205) and finishing
with the more crudely made and numerous *nomoli*
which exist by the thousand. This example belongs
to their third group, which they date hypothetically
to the 16th and 17th centuries, perhaps when the
Sherbro had begun to use an alternative material
to ivory, which was then in short supply after the
indiscriminate slaughter of elephant herds.

This figure is one of the finest of all known *nomoli*.
The balance of form and precision of carving com-
bine with a relatively unexaggerated '*nomoli* face'
to make what could well be a portrait by a master
carver. The cross-legged pose, with 'plasticine'
treatment of the legs, recalls the famous recumbent

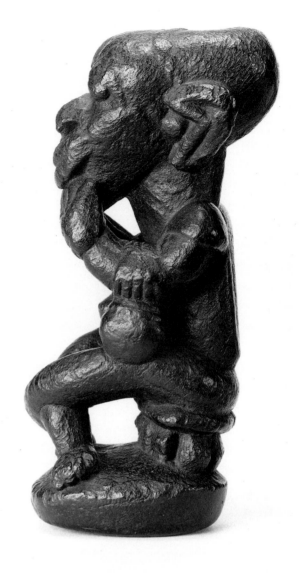

nomoli in the Museum of Mankind (see Fagg, 1965: 5-6), though this is not to suggest that both pieces are by the same hand, or even from the same workshop. The bent arms are supported at the elbows by what are probably heavy cast metal (perhaps gold) armlets with integral ball rattles, comparable to the massive anklets worn among the Kru of Liberia. The Museum of Mankind *nomoli* has a similar armlet on the left arm. This figure, probably male, is sitting on a stool with six bent legs and is holding to its chin an unidentifiable curved object. A faint ridge from the V of the hairline down the forehead to the nose represents scarification. The stone is unusually dark in colour, and close examination, especially of the base, suggests that it was originally grey (the normal colour for steatite) and that it has been artificially patinated, probably with a mixture of lamp-black and oil, though apparently it was already black when brought to Europe in the 1940s.

The original purpose of *nomoli* is not known, but they possibly represented clan or tribal ancestors and were used in divination or propitiatory rituals. However, since the recent Sherbro were quite unaware of their origin, and they were often dug up when preparing ground for agriculture, they often became used as 'rice gods'. Accounts of this use vary: they might be hidden in a corner of the field; or they might receive offerings of rice flour or ritual flagellations to make them cause a good harvest.

Provenance: Reportedly found at Bo, southern Sierra Leone. Brought to England by Basil Jonzen, *c.* 1944.

78

Sierra Leone (?)

Fragment of an oliphant
18th century (?)
Elephant ivory
h. 4¾ in (12.0 cm)
Acquired 1971 UEA 271

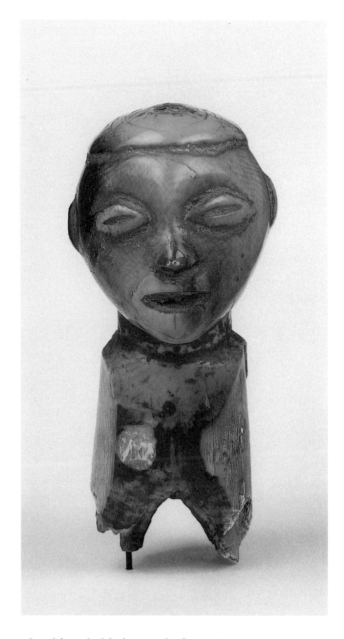

This fragment, a head wearing a skull-cap and carved out of reddish-tinted ivory, is damaged at the back and at the lower end, apparently by fire. There is little difficulty in recognising this fine old ivory as the finial of a trumpet or oliphant, since the damaged torso retains about one third of what is plainly the embouchure or mouth-piece, which, as is standard in all African horns, is on the side near the point where the nerve cavity ends. Its provenance, however, is less clear. It has generally been attributed to the Congo Basin, but it is more likely to have its origin near the source of the Niger, where there has been a well-established although little-known tradition of ivory carving, especially of the making of oliphants, since before the arrival of the Portuguese in the fifteenth century. However, parallels for this piece should probably be sought from about the eighteenth century among the royal trumpets used by chiefs to arrest the attention of the populace, for example among the Sherbro, Temne and Mende tribes.

A tusk as massive as this should indeed have been a chief's property, the more so as wanton slaughter of elephant herds had caused a shortage of ivory by the 17th century (Kup, 1961: 17). The nerve cavity, reaching to the crown of the head, has been plugged with an ivory peg, while the missing portion would have been at least eighteen inches in length, with a girth commensurate with the thickness of the surviving fragment. There is a row of small circular holes on the back of the head. A light-coloured circular patch above the V of the opening is probably the end of a suspension loop which has broken away.

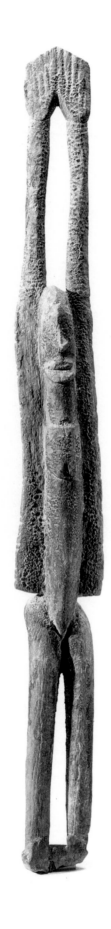

Mali: Tellem/Dogon

Standing figure
Wood
15th/16th century (?)
h. 28½ in (72.5 cm)
Acquired 1986 UEA 928

Tradition tells that the Dogon came to their present
home in about the fifteenth century to find the
Tellem already there, and they coexisted with them
for about two centuries before the Tellem, already
in decline, finally disappeared. Statues found in caves
were used by the Dogon as part of their heritage,
and were highly venerated. In 1960, investigations
began in some of the caves of the Bandiagara cliff
escarpment, an impressive natural feature some two
hundred kilometres long and six hundred metres
high. Several exploratory expeditions have taken
place with the cooperation of the Mali authorities,
and as a result there is now a *corpus* of finds, including
skeletal remains, showing that the Tellem were
distinct from the Dogon (Bedaux, 1977: 74-8).

Radiocarbon dating for the wood of thirty statues
spans the 11th to the 17th centuries, divided into
three periods: Tellem (11th-15th centuries); Tellem–
Dogon transitional (15th-16th centuries); and Dogon
only (17th century on). Given that the African carver
usually prefers to work with fresh wood, which is
easier to carve, and that old wood is very scarce in
the Bandiagara region, these sculptures are probably
contemporary with the wood. Two comparable
figures shown by Bedaux have been radiocarbon-
dated to the Tellem period (11th-15th centuries).
Nevertheless, a question mark still hangs over
the early dating of 'Tellem' wood-carvings, as the
radiocarbon analysis reports have been mislaid
(Bedaux, 1977: 76). Many 'Tellem' pieces could be the
work of Dogon carvers working in the transitional
period or later; some of the stylistically 'Tellem'
statuettes had a later radiocarbon reading than
others which were apparently Dogon. It seems likely
that facets of Dogon cosmogony and art stem from,
or were influenced by, Tellem culture.

The thick crust of sacrificial patina on many
Tellem/Dogon pieces is a mixture of boiled millet
and blood applied by the Dogon, and perhaps also
the Tellem, as part of their rituals. In this figure the
patina has mostly been cleaned off, revealing the
faintly roseate tinge of the wood, and also some of
the carving detail.

Contemporary Dogon cosmology has been studied in depth since the 1930s by French researchers, most notably Marcel Griaule and his students, and Dogon origin myths may assist in illuminating this possibly transitional Tellem/Dogon piece (see Griaule, 1965). The Creator God, Amma (the sky), made the Earth, and had intercourse with her. The offspring were a pair of celestial beings, *nommo*, and then four other pairs. The *nommo* brought the skills of farming, weaving, and iron-working to mankind. Twinship and androgyny are basic elements of Dogon religion, so *nommo* are depicted as hermaphrodite or asexual, befitting their role as immortals, usually with sinuous bodies and with raised arms. This may refer to the Cosmic Figure with Raised Arms, alluding to man's desire for immortality, and also the *axis-mundi* linking the earth (female principle) to the sky (male principle), *Nommo* are often shown as seated pairs (see the crown in no. 80, UEA 927); where they occur singly they may show both male and female characteristics. Many *nommo* are carved with a flat, plank-like back; in this example the small figure standing on the buttocks of the larger is a rather unusual portrayal of a *nommo* pair.

On the outer edge of the raised plank-like arms the small notches, in groups of three, may refer to the Dogon ritual ladder (a notched log), and to the 'chain' that held the *nommo* ark during its descent to earth and by which *nommo* 'climb back up' to the sky. They may also refer to the broken line, a concept of Dogon thought associated with the vibratory movement of growth when combined with verticality.

Almost all African figure carvings portray the arms in relationship to the body, whether at the sides, on the stomach or breasts, or holding a child or object. Tellem sculptures form a group apart, as they raise their arms above the head; this characteristic attitude combined with their encrustation suggests that they indeed belong to a different, older, culture.

Provenance: Formerly in the Lazard Collection, Paris. Collected at Sanga (in the southern Bandiagara escarpment) in 1956.

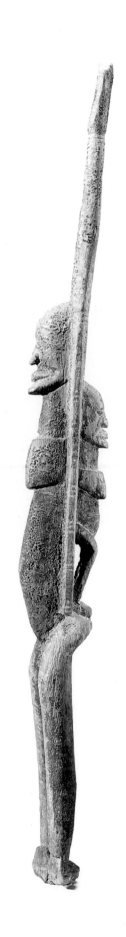

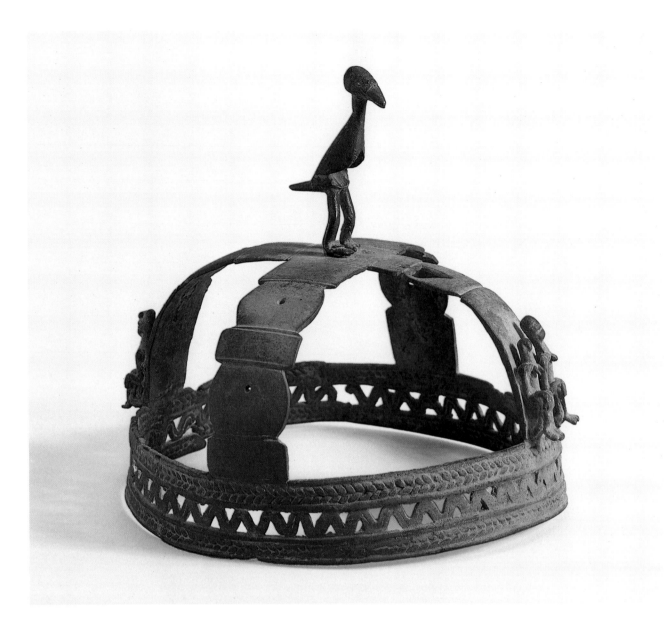

Mali: Dogon

Chief's regalia
16th-19th century
Brass or copper alloys
h. (see below)
Acquired 1986 UEA 927 A–J

This exceptional group of *cire perdue* (lost wax)
ornaments was purchased as being 'Dogon chief's
regalia, Mali. Found in the lower falaise [cliff] of
Bandiagara. Site – village of Irrele [? Tireli]'. There is
no certainty that the ten pieces form a group, since
they are an unmonitored find; in the absence of
comparative material from scientific excavations
their age and context cannot be established with any
certainty. Southern Mali, an archaeological research
area of enormous potential, is currently being left to
more or less indigenous dealers, who may even, it is
rumoured, be granted an official 'licence to prospect'
for artefacts.

 The crown (a) is at once the major piece of the
group and the best confirmation of a Dogon origin.
Most Dogon bronzes are rings or pendants not
exceeding four inches in size, and many are smaller,
making this an exceptionally large ornament and
a true sign of rank in a region where subsistence
farming cannot support prodigal use of valuable
imported metal. It is cast in one piece, except for the
bird on the summit, which has been separately cast
and riveted on. Two intersecting arches join on to a
circlet with 'burn-in' repairs at three points where
the brass casting proved incomplete. The metal is

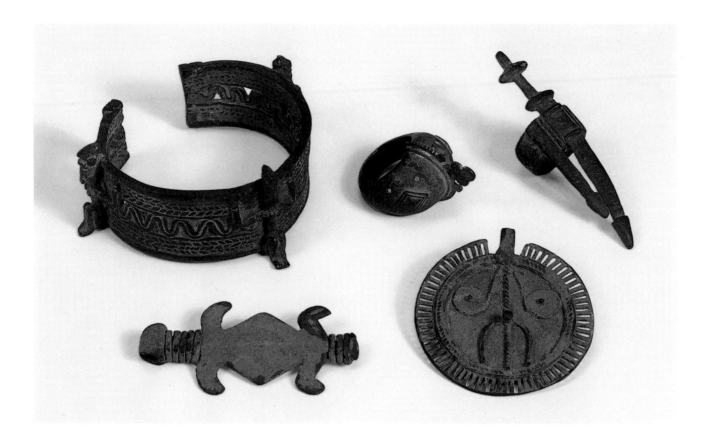

brass, with a hard, light-green patina, apart from a few spots of verdigris inside the circlet (which may point to its having been worn). At opposite points of the circlet's diameter are two pairs of figures seated in hieratic pose, with hands resting on and overlapping the knees. Those behind the bird appear to be male, those in front, female, though the distinction is not emphasised. They are surely *nommo* (see no. 79, UEA 928), and may represent in bisexual form the lineage heads of the four Dogon clans. The style of the figures and their pose is consistent with a Dogon origin. The circlet, made up of two bands of twisted cord ornament enclosing a wavy line, may allude to the concept of the vibration of matter, light and water which is central to Dogon cosmic philosophy and is commonly indicated by spirals and wavy lines. The very shape of the crown is perhaps to be interpreted as a rendering of the world-system, which, according to Griaule (1965: figs. 2-3), is to be seen as a circular plan divided into four quarters – the circular base being the sun, the square roof the sky. While birds are rare in Dogon art, the bird here, on its square base, may be a sky symbol.

The pair of pendants (b) and (c) are circular discs with a central boss and suspension loop. The holes for rings and peg pendants have been punched in after casting. The chains include long *cire perdue* links,

plain or in twisted rope design, joined by circular rings of square-sectioned brass with butted ends. It has been suggested that these pendants are horse trappings. However, Dogon horse furniture is usually shown as a saddle with high pommels, a broad collar and a bridle, so these pendants could well be part of a *hogon's* (priest's) insignia.

The disc pendant (d) has an anthropomorphic design of two spirals on either side of a vertical rope-twist, ending in a boss and tripod (*cf.* Fisher, 1984: 142, fig. 3). The tripod and three small bosses may symbolise the male principle (three is the male number). The Dogon believe that Amma created the world in the form of a spiral; the two spirals on the pendant could refer to this, and also to the male/female duality that is intrinsic to Dogon thought.

The animal-shaped pendant (e) may represent the crocodile at the centre of the earth, where the genital of the dismembered *nommo* was thus transformed. The pale green patina has flaked off in a few places to show dark metal below, which may be copper, or a copper-rich alloy. Copper is associated with the serpent Lébé, the *nommo* who was sacrificed when the eight heads of lineage reached the earth. Lébé, the guiding spirit of the Third Word of Amma (the present world), is an important cult figure among the Dogon, and the *hogon* are priests of his cult.

The ring (f) may perhaps be later than the other pieces; file marks on the sword scabbard suggest a date within the last century or so. Laude (1973: no. 77) illustrates a ring similar to (g), which he describes as 'in the form of a skullcap(?)'. It is larger in finger diameter than (f).

The penannular armlet (h) is made with three integrally-cast seated figures. The band is made up of two rows of three twisted cords with a wavy line between. The seated figures may be *nommo* or lineage ancestors. The central figure and that on the right have their arms at right angles to the body with forearms raised vertically; the one on the left has its right arm similarly raised while holding a staff in the left hand. They seem to be bearded, to have crested caps or coiffures, and may wear bracelets. A figure with arms raised but separated can be read as beseeching Amma to stay near, 'like a child reaching out to his father'. The metal is a copper-rich alloy. A pair of armlets, (i) and (j), appear to be made of brass and are only distinguishable by the central disc

ornament on (i), and a slight difference in size.

When a *hogon*, who is a priest of the cult of Lébé, and a priest-ruler of the Dogon, dies, copper rings are put on his fingers and arms. These belong to Lébé, who is particularly associated with copper, a sort of life essence, and are later taken off and given to the next *hogon* but one. 'Every Hogon had had the rings in his possession while his predecessor held office. He is impregnated with copper. He is like copper . . .' (quoted in Griaule, 1965: 120). While copper is the metal specifically named, perhaps it is to be read as copper alloy, and therefore many, if not all, of the ornaments in this assemblage may have belonged to a *hogon*; in such a context the symbolism detectable in design and decoration is wholly appropriate.

Details: (a) diam. $6\frac{7}{8}$ in (17.5 cm); (b) l. $29\frac{1}{8}$ in (74.0 cm); (c) l. $27\frac{5}{8}$ in (70.2 cm); (d) diam. $2\frac{1}{2}$ in (6.5 cm); (e) l. 3 in (7.5 cm); (f) h. $3\frac{1}{2}$ in (9.0 cm); (g) h. 2 in (5.1 cm); (h) w. $3\frac{5}{8}$ in (9.2 cm); (i) w. 4 in (10.2 cm); (j) w. $3\frac{1}{4}$ in (9.6 cm).

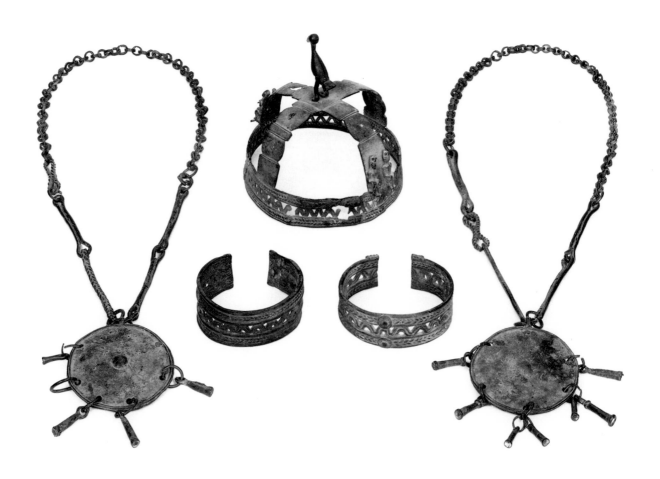

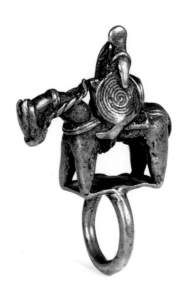

81

Mali : Jenne or early Dogon

Dress ornament in the form of a horseman
15th/16th century
Brass
h. $3\frac{1}{8}$ in (7.9 cm)
Acquired 1980 UEA 768

The sad state of archaeology in southern Mali is
responsible for the uncertain tribal attribution of
this ornament (purchased as from the Dogon). The
ambiguity arises from the overlap between the Jenne
style and that of the early Dogon, who undoubtedly
were in at least occasional contact with the horse-
men of the empire of Mali. The figure is that of a
man riding side-saddle, holding a bow in his left
hand and with a quiver over his right shoulder. He is
bearded, with long braids in front of each ear, and he
wears a conical hat and patterned kilt; the horse has
a bridle and neck bands and seems to be secured on a
very short tether to what may be a tall post. The hat
would seem to identify the rider as a *hogon* (a priest-
chief of the Dogon, see no. 80, UEA 927, and Griaule,
1965: pl. ivb).

The piece does not seem to have been a pendant,
since the two loops at the back would cause it to
hang crooked. It may have been worn strapped to
the arm, and it may have had rings hanging from
the small holes on the lower edge.

82

Mali : Dogon

Ring with figure on horseback
16th/19th century
Brass
h. $2\frac{1}{2}$ in (6.4 cm)
Acquired 1967 UEA 202

Although representations of horsemen are fairly
common in Dogon art, the country is unsuited to
horses; indeed, the Dogon fled the Mossi cavalry to
the refuge of the Bandiagara cliffs. Perhaps we have
in this ring an allusion to the myth of the Primordial
Blacksmith, the ritual thief who brought fire to
mankind on earth by stealing a piece of the sun and
hastening down a spiral path on the rainbow. The
nommo remaining in the sky attacked the Blacksmith
by hurling firebrands at him, which he warded off
with the skin of his bellows, which was transformed
into a shield embodying a piece of the solar essence,
so that it became fireproof. The rider's shield could
well refer to this, since a whirling copper spiral
propels the female sun (Griaule, 1965: 20, 71) and
'the sun is . . . surrounded by a spiral of copper with
eight turns' (quoted in Griaule, 1965: 16). The 'spear'
could be the thief's crooked stick.

Such rings, all cast by the *cire perdue* (lost wax)
process, probably belonged to Dogon elders (see
Fisher, 1984: 116, fig. 1; 117, fig. 6).

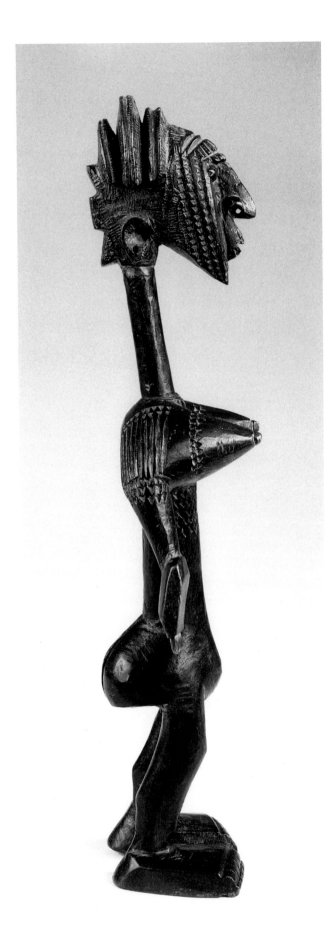

Mali, Ségou: Bambara

Standing female figure
Early 20th century
Wood, brass nails
h. 15 in (38.0 cm)
Acquired 1953 UEA 198

This figure is an admirable product of the Ségou
school of carving; some forty-five carvings are
recognised as belonging to this group, including
eight standing female figures, of which this is perhaps
the finest. An initial study by Allen Wardwell (1966)
identified the carver of this figure as the creator of
some other pieces of the Ségou *oeuvre*. Later, Ezio
Bassani (1978) reviewed the whole body of known
Ségou pieces and concluded that the hands of three
master carvers could be detected. He has suggested
that the three carvers should be named: the Master
of the Antelopes, the Master of the Slender Figure
and the Master of the Aquiline Profile. As far as can
be conjectured from the known history of Ségou
carvings, they fall into three periods: the first around
1906 (the date of the Mission Desplagnes, when a
N'tomo mask was collected and the celebrated photo-
graph of Bambara antelope maskers was taken by
Delafosse), the second about 1919-23 and the third
in the 1930s. Of these, the Master of the Slender
Figure, the carver of the present piece, was active
during the second period.

The Ségou style, with its characteristic head
profile, may well be of several centuries' standing,
since there is a terracotta head in the Museum of
Mankind (1972 Af 29.3), which, though undocumented,
is clearly from the cemeteries near Konodimini and
Barouéli, between Ségou and Bamako. This matches
the heads of the modern Ségou-style wood carvings
sufficiently well to give this hypothesis credence.

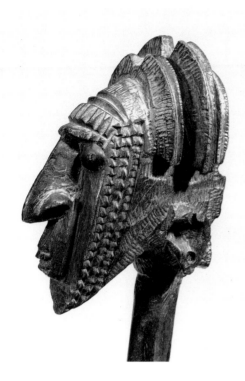

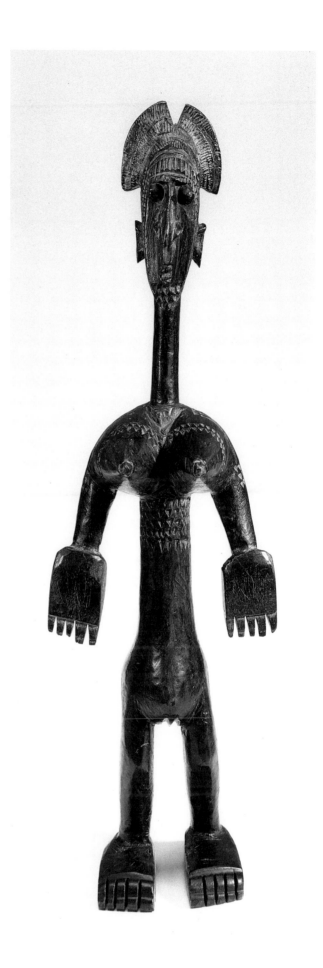

These cemeteries date to about AD 1200-1500, the period between the apogee and the decline of the empire of Mali. The Bambara (more correctly Bamana) came from the east to their present area in about the 16th century, and founded Kaarta and Ségou, two important states of Mali.

Among the Bambara, carvers belong to the black-smith caste; they carve utilitarian objects such as hoe-handles as well as the masks and figures that interest us. The figure is typically Bambara, with its angular features and conical breasts; the carver's artistry is manifest in the dynamic, balanced angles of the profiled head and body contrasting with the narrow, almost angelfish-like frontal view of the head and the robust hands and feet. The surface enrichment of cicatrisations shown as chip-carved rows of triangles is not a rendering of Bambara body decoration. Masks of the *N'tomo* society, which relates to the progressive stages of a boy's life and which holds its main festival at harvest time, chiefly come from the region to the south-east of Ségou; some of these masks are surmounted by female figures closely resembling the present one. They are said to represent the twin of the ancestor who invented agriculture and stole seeds from the sky in an attempt to conquer the world. The separately carved figures may have been placed around or near to altars.

Provenance: Formerly owned by Paul Elsas.

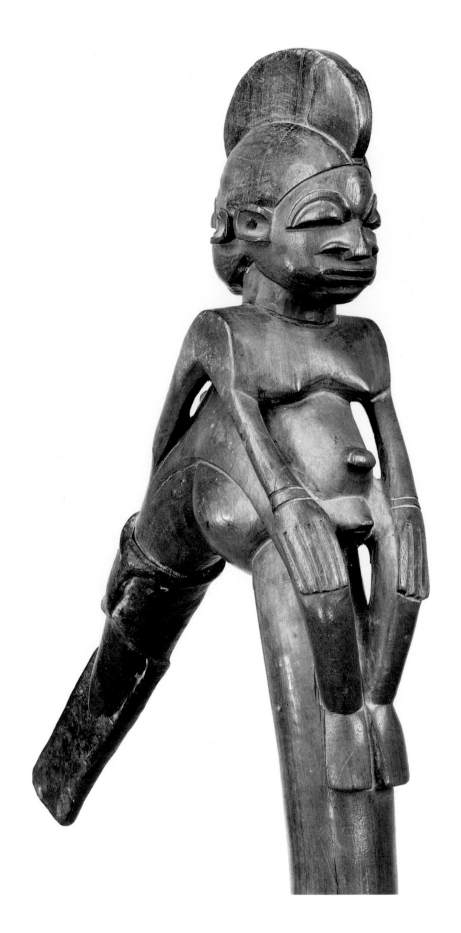

84

Burkina Faso: Lobi

Ceremonial axe with janiform figure
20th century
Wood, iron
h. 26½ in (66.5 cm)
Acquired 1970 UEA 199

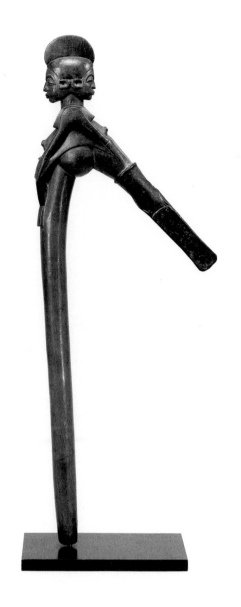

Ceremonial axes, batons and messenger staffs often serve to identify a chief's envoy or spokesman as well as being regalia or potential diplomatic gifts. Such objects may have the form of an everyday artefact but are distinguished by more or less elaborate decoration with engraved or chased blades, often of a non-functional nature. This one appears to have a female figure issuing from the socketed blade, while that attached to the shaft is male (see Leiris and Delange, 1968: fig. 316, for a very similar axe with missing blade; also Meyer, 1981: 127, 140).

This is recognisably a work by the acknowledged master of all Lobi carvers of this century, Sikire Kambire of Gaoua (just within the Burkina Faso border), who lived from 1895 till 1963. In the late 1920s Professor Henri Labouret, who was much impressed with his carving in the Lobi tradition, took him some Baule masks as an experiment, asking him to carve copies of them. Sikire liked the Baule style so much that he immediately used elements from it, notably the strict, almost architectonic arcading of the eyebrows, which are of even width, not pointed as in the Lobi way. He had many followers, though none who equalled his bold and sure hand. His hand – though perhaps not his name – was known far and wide throughout all northern Ghana, where the chiefs were accustomed to keep fine carvings from which they made diplomatic gifts to other chiefs and to the more important colonial administrators on tour. After 1930 he probably produced more works for trade than for tribal use, yet this sculpture seems to have been made for use by an African chief.

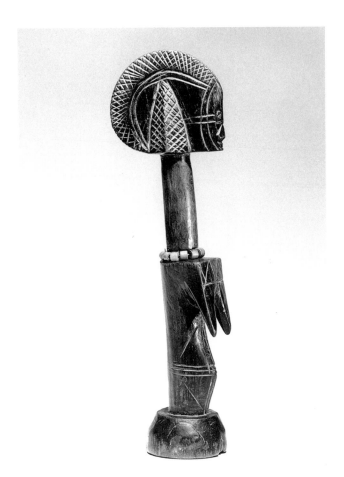

85

Burkina Faso: Mossi

Ritual doll
Mid 20th century
Wood
h. 11½ in (29.0 cm)
Acquired 1974 UEA 573

Christopher Roy's illuminating article on Mossi dolls (*biiga*) allows us to ascribe this doll to the Boulsa kingdom in eastern Mossi country, and to the hand of Zimwomdya Koudougou or his son Somyogede Koudougou (Roy, 1981: fig. 9), who works in the Logda smith neighbourhood of Bonam village, some fourteen kilometres north of Boulsa town.

The dolls were first described by a missionary writing in 1921; young girls play with them and carry them tucked in the waistband of their skirts. They are all female and have the long breasts that are a desirable symbol of motherhood. A bride will take her doll along when she leaves for the home of her new husband, to help her to become pregnant. If she has a baby of her own as a result, she tends the doll for a while, since it will prevent harm to the baby.

86

Ivory Coast or Liberia: Dan

Dance mask
Late 19th/early 20th century
Wood
h. 9½ in (23.5 cm)
Acquired 1949 UEA 208

Fischer and Himmelheber, in their authoritative study of Dan art (1984), stress that the variations in form and function of Dan masquerades are too confusing to allow any clear-cut classification, since masks often change their roles during their careers. If a mask has been divorced from its original context, it is often not feasible to assign to it a definite status, although it may be possible to fit it within a broad category. Among the Dan, narrow eyes are a sign of feminine beauty. In this mask, such eyes, together with the oval beardless face, indicate that it is a *gle mu*, a 'gentle' mask, and since it has eyes, it is probably a *tankagle* rather than the similar *deangle*.

Tankagle is a 'dancing, miming masquerade' and may be accompanied by an orchestra and chorus. The masker usually wears leg-rattles, carries a calabash rattle and may be dressed in a fabric cape and enormous fibre skirt. Holes around the rim of the mask are for a bonnet-like head-dress (*komo*) with cowrie-shell decoration; the head-dress is important in defining the role of the mask.

Tankagle masks usually have attractive feminine faces; the vertical cicatrisation scar on the forehead and nose is a feature of the southern and western Dan, and emphasises bilateral symmetry, admired in Dan beauty. Inside, the smoothly carved interior has hollows just below the eyes with a median trough which seem clearly designed to accommodate the nose and cheekbones of the masker.

The men who wear the masks are called *ʒo* (master); to become a *gle ʒo* (performer of the masquerade) he must have had a dream sent to him by the mask-spirit. While the actual mask may be handed down through generations by inheritance, the masquerade itself depends on the dream – an 'acknowledgement' by the mask. A mask may thus spend as much as a generation 'resting' until a new *ʒo* is visited by a dream. Its re-emergence may be accompanied by a different masquerade – costume, movements and musical accompaniment – as dictated in the dream.

Provenance: Formerly owned by James Keggie.

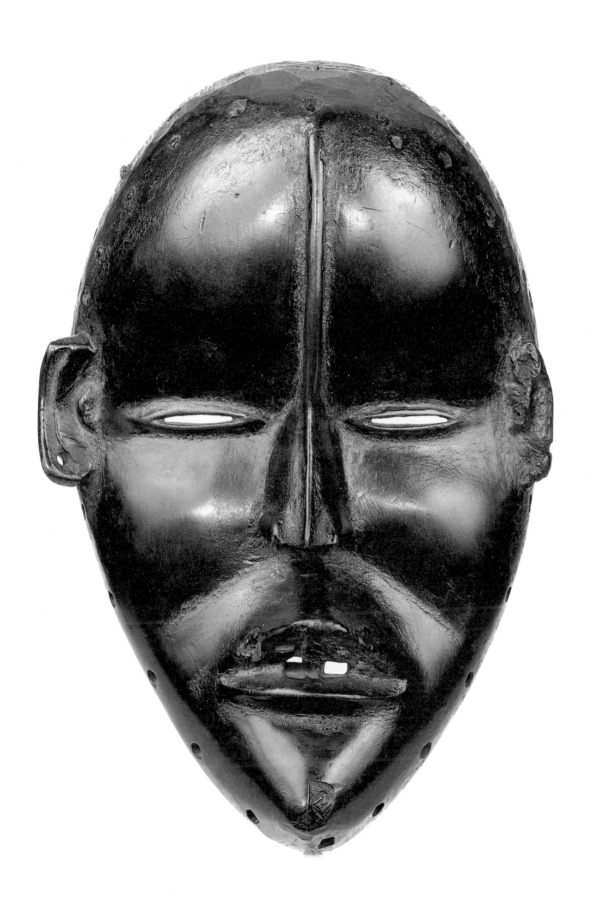

87

Ivory Coast or Liberia: Northern Dan

Dance mask, bird form
20th century
Wood
h. 14 in (35.5 cm)
Acquired 1975 UEA 608

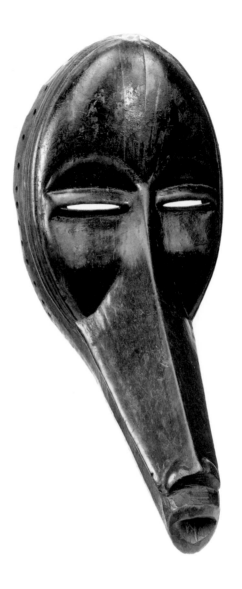

The narrow-eyed oval face, grooved on the outer edge, and the long
beak make this a typical mask of the *gegon* (bird) masquerade. Such
masks generally represent the hornbill, which is held to be the king of
birds. The beak is normally edged with a long black fringe of colobus
monkey fur; here the unfinished sides of the beak suggest that one was
intended, so perhaps the mask was never occupied by a mask spirit.

Gegon is a male masquerade, found exclusively among the northern
Dan (see Fischer and Himmelheber, 1984). It belongs to the *kagle*
(hooked-stick) group of masquerades, so named because the dancer
holds hooked sticks which he whirls around at knee level making people
jump out of the way. In the rapid whirling dance he frightens women
and livestock and knocks pots over; meddling or conceited people may
get punished, thus releasing village tensions.

The *gegon* dancer wears rows of cowrie shells above the forehead and
a tall cylindrical hat covered with feathers. He has a thick raffia skirt
on his hips and a body covering of thick blue and white cloth; he may
hold cowtail fly-whisks in each hand and be accompanied by drummers
and singers.

Ivory Coast or Liberia: Dan

Dance mask
Late 19th/early 20th century
Wood
h. 9 in (22.8 cm)
Acquired 1979 UEA 715

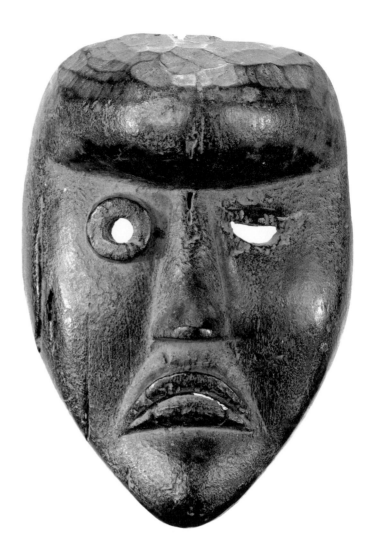

It is rare to find Dan masks that depict illness in the same decisive way as is found, for example, among the Ibibio and Idoma of Nigeria (*cf.* no. 125, UEA 595). This mask, with one eye half closed with drooping upper lid, seems to belong to Fischer and Himmelheber's category 8 of Dan masquerades, which represent symptoms of illness.

Concerning such masks, they write (1984: 80), 'These face masks should be categorised as "flaw-finding masquerades" rather than as representations of a sick person . . . One is not supposed to laugh at the sight of such a masquerade however much the comic gestures or facial distortions may provoke one to do so. When these masquerades appear, they continually scratch themselves with great vigour, limping about and appearing to collapse. Whoever laughs at them must pay an immediate fine, or else suffer an infliction of the same sort of facial disorder. For this reason mothers shepherd their children indoors . . . thereby avoiding any need to make expiation for their inadvertent laughter. If one of these masqueraders encounters someone with the same symptoms as his own, he . . . says, "Why are you trying to mock me by copying me?" and demands payment of a fine.'

89

Ivory Coast or Liberia: Dan and Bassa

Ten miniature masks
Late 19th/early 20th century
Wood, fibre, beads
h. (see below)
Acquired 1982 UEA 834 A–J

Dr G. W. Harley, the American missionary of Ganta
in north-east Liberia between the wars, was the
source of the great collection in the Peabody Museum
at Harvard, on which for many years our knowledge
and understanding of the Dan was largely based. He
also collected for other institutions and collectors,
and the present small group was acquired some years
after his death.

In the photograph, viewing left to right, top to
bottom, the miniatures (e), (f) and (i) appear to be
of the *deangle* type especially associated with
circumcision ceremonies. Masks (d), (g), (h) and (j),
since they have ears, are the *tankagle* type, often
called the 'beautiful woman' mask. Mask (c) may be
a miniature of a bird mask (*gegon*), and (b) a monkey
mask (*kaogle*). The bulbous forehead of mask (g) may
place it among the Bassa or De, to the south-west of
Dan country. Mask (a) is in a category of its own; the
wood is probably from the temperate zone, and it is
likely to be a work from Dr Harley's own hand. If so,
though not unique, it is an interesting addition.

Provenance: Formerly owned by Dr G. W. Harley.

Details: left to right, top to bottom. (a) $4\frac{1}{8}$ in (10.5
cm); (b) $3\frac{3}{8}$ in (8.6 cm); (c) $4\frac{1}{8}$ in (10.5 cm); (d) $4\frac{1}{4}$ in
(10.8 cm); (e) $4\frac{1}{4}$ in (10.8 cm); (f) $3\frac{3}{4}$ in (9.5 cm); (g)
$3\frac{3}{4}$ in (9.5 cm); (h) 4 in (10.2 cm); (i) $3\frac{1}{4}$ in (8.3 cm);
(j) $3\frac{3}{4}$ in (9.5 cm).

Ivory Coast or Liberia: Dan

Miniature mask
Late 19th/early 20th century
Wood
h. 5⅝ in (14.0 cm)
Acquired 1967 UEA 209

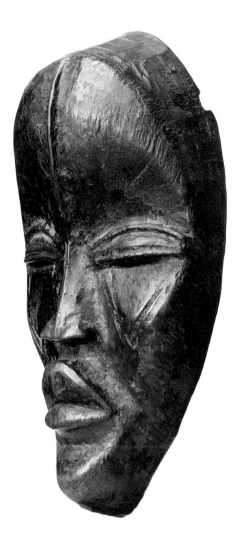

Fischer and Himmelheber have given, in their exhaustive work on the Dan (1984), a very useful account of the miniature masks, from which it is clear that they are best named not for the purposes to which they are applied, for these are many, but for their morphology. Thus, not 'passport' masks, etc. but small (or miniature) heads (in Dan, *ma go*).

Anyone who is an important mask-owner may commission a miniature of it, and make sacrifices to it, for example, when travelling. Ownership of such a miniature is somewhat equivalent to having a passport, since it identifies the holder as the warden of an important mask even when he is outside his district. Women, who are not permitted full-size masks, may commission a miniature mask of their choice and may benefit from the association, for behind all masks, large or small (though in the case of the latter at one remove), is a mask-spirit.

We may infer that this is almost certainly a miniature of a famous full-size mask, judging from the quality of the carving. The mask depicts an attractive feminine type as shown by the oval face, narrow eyes, central ridge scar, crisply carved nostrils and full upper lip.

The absence of ears suggests that this may be a *deangle* miniature rather than the similar *tankagle* (see no. 86, UEA 208). *Deangle* means 'joking or laughing masquerade', and is the mask associated with the circumcision camp; the masker, who is without music or dance accompaniment, asks the women to give food for the men and boys secluded in the camp. A miniature mask can play a part in the camp as a witness to the operation; the circumciser passes his knife over the mask as it is laid on the ground to achieve a 'spiritual sterilisation'. Hence many miniature masks have knife-marks on the forehead or face edge, and faint traces of such lines may be seen on the left-hand temple of this one.

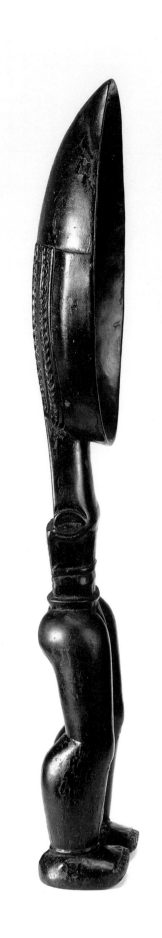

91

Ivory Coast or Liberia: Dan

Spoon
Late 19th/early 20th century
Wood
h. 18¼ in (46.5 cm)
Acquired 1970 UEA 206

This is a rare form of Dan spoon, having the handle
carved as the torso and legs of a woman. More
usually the handle is carved as a beautiful female
head, or sometimes the head of a ram or cow. The
use of these spoons (*wakemia* or *wunkirmian*), which
are often called rice ladles, may be seen as an insti-
tutionalisation of hospitality, an attribute which
is highly valued in traditional African culture and
morality. Since women grow and prepare food, this is
regarded as a particularly female virtue, and certain
eminent women, called 'at feasts acting woman', or
'most hospitable woman' (*wakede* or *wunkirle*), are
entitled to own such spoons. The office of spoon-
holder, which entails the periodic distribution of
lavish hospitality at festivals, provides an outlet for
celebrating the dignity and importance of woman's
role in society. It is also enhanced by the beauty of
the spoon, which is often recognised as the work of a
master carver and is almost always fine enough to be
a fitting honour for the *wakede* and her hospitality.
The spoon is generally kept hung out of the way in
the hut; if someone accidentally touches it, it means
that a feast must be provided.

The festival of merit, or cow-festival, is the most
important one for the *wakede*. She dances through
the village wearing men's clothing – 'because only
men are taken seriously' (Fischer and Himmelheber,
1984: 156-68) – and carries her spoon with the bowl –
'the belly, pregnant with rice' – angled to display
small coins or rice, while her helpers accompany her
bearing plates and fans. The woman's chief assistant
is her *kumane*, who extols her liberality and urges her
to outdo her previous efforts.

A *wakede* needs the help of a spirit to achieve what
is expected of her; this spirit may appear in a dream
and ask her to use and take care of the spoon, the
spirit's home, as a preliminary to telling her where
it is to be found. Such a spoon may be passed on by
inheritance to another woman who, energetic and
efficient, is judged to be a fitting spoon-holder; but
she must wait until the spoon-spirit acknowledges her
in a dream before assuming the honoured position
of *wakede*.

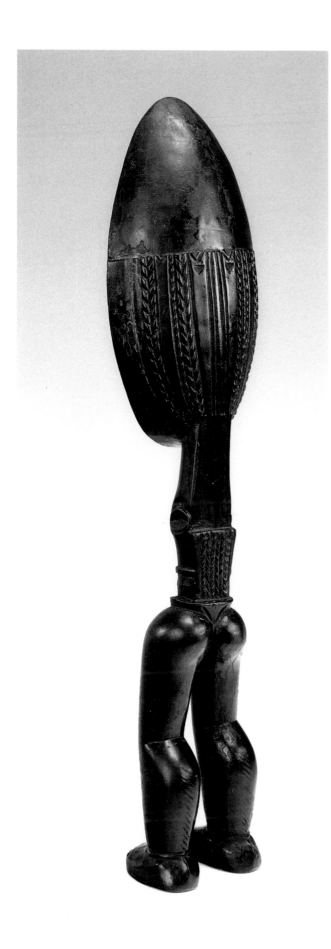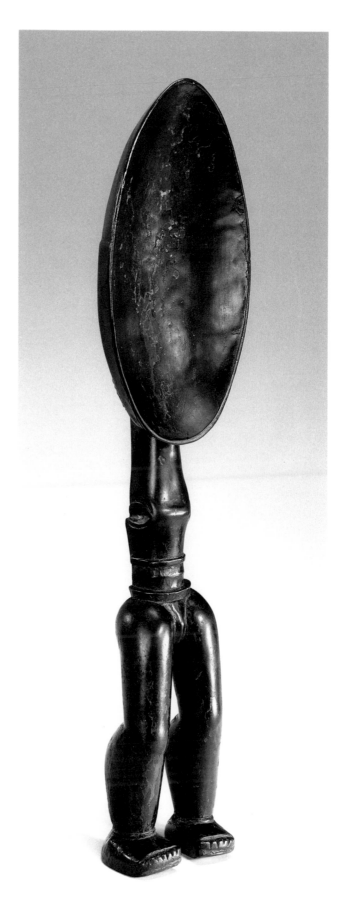

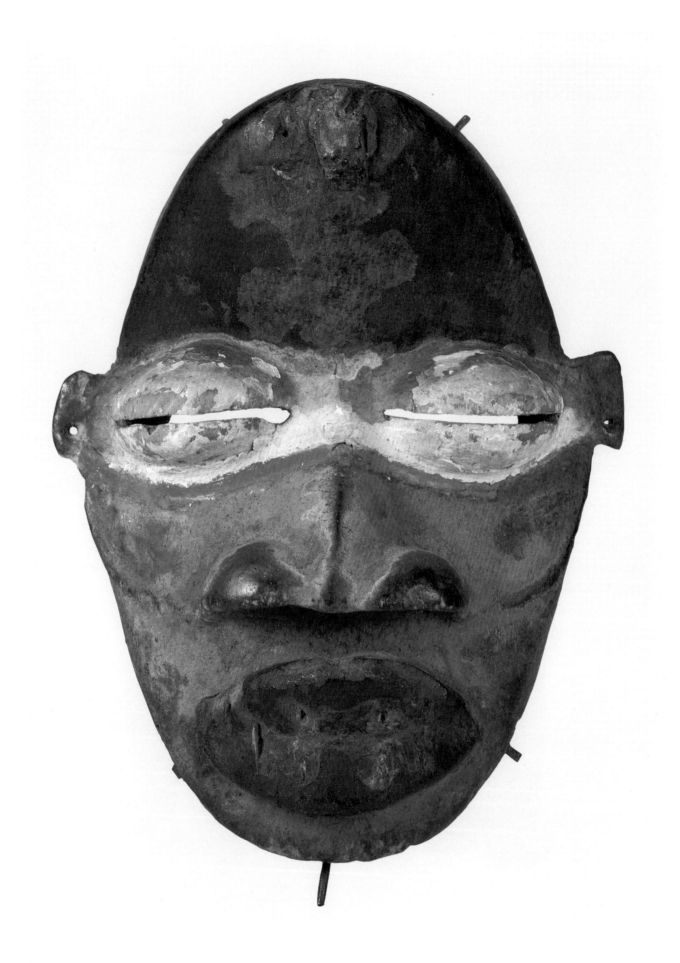

92

Ivory Coast or Liberia: We

Mask
Late 19th/early 20th century
Wood, metal, quills
h. 8½ in (21.6 cm)
Acquired 1949 UEA 211

This, perhaps the most famous of the 'ugly' masks
published in Paris between the wars (Portier and
Poncetton, 1936: pl. XIII), may serve as an indicator
of how fashion in European taste changes over the
years. The We style may indeed have seemed brutish
when contrasted with the elegant *gle mu* masks from
the Dan; today's beholder, on the other hand, might
well prefer the majestic strength and serenity of
masks such as this, and deem them beautiful.

 Some We masks have exaggerated features, with
horns, tusks, protuberant eyes and bulging foreheads;
some have been called cubist. By comparison, this
mask is restrained, the only ornament being the red,
white and blue paint (camwood, kaolin and Reckitt's
blue), and quill teeth. Formerly there may well have
been bells around the chin, as perforations indicate.

Provenance: Formerly in the collections of Paul
Eluard and Pierre Loeb.

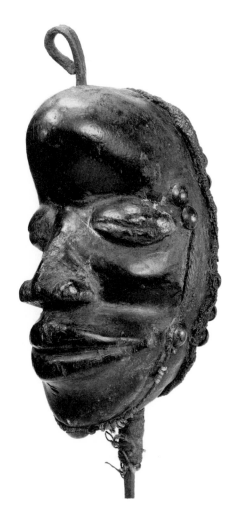

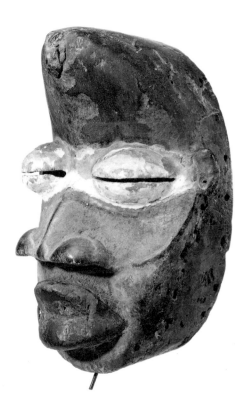

93 (*above*)

Ivory Coast or Liberia: We

Pendant mask
20th century
Wood, metal, fibre
h. 5⅝ in (14.3 cm)
Acquired 1975 UEA 620

The 'coffee-bean' eyes, flattened nose, wide mouth
and projecting forehead are characteristic of masks
of the We tribal group (formerly called the Ngere).
This mask, described as a rattle and a pendant mask
worn by a dancer among his hangings, might instead
be a hand mask containing fetish material; one such
is illustrated in Fischer and Himmelheber (1984:
fig. 97), and the cultural affinity between the Dan
and the We could perhaps allow this analogy.

 The mask is quite deep, and the cavity is covered
with varnished cloth attached by brass upholstery
nails. The iron spike and loop on top may be for
mounting the mask in a shrine or spirit house.

94

Ivory Coast: Guro or Yaure

Dance mask
19th/early 20th century
Wood
h. 9½ in (24.1 cm)
Acquired 1935 UEA 213

This mask shares with the Fang reliquary head (no.
130, UEA 240) the honour of being a founder-member
of the African part of the Sainsbury collection. Both
formerly belonged to Paul Guillaume, who for over
twenty years had been in the first rank of French
connoisseur-dealers in African art. Still among the
most prized and beautiful carvings in the collection,
they bear witness to Paul Guillaume's discernment.

Many Guro masks are demonstrably and, on
the part of their sculptors, consciously made to be
'beautiful', and perhaps conform to a universal ideal
of beauty – a view shared by André Malraux, who
included this mask in his *Musée Imaginaire* (1952: 400).

Corroboration of Guro aspirations towards the
beautiful may be sought among the numerous masks
in which the human face is accompanied by animal
representations, which in many cases appear to
follow a different standard. A notable example is the
beautiful human mask in the University Museum in
Philadelphia (Fischer and Homberger, 1985: fig. 168),
which is surmounted by a particularly ungainly white
bird (perhaps a heron or egret). The work of Guro
and Baule artists may, especially when influenced
by European responses, tend too much towards
self-consciously suave virtuosity to appeal to our
contemporary taste. The fine pieces, however,
while still within the smooth tribal style, have an
underlying harmonious strength that allows Baule
and Guro art to be counted among the great schools
of African art.

Although generally ascribed to the Guro, this
mask has features which associate it with the Yaure,
a small group living east of Bouaflé who culturally
and geographically are midway between the Guro
and the Baule. Masks bearing horns, whether of ram
or buffalo, or the figure of a cock, are linked with
fecundity and may have been used in the men's secret
society *die*. The *die* calendar, which follows the lunar
year, marks different phases of agricultural work;
the dance masks sometimes incorporate an allegoric
personage and tend to have feminine faces.

In addition to the bird's feet on the crown, the
facial shape, with its slight fullness, and the ram's

horns framing the top of the head, suggest Yaure
influence if not a Yaure origin. Three perforations
and a ridge are provided for the attachment of an
occipital cap, head cloth and dance costume (Fischer
and Homberger, 1985: 143).

The finish is exquisite; the silken outer surface has
been darkened with vegetable stain; kaolin highlights
the grooves of hairline, eyes and mouth. Inside, on
the left-hand edge is written 'Zouénoula' (a place in
central Ivory Coast), possibly in Guillaume's hand.
The stand (not illustrated), precision-made of oak
and darkened with a secret stain, bears the stamp
of Inagaki, the renowned Japanese craftsman who
worked in Paris in the 1930s.

Provenance: Formerly owned by Paul Guillaume,
and acquired from his widow in 1935.

Ivory Coast: Guro

Dance mask
20th century
Wood
h. 12 in (30.5 cm)
Acquired before 1939 UEA 214

This mask from the northern Guro represents *gu*, the wife of *zamble*, the antelope, in the most celebrated of their mythological masquerades. These masks are very popular, and their appearances are welcomed, the more so because only the most accomplished dancers are entrusted with wearing them. Compared with no. 94, UEA 213, this example is conceived in a slender, even coquettish mode; the type is among the narrowest of all Guro masks, as is confirmed in a review of the 135 masks in the recent definitive exhibition at the Rietburg Museum, Zurich (Fischer and Homberger, 1985).

The slenderness of the design helps to place emphasis on the topknot. This is held in place by four square motifs which are identified as leather-covered Koranic charms worn to bring good luck. Fischer and Homberger (1985: fig. 23) illustrate a woman with her hair in a topknot similarly bound with amuletic charms; the five 'fingers' below the topknot must be hair braids converging on the crown.

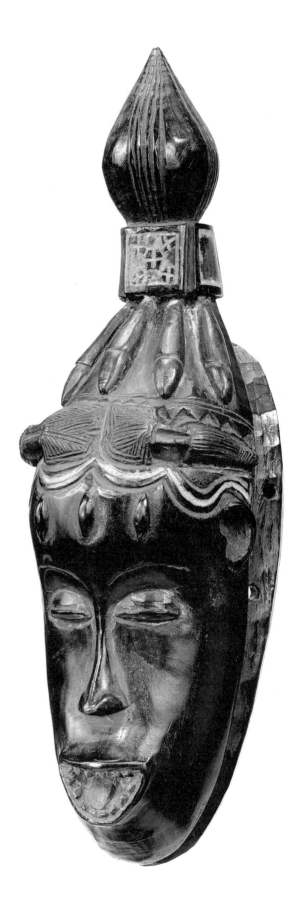

Ivory Coast: Ligbi

Heddle pulley holder
20th century
Wood
h. 6⅜ in (16.0 cm)
Acquired 1962 UEA 201

The Ligbi are a small tribe culturally typical of a
number which are clustered to the east of Bonduku,
in the eastern Ivory Coast, and extend across the
Ghana border near Wenchi. These tribes, sandwiched
between the Senufo (or Siena) and Baule tribal areas,
show unmistakable evidence in their art of strong
influence from the Senufo, notably in their masks and
in the minor arts, such as the carving of ornamental
pulley holders. These support a pair of heddle rods
which allow the rapid shed-changing that is such a
feature of West African double-heddle narrow-loom
weaving (see Lamb, 1975: 50-53 for weaving details).

In the Ivory Coast area, heddle pulley holders are
surmounted by animal or human heads by which
they are suspended from the loom framework; the
heads are apparently ornamental rather than ritual.
In this case an antelope's head is represented; like
many such, the portrayal has anthropomorphic
elements. The strength of the triangular full-face
aspect and vertical profile, combined with the
backward slope of the chin and arch of the neck
which create a triangular space intended to accom-
modate the suspension cord, show the carver's
mastery of both function and aesthetic.

97

Ivory Coast: Baule

Male mask
19th/early 20th century
Wood
h. 12¼ in (31.0 cm)
Acquired 1936 UEA 216

In discussing this mask, Leon Underwood (1948: pl. 15) refers to
its 'very human expression'. Some of this is to be explained by the
understated facial scarification, and the beard which fans out like a
real one, unlike the commoner cylindrical twists or plaits (*cf.* no. 99,
UEA 684a). There is also a feeling of portraiture in the face, strengthened
by the absence of stylised features such as strongly-marked eyebrows.
Furthermore, study of the finer Baule masks shows that their apparent
symmetry is an optical illusion. Since the human face, however regular,
is itself composed of two separate halves, the imbalance in such masks
as this is a humanising trait.

Traces of what may be a bird claw on the surviving right-hand part
of the crown perhaps explain the deficiency of the rest of the mask
summit, which, had there been a bird there, might have been broken
away at the same time. In that respect, this mask somewhat resembles
no. 94, UEA 213, though in terms of projecting the image of a real human
being, there can be no equation. The mask is made of dark, rather heavy
wood; there are signs of domed upholstery nails used to ornament the
forehead close to the hairline.

Provenance: Formerly owned by Pierre and Suzanne Vérité.

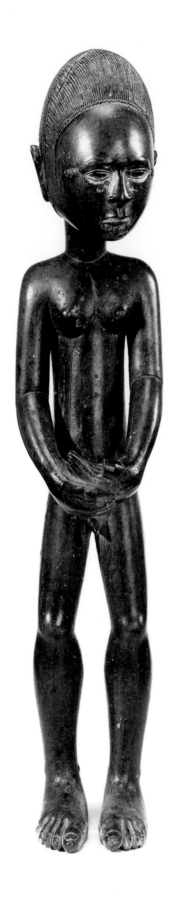

98

Ivory Coast: Baule

Male figure
19th/20th century
Wood
h. 14¾ in (37.5 cm)
Acquired 1960 UEA 215

Ancestor figures are never carved among the Baule;
the ancestors, who are a powerful force, instead
receive sacrifices on special stools and chairs. Figures
(*waka sona*, wooden persons) like this one are the *locus*
for spirit spouses. The Baule believe that everyone
had a spouse in the other world before they were
born into this one (see Vogel, 1981: 73). Men would
have a *blolo bla*, a 'spirit wife', while women have a
blolo bian, a 'spirit husband'. The diviner may advise
anyone who has difficulties with marriage, fertility,
etc., to commission a figure of a spirit spouse and set
up a shrine for it, as such problems are attributed
to a restive spirit spouse who must be appeased. The
spirit itself may indicate to the diviner, the client
and the carver the details of posture, scarification
and coiffure, and even which tree should be used in
making its figure.

This statuette, with cupped hands held loosely in
front, is unusual in posture and proportions. Most
Baule figures have the arms carved along the sides
of the body, whether attached or free. The normal
'African' scale is one of large head, long body and
short legs (see no. 99, UEA 684) – yet here, the head
is rather smaller than the Baule standard, and the
body is considerably shorter than the legs. The
slender build and exquisite finish give an impression
of other-worldly beauty which is heightened by
the naturalistic, yet serenely idealised head with
its minimal tribal scarification. The coiffure is
marvellously detailed; the long legs with muscular
calves and astonishingly long feet may embody a
canon of male beauty. The ears are shown as larger
than the norm – perhaps it is not too fanciful to
suggest that this spirit husband's pose was intended
to convey an aura of receptive, even sympathetic
attention.

A male figure, illustrated by Meauzé (1968: 68-9),
may be by the same carver, since it too is unorthodox
in attitude and proportions; if so, we have here one of
only two known works by the hand of a Baule master.

An old split down the right side of the head and
body has at some time been filled; this serves only
to accentuate the original poignant twist to the head.

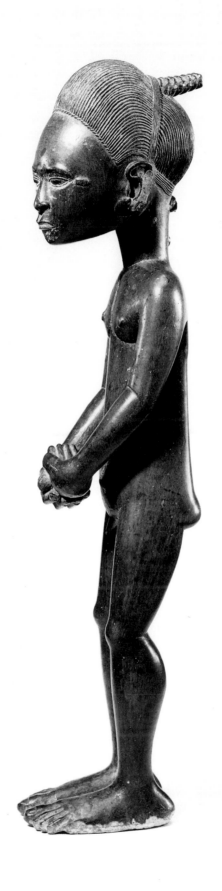

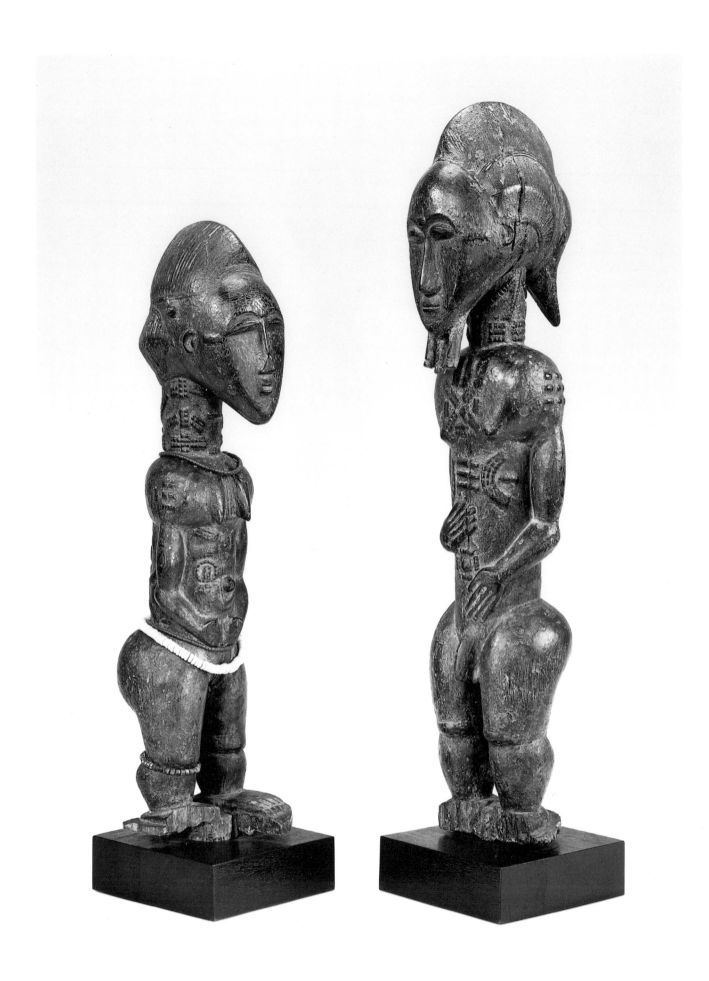

Ivory Coast: Baule

Two standing figures
20th century
Wood, beads
h. 17⅜ in (44.2 cm); 20⅞ in (53.0 cm)
Acquired 1977 UEA 684 A–B

An undocumented single Baule figure, whether
male or female, may have to be labelled 'purpose
unknown' owing to doubt whether it was intended
as a representation of a 'spirit spouse' (female if the
owner is a man and *vice versa*) or of a bush spirit
(*asien usu*). The reason is that spirit-spouse images
are kept by tradition in the best possible conditions
(so as to please the spirits), whereas the bush spirits
are content with the most rudimentary attentions,
and in general their figures are left in the dirt and
given no place of honour. If, on the other hand, two
figures (male and female) have been found together,
in conditions which make it clear to the practised
eye that they were made at the same time and have
remained together ever since, then this is the rare
case where the diviner (who is, of course, consulted
in all cases of visitation, whether by spirit spouses or
by bush spirits) has prescribed exceptionally the use
of two *asien usu*. In such a case, we know that the
couple represent bush spirits, even if they have lost
all the dirt with which they were once encrusted.
These two figures, therefore, are among the very few
Baule statues of which it can be said that we know
for certain the purpose to which they were devoted
while in the tribal context.

Traces of dirt or of offerings are visible on both
figures; the termite erosion on the feet also indicates
that the figures were not looked after as carefully as
spirit-spouse figures would have been.

Vogel (1981:73) writes that bush or nature spirits
and their representations are less numerous than
those of spirit spouses, and that they may require
their human companion to become a professional
medium and conduct divinations for clients while
in a trance.

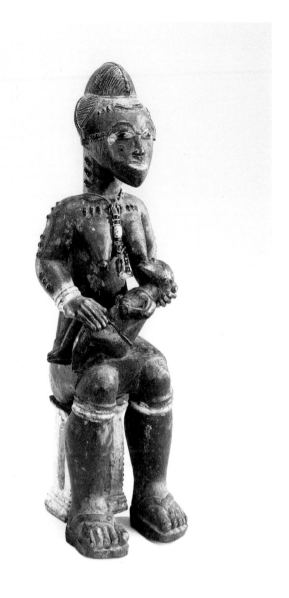

Ivory Coast: Baule

Female figure with child
20th century
Wood, beads
h. 18 in (45.7 cm)
Acquired 1974 UEA 572

As explained above, it is usually impossible to be
precise about the role of an undocumented Baule
figure carving. The thickish coating of red and
indigo paint makes it hard to determine whether the
figure has been well tended (as in the case of a spirit
spouse) or neglected, which would make it a nature
spirit (*asien usu*). The abundant body scarification
suggests that the carver's brief was to portray an
ideal of beautiful motherhood.

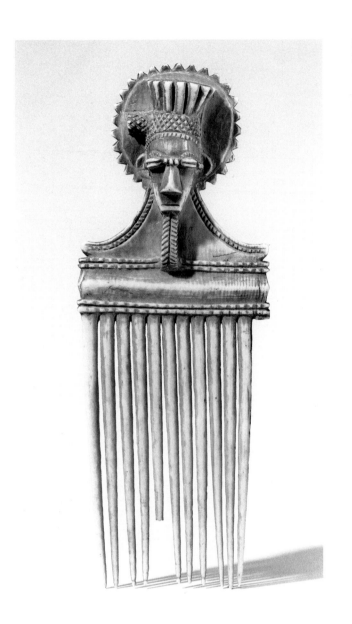
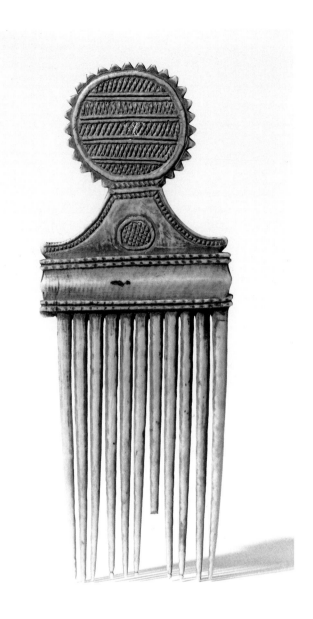

101

Ivory Coast: Atye

Comb
19th/20th century
Elephant ivory
h. 7⅝ in (19.3 cm)
Acquired 1960 UEA 219

Combs of this type were worn by Atye women on special occasions such as celebrations for her first child, or during marriage festivities; such ornaments enhance her beauty, and also affirm her status as a productive member of a family and lineage.

There is a possibility that this comb is not authentic; similar examples, such as that in Lisbon (de Oliveira, 1968: pl. 117), with no documentation before 1962, do not assist authentication. It is nevertheless of some interest, and is said to have been excavated at Kongoti village near M'Bayakto (Mbahiakro ?). Philip Ravenhill writes (personal communication) that genuine pieces in this style exist; copies are usually patinated by permanganate, which gives the ivory a rich brownish tint (here the ivory is pale).

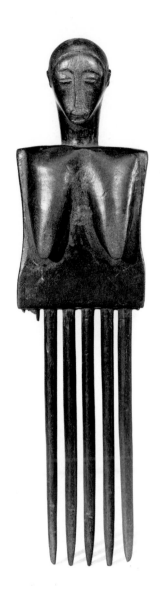

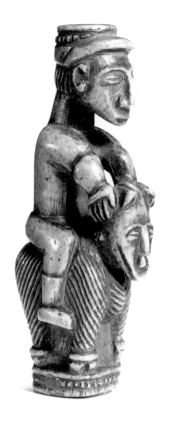

103

South-east Ivory Coast: Atye

Handle in the form of horse and rider
17th-19th century
Elephant ivory
h. 3⅞ in (9.8 cm)
Acquired 1966 UEA 212

This figure, which may have surmounted a chief's
cane or formed the handle of a fly-whisk, shows a
delightful indifference to equine physiology in the
horse's portrayal with a humanoid face (echoing that
of the rider), cloven hooves and a body grooved all
over in a manner reminiscent of the strange Sherbro-
style ivory beast in the Museum of Mankind (Fagg,
1959: pls. 30-32).

Since the West African carver, when he wished,
could produce an adequately realistic representation
of a horse (see no. 115, UEA 231), it is tempting to
speculate that the artist was either carving a horse
from hearsay, or intending to portray some other
animal associated with chiefship and its attributes.
The peaked cap suggests that the rider could be a
European or a chief wearing a cap. Visonà (1987: 63,
fig. 7) illustrates a staff finial with comparable figures.

102

Ivory Coast: Baule

Comb
20th century
Wood
h. 9¼ in (23.5 cm)
Acquired 1967 UEA 217

Although attributed to the Baule, who inhabit the
central part of the Ivory Coast, the rather austere
treatment of the head and bust surmounting this
comb suggests that it ought rather to be located near
the frontiers of Baule country, perhaps bordering on
the Ligbi or the Senufo. If it is a woman's dress comb
(see no. 101 opposite), it must reflect a lesser degree
of affluence.

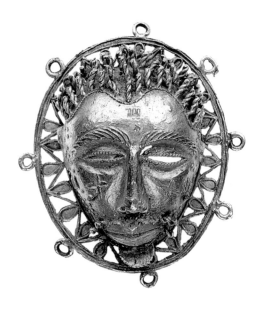

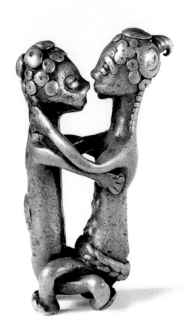

104

Ghana: Akan

Pendant mask
19th century
Gold
h. 2¾ in (7.0 cm)
Acquired 1967 UEA 218

This mask is almost certainly a relic of the second
campaign against the Ashanti in 1896 (the first was in
1874), and was probably acquired by the Pitt Rivers
Museum before 1899. After the third campaign, in
1900, goldsmiths of the subjugated Ashanti and other
Akan-speaking peoples turned their attention to the
making of copies and trinkets for expatriates.

 The hairstyle, in small skein twists, and the facial
scars show that the head is not that of an Asante.
The setting shows affinity with Baule work. Malcolm
McLeod (personal communication) notes that it does
not resemble documented Asante gold masks, and he
suggests that it is a pectoral pendant rather than an
ornament to be sewn on to a costume. The weight is
52.3 grammes. Analysis has shown the gold to be
about 22 carats, with possible silver inclusions.

Provenance: Formerly in the Pitt Rivers Museum at
Farnham, Dorset.

105

Ghana: Akan

Goldweight representing a human couple
18th/19th century
Brass
h. 2⅞ in (7.5 cm)
Acquired 1972 UEA 222

Goldweights were used by the Akan-speaking peoples
of Ghana and the Ivory Coast to weigh gold dust and
small ingots. These were used as currency before
British and French colonial administration took over
and imposed their own (see Garrard, 1980). Gold-
weights, which were cast in brass by the lost-wax
(*cire perdue*) process, sometimes document Akan life
and custom. Representation of human intercourse, as
shown here, is an uncommon subject, perhaps from a
feeling that pollution might ensue.

 The characteristics of this and the following two
goldweights (nos. 106 and 107) – large size, ringleted
hair, tattoo markings and carefully modelled heads
and faces – suggest that they may have originated
among the Baule section of the Akan-speaking
peoples, and were made for the use of a chief.

Provenance: Formerly in the collection of Madeleine
Rousseau, Paris.

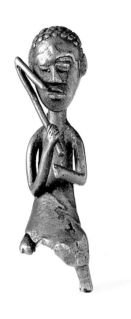

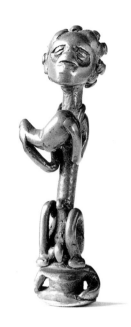

106

Ghana: Akan

Goldweight representing a drummer
18th/19th century
Brass
h. 2¾ in (7.1 cm)
Acquired 1972 UEA 223

If this goldweight was intended as a drummer with
talking drums (*ntumpane*), he would be standing
behind a pair of tall drums propped up away from
him at an angle of 45°, which he would beat with two
elbow-headed drumsticks. Akan languages have tonal
speech patterns which lend themselves to being
transmitted in the form of drum phrases; messages
can be sent rapidly by this means, and 'talking drums'
were an important part of a chief's establishment.
There is a proverb referring to the skill and wisdom
of such a drummer: 'If the drummer Nyanno is skilful
in drumming he drums for the Asantehene, not for
ordinary people' (Cole and Ross, 1977: 80).

 Despite the absence of the drums, the treatment of
the head shows that the modelling was done by a fine
craftsman. Some goldweight mutilations arose out of
the need to change a Portuguese weight to an Islamic
one; the Portuguese scale of weights operated from
the mid fifteenth to the mid seventeenth century.

107

Ghana: Akan

Goldweight as a seated man
17th-19th century
Brass
h. 2⅞ in (7.5 cm)
Acquired 1971 UEA 224

The subject matter of this goldweight presents some
difficulties of interpretation. The round stool-like
object on which the man is sitting is a form that does
not normally occur in the Akan countries. However,
the travellers Azambuja (1481) and Towrson (1555)
mention round stools in the coastal parts of the Gold
Coast; the form may well survive in a ritual context
in southern Ghana, as Roy Sieber (1980: 159, 161)
describes, with the suggestion that it is a pre-Asante
form, and thus before the early eighteenth century.

 The gourd-like object is also a puzzle: gourd rattles
are normally used by women and drinking gourds
are usually round. There is always the possibility that
obsolete customs and artefacts will be depicted in
a goldweight of this age. Since the Baule have fig-
urative goldweights, their development among the
Asante and other Akan-speaking peoples may well
predate the mid eighteenth century, when some
groups moved to the Ivory Coast.

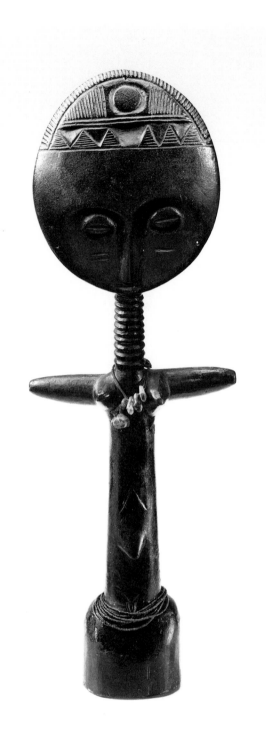

Ghana: Asante

Ritual doll
Late 19th/early 20th century
Wood, beads
h. 15¾ in (40.0 cm)
Acquired 1965 UEA 226

These ritual dolls, generally called *akua'ba* (plural *akua mma*), fill a multiple role since they may at the same time be a girl's plaything, a fertility aid for a barren woman, or a charm carried by a pregnant woman in the hope of a beautiful girl-baby (Cole and Ross, 1977: 103-7). A myth tells of the woman Akua who was barren; a priest advised her to commission a carver to make her a small wooden child (*dua ba*). She was told to care for it in every way and carry it on her back tucked into her waist cloth as if it were a real baby. Even though the other women mocked her, she did these things and eventually had a beautiful daughter.

The characteristic features of these dolls are: flat round head, female sex and ringed neck. The round head embodies the Asante ideal of a high forehead slightly flattened by moulding the skull during infancy. The dolls are female because Akua's first child was a girl, and in matrilineal Asante society a daughter will carry on the family name; mothers also prefer daughters, who will help with chores and the younger children. Male *akua mma* dolls are a rare and deviant form. The ringed neck is a convention for depicting rolls of fat, a sign of beauty and prosperity. An *akua'ba* should be consecrated by a priest to be an effective charm against barrenness.

An Asante woman when pregnant takes care to avoid looking at anything ugly or deformed lest it affect the foetus, thus the dolls embody an ideal of beauty. The small scars on the face are a prophylaxis against infantile convulsions. There is a panel of engraved designs on the back of the head which have been explained as a device against witchcraft; they are found on about a fifth of *akua mma* and may be related to somewhat similar symbols on Mossi *biiga* dolls from the Upper Volta (see no. 85 and Roy, 1981: 47-50). The tiny blue beads may be the kind that were made in the early years of the nineteenth century, but were soon afterwards discontinued, as their small size made them too difficult to thread.

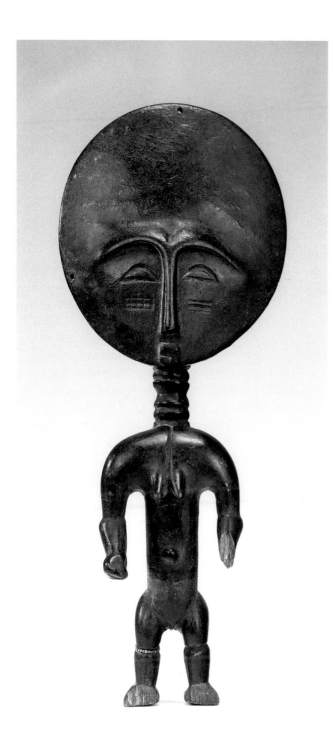

109

Ghana: Asante

Ritual doll
Late 19th/early 20th century
Wood, beads
h. 10 in (25.4 cm)
Acquired 1975 UEA 631

This is an extremely fine example of the much rarer form of *akua'ba* with complete limbs. It has been suggested that such images are of later date; yet the quality of this piece does not suggest the decadence that often characterises stylistically late carvings. Malcolm McLeod (personal communication) has pointed out that a doll of this shape does not lend itself to being carried in a woman's waist band, and that it could well have been carved for a shrine. Some shrine *akua mma* are large; the modest size of this one may indicate that it belonged to a family shrine, perhaps that of an important family.

Until about thirty years ago, *akua mma* were virtually the only Asante wood carvings brought home by Europeans, although large numbers of excellent group carvings, some of considerable age, have subsequently appeared. The tiny red beads on the right leg suggest that this *akua'ba*, like the example opposite, may be of nineteenth-century date.

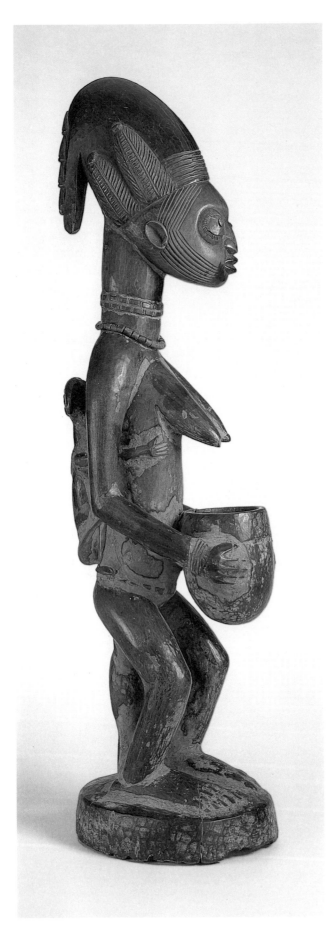

Nigeria, Oshogbo: Yoruba

Shrine figure of a mother and child
Late 19th/early 20th century
Wood, beads, metal
h. $31\frac{7}{8}$ in (81.0 cm)
Acquired 1975 UEA 598

This superb shrine figure is from the immediate
neighbourhood of Oshogbo, one of the finest of
the Yoruba carving centres. A comparable figure,
possibly by the same hand, is illustrated by Beier,
and another is seen in the distance being carried on the
head in the annual Festival of Images at Ilobu (Beier,
1957: pls. 26, 53). A great number of fine carvers
flourished in Oshogbo itself and in Ilobu and Erin, the
last perhaps the most important of all, being the seat
of the principal carvers known to us by name, Maku
(who died about 1915) and his son Toibo (neither of
whom seems to have been the carver of this piece).

The excellent condition of the piece, seeming to
belie its probable age (perhaps eighty years), suggests
that, wherever it was carved, its home may have been
at Ilobu. According to Beier, these images, none of
which was privately owned but all kept in *orisha*
houses, were devotedly cleaned and washed once in
every four-day Yoruba week. Additionally, they
were painted with indigo or camwood, both insect
deterrents.

Orisha constitutes a religious concept that can be
equivalent to a god, a deity or a saint. While the
Yoruba believe in a Great God, he is too far from
human understanding for direct worship, and thus
has no shrines or sacrifices. Usually an *orisha* is an
ancestor, hero or former king who manifests some
aspect of divine power or is allied to a force of nature
such as thunder, storm, or a river (see Fagg and
Pemberton: 1982, 195-9). *Orisha* are rarely depicted
in person; a carving will be of a priest or devotee.
The carving itself is never worshipped; it is a symbol
of the spiritual being and as such has no direct part
in ceremonies, nor does it arouse awe. The figure
illustrated by Beier is shown in a shrine to Oya, wife
to Shango, also an *orisha* (see no. 112, UEA 227); it is
therefore likely that this carving too came from a
shrine to Oya, and represents a female devotee with
offering bowl.

The inclusion of a coiled mudfish in the design of
the stool probably indicates that it is an acceptable
sacrifice to the *orisha* (but apparently does not have
a correlation with royalty, as it has at Benin).

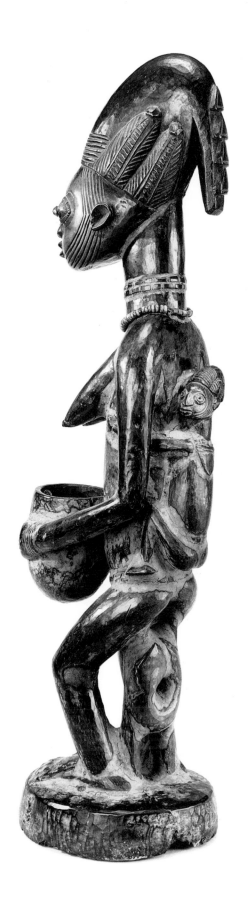
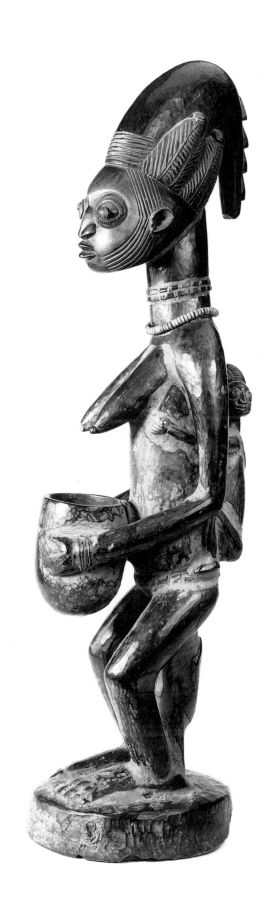

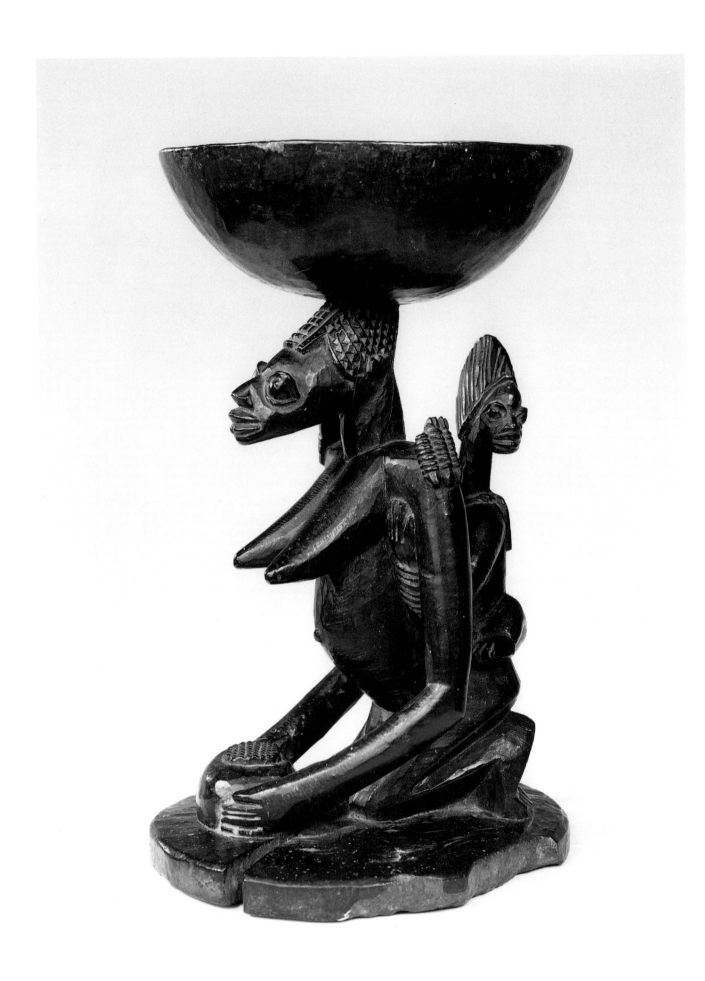

Nigeria: northern Yoruba

Divination cup with caryatid support
Late 19th/20th century
Wood
h. 9¾ in (24.0 cm)
Acquired 1956 UEA 228

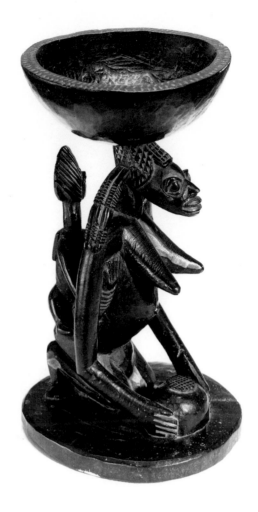

This is a cup (*agere ifa*) used to hold the sixteen palm nuts used by the diviner (*babalawo*) in casting the Ifa oracle. Ifa is a system of divination at the heart of Yoruba religion, consulted by individuals, cult groups, even rulers – nothing may be done against its advice.

Ifa is complex, and the diviner spends many years learning the system and the 4096 *odu* or sacred poems. To begin with, he scoops up from the cup sixteen palm nuts in his right hand, either four or eight times; whether one or two are left behind indicates 'heads' or 'tails', which he marks upon a wooden divination tray (*opon ifa*) covered with powder. If four scoops are made, sixteen basic combinations may arise; if eight, two hundred and fifty-six permutations are possible. The sequence of 'heads' and 'tails' will suggest an *odu* verse, which he then recites. Having recited it, he will then select and interpret various phrases for his client. There are differing accounts of how the palm nuts are manipulated; practices may vary in different areas, but Bascom (1969) gives a full survey of the subject.

Most *agere ifa* cups are carved with an astonishing array of subjects which are not confined to those relating to Ifa. Such indulgence on the part of the *babalawo* (who clearly commission them) towards secular and even on occasion towards the sacred objects of other *orisha* cults is especially striking in the light of the strictly prescribed decoration of the divination tray (*opon*): this may be an act of deference to the carver's quasi-priestly craft, allowing him to deploy his finest skills, irrespective of subject. This cup may come from the Igbomina subtribe or a town in the greater Oyo area.

While one may consider the *agere ifa* and its support as a cylinder, defined at top and bottom by the cup and its circular base, within which the caryatid mother and child are 'stretched' to fit the space provided, Heslop (1987) has suggested a convincing alternative explanation for the noticeable forward thrust of the mother's face, breasts and hands. Among Yoruba criteria for art appreciation is the concept which Thompson (1971: chapter 5) translates as *visibility*; it seems to be important that the attributes and proportions of a carving should be 'legible' from a distance, and that important features should be clearly defined. When in use, the *agere ifa* cup is on the ground beside the diviner, and the client will see it as he approaches or is sitting down. The support is thus liable to be obscured by the cup itself. If one assumes that the woman's face, breasts and forearms holding an offering bowl should be 'visible' when viewing the cup from above, the 'distortion' becomes explicable, and in fact the sculpture looks 'right' when viewed from above as postulated. In addition, the figure when seen from the side offers a delightful series of parallel diagonals – the mother's profile, breasts, arms and thighs, together with the arms of the alertly attentive baby. We have thus a practical, even sophisticated, approach to solving a prime concern of the Yoruba carver – that his work should be visible and 'legible'. Such an approach to the perspective of form recurs in African art; the steatite head from Sierra Leone (no. 76, UEA 205) is another good example.

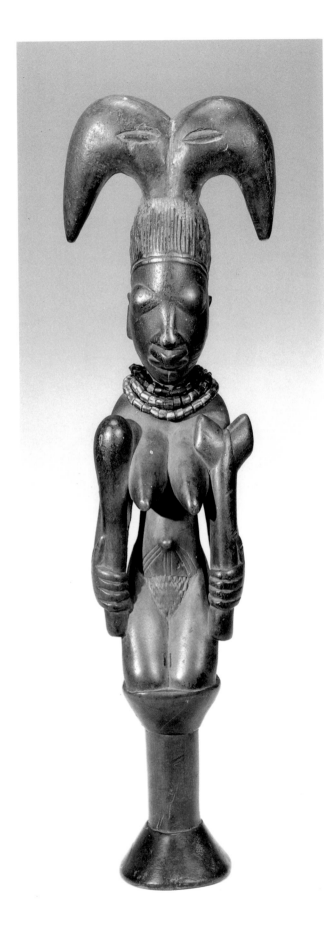

Nigeria, Oyo: Yoruba

Shango staff in the form of a woman
19th/early 20th century
Wood, beads
h. 15¼ in (39.0 cm)
Acquired 1953　UEA 227

The prime purpose of these staffs (*oshe shango*),
of which there are several at each Shango shrine
(reposing when not in use upside down among the
shrine carvings), is the achievement of possession
by Shango, the thunder god. He is an abrasive and
extrovert deity, and his devotees are said to take on
these traits of character. Pemberton writes: 'The
female figure with the twin celts or thunderax of
Shango, *edun ara*, balanced upon her head, is an extra-
ordinary image when seen in the hands of a devotee
possessed by the *orisha*. Dancing to the piercing,
crackling sounds and staccato rhythms of the *bata*
drum the possessed devotee, the *elegunshango*, will
wave the *oshe* with violent and threatening gestures
and then, in an instant, draw it to him- or herself in
a motion of quiet composure. The thunderbolts, like
lightning, clearly convey the sudden, overwhelming
and seemingly capricious power of Shango' (Fagg and
Pemberton, 1982: 74).

The bilobe represents the double axe motif which
is the thunderbolt, symbol of Shango, also occurring
on the staff in the woman's left hand; the horn-like
summit recalls a ram's horns too – the ram is sacred
to Shango because its quick head movements suggest
lightning. In her right hand the woman holds a gourd
rattle (*shere*), which is used in dances honouring
Shango, the legendary king of ancient Oyo. He was
noted for raising devastating thunderstorms and
was regarded as an *orisha* (see previous entry). The
Shango cult, which spread from Oyo to become one
of the most important in Yorubaland, is concerned
with the intensity of life and the principle of increase;
the horn-like ends of the woman's coiffure express
the curve of growth.

This staff is one of the most beautiful and res-
trained known, and since so great an artist would
never make a work which would not give pleasure
to the god, we may well imagine that his intention
was to show his devotee *after* the attainment of full
possession or trance; in this light, the figure takes on
a kind of ghostly transfiguration. It is not precisely
provenanced, but is probably from Ogbomosho in
the Oyo area in north-west Yorubaland.

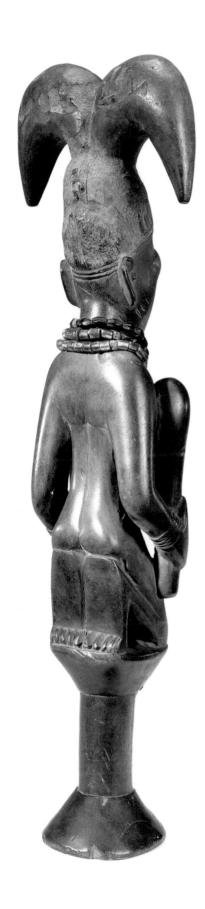
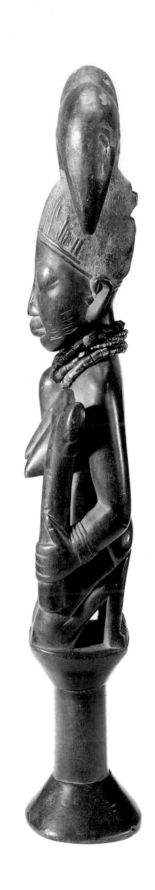

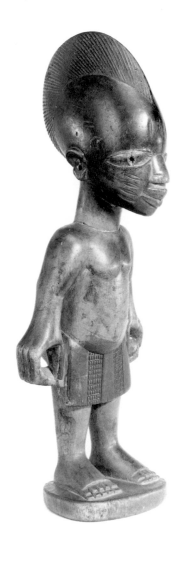
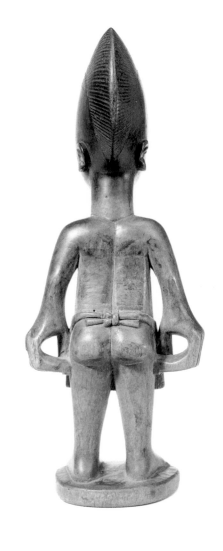

113

Nigeria, Abeokuta: Yoruba

Male twin-memorial figure
Mid/late 19th century
Wood
h. 10 in (25.4 cm)
Acquired 1963 UEA 229

Twins, which are common in Yorubaland and are
more likely to die at birth or in infancy than single
births, are looked on as powerful spirits. If one twin
dies the parents consult a *babalawo*, or diviner, who
may say that a memorial figure (*ere ibeji*) must be
carved. When the figure is completed, it is tucked
in the mother's wrapper like a living baby and taken
home, then set in a small shrine in her house. It is
washed, dressed, 'fed' and rubbed with red camwood
powder, oil and indigo. If the figure is honoured, the
spirit of the dead twin will bring its parents luck and
wealth; it is also a psychological surrogate.

Since *ere ibeji* are numerous, are made by almost
every carver throughout Yorubaland, and date back
at least one hundred and fifty years, they constitute
an unrivalled index for stylistic studies, whether of
an individual master, a workshop or a village. During
the 1840s a great war camp was set up which became
the city of Abeokuta. By the 1850s carvers were
needed, and soon two arrived – Ojerinde, nicknamed
Adugbologe (the womaniser), about 1850, and then
Eshubiyi in 1862. They developed separate substyles
within a wider Abeokuta style; a considerable body
of work survives from the second half of the century,
including large numbers of twin figures.

The formal position of the hands (to hold strings
of cowries) shows this figure to have been made by a

114

Nigeria: Yoruba

Janiform head
Late 19th/early 20th century
Elephant ivory
h. 2½ in (6.5 cm)
Acquired 1975 UEA 601

member of Eshubiyi's house, since it is not found in other carvers' work. There seem to have been at least three very fine master carvers flourishing in the house during the later nineteenth century, one of whom is presumed to have been Eshubiyi himself. His son Akinyode and grandson Shokon, subsequent heads of the house, have during this century kept up what is clearly the house style.

The present *ere ibeji*, in a rare style, may well turn out to be an early work by Eshubiyi himself. The figure shows signs of indigo staining, especially on the loincloth, hair and forehead, and the features are somewhat worn down, an indication of loving care. The face shows typical tribal scarring on the forehead and cheeks. Figures carved by Akinyode and Shokon have a 'logo' of three concentric squares carved on the base; those carved by Eshubiyi are unmarked, as in this example.

This unusual piece can be immediately identified as Yoruba and in all probability connected with a snake cult, but little more information can be given about it. While snake cults may be found over most of Yorubaland, they are especially common along the western fringe, near the frontier between Nigeria and Bénin (formerly Dahomey), where Yoruba and Fon are in contact. It does not appear to be a pendant, but rather to have come from the end of a staff, sceptre or fly-whisk handle. Both faces are carved with a labret or lip plug in the lower lip and thus both are probably female.

Small metal nails originally filled all the holes along the snake bodies and eyes, though most are now missing. The Yoruba fondness for interlacing is manifested in the pattern made by the intertwined snakes, which form inverted hearts at the sides, with a half knot above and below each face.

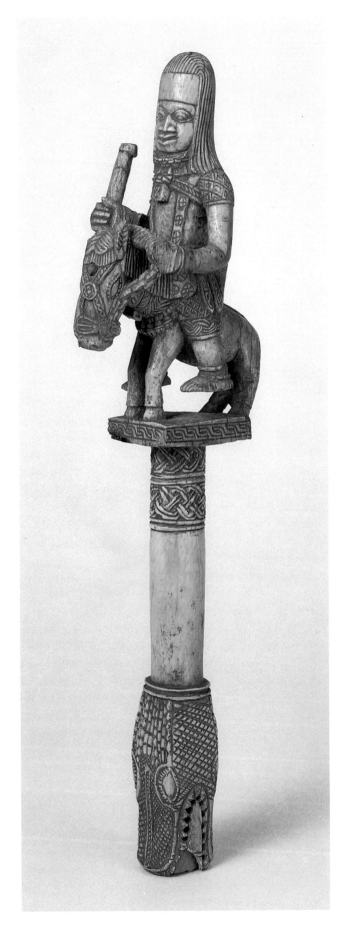

Nigeria, Benin

Royal sceptre
16th-18th century
Elephant ivory
h. 15¾ in (39.0 cm)
Acquired 1957 UEA 231

Our certainty that this is indeed a royal sceptre
(or sceptre/fly-whisk) resides especially in the fact
that it is so obviously, in the language of artists and
artisans, a 'one-off'. It is arguably the largest and
most masterly in conception and in detail of all Benin
ivory sceptres, depicting the Oba (king) as a mounted
warrior.

But if we ask to which Oba did it belong originally
or, in other words, what is its approximate date, we
are confronted by a very wide margin of error –
perhaps as much as three centuries – and this, once
again, by reason of the 'one-off' nature of the
sculpture. The artist was clearly a past master of the
well-known repertore of motifs of the *Igbesamwan*
(or guild of ivory and wood carvers), which motifs
remained virtually unchanged through those three
centuries to which the sceptre is provisionally dated.
Even the motif surrounding the platform on which
the horse stands – which might be interpreted as a
degenerate guilloche, indicating a late date – is seen
on two Bini-Portuguese oliphants probably dating
from about 1550 (Fagg, 1963: pl. 54b). The circled
cross motifs on the rider's skirt, and the absence of
a choker necklet as worn by the rider on a somewhat
similar sceptre (Pitt Rivers, 1900: pl. v, figs. 19-21),
may suggest a date earlier rather than later within
the three centuries adduced.

The aspects of the work which are clearly the
artist's creation, such as the glowering visage of the
Oba under his great domed headgear, his asymmet-
rical crouch, and the monstrous animal jaws at the
base (probably of a python, such as those mounted
above the palace gates), are all unique, and give us
little clue to the epoch in which the carver lived.
The piece has been given a misleading impression
of modernity by nearly sixty years' exposure – along
with other Benin ivories – to the sun's bleaching rays
under the skylight roof of the Pitt Rivers Museum in
Dorset.

The Oba's costume well repays detailed study as a
document of Benin regalia; his head-dress appears to
be of coral beads with a back neck covering; a queue
continues down his back, and he wears a variety of

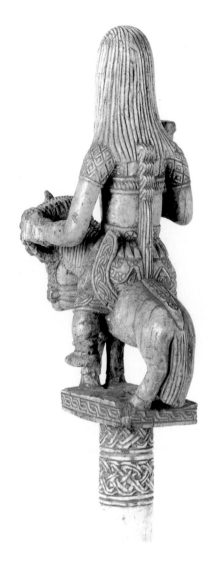

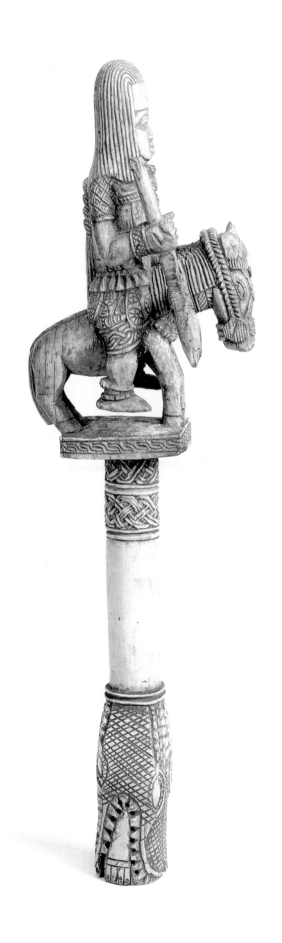

ornaments. The only horse furniture appears to be the bridle; the reins seem partly to represent braided leather and partly chain-link – yet there are hints of a martingale and crupper which suggest that a saddle was intended. A split across the horse's neck has been stabilised with an ivory peg, visible in its forehead.

Provenance: Formerly in the Pitt Rivers Museum at Farnham, Dorset (see Pitt Rivers, 1900: pl. v, figs. 22-4). It was bought from W. D. Webster, Bicester, Oxfordshire, on 14 April 1898 for £25, having been brought to England after the Benin Expedition of 1897 (Ling Roth, 1903). One result of the expedition was that large numbers of ivories, plaques, heads and other artefacts were looted by its members and soon found their way into European collections, notably in England and Germany (see also Dalton and Read, 1899; von Luschan, 1919).

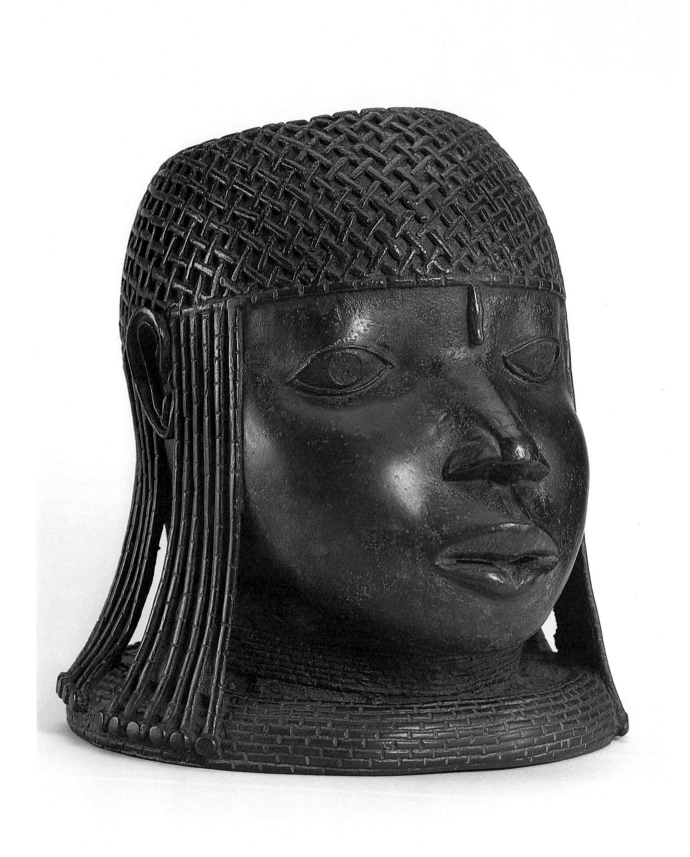

Nigeria, Benin

Head of an Oba
Early 16th century (Early Period)
Brass, iron
h. 9⅛ in (23.0 cm)
Acquired 1966 UEA 232

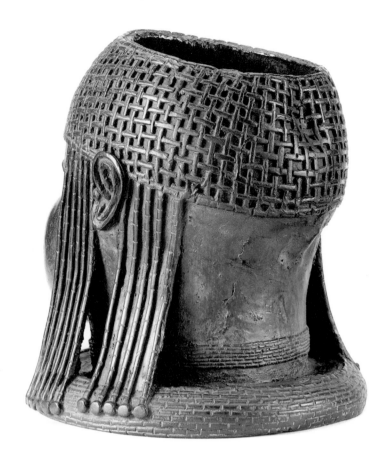

This is one of some eight or ten heads of this form which may well
represent the pinnacle of Benin artistic achievement, matching or
surpassing, for most discerning judges, the early Queen Mother heads,
which are the closest relatives, and the superb ivory masks which are
similarly thought to be contemporary with them (Fagg, 1963: pl. 51).

Several hands have been at work among this group but all seem to
match well enough for us to assume that they were all made for a single
funeral (possibly the first occasion on which a battery of about eight
altar heads (*uhumwelao*) were dedicated, a practice which continued for
the kings of the Middle and Late Periods). There were only two funerals
in the first half of the sixteenth century at which the present head may
have been used – that of the warrior king (Oba) Ozolua, performed by
his son Esigye about 1505, and that of Esigye himself about 1551.
Besides being a great warrior, Esigye was the founder of the practice
of elevating the Oba's mother to the honour of Queen Mother; and the
most natural explanation for the four early Queen Mother heads is that
they were all made for Esigye's mother Idia, though it is not known
whether this would have been on the occasion of her elevation or her
death. It can be shown on a minute comparative examination of the
Queen Mother heads, and of the male heads such as the present one

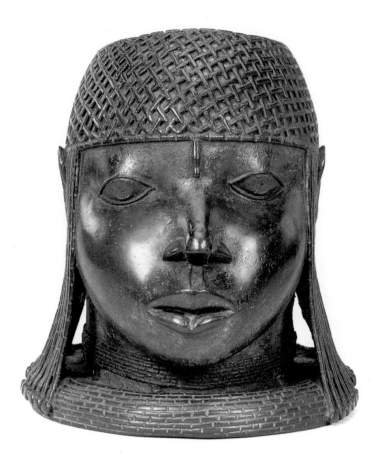

(notably in the matter of the very simplified ear forms), that all were
probably made within a fairly short period of time. Although described
as bronze, early Nigerian castings should more correctly be described
as brasses; by the mid sixteenth century the Portuguese had imported
vast quantities of European tin bronze, and Benin ancestor altar heads
suddenly became much heavier. The thinness of this casting would date
it to before this massive influx of bronze.

From this concatenation of assorted facts (and a host of others) a
very strong presumption arises that these bronze heads were made in
or about 1505 to crown the tomb of Ozolua and that the Queen Mother
heads were made some time during the following ten or twenty years.
Ancestor altars were generally platforms some two to three feet high;
the *uhumwelao* heads (by means of a hole in the crown) also supported
carved elephant tusks (Fagg, 1970: pl. 11).

Underwood (1949: pl. 24) was the first to draw attention to 'a fine
appreciation of anatomy in the fusion of the separate forms of skull,
face and neck' in this head, considering this to be due to Ife influence
(though even there this mark of supreme sculptural awareness is
extremely rare). On the technical side, the iron inserts in the eyes (and
perhaps in the upper lip) served a dual purpose of imparting realism and

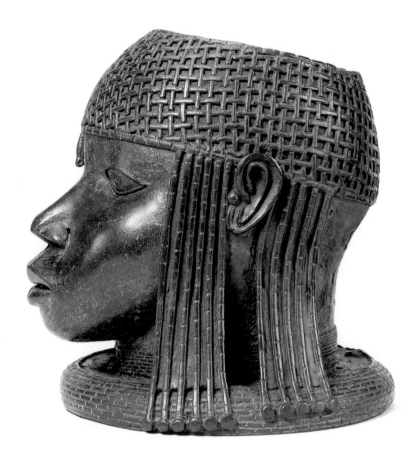

serving as anchor points to prevent displacement of the core within the investment after melting out the wax model in the *cire perdue* process (see Dark, 1973: 46-53). Here, despite this precaution and the caster's skill (manifest in the lovely surface of the face), there is a casting flaw at the back on the right side. The head-dress and neck ring depict coral beads; these would have come from the Mediterranean, probably by trans-Saharan trade; red jasper beads are also worn by Benin royalty (red is considered a threatening colour, with the capacity to repel evil).

Briefly summarised, the Early Period of Benin art, that of the finer bronze heads and the ivory masks, dates from the fifteenth to the mid sixteenth century. The Middle Period, to which the plaques and many heads and other bronzes, such as some of the cocks, aquamaniles and Portuguese soldiers belong, is approximately 1550-1650. The Late Period, characterised by heavy, flamboyant Oba's heads and a decline in craftsmanship, spans the time between 1650 and 1897, the date of the Benin Expedition (see Fagg, 1963: 32-8, for a more detailed exposition).

Provenance: Formerly in the Pitt Rivers Museum at Farnham, Dorset (Pitt Rivers, 1900: pl. XIV, figs. 82-3). It had almost certainly been brought to England after the Benin Expedition of 1897.

Nigeria, Benin

Plaque fragment representing a Portuguese
Mid 16th/mid 17th century (Middle Period)
h. 11½ in (29.1 cm)
Acquired 1971 UEA 234

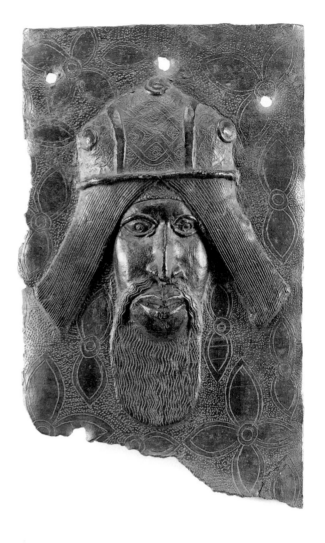

Plaques of this width were placed on the two narrow
sides of the stout wood pillars on which the palace
roofs were raised. The dimensions of these can be
calculated from the two typical plaque sizes. One the
same width as the present example, together with a
wider one with side flanges, would accommodate a
pillar of some eight by fifteen inches in section.

Portuguese influence at Benin from about 1485
coincided with a time of great political and artistic
development. The production of plaques flourished
during the period of Portuguese contact and may
have been inspired by books with illustrations. Since
they came from across the sea, the Portuguese
became associated with, or even generated, some
of the complex of ideas linked up with Olokun, ruler
of the seas and provider of earthly wealth through
overseas trade in bronze manillas, coral beads and
cloth, which were exchanged for pepper, ivory and

slaves. By the beginning of the Middle Period (about
1550), Portuguese soldiers had become a kind of lay
figure in art, who did honour to the Oba by their
presence. They are depicted either full face or in
profile, with straight hair, beard and moustache,
aquiline nose and a helmet – perhaps officer types;
infantrymen wear sixteenth-century uniform and are
beardless, usually with weapons such as matchlock
guns or crossbows.

Representations of Portuguese were often accom-
panied by Olokun symbols such as the quatrefoil (*ebe
ame* 'river leaf') as shown here; these were used by
Olokun priestesses in curing rites.

Provenance: Formerly in the Pitt Rivers Museum at
Farnham, Dorset (Pitt Rivers, 1900: pl. XXXVIII, fig.
289). It was almost certainly brought to England after
the Benin Expedition of 1897.

Nigeria, Benin

Armlet
Mid 18th century
Gilt bronze
l. 5¼ in (13.3 cm)
Acquired 1976 UEA 652

This is one of the finest examples of perhaps some fifty surviving gilt-bronze objects, all of which appear to have been made within a fairly short time, and, moreover, by a small number of highly perfectionist artists. Research on this subject has languished for many years, but has recently been stimulated by the appearance of a beautiful bronze bowl (Christie's, 1984: 44-5), which is by far the largest object to be so treated. It allows us to suggest with much more confidence the period in which the process – that of mercury gilding, which would have been introduced to Benin in the eighteenth century, perhaps by a naval armourer or other expatriate craftsman – was probably carried out. This was the time remembered in Benin history as the Eresonyen revival of bronze-casting (Ben-Amos, 1980: 34-8), following the collapse of the industry at the end of the Middle Period about 1650. Oba Eresonyen came to the throne in 1735 and died in 1750; in his short reign he succeeded in establishing, and sometimes in re-establishing, many important traditions – of which excellence in craftsmanship is the principal feature.

This armlet is in an artistic sense a more developed production than the gilt-bronze bowl, the decoration on which is incised (in the wax original), since here the Portuguese heads in particular are modelled (also in the wax) in extremely fine relief. The mudfish alternating with Portuguese heads refer to Olokun, ruler of the seas, and to the wealth which the Portuguese brought with them in the form of trade goods which the Bini of Benin regarded as luxuries, notably bronze manillas, coral beads and cloth.

Provenance: Formerly in the collection of James Hooper, no. 1820 (Phelps, 1976: 392). Collected in the royal compound at Benin City during the Expedition of 1897 by Lieutenant (later Admiral) E. R. Pears.

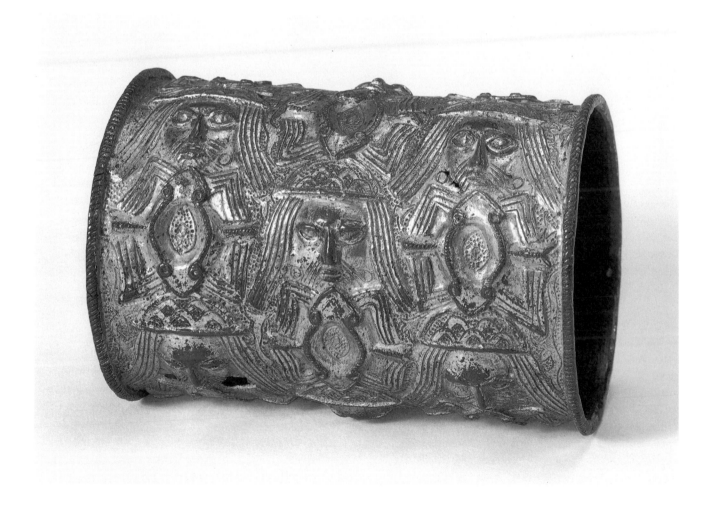

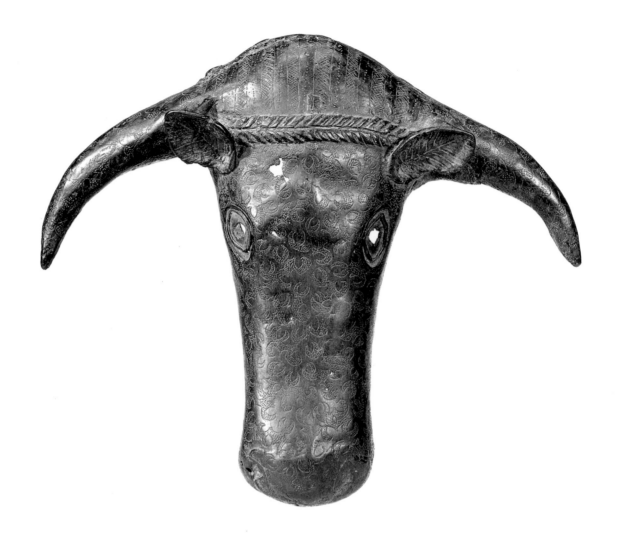

119

Nigeria, Benin

Mask of a cow
Mid 18th century
Bronze
h. 9½ in (24.1 cm)
Acquired 1974 UEA 569

This cow mask may have some connection with a
kind of reredos which can be seen at the back of some
of the photographs (see Fagg, 1970: pl. 11) of the royal
ancestor altars (which are believed to surmount the
deceased king's burial chamber). On this reredos are
carved stylised cow's heads at intervals of about a
yard. The reference must be to the prime sacrificial
animal in the descending series at the Oba's annual
Igwe (the worship of his head), the cow being the
penultimate offering before human sacrifice until the
Expedition of 1897 brought that part of the ritual to

an end. When it came to those last two sacrifices, a
sheet was raised between the Oba and the victims,
since he was strictly forbidden to see them, though
fully responsible for their deaths. Nowadays, the
delicacy of this arrangement is commemorated by
the raising of the sheet for the most important
animal to be sacrificed. In 1958 Oba Akenzua II had
a cow tethered in full sight of the populace, but a
ram was sacrificed instead.

The arabesque decorations on the animal's face
are normally a mark of pieces believed to have been
made during the Eresonyen revival of bronze-casting
(1735-50), though they were introduced in the Middle
Period (1550-1650) as a decoration on clothes, esp-
ecially those of Europeans. This pendant, which is
perhaps unique in its form, is an excellent example of
the work of the *Iguneromwon* (bronze-casters' guild)
under Eresonyen. It is a technically adventurous,
perhaps even 'one-off' piece of bronze-casting,
despite indications that the caster may perhaps have

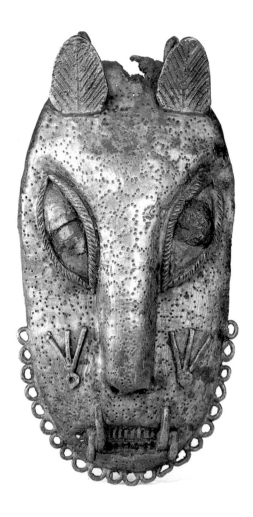

Nigeria, Benin

Leopard head hip mask
Late 18th/early 19th century
Bronze, iron
h. 6 in (15.2 cm)
Acquired 1972 UEA 233

Benin bronze heads, figures and masks, human or animal, may be divided into those which were made before or after about 1775, the criterion being the presence in the later ones of hatched eye borders, as here; deviation from this 'rule' is extremely rare till after the Expedition of 1897. The date of this piece is therefore probably *c.* 1800, plus or minus twenty-five years.

These masks, mostly human or leopard, are presented by the Oba to chiefs upon installation, and are tied on over the crossing of the skirt on the left hip; the Oba on the ivory sceptre (no. 115, UEA 231) is shown wearing one. Chiefs of all ranks wear a bronze pendant-mask (*uhunmwunekhue*) on the left hip when in full ceremonial regalia. In form they are related to the bronze pendant-masks sent to vassal rulers (*cf.* Willett, 1971: figs. 96-7), and the ivory pendant-mask worn by the Oba.

Tradition relates that when Oba Ewuare (about mid fifteenth century) was in exile he slept under a tree, and in the morning found a leopard on a branch over him. Ewuare took the leopard as a sign of future good fortune, and vowed that, if he became king, he would sacrifice a leopard every year to his head, the *locus* of his luck and power. Leopards have a special place in Benin symbolism (Ben-Amos, 1980: 64, 88), where the sacrifice of the leopard stands for triumph over the bush; the Oba as king of the settled land has shown that he has power over the leopard, who is king of the wild country. There was a guild for capturing wild leopards, and a leopard face on cloth was intended to strike fear into enemies' hearts.

There are two suspension loops inside the mask behind the ears. The surface of the leopard's face is covered with small rosettes made of impressed dots; the feline whiskers are shown as a pair of 'tridents' on either side of the nose. The rings bordering the lower edge may have been for pendant rings or bells.

Provenance: Formerly in the Pitt Rivers Museum at Farnham, Dorset (Pitt Rivers, 1900: pl. x, figs. 60-1). It was almost certainly brought to England after the Benin Expedition of 1897.

overreached himself – as evidenced by the gap between the ears and several 'burn-in' repairs. In a straightforward piece of lost-wax casting, a wax model is made on a clay core which is then encased in a clay investment, complete with casting vents; the wax is melted out and molten bronze is poured in till the mould is full. If there is insufficient metal, or an air pocket develops, the casting will be somewhat deficient. Here, the artist attempted an ambitious task; the horns and ears would have posed problems in the casting flow. When making a 'burn-in' repair, a wax mould of the deficient areas is made to fill the gaps in the casting; the whole is re-encased in a clay investment and the casting process is repeated. Sometimes the repair is virtually unnoticeable from the outside, but traces on the inside are clearer.

The horns are complete at the back (though hollow for about two thirds of their length); there are nail holes for suspension behind each ear, and the ears are supported by integral rods.

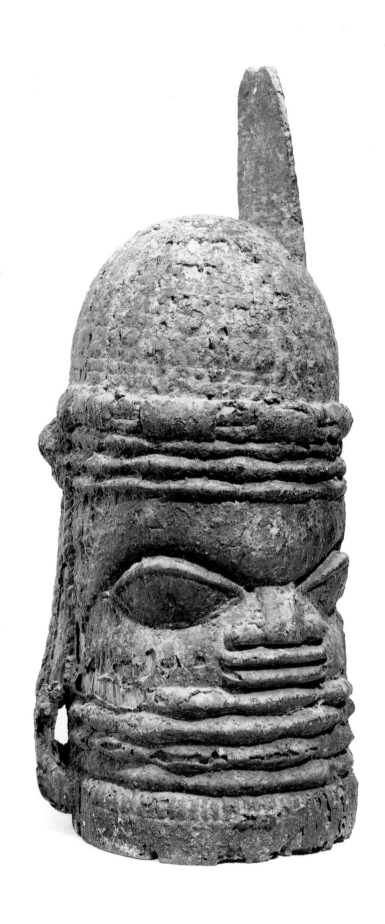

121

Nigeria, Benin

Head for chief's ancestor altar
19th century
Wood, iron
h. 11 in (28.0 cm)
Acquired 1959 UEA 236

There is a well-attested tradition in Benin,
(confirmed by the late R. E. Bradbury in a personal
communication in 1958) which relates how the chiefs
of the royal lineage petitioned the Oba to allow
them to decorate their fathers' altars (*aru erha*) with
wooden human heads (comparable to the bronze
heads on the Oba's own altars), instead of ram and
antelope heads as heretofore; and the Oba was
graciously pleased to assent.

 The traditional starting date for the use of wooden
commemorative heads (*uhumwelao*) on chief's
paternal ancestral altars is placed in the reign of Oba
Osemwede (*c.* 1816). They were certainly in use by
1862, when Sir Richard Burton visited Benin city. He
wrote, 'The domestic altar is "rigged up" ... [with]
men's heads coarsely imitated in wood and metal ...'
(Burton, 1863; quoted in Ben-Amos, 1980: 42). Earlier
accounts such as those given by the Capuchins in
1651-2 and by Landolphe and his party in 1787 make
no mention of heads on the chiefs' altars. A chief's
paternal ancestral altar has rattle staffs, bells and
swords, as well as a wooden head, which is thought to
be primarily decorative, and not spiritually powerful.
The normal size of the wooden heads is about two
feet (see Pitt Rivers, 1900: pl. xxxvi, figs. 277-8),
whereas this head is half that height, which is very
much rarer.

 This head is coated with sacrificial material,
probably blood and eggs, and is partly blackened.
Termite damage has removed some of the wood at
the back; there is a vertical hole down the centre of
the head, lined with black encrustation, which would
have held a ceremonial rattle. Flat-headed iron nails
are used to indicate the eye pupils; there is no sign
that the head was embellished with strips of sheet
bronze as is the case with many of the larger wooden
ones. Coral bead ornament is shown by carved rings
at the base of the headgear and round the neck,
though (as is appropriate to a mere chief) in lesser
quantity than on an Oba's head. The upper projec-
tion represents a feather, possibly of the red parrot,
which was worn to ensure success in war (if on a
helmet) and could here be a sign of achievement.

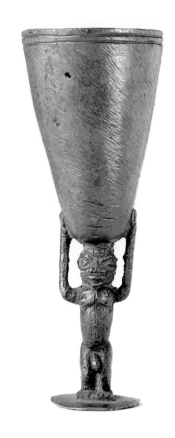

122

Nigeria, Benin

Cup supported on male figure
Mid/late 19th century
Bronze
h. 4 in (10.2 cm)
Acquired 1965 UEA 235

A small number of these imitations of European wine
glasses came to light in early collections, but without
indication of whether they came from the palace or
elsewhere in the kingdom, or whether they were in
fact for drinking or for libation or some other use.

 A certain crudity in the casting suggests an origin
in the middle or late nineteenth century, although
the absence of hatching about the eye borders would,
in a more ambitious piece, probably mean a date
such as 1775. In shape the bowl somewhat resembles
ale or wine glasses in use in the second half of the
eighteenth century. Remains of a pontil on the
underside of the base indicate that the cup was cast
in an inverted position.

123

Nigeria: Ibibio

Dance mask for the Ekpo society
Late 19th/early 20th century
Wood
h. 10 in (25.4 cm)
Acquired 1949 UEA 237

The Ekpo society is, or was, the principal men's secret society among the Ibibio-speaking peoples, who believe that at death a person's bodily soul (*ekpo*), which is immortal, either transmigrates to the land beneath the earth to await reincarnation, or turns into an evil ghost as the result of a wicked life. The Ekpo festival is held during October after the yam harvest, and masked society members dance in special groves, impersonating the return of the ancestral spirits to the land of the living. The Ekpo title gives a man high social status and political authority; the holder must have passed through at least two junior grades and be wealthy enough to bear the expense of membership. The organisation is decentralised; every village has its own lodge. The society is believed to protect the community by magical and religious means; like so many secret societies it provides funerals for its members (see Messenger, 1973: 101-27 for details).

Idiok ekpo masks such as this one are 'fierce', 'ugly', and represent evil ghosts. The masker speaks jargon, shakes his arms and shoulders, and frightens women and non-members, sometimes beating or even killing them. Among the recognised signs of an *idiok ekpo* mask are that it is painted black, brown or blue which are 'evil' colours; the raphia fringe is dyed black; and it may have an animal instead of a human face (e.g., cow, goat or antelope). This has goat's horns which have been partly broken off; also an 'ugly' bulging forehead and wide thick-lipped mouth. The costume formerly attached to it would have consisted of raphia fringes, cloaks and skirts ending at the knees to allow the masker's arms and legs free movement.

Messenger (1973), describing the making of *ekpo* masks, says that a mask, if cared for properly, will last for twenty years, but it must be repainted and re-oiled every year and kept hung where termites cannot reach it. Most members own their masks, but some may borrow or rent one for the '*ekpo* season'. If he has a run of misfortune, he may change his mask, perhaps going to a different carver; while if things go well, he will stay with the same design. The highest rank in Ekpo appears to be the Idiong, a select group whose titular membership is made manifest in the form of *idiong* rings or crowns – though not in this mask.

This mask is from the eastern Ibibio and is in the typical Ibibio style, although showing some originality in the 'compression' which seems to be applied from top to bottom, as though in a press.

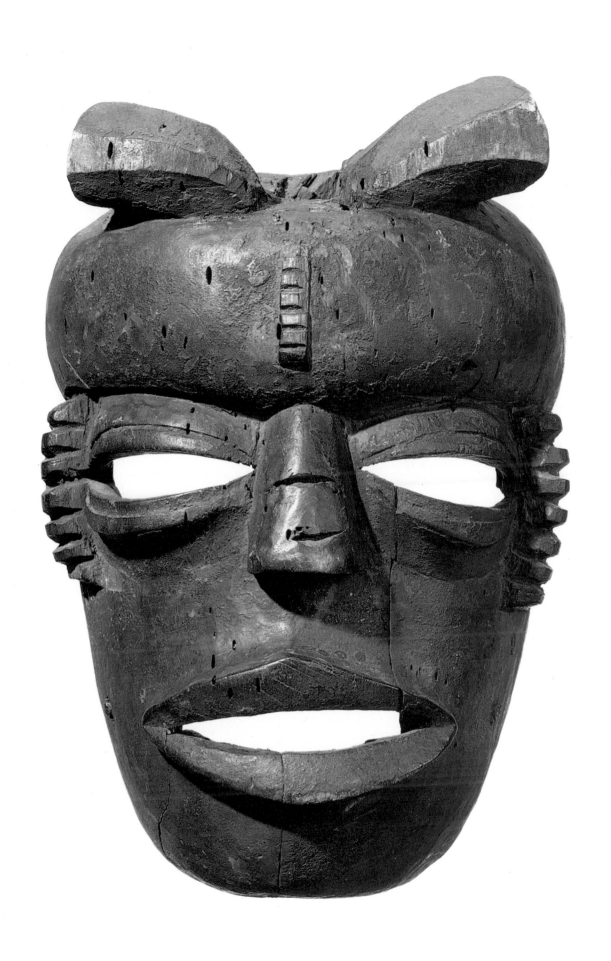

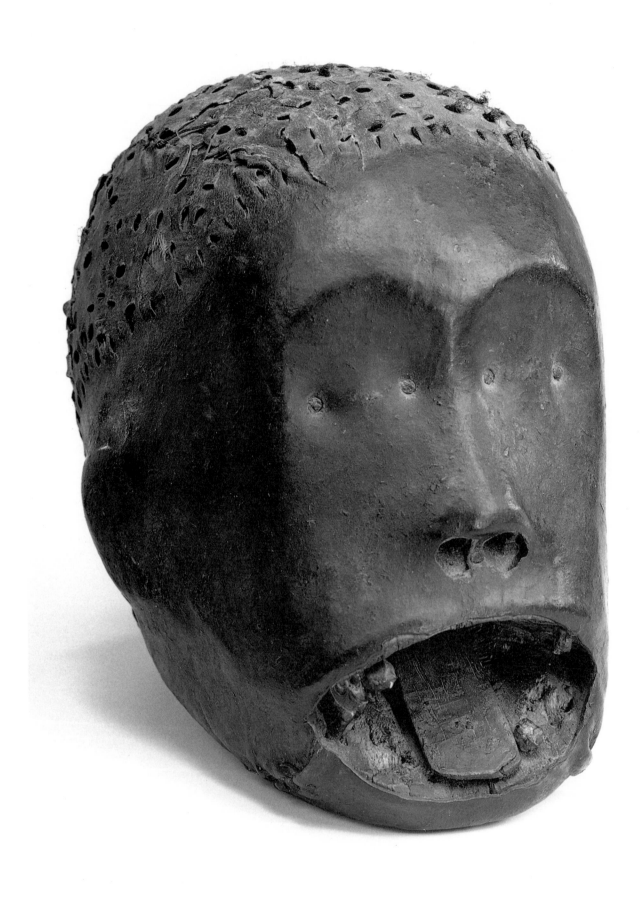

124

Nigeria: Ejagham or related tribe

Head
20th century
Wood, skin, hair, animal teeth, metal
h. 8½ in (21.6 cm)
Acquired 1975 UEA 602

The Ejagham group of peoples, often referred to as
the Ekoi, live on either side of the Nigeria/Cameroon
border. Keith Nicklin (personal communication)
has suggested that this head comes from the middle
Cross River region, from either the Ogoja area or
Obubra – probably the latter. Skin-covered heads
could be used in two ways: as a surrogate head
carried in men's warrior association dances, funeral
ceremonies and masquerades, for example in the
Yakö area; or as part of a cap mask. Surrogate heads
were made either of wood (like this one) or a human
skull, covered with skin, normally antelope skin,
and were carried in the hands. In former times, a man
could only join a warrior's association after killing an
enemy and taking his head. By the early twentieth
century these warrior's societies became prestige
associations open to those who could pay fees and
complete initiation; the heads were those of sacri-
ficed slaves or, later, made of wood and skin. The
main purpose of such groups in the 1920s was to
ensure that a man could have an elaborate second
burial.

Here, however, since the skin does not cover the
whole base, where there is a roughly circular bare
patch ringed with peg holes, the head is more likely
to have formed part of a cap, or head-dress mask,
where a head or figure is mounted on a basketwork
pedestal which the masker wears on his head (see
Thompson in Vogel, 1981: 175-6). While the use of
skin to cover the heads undoubtedly enhances the
realism, Thompson suggests that the pegging down
of skin was a charm or symbolic indication of the
embedding and controlling of the spirit in political
contexts. He also refers to a skin-covered skull in
the Linden-Museum, Stuttgart, which was found to
contain a variety of substances, making it a power-
fully 'loaded' charm.

The scalp has numerous small incisions; these held
tufts of human hair, of which a few traces remain;
other similar masks use a piece of animal skin with
its hair attached.

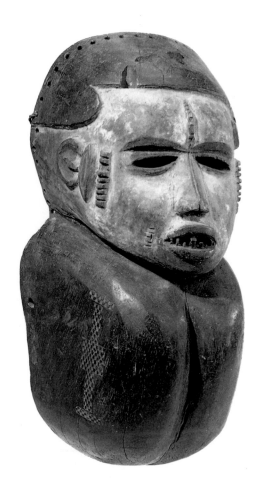

125

Nigeria: Idoma

Mask with goitre
20th century
Wood
h. 13½ in (34.3 cm)
Acquired 1974 UEA 595

The Idoma, living in the Niger-Benue angle, north
of the Ibo, produce masks in a distinctive style, often
having vertical rows of keloid tribal marks. *Aribo*
goitre masks like this one, though not common
among the Idoma, appear to have been made in the
district of Okobi, to judge by the similarity to works
by a famous carver named Ochai. Sieber (quoted in
Neyt, 1985: 146) affirms that such masks refer to
women afflicted with goitre; in the past they could
have had a medical or religious function, but now
they seem to be for entertainment. Other forms
of deformity and disease, such as yaws and gangosa,
its tertiary form, are found represented in *ekpo*
masks among the Annang Ibibio of Ikot Ekpene.

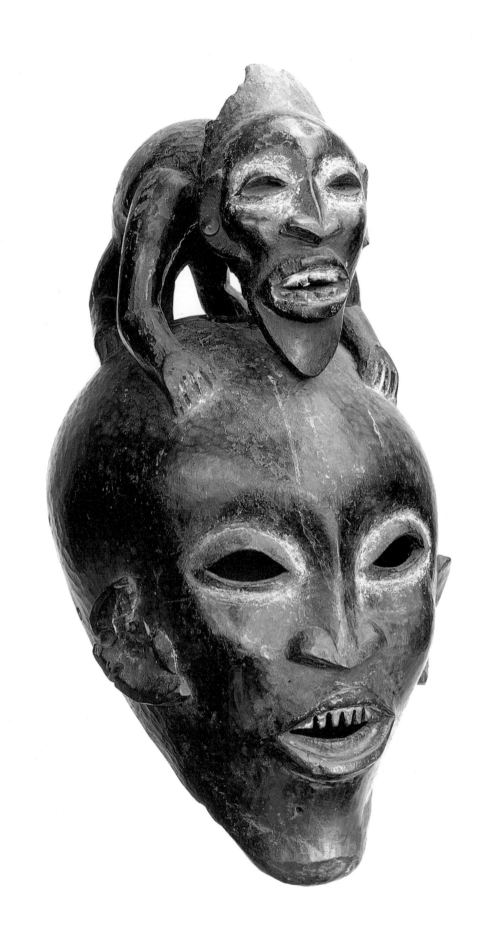

126

Cameroon: Bamileke

Dance mask
20th century
Wood
h. 18 in (45.7 cm)
Acquired 1973 UEA 526

The Bamileke cluster are a group of tribes comprising
several chiefdoms, with a common culture, living in
the grasslands of the former French Cameroons.
Some of the chief administrative/tribal areas of the
Bamileke are Bafang, Bafoussam, Bangangté, Bangu,
Bangwa and Dschang. In general, Bamileke art is
vigorous and, by comparison with much African
sculpture, full of movement, whether it be arrested
movement portrayed or the lively rhythm of inter-
locking surfaces. Here the crouching animal with a
curling tail (perhaps a panther or chameleon) appears
to be masked in a way which echoes and complements
the form of the main mask. The tilted almond eyes
and the half-smile showing teeth are typically
Bamileke.

Some Cameroonian students who studied this
mask in 1984 said that it came from western Cameroon
and was used in dances called *ku'ngga'ng* or *ku'gbe*,
in which at least five different types of mask were
worn. Such masks were only for male initiates who
wore costumes to avoid recognition. When not in use,
such a mask was a decorative object and could be
owned by anyone. The form is ornamental, and has
no symbolism except within the context of the dance.
Although carved from seasoned hardwood (probably
ka), the face mask is quite thin, and so is not heavy.
The inside is so well hollowed that visibility from
within is excellent.

127

Cameroon

Janiform amulet
Late 19th/20th century
Elephant ivory
h. $3\frac{5}{8}$ in (9.2 cm)
Acquired 1973 UEA 527

The Bafo and Bakundu of the forest areas of southern
Cameroon produce miniature ivory carvings including
small oliphants (no. 128, UEA 742) and janiform
figures. Such figures are not, however, restricted to
southern Cameroon; the trumpet (no. 129, UEA 630)
has more of a Grasslands feel about it, and the same
may be said of this piece. Krieger (1965: III, plates
254-5) illustrates a trumpet from the Bangwa with a
similar double figure, which came to Berlin in 1907.
Comparable amulets from the Tikar-Bekom are
shown by Gebauer (1979: 326-9). This may also be
an amulet, as there is a perforation at neck level
between the two figures; it may equally well be the
end of a fly-whisk handle which has been trimmed.
The figures are male and female; the former holds a
horn-shaped object to his chest, possibly a cup; the
latter clasps her hands beneath her breasts.

Nigeria/Cameroon border

Trumpet with standing figure
Late 19th/20th century
Elephant ivory
l. 9⅞ in (25.0 cm)
Acquired 1979 UEA 742

In form this trumpet could well be Ejagham (Ekoi),
where side-blown horns surmounted by human
figures occur, but the style does not quite fit, and a
provenance further into Cameroon, perhaps among
the Bakundu, or in the Bakundu-Balong area, might be
more likely. Krieger (1965: I, pls. 141-4; II, pls. 251-3)
illustrates several of this type coming from coastal
Cameroon east of the Cross River, north of the
Duala, which were acquired in the late nineteenth
century. Salmons (1985: 59) says that, 'throughout
the Cross River region, side-blown horns of elephant
ivory were used for mustering warriors and issuing
campaign orders . . . The Ekoi [Ejagham] . . . tend to
decorate ivory horns . . . with an animal or human
head carved in the round at the narrow end . . . Today
ivory horns are no longer used in warfare and those
few examples still existing at the original field
locations are important principally as chiefly regalia.'

The vernacular languages of the Cross River
area are tonal, lending themselves well to the use
of 'talking' instruments, whether clapperless bells,
drums or horns; hence their suitability for issuing war
commands. Such horns were blown after a warrior's
death and burial, though not if he were killed in
battle, in which case his spirit might remain hostile
to the enemy.

Figures on horns from the Bakundu region have
similarly sinuous arms; here it is not clear whether
the hands are joined or are holding a beard, small
whistle or similar object. A suspension loop is carved
behind the embouchure and A.67. is painted in white
beneath the left side of the figure.

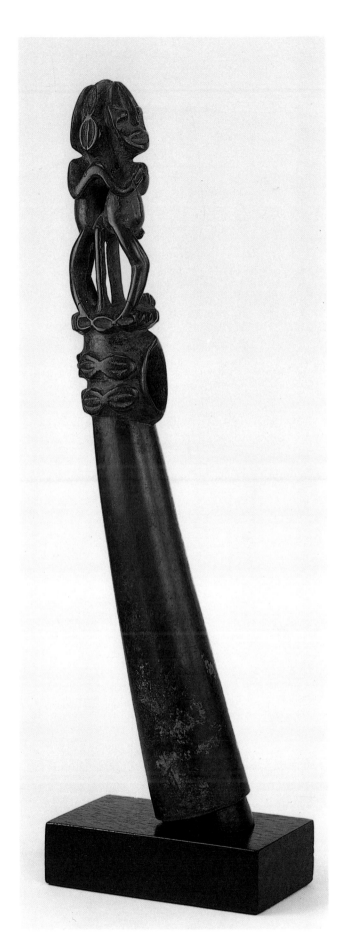

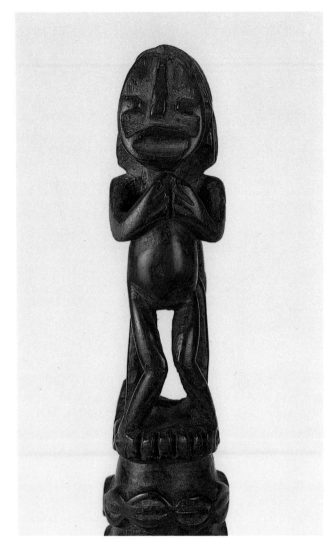

129

Cameroon Grasslands

Trumpet with double figure
Late 19th/20th century
Elephant ivory
h. 14½ in (36.8 cm)
Acquired 1975 UEA 630

The same general remarks made about no. 128 (UEA 742) apply to this trumpet, which is surmounted by a pair of figures with flat mask-like faces standing back to back. The arms of the two figures make a continuous wavy band from the shoulders to the joined hands, spanning both sides. Carved cowrie ornament between the two heads and forming a double band below the figures are a mark of status and suggest that this could be part of a chief's regalia. The deep reddish patina may be due to palm oil. The left leg of the inner figure is broken.

Central and Eastern Africa

130

Gabon: Fang

Reliquary head
Late 19th/early 20th century
Wood, brass discs
h. $10\frac{1}{4}$ in (26.0 cm); $13\frac{1}{2}$ in (34.3 cm) with stump
Acquired 1935 UEA 240

The Fang, Kota, Hongwe and Mbete tribal groups of Gabon share, with variations, a practice of keeping skulls and small bones of lineage ancestors in cylindrical bark boxes or skin-covered baskets surmounted by guardian figures. These relic containers were housed in small huts built for the purpose at a little distance from the village, away from prying or sacrilegious eyes, and were tended by a specially appointed elder. The containers might also include 'medicines' such as cowries, snail shells, small animals, seeds, etc., to increase the potency of the ancestral relics. The ancestors' help was invoked to procure blessings, avert misfortune, smell out witchcraft or whatever else might be needed in a life surrounded by inexplicable and often dangerous forces.

The Fang guardian figures (*bieri*) might be whole figures, either male or female, or heads alone. This head belongs to the Nzaman-Betsi substyle, located in the valleys of the Okano, Ogowe and Abanga rivers, which is rated 'the most classical' of all Fang statuary (Perrois, 1979). Paradoxically, the energetic and warlike Fang produced sculpture that impresses us with its palpable serenity. To strengthen their power, Fang *bieri* were ritually anointed with palm oil; some examples, like this head, have had the excess cleaned off, while others are still very sticky. An eroded stump, by which it was originally fixed into the basket or box, projects beneath the neck for $3\frac{1}{4}$ inches.

The earliest Gabonese carvings were imported into Europe before 1850, but artistic awareness of their quality came later, in the early years of the twentieth century. The harmonious solidity of heads such as this, with its subtle assorted planes, provided inspiration for modern artists: echoes of Fang style are discernible in the work of Epstein, who owned several superb examples (Rubin, 1984: 292, 430-39).

Provenance: Formerly in the collection of Paul Guillaume, Paris, a pioneer dealer in African art between 1911 and his death in 1934. Acquired from his widow in 1935. The significance of '3' is not known.

Further illustrations overleaf

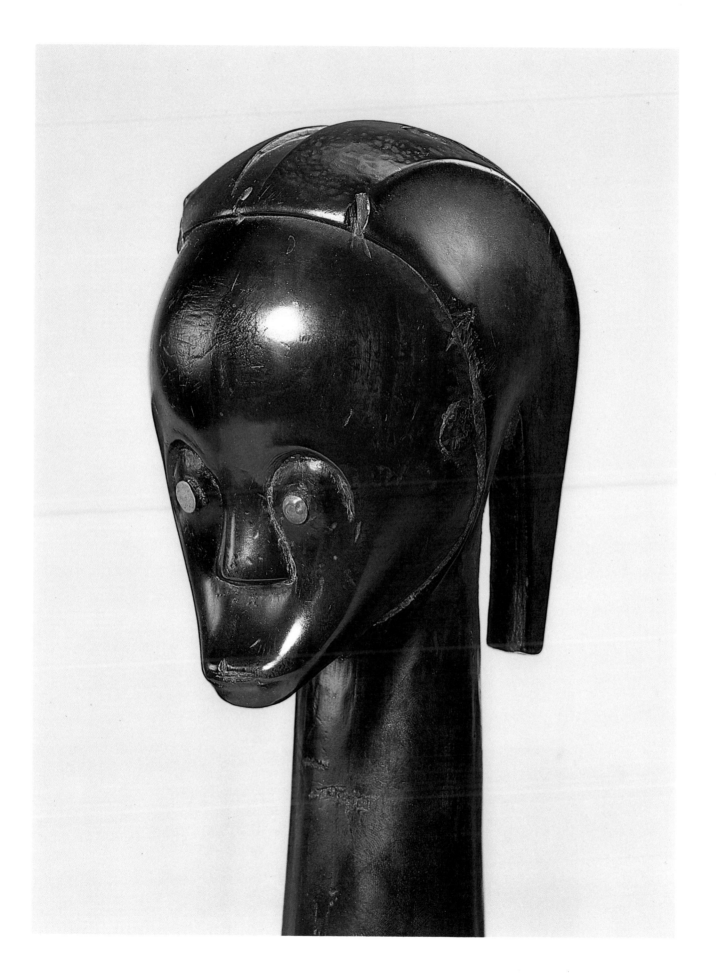

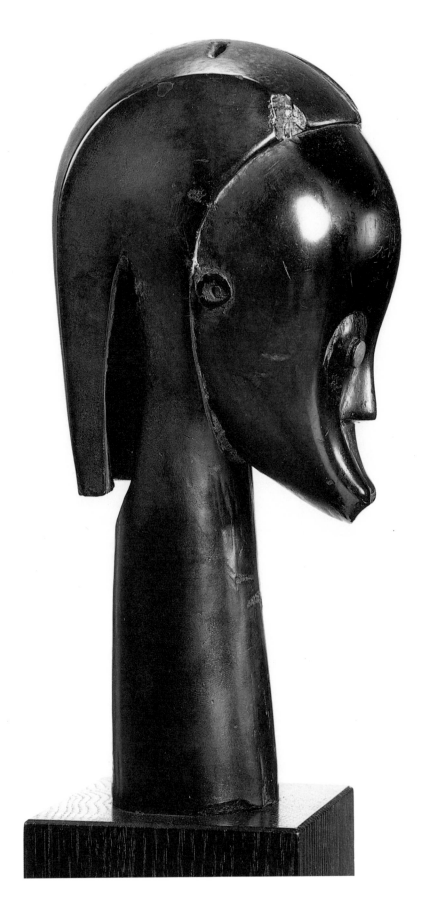

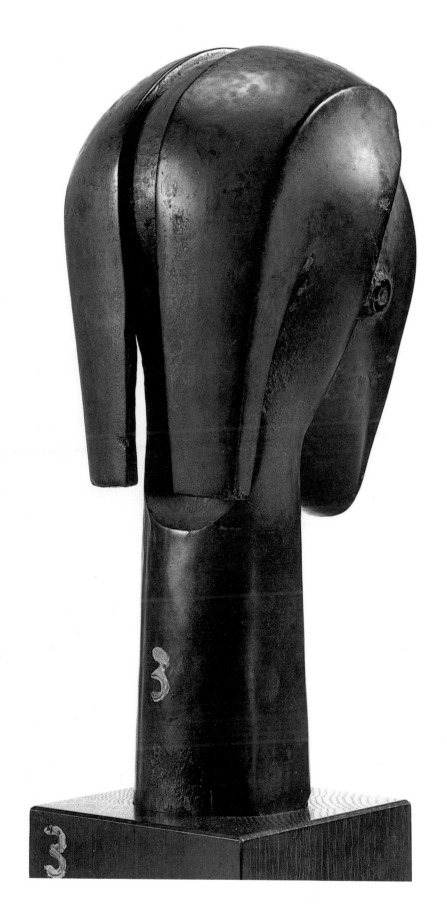

Gabon: Fang

Miniature head
Late 19th/early 20th century (?)
Elephant ivory
h. 2¼ in (5.7 cm)
Acquired 1950 UEA 241

This miniature ivory head was omitted from the previous catalogue of the Collection (Sainsbury, 1978), since there were then doubts whether it was a genuine tribal piece. It had been acquired in 1950 as of doubtful authenticity, although a previous owner had an acknowledged flair for African art. Subsequent research has prompted a more optimistic view of its pedigree, hence its inclusion here.

Stylistically the head belongs to the Nzaman-Betsi group of the Fang, who live in the western part of Fang country: the exquisite detail of the hair, braided to a queue at the back, the concave face and 'cowrie-shell' eyes are all characteristic. This style is, however, typically represented by wooden heads some 9-12 inches (22-30 cm) high or by whole figures, carved as guardians of bark boxes containing the bones of ancestors (see no. 130, UEA 240), and this miniature head does not fit into that pattern.

In Gabon, miniature heads do in fact occur on the ends of fly-whisk handles, ceremonial iron gongs and ivory horns (Perrois, 1979: pls. 233-5). Perrois's plate 233, illustrating the end detail of an ivory horn from the Tsogho, who live to the south and south-west of Fang country, makes it almost certain that this head is the end of a similar oliphant from the Fang.

In the Gabon area, if a ritual object (such as this oliphant would have been) was damaged, it might be thrown away or burnt before its replacement with a fresh piece. Such a practice is at least one hypothesis to explain the fire-damaged condition of this head.

Provenance: Formerly owned by Marie-Ange Ciolkowska, Paris.

Gabon: Shira-Punu group, Lumbo

Miniature figure of a drummer
Late 19th/early 20th century
Wood
h. 5¼ in (13.3 cm)
Acquired 1965 UEA 242

Perrois (1979: pls. 277, 277a, 279) attributes several miniature carvings like this to the Lumbo, one of the Shira-Punu group of peoples in southern Gabon, around the Nyanga river valley. The backward-projecting coiffure is characteristic of this style and has led to some of these carvings, including this one, being described as hooks. This figure has a pith channel running all the way from the top of its head, through the body, and across the ring. This would severely weaken the ring, and when other pieces in the style, some with flat bases, are considered, the hook hypothesis seems unconvincing. It is possibly an amulet or charm which could be worn as a pendant, whether carried in the hand or on a finger, or even hung on a wall. The figure is apparently male, and the position astride the drum is one commonly adopted when playing the long cylindrical drums found in this part of Africa.

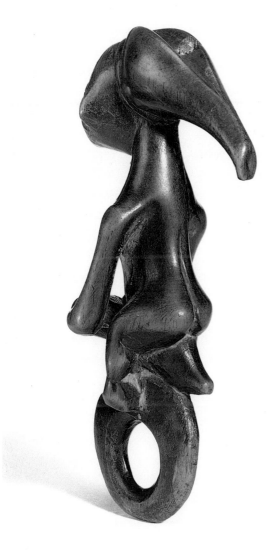
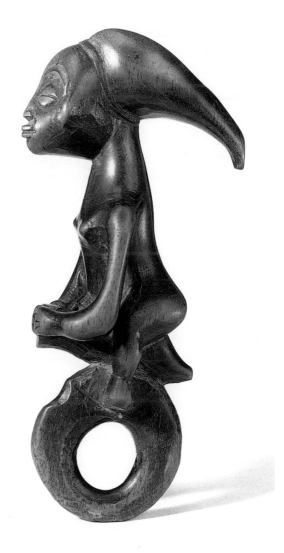

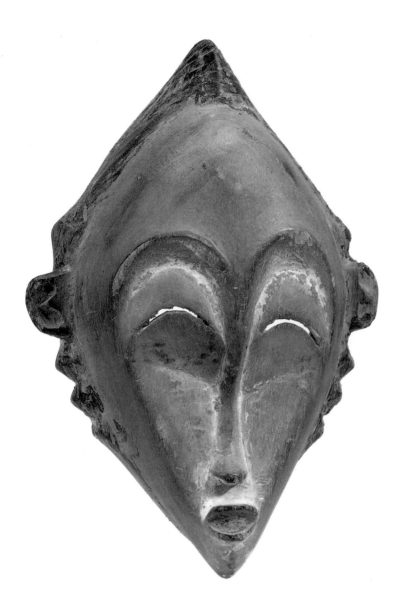

133

Gabon: Fang in Shira-Punu style

Mask
20th century
Wood
h. 10½ in (26.7 cm)
Acquired 1966 UEA 244

The pattern of tribal grouping in Gabon was severely disrupted by slave raiding which continued well into the nineteenth century. Thus, traditional information about the white-faced masks is somewhat limited. They were formerly described as M'Pongwe or Lumbo, but now Shira-Punu (a linguistic grouping) is the preferred term with, where possible, a subsidiary attribution added. The Shira-Punu group comprises the M'Pongwe, Lumbo, Shira, Punu, Shango, Tsogho, Vuvi and others, and white-faced masks have been recorded among several of these tribes.

This mask is similar to one in the Musée de l'Homme (no. 65.52.1), collected by Philippe Guimiot among Fang living on islands in the Ogowe river, and may be by the same carver. While clearly under Shira-Punu influence, the Fang style of carving accounts for the concave profile and triangular face which give this mask a hybrid appearance, heightened by the omission of the tribal scarifications found on most white-faced masks. White is the colour of the dead, who may be represented by beautiful female ancestral spirit masks which appear in the course of dances honouring the ancestors.

134

Gabon: Fang

Mask
20th century
Wood
h. 10⅝ in (27.0 cm)
Acquired 1968 UEA 243

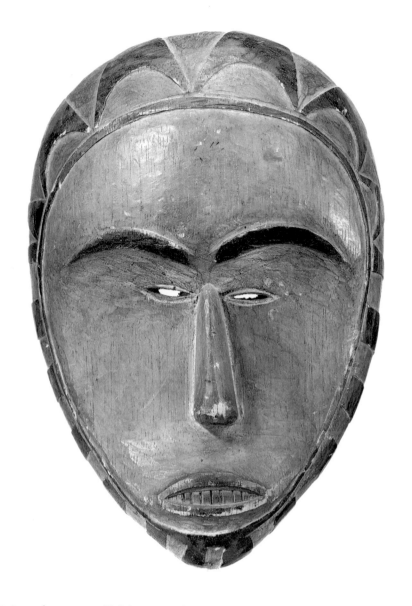

It is perhaps one of life's more pleasing little ironies that the mask
which, more than any other piece of African art, has had a seminal
influence on that of twentieth-century Europe should be apparently one
of a series made for sale to European colonial administrators or sailors,
rather than for tribal use. The mask in question, known as the 'Derain'
mask (formerly owned by Vlaminck and Derain), was first recorded in
1906, and is now in the Musée National d'Art Moderne in Paris (Rubin,
1984: 213). In all, there may be a dozen such masks: William Fagg has
dubbed the carver the 'Master of the Close-Set Eyes'. Some, like the
original 'Derain' mask, and two masks in Antwerp, date to the turn of
this century. A later, slightly smaller-scale, series (of which this is one)
appeared after 1945. None of the masks shows signs of tribal use or has
attachment holes for a masker's costume. All are carved from yellowish
wood with traces of kaolin on the face. Perrois (1979: 100) describes
such masks as *ngontang* (young white woman), yet one of the Antwerp
masks appears to have curling moustaches, and it has been suggested
that the masks portray Europeans rather than female ancestors.

Congo Republic: Kwele

Mask
Late 19th/early 20th century
Wood
w. 11 in (27.9 cm)
Acquired 1969 UEA 246

This Kwele mask closely resembles a famous one owned by Christophe Tzara and previously by André Derain. That may have been one of the early group brought back from French Equatorial Africa by the administrator Aristide Courtois (Leuzinger, 1972: 252). All those masks came from one cult house: some were meant to be worn as face masks, perhaps tilted on the dancer's forehead at an angle of forty-five degrees, while others were hung on the wall at ritual gatherings in perhaps a similar manner to the use of Lega masks.

This mask is almost flat, with a hole on each side which might indicate that it is one of those meant to be hung on the wall. The kaolin-whitened face may mean that it had some part in the ancestors' cult so often found in central Africa.

Little is known about Kwele art and its context, which is the more regrettable since some of their masks such as the archetypal 'heart-face' (as here), the great W-mask in La Rochelle (Leiris and Delange, 1968: fig. 379), the antelope and gorilla masks, make an immediate and powerful impact.

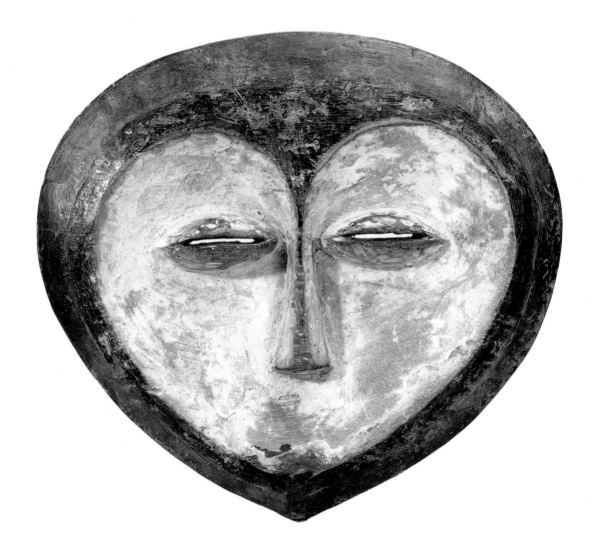

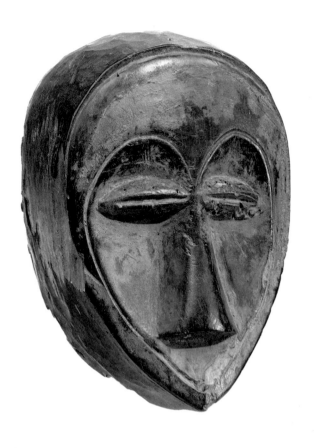

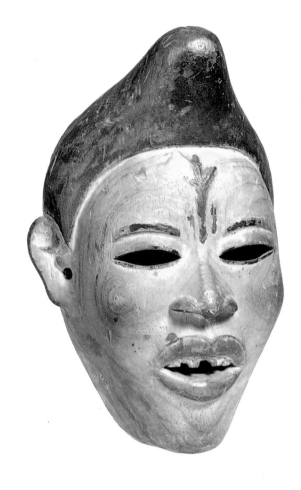

136

Congo Republic: Kwele

Mask
20th century
Wood
h. 11⅛ in (28.3 cm)
Acquired 1968 UEA 247

This mask is described as coming from the region of
Swanke (French *Souan-Ke*) close to the Gabon border.
It is clearly meant to be worn as a face mask, as it
has holes all round the rim and a notch under the
chin, for attaching a costume. Signs of kaolin in the
heart-shaped groove outlining the face suggest that
this was originally a white-faced mask somewhat
similar in type to no. 135 (UEA 246), although this is
much more robustly carved.

137

Zaire/Congo Republic: Yombe or Vili

Mask
20th century
Wood
h. 10¾ in (27.3 cm)
Acquired 1973 UEA 528

Masks of this type come from around the lower Zaire
river and are generally attributed to the northern
Yombe or the Vili. The mitre-like cap and chipped
teeth point to a Yombe origin: yet masks with faces
painted in polychrome designs do appear to have Vili
connections. There has been so much culture change
in this area that very little can be said with certainty
about the culture context of these masks. Maesen
(n.d.: pl. 6) records a suggestion that they may have
been associated with divinatory rituals. Since modern
Yombe have forgotten even the generic name of the
painted-face masks, one can only guess that a white-
face mask might relate to an ancestor cult.

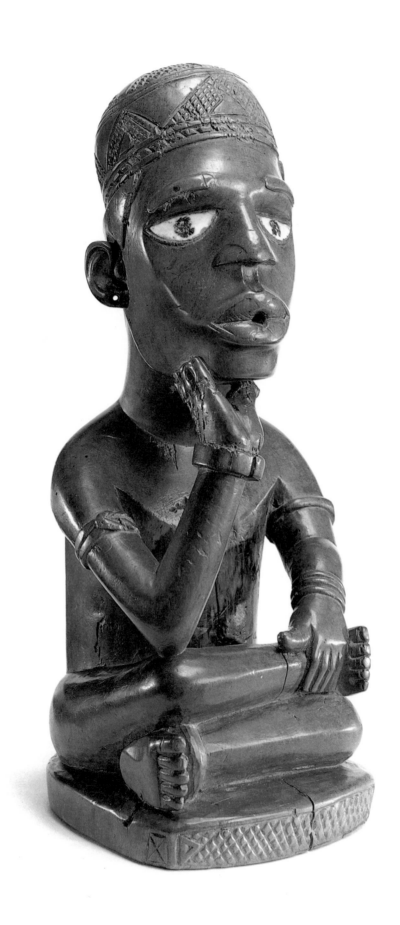

138

Zaire/Congo Republic: Yombe

Seated figure
Late 19th/early 20th century
Wood, porcelain
h. 11 in (27.9 cm)
Acquired 1985 UEA 915

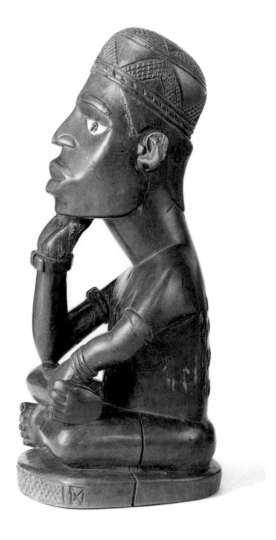

A carving of this type, with 'medicine' or its traces (as here), is known as a *nkisi* (or, loosely, a 'fetish'), a figure endowed with magical power. The 'medicine' was on the chest; its traces are to be seen in a discoloured patch with small nail holes at the top and bottom. In a letter, Dr van Geluwe says that a *nkisi* figure such as this one, wearing a chief's regalia (plaited skull-cap and investiture armlets), is not so much representing the chief himself as emphasising the rank of the figure in the *nkisi* hierarchy; 'it is an important one since it is a chief *nkisi*'. The cross-legged attitude, with the head resting on the right hand, is a convention signifying the thoughtfulness and wisdom to be found among chiefs and elders.

Nkisi figures were used in a variety of rites which are not clearly understood or defined. The 'medicine' is what makes a figure into a *nkisi*; this is a mixture of various substances (wax, rubber, blood, earth, bark, roots, seeds, etc.), put together by a *nganga* or diviner ('witch doctor') and visible as a lump on the figure's stomach or head (as in no. 145, UEA 262); in other cases the magic mixture may be in a body cavity sealed by a piece of glass or mirror, or placed in a small horn. *Nkisi* are not effective unless validated by the *nganga*'s rituals; they are generally understood to be protective and propitiatory charms.

The cross-legged attitude, with the chin resting on one hand, recalls the stone funerary figures (*mintadi*) produced in the area of the Mboma and Solango, by the lower Zaire river. This figure is carved from heavy fine-grained wood, and has a good patina. The carving is skilful, with precise detail on the chief's cap, the dorsal keloids, armlets, hands and feet. The eyes are realistically rendered in porcelain with the pupils painted black; there is no chronological distinction between eyes in glass or in porcelain.

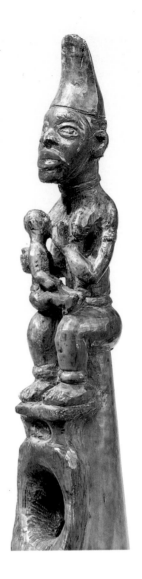

139

Zaire/Congo Republic: Yombe

Trumpet, the point as a maternity group
Late 19th/early 20th century
Elephant ivory
h. 16¾ in (41.6 cm); figure h. 3⅞ in (9.8 cm)
Acquired 1967 UEA 251

Maternity sculptures in the Yombe area are not
connected with the sixteenth-century introduction
of Christianity, but are now known to refer to the
principle of fecundity and its importance in main-
taining the chief's power. Since the chief was head
of the tribe, his own fecundity affected that of his
people, their prosperity and stability. A chief's
obligations included carrying out rituals at the start
of any important initiative such as first crop-sowing
or an armed raid. These rites, aimed at ensuring a

Zaire/Congo Republic: Yombe (?)

Horn with mask
20th century
Elephant ivory
l. 19½ in (49.5 cm)
Acquired 1979 UEA 743

Almost without exception African horns are side-
blown: that is, blown from the side with the mouth-
piece at the point where the tusk cavity ends. This
horn has the mouthpiece on the concave curve of
the tusk, which is standard for oliphants from the
Congolese culture area. The mask at the tip has the
Yombe mitre-like head-dress.

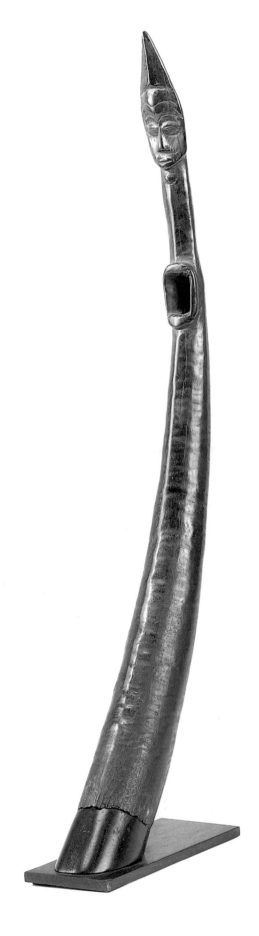

successful outcome, could be invalidated by sorcery
or the chief's personal lack of strength. Thus the
chief's own potency, manifest in the birth of many
children, was of considerable importance.

Rites to maintain and increase this power provide
the context for this horn, with the prescribed mater-
nity group on the tip. The mother sits upright in
a hieratic pose, her feet on a stool; she supports and
nourishes her child as the chief is expected to support
his people.

Zaire/Congo Republic: Yombe

Seated figure of a chieftainess
Late 19th/early 20th century
Wood
h. 14¾ in (37.5 cm)
Acquired 1968 UEA 253

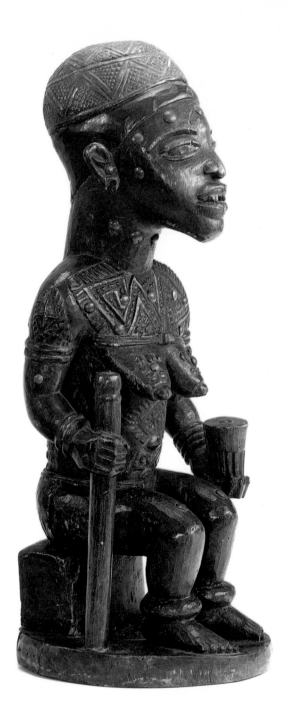

In addition to maternity groups (*phemba*) and 'fetish figures' (*nkisi*), the Yombe carved ancestor figures. Here we have the ancestor figure of a chieftainess. The patterned skull cap (*mpu*) is the mark of a chief after investiture; the seat and the staff of office reinforce this image. The European-looking tumbler held in the left hand could be for palm-wine libations to ancestors. Since liquor was imported by Europeans during the nineteenth century, bottles and glasses became status symbols; the glass here may be yet another sign of a chief.

The pose is reminiscent of English toby jugs which were made from about 1770, and could have reached the Kongo soon after. In pre-colonial times, Kongo chiefs used to drink their palm wine out of human skulls to impress their subjects with their powers over life and death. Since the heads of toby jugs come off to form drinking cups, and they represent Europeans, they were appropriate prestige objects for chiefs, and some are still to be found on Kongo chiefs' graves. While there are actual copies of toby jugs in wood and stone, in general the idiom is translated into figures like this, expressive of the intimidating power of an ancestral chief.

The back and front of the body are covered with elaborate scarifications to enhance female beauty. The lengthy process started at about ten years of age and was completed when the woman was adult and marriageable. The lozenge and chevron patterns echo those used in basketry and textiles. The cord with a bead or amulet tied tightly across the top of the breasts is often found on female figure carvings and seems to be intended to make the breasts project. Tooth-chipping (now discontinued) on men and women was done for aesthetic reasons and was also a mark of tribal identity.

The figure is made of light-coloured wood, now darkened, with pyrogravure features; traces of yellow ochre and white kaolin paint remain. An ancestor figure kept at home might get spat over with the saliva produced by chewing kola nuts, thereby reinforcing the statue's vitality. Sometimes palm oil or palm wine was used as an offering to the figure, and so by extension to the ancestral spirits. Brass nails constitute further offerings to the ancestor and add to the carving's decorative impact.

Provenance: Reported to have been owned by Ary Leblond (brother of the Governor of Brazzaville, French Equatorial Africa), later Director of the Musée des Colonies, Paris, who brought it from the Congo in 1905.

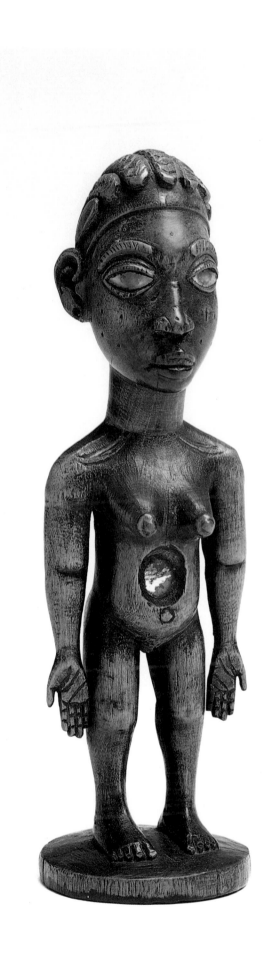

142

Zaire/Congo Republic: Yombe or Kongo

Standing female figure
Late 19th/20th century
Wood, glass
h. 8 in (20.3 cm)
Acquired 1974 UEA 567

Many carvings from the Yombe or Kongo tribal
groups exhibit a considerable degree of realism, as
this little figure shows. This may be the result of
prolonged contact with Europeans and their attitude
to representation: since the late fifteenth century,
Portuguese, French, Dutch and English traders have
visited the old kingdom of Kongo. Christianity was
introduced early in this period, which may explain
why naturalism in the head combines with hieratic
stiff attitudes in the rest of the body; here, the palms
are turned outwards in an unusual pose.

'Descending perspective' is clearly in evidence
from the head, measuring one third of the total
height, diminishing in scale down to the tiny feet.
The piece of mirror in the belly shows that this is a
nkisi figure. A piece of mirror was a device to ward
off malign influences in much the same way as an
amalgam of 'medicine': in some *nkisi* a fragment of
mirror might seal in a lump of 'medicine'.

143

Zaire/Congo Republic: Yombe

Standing female figure
20th century
Wood, brass wire
h. 11¾ in (29.8 cm)
Acquired 1964 UEA 254

The head of this figure is well finished, with a
decorative hairstyle on the back, hatched eyebrows
and carefully carved ears with brass wire earrings.
Yet the front of the body and the hands are blocked
out without any detailed finish, making it appear that
this is an unfinished fetish figure which would have
had 'medicine' applied to an abdominal cavity or
straight on to the body. The mitre-like cap, glass-
inlaid eyes and filed teeth are typically Yombe.

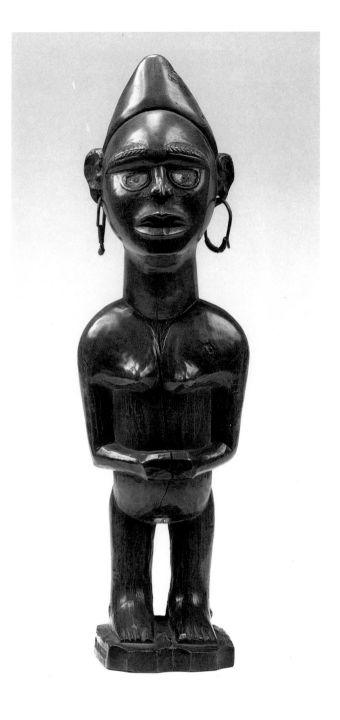

144

Zaire/Congo Republic: Yombe or Kongo (?)

Pipe
Late 19th/early 20th century
Wood, cane
l. 6 in (15.2 cm)
Acquired 1986 UEA 929

This delightful African miniature has 'classical' (in
the pure sense) features, making an attribution on
the criterion of tribal style difficult. A Yombe or
Kongo origin seems most probable. The small size
and short stem have more in common with Euro-
pean pipes than the African model, whether for
smoking tobacco, as here, or hemp. The pipe has
been well used; the bowl is charred, especially on the
right-hand side, indicating that the owner lit it with
his right hand. The stem may be a replacement.

145

Zaire: Kongo

Seated figure
Late 19th/early 20th century
Wood
h. 5¼ in (13.3 cm)
Acquired 1972 UEA 262

Unlike no. 138 (UEA 915), where 'medicine' is missing,
this figure has a good-sized lump on its abdomen
and another on its head. There may well be a cavity
in the head intended to accommodate part of the
'medicine'. The neuter figure is meticulously carved,
especially the left hand, and the cross-legged position
is clearly carved from the underside as well as on top.
Nkisi figures were made and used to give protection
against misfortune, whether from natural or super-
natural sources, which, in tribal Africa, comes to
the same thing.

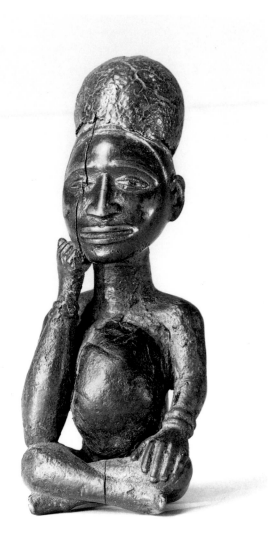

146

Zaire: Kongo (?)

Whistle in the form of a finger
20th century
Elephant ivory
h. 5¾ in (14.6 cm)
Acquired 1980 UEA 769

This whistle is carved as a human finger with
well-marked fingernail and lines marking the first
joint. It is sounded by blowing across the opening at
the end; the air-vent is below the side loop. Whistles
were used in hunting, which often took the form of
a line of beaters driving game towards a net where
other hunters were waiting. In thick bush, whistles
served as signals to regulate the line: if there was a
kill, a whistle might sound a paean of triumph. In
dancing, whether masked or not, whistles still play
an important part in the musical accompaniment.

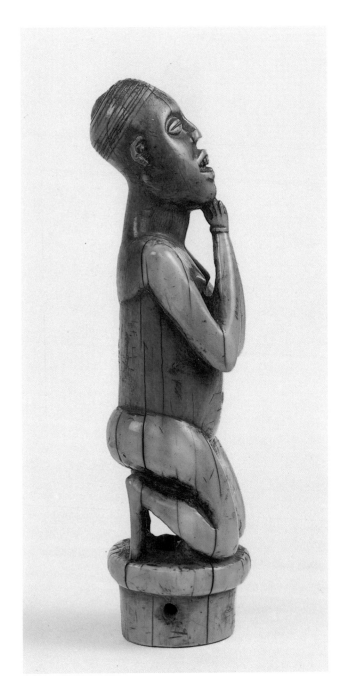

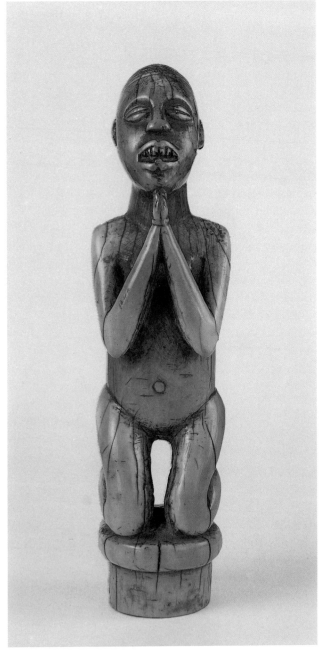

147

Zaire: Kongo

Kneeling figure
19th century
Elephant ivory
h. 6¾ in (16.2 cm)
Acquired 1963 UEA 252

This unusual figure is certainly the top of a chief's
staff of office, *mvwala*, a potent symbol of authority.
Two perforations in the sides of the hollow base are
for attaching it to the wooden staff: the patina is
highlighted where it would have been grasped.

The figure, apparently female, is shown kneeling in
an attitude of prayer foreign to African art, though
often found in that of Europe. It seems probable that
here, as in the sixteenth-century crucifixes of the old
kingdom of Kongo, we have a true example of culture
contact. Kneeling women appear often in African art,
but very seldom with hands joined in prayer. The
teeth are filed in the Kongo fashion, the cap is the
type worn by chiefs in the Kongo-Yombe area (see
no. 141, UEA 253). Perhaps one may read the figure as
invoking divine support for the chief in his dispensing
of justice.

148

Zaire: Bembe

Ancestor figure
20th century
Wood
h. 8¼ in (21.0 cm)
Acquired 1970 UEA 255

Ancestor figures of the western Bembe of the Lower
River region of Zaire (as distinct from the Bembe
just west of Lake Tanganyika) form one of the most
individual groups in African art. They are small,
and may constitute an actual representation of an
ancestor, since they are shown holding an object
evocative of the person concerned. In this case the
man is holding a flintlock rifle and a large knife,
showing that he was a good hunter and warrior.

The figures have the generic name *mukuya*, and
have an anal cavity through which the diviner
(*nganga*) introduces the ancestral spirit (*mukuya*)
which only remains within the statue for as long as it
stays with its original family. The figures form a link
between man and the Creator Nzambi: their role is to
protect the lineage and punish infringements of tribal
custom (Cornet, 1978: 84-7). Bembe figures have eyes
typically made of chips of bone or china or, as here,
with glass beads; the detailed rendering of tribal
cicatrisations on the abdomen adds to the realistic
effect. They are cared for and rubbed with palm oil,
so most have a lustrous dark patina.

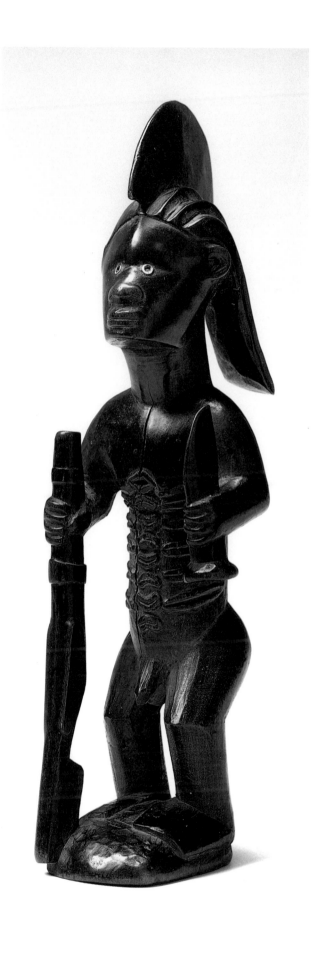

149

Zaire/Angola: Zombo or Yaka

Mother and child group
20th century
Wood
h. 12½ in (31.7 cm)
Acquired 1973 UEA 534

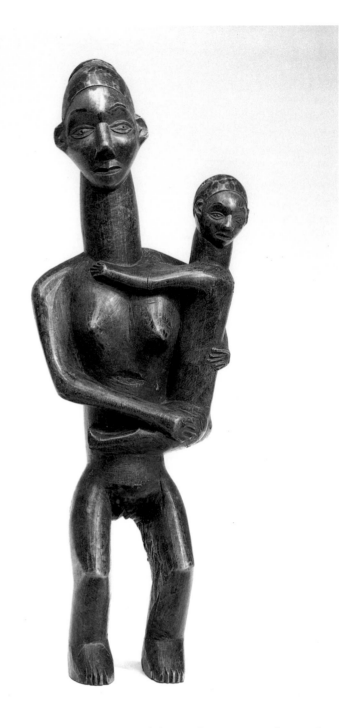

The mother and child theme occurs widely in African art, evidence of
the importance of the principle of increase. In many cases the child is
portrayed on the mother's back, the usual place for carrying a baby.
Around the mouth of the Zaire, mother and child groups (*phemba*) often
show the child on the mother's lap, sometimes dead, sometimes being
suckled. It is unusual to see a child depicted in its mother's arms and
straddling one hip, as here; yet there is another figure in the Lisbon
Ethnological Museum attributed to the Yaka showing a similar group,
although by a different hand (de Oliveira, 1968: pl. 176). Somewhere on
the Zaire/Angola border seems a likely place of origin. The retroussé
noses and columnar necks are characteristic.

150
Zaire: Yaka or Suku

Headrest
20th century
Wood, brass nails
w. 6¾ in (17.1 cm)
Acquired 1973 UEA 531

The 'Yaka spectacles', mouth full of teeth, and double-jointed legs, with
feet tensely gripping the rectangular base, give an impression of latent
vigour and ferocity to this animal-shaped headrest. The creature might
be the yellow baboon which occurs in this part of Africa: despite the
absence of a tail the pose is quite realistic. A grease mark on the curve of
the animal's back shows that the headrest has been used by the original
owner, who might even have been the carver. The fingers of the front
paws overlap the vertical edge of the base, but the back feet, while
executed in perfect symmetry to those in front, defy all anatomical
possibility, since they are turned round in 180 degrees so that the toes
face backwards, curling round and under the base.

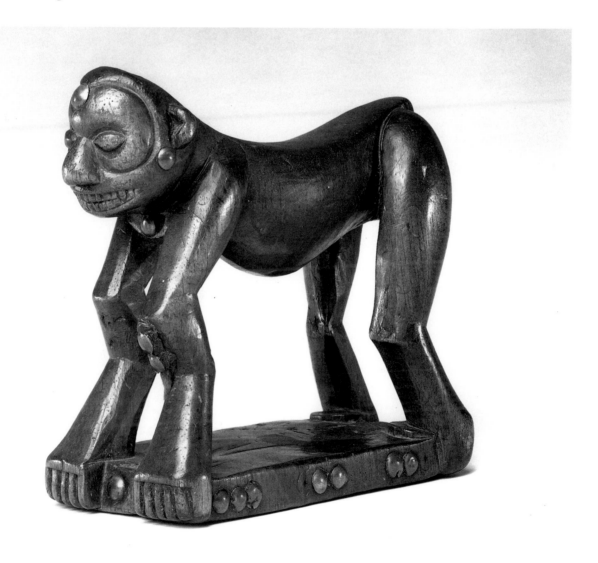

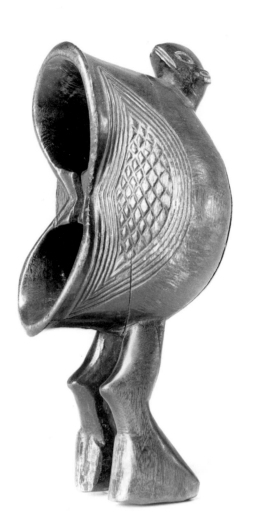

Zaire: Yaka or Suku

Drinking cup with figure
Early 20th century
Wood
h. 5¾ in (14.6 cm)
Acquired 1972 UEA 256

The form of cup for the ceremonial drinking of palm wine has here an addition in the form of a bipod figure with a rather sheep-like animal head. The cavity is not divided, but unlike the other two cups (nos. 152, 156) it would be possible to drink from one end only. Patina occurs where one would expect if the cup were held with the head towards the drinker; the heavy, typically Yaka legs would allow this cup to be set down without tipping over.

Such cups pass by inheritance within the lineage. Bourgeois (1984: 56-7) writes: 'A recitation of previous owners typically details the presentation of this vessel at the decline or deathbed of its owner to his successor, together with admonitions on how lineage members are to be treated.' A fine small cup like this might have been made for a chief, since it was thought vulgar to use a large cup. A chief might drink thirty to forty small cups of palm wine, but would lose dignity if he were to use a large cup.

It is tempting to speculate whether a spirit of fantasy caused this cup to be carved with head and legs, or whether some magical apotropaic purpose was intended.

152

Zaire: Suku or Yaka

Cup
Late 19th/early 20th century
Wood
w. 3⅞ in (9.8 cm)
Acquired 1972 UEA 258

This is a wooden copy of a small cup (Suku, *kopa*; Yaka, *kyopa* or *mbaasa*) made from a pumpkin-shaped gourd, halved vertically. The cavity within is not divided and in use the drinker would hold one end of the cup in the hollow of his palm, with index finger and thumb in the middle recesses.

On both sides is a face representing a *hemba nkisi*, a northern Suku charm and initiation mask, intended to ward off unauthorised touching of the cup.

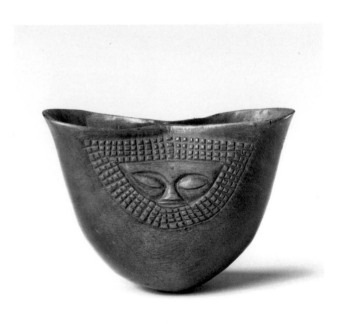

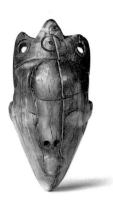
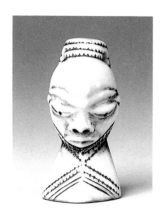

No. 153 (UEA 260) is almost featureless from much wear, and is stained a deep coffee brown from camwood and oil on the wearer's skin. The three-pointed head-dress represents a chief's cap. It has been broken down the middle and repaired. No. 154 (UEA 259) has a beard, showing that it represents a ruler. A suspension hole is pierced across the head.

Of the three masks in this group, no. 155 (UEA 657) is the closest to a *mbuya* mask. It shows the facial scarification, a zig-zag line along jaw- and brow-line which suggests hair, and the three-pointed hat worn by a chief.

153-155

Zaire: Pende, Katundu chiefdom

Three miniature masks
Late 19th/20th century
Elephant ivory
h. 1¾ in (4.4 cm); 1¾ in (4.4 cm); 3 in (7.6 cm)
Acquired 1949, 1971, 1976 UEA 260, 259, 657

Minyaki, or *ikhoko* (carved things) are ivory miniatures which were worn on a necklet or armlet by men who had undergone the initiation rites of the Mbuya secret society. To some extent, they were protective amulets, but their main purpose was to remind the initiate of his symbolic death and rebirth into adult society and the lessons and obligations that he learned during his period of seclusion in the bush. They were generally worn on a string of red or blue glass beads.

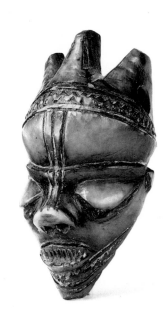

156

Zaire: Pende or Yaka

Cup
20th century
Wood
w. 4½ in (11.4 cm)
Acquired 1972 UEA 257

This cup is made of less close-grained wood than the other two examples, and has two circular mouths instead of a single opening almost meeting in the middle. The Pende (de Sousberghe, 1958: pl. 265) use cups of similar appearance and for the same purpose, the ceremonial drinking of palm wine. The cup has a single cavity; a suspension lug on one side is decorated with incised cross-hatched rhombs; the other side has a single rhomb only.

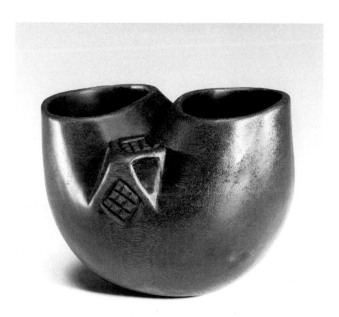

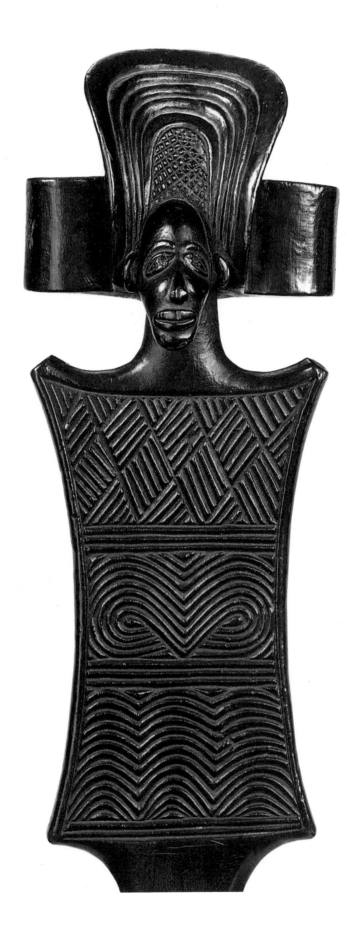

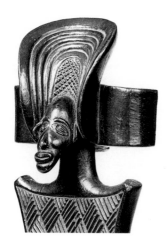

157

Angola/Zaire: Jokwe

Sceptre
Mid 19th/early 20th century
Wood
h. 16⅝ in (42.2 cm)
Acquired 1971 UEA 272

The Jokwe, a numerous tribal group, inhabit much
of Angola and southern Zaire eastwards to western
Zambia. They are a vigorous people, great hunters
and former slave-raiders who in the nineteenth
century even overcame the powerful Lunda kingdom
in eastern Zaire.

This sceptre is surmounted by a head wearing a
chiefly coiffure reminiscent of the mask *mukishi wa
cikungu* which can only be worn by a chief or his heir,
a sororal nephew, since it represents *mwanagana*, the
chief's ancestors; the sceptre itself, therefore, is
that of a chief (Bastin, 1961: II: 301, pls. 77-8).

Jokwe love of surface decoration is clearly shown
in the fine incised patterns on the front and back of
the rectangular panel below the head. Each pattern
has a name. On the front, from top to bottom they
are *manda a mbaci*, the scales on a tortoise shell;
liso, eye; and *mahenga*, wavy lines. On the back, from
top to bottom, are two rows of hatched triangles
mapende, the Gaboon viper; in the middle is *cisonge
ca yishi*, a fish's backbone; then at the bottom the
interlacing lines represent either *ukulungu*, the loops
on the end of a copper wire ear pendant, or *cijingo*,
a spiralled bracelet which can also symbolise an
instrument of divination and could be appropriate
to a chief's sceptre (Bastin, 1961: I: *passim*). The wood
is almost certainly *mulima*, and it is polished with oil.
The rear curves of the coiffure are broken.

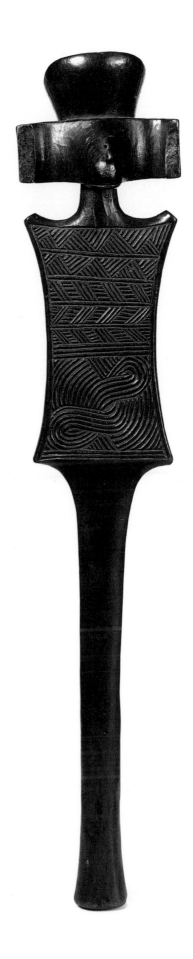

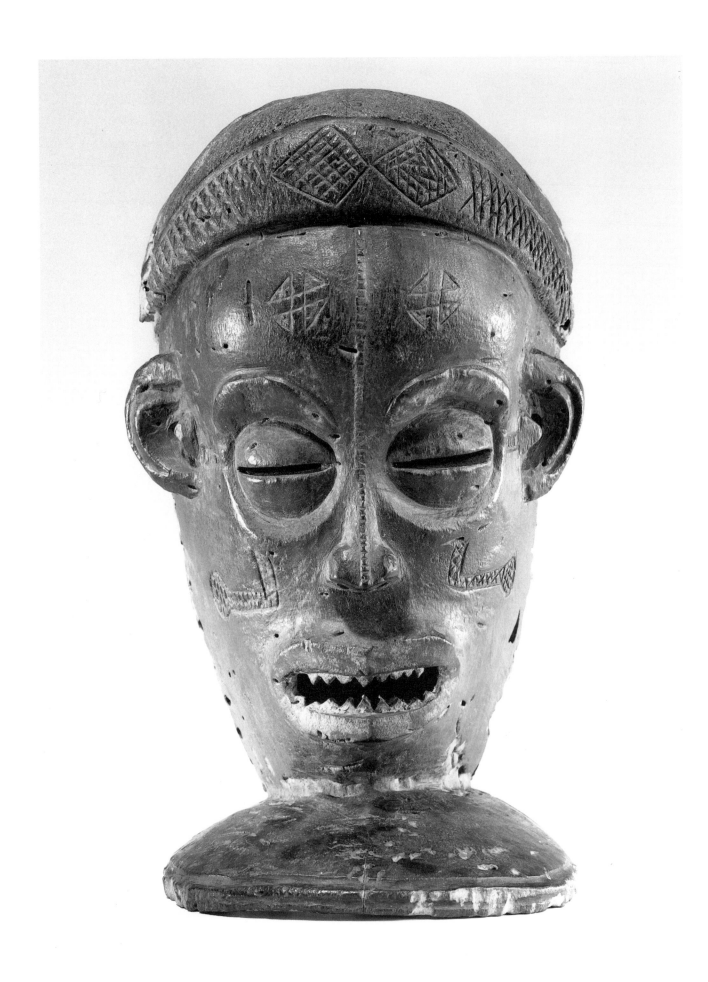

158

Angola/Zaire: Jokwe

Mask
20th century
Wood
h. 9 in (22.9 cm)
Acquired 1975 UEA 613

Jokwe masks are usually made of barkcloth or resin
and barkcloth on a lightweight basketwork frame.
This method of construction gives scope for towering
head-dresses, projecting side pieces and sometimes
entire bodies. Masks with wooden faces incorporated
into a head-covering of net or barkcloth are also
made; this example is from one of this type. Where
the mask covers the head alone, a leotard (*civuvu*)
often coloured in bands and triangles of black, brown,
red and natural cream completes the ensemble.

 This mask, *mukishi wa cihongo*, symbolises wealth.
It is sometimes worn by the chief himself, more
often by the chief's son, but always by a good dancer
(Bastin, 1961: II: 376-7, pls. 242-3). *Cihongo* embodies
the male spirit, and partners the maiden mask *pwo* in
dances held on the return of initiates from the bush
or on other important occasions. It is used in many
festivals to summon the spirit of strength.

 Old *cihongo* masks were made in resin or resin
and barkcloth; nowadays they are made of wood or
painted barkcloth on a frame. The holes around the
upper edge are for a fan-like head-dress made of
light wood and leaves or feathers, perhaps enhanced
with trade cloths, and bordered by the cross-hatched
browband. The face is coloured red with a paint made
of red earth heated with oil; the black and white
contrast comes from pyrogravure and kaolin. The
incised marks (*masoji*, 'tears') below the eyes and the
Maltese cross (*cingelyengelye*) are characteristic of
Jokwe wood masks. The cross is in fact the symbol of
the Order of Christ of Portugal, founded in 1319; its
appearance on Jokwe masks is an instance of cultural
borrowing, and tends not to occur on those from the
eastern Jokwe.

Provenance: Reportedly collected near Chambwanda,
Tshikapa section, south-west Kasai province, south-
ern Zaire, just to the north of eastern Angola.

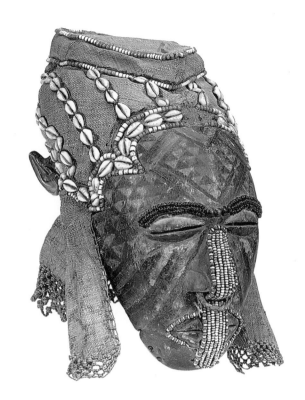

159

Zaire: Kuba

Dance mask
20th century
Wood, raphia cloth, beads and cowries
h. 14 in (35.6 cm)
Acquired 1974 UEA 594

Kuba royal masks are characterised by composite
construction: here we have a wooden face mask
painted in a design of light and dark triangles,
combined with separately carved wooden ears and a
painted and beaded hood of woven raphia cloth and
blue calico. The principal royal mask, *mosh'ambooy
mu shall*, representing Woot, the mythical ancestor-
hero of the Bushoong ruling dynasty, is the most
elaborate and spectacular of these. This mask is
Ngady a mwaash (sometimes called, incorrectly,
shene malula), his sister-wife and co-founder of the
Bushoong line (Cornet, 1978: 198, pl. 107; 1982: 270).

 The *Ngady a mwaash* mask is said to have been
introduced by Ngokady, a Queen-Mother/Regent who,
according to tradition, lived in the late sixteenth to
the early seventeenth century. She wanted to improve
women's status by means of a dance-mask; even so
she was constrained to find a man and ask him to
dance in imitation of a woman's steps.

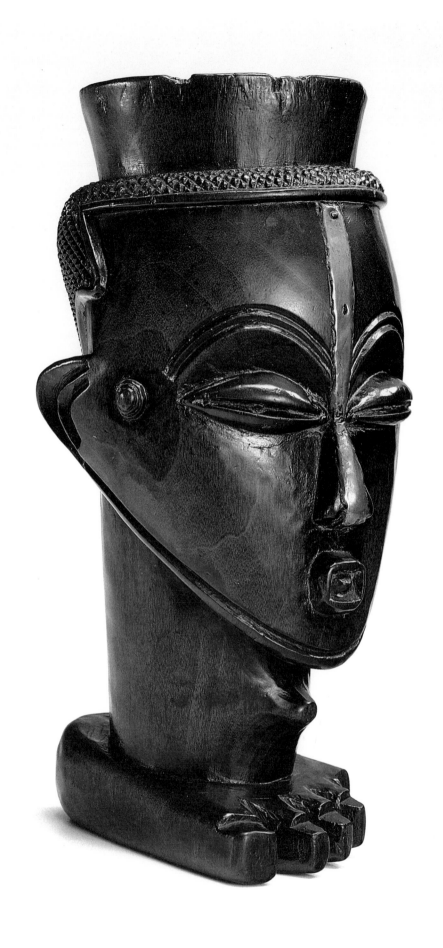

160

Zaire: Kuba

Cup on foot
Early 20th century
Wood, copper
h. 7¼ in (18.4 cm)
Acquired 1974 UEA 566

The ceremonial drinking of palm wine seems to have been one of the most important, and doubtless one of the most enjoyable, activities of Kuba men's clubs, which may explain the large variety of cups found. It is almost impossible to find one that is not good to look at. They come shaped as tumblers or goblets or mugs, sometimes with the handle in the form of an arm or a man. Such cups are covered in a variety of interlacing patterns, showing the Kuba love of intricate design which finds its fullest expression in embroidered raphia cloths. Other cups may come as a manikin standing with arms akimbo: many, like this, are formed like a human head open at the crown. Head-shaped cups often come from the Lele, living just to the west of the Kuba in Kasai province, but this cup is rather more Kuba than Lele.

The head is plain to the point of austerity; in profile the line of jaw and ear seems to echo the eyebrow line; the jutting nose, mouth and Adam's apple (umbilicus?) are balanced by the spreading toes and heel of the foot below. A copper strip, part applied, part inlaid, down the centre of forehead and nose is a rendering of the tribal marking often shown as a beaded strap on masks, but appearing less commonly on drinking cups or figures.

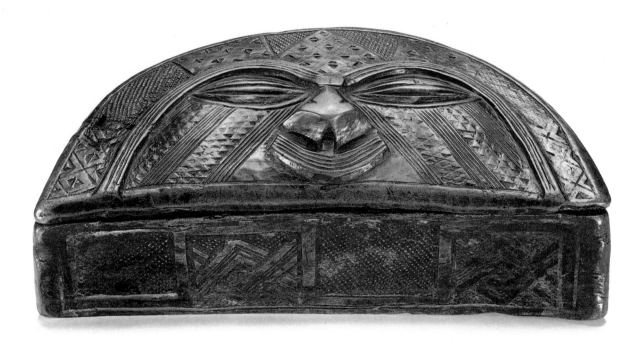

161

Zaire: Kuba

Cosmetic box
Late 19th/20th century
Wood
w. 10¼ in (26.0 cm)
Acquired 1973 UEA 530

Boxes for camwood powder (*ngedi mu ntey*) are among the pleasantest and most typical pieces of Kuba domestic art. Camwood powder is red, almost cerise, in colour and usually comes from the heartwood of the *mulombwa* tree, which occurs over most of central Africa. When ground to a fine powder and mixed with castor oil it makes a paint that is widely used in the Congo Basin area as a cosmetic or dye. Among the Kuba, this cosmetic is called *tukula* or *twool* and it is mixed in the inverted lid of the camwood powder box.

The top of the box is decorated with a mask and bordered with the interlace patterns which so reflect the Kuba love of surface pattern: similar designs surround the sides of the box. The crescentic shape recalls the half-moon phase in the lunar cycle, traditionally the time of greatest fecundity in women.

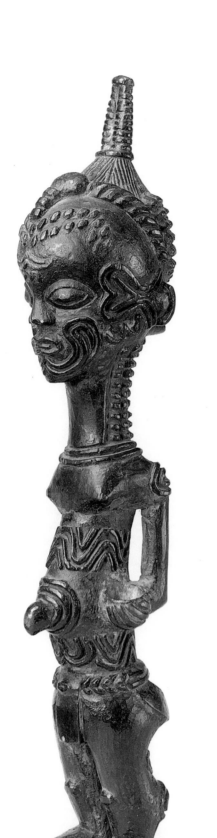

Zaire: Luluwa

Male figure
Mid/late 19th century
Wood
h. 12½ in (31.7 cm)
Acquired 1968 UEA 263

The Bena Lulua, or people of the Lulua river, have
as their tribal name a term coined by the Germans
von Wissmann and Pogge in 1881 to describe various
people (including the Luluwa) living on the banks of
the Lulua who had been displaced by Luba and Kuba
expansion. The Luluwa have an ethnically diverse
origin arising out of migrations, invasions and fusions
with groups of slaves. Their distinctive and extensive
body scarification was a means of establishing ethnic
identity and is a striking feature of their figure
carving.

While Luluwa masks have some characteristics in
common with the art of the neighbouring Kuba, their
figures are *sui generis*, even where the cicatrisation
is less extensive than here. This carving is a type
called *mbulenga* and is a charm to bring fortune and
beauty. At the birth of a child, magic ingredients
mixed with kaolin were placed in the little cup in
mbulenga's left hand as an offering to bring good luck
and beauty to the child. *Mbulenga* figures were 'fed'
by having food placed on the spiked head-dress, and
they might be rubbed with red camwood powder
and oil (*tukula*) to strengthen their magical power.

The making of *mbulenga* lapsed for a while after
the Luluwa migration in the 1880s: later carvings
have less extensive surface decoration.

Zaire : Luluwa

Pipe-bowl
Late 19th/early 20th century
Wood
h. $4\frac{1}{4}$ in (10.8 cm)
Acquired 1972 UEA 264

Besides beautiful standing figures with intricate scarifications, the Luluwa carve snuff-mortars and pipe-bowls which include some highly imaginative treatments of the human body, as here. A second look at the little man forming the pipe-bowl shows that his thighs are absent: the forearms and elbows are supported by a downward continuation ending in the feet. The balance of parts is such that even when the missing thighs are noticed the figure still looks right.

The pipe stem would have been fairly thick, of hollowed wood with a cane mouthpiece. The man's head forms the bowl of the pipe, with a hole pierced through to the square perforation in his body to link with the stem.

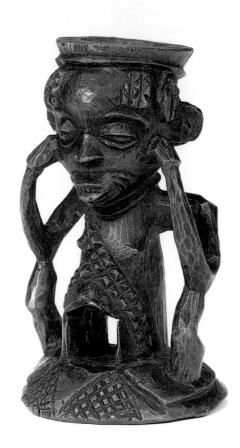

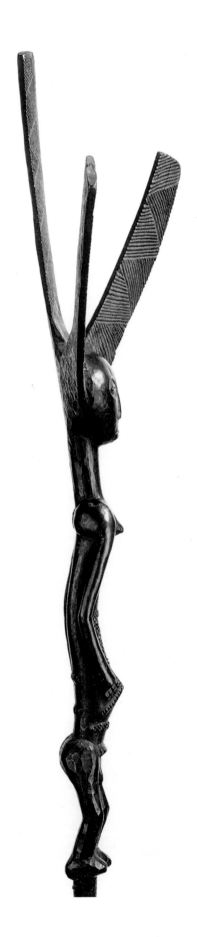

Zaire: Luba-Hemba

Ceremonial bow-stand
Late 19th/early 20th century
Wood
h. 26½ in (67.5 cm)
Acquired 1961 UEA 267

Among the regalia of a Luba chief were the royal bow and arrows without which he could not validly succeed to his position. As symbols of his authority, they might be placed before him when he was receiving important visitors or sitting in audience and delivering judgement. The trident support for these is usually borne by a female figure with tribal scarifications on the belly; this is held to represent a female ancestor, if not the actual founding mother of the tribal group. Such figures may refer to the principle of succession through the female line among the Hemba and the symbolic role of women.

The use of ceremonial bow-stands extends beyond Luba-Hemba lands proper into areas of Hemba contact, such as Bemba country in northern Zambia. A delightful bow-stand in the Royal Museum of Scotland (no. 1981.11), of Hemba style, was acquired, doubtless as a diplomatic gift, by a missionary working in LuBemba around the turn of the century. Bow-stands made solely of wrought iron also occur and Senior Chief Mwamba of the Bemba still owned two of these in the 1930s.

This trident bow-stand with its supporting figure would have been fitted to an iron spike some 2-3 feet long to enable it to be planted in the ground before the chief, with the bow, arrows and other chiefly insignia supported upon it.

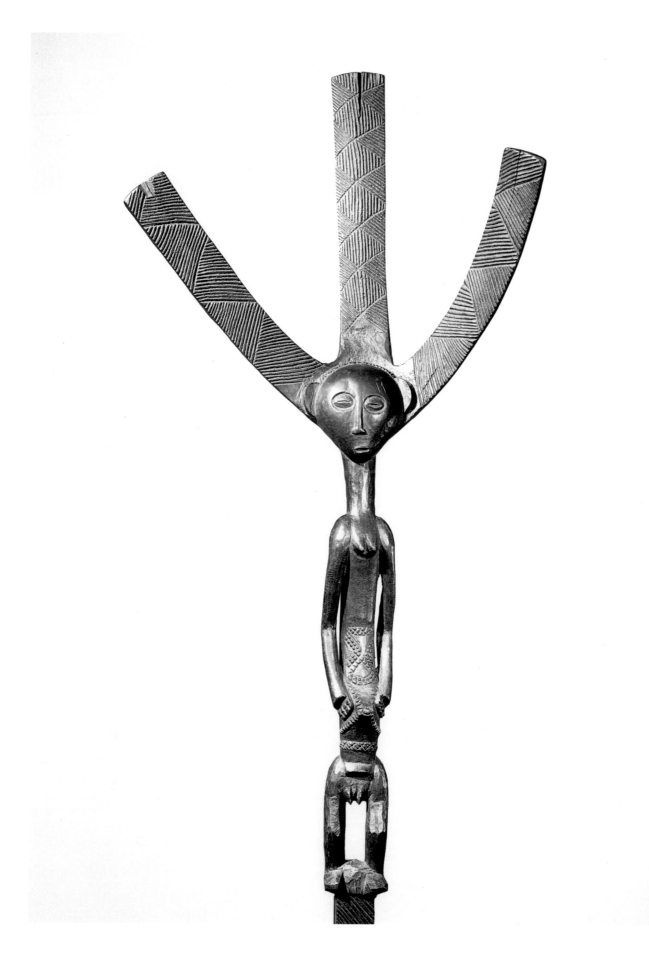

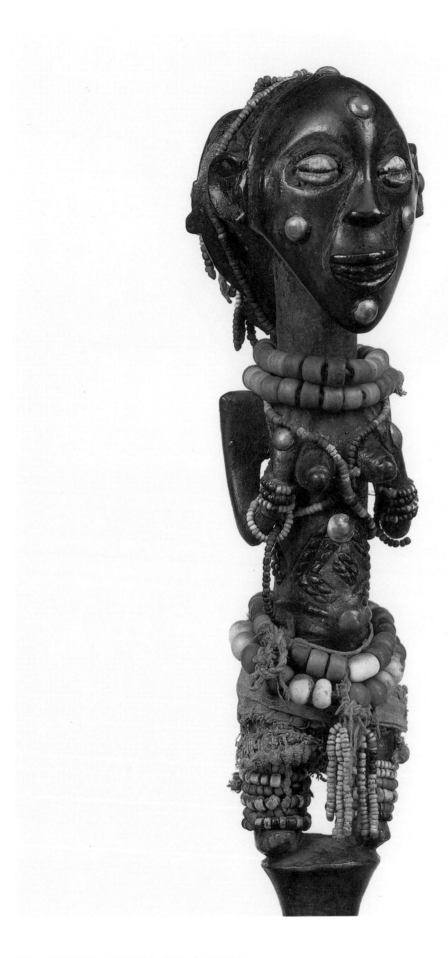

Zaire: Luba-Hemba

Ceremonial staff
Late 19th century
Wood, iron, brass, beads, shells, fibre
h. 57½ in (146.0 cm); figure h. 9½ in (24.1 cm)
Acquired 1953 UEA 266

The Luba people of south-east Zaire are one of its
largest tribal groups, comprising a number of related
people who have combined under a paramount
chief (*mulopwe*) from the sixteenth century onwards.
The empire expanded considerably, causing great
population shifts, especially in the eighteenth and
nineteenth centuries. After 1885 the empire began to
break up; the colonial period followed shortly after,
'freezing' tribal locations. Much research is needed
to unravel Luba traditions and history: analysis of the
differing art styles within the Luba orbit should
illuminate the historical enquiries.

The Luba-Hemba subdivision live in the eastern
part of the territory, east of the Lualaba river, in the
area that nineteenth-century explorers called Urua.
Luba sculpture is in the top rank of African art, and
the Luba-Hemba substyle (which furnished the Buli
carvings) is perhaps its supreme expression. This
chief's staff (*kafunda ya kutembele*), surmounted by
an elaborately attired standing female figure
(identifiable as Hemba by the cruciform coiffure),
depicts a female ancestor, perhaps a founding-mother
of the tribe, and consequently most appropriate to
a royal sceptre. Such sceptres symbolised formal
leadership among the Luba; they served to identify a
chief or his spokesman: they were used to emphasise
points of judgement or validate important parts of a
message and to stress their binding nature. One of
the chief's wives kept them in her charge.

The wooden part of the staff, comprising figure
and hand-grip, is attached to a tanged iron spike
over three feet long, enabling it to be driven into the
ground beside the chief as he sat in audience among
his counsellors. The varied and numerous bead
ornaments, spiked and domed brass nails and cowrie-
shell eyes give this figure a great feeling of tradition
and authority; the tribal belly scarifications reinforce
the ethnic identity.

Provenance: Formerly in the Pareyn Collection,
Antwerp.

Further illustrations overleaf

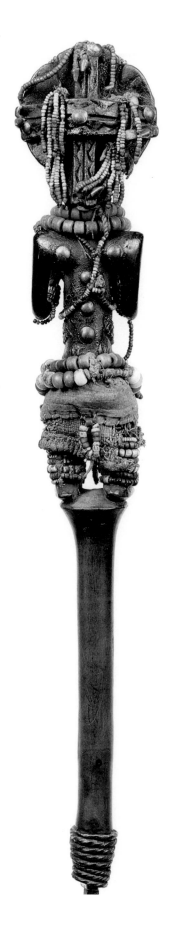

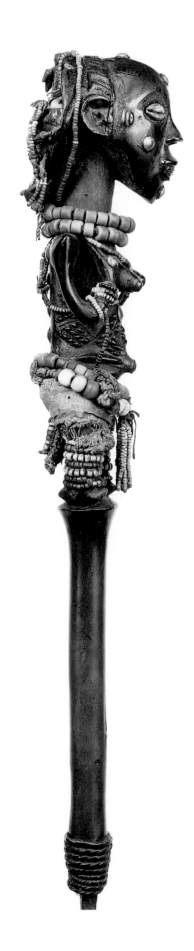

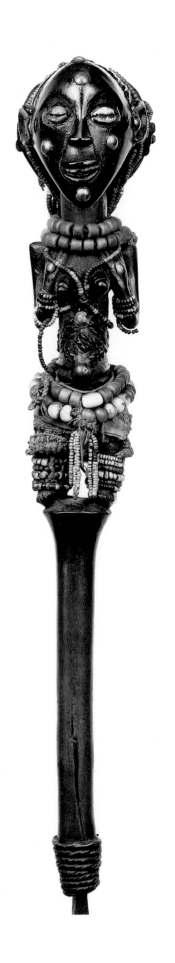

Zaire: Songye

Female fetish figure
Late 19th/early 20th century
Wood
h. 31½ in (78.7 cm)
Acquired 1974 UEA 592

The Songye, a Luba-related tribe, are found in the
Cabinda region of Kasai province, roughly between
the Sankuru and Lomami rivers. They produce
striking masks for the Kifwebe society derived from
the Luba, and fetish figures (*bwanga*) pulsing with
magical force (see Cornet, 1978: 276-80, 188-91).

Most Songye fetishes, which are often ancestor
figures charged with extra 'medicine' to strengthen
their powers, are male. The arms are usually bent at
the elbow, as here, and the hands placed on either
side of a swollen belly. The 'figure-of-eight' mouth is
a hallmark of Songye figures and masks; male figures
have a square-cut chin suggestive of a beard. Cavities
for 'medicine' in the belly are often sealed with a
small sheet of copper or skin: those in the crown of
the head usually have horns, nails or feathers stuck
into them, while additional 'medicine' or offerings
may be attached in snakeskin neckrings, gourds,
strings of beads, raphia cloth or skin skirts, while
head and body are often garnished with strips of
copper and brass-headed nails (Cornet, 1978: 282-7).

This figure, denuded of all fetish material, is full
of restraint and dignity: it is easy to imagine her as
a venerable tribal ancestor. The wood is hard and
heavy, the feet have been attacked by termites. The
sightless eyes may have been of cowrie shell, copper
or brass; the long neck surely had strings of glass
beads and the rest of the body would have been
apparelled in a manner befitting her obvious status.

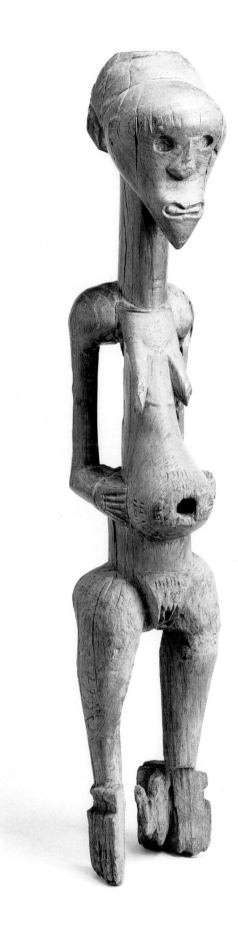

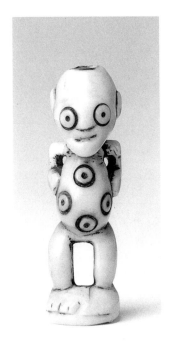
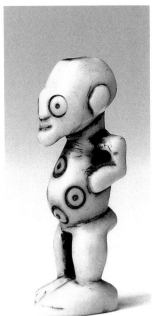

167

Zaire: Songye

Standing figure
Late 19th century
Elephant ivory
h. 2¾ in (7.0 cm)
Acquired 1968 UEA 265

The position of the arms and the hole in the crown of
the head for 'medicine', or a small horn containing
'medicine', make a Songye attribution for this gnome-
like little figure very possible, despite the absence of
comparative material. The ring-and-dot marks form-
ing the eyes and decorating the abdomen seem to
indicate that East African Arab influence had by then
reached that part of central Africa: a date after about
1850 seems likely.

The neuter figure may have been suspended by a
thong or cord passing in front of the neck and under
each arm.

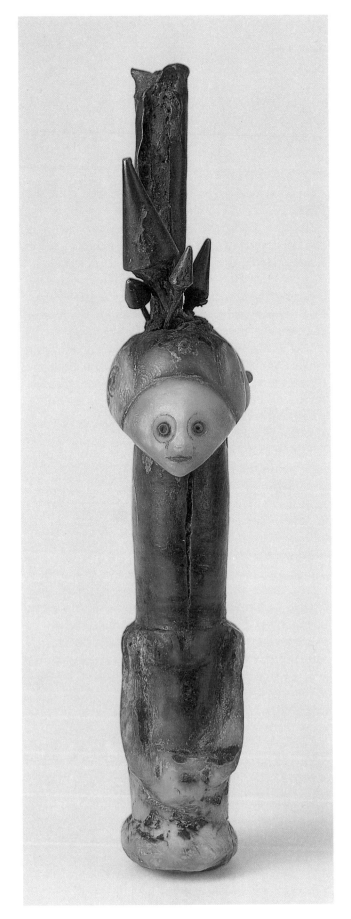

Zaire: Tetela (?)

Figure
Late 19th/early 20th century
Elephant ivory, metal
h. 8⅜ in (21.3 cm)
Acquired 1974 UEA 535

In all probability, this small ivory figure, its bottom
ending in a ring base, was made to go on top of a
gourd filled with fetish material. Such 'fetish gourds'
were filled with 'medicine', assembled and com-
pounded with proper ritual by the witch-doctor
(diviner, *nganga*) with the purpose of bringing good
luck and averting misfortune.

The cavity in the head of this figure has 'medicine'
in it, and in addition four brass cones on stalks, a
ferrule-like brass object filled with 'medicine' and
a small barbed arrowhead have been stuck into
the hole. If these six items are extra to the original
charge of 'medicine', it is tempting to see them as
six subsequent invocations or thanksgivings to the
power within the fetish gourd and its figure.

Since these figures are generally made of wood, it
is possible that this one is connected with elephants
and ivory in some way, and might have been part of
the equipment of an elephant-hunters' guild. Such
guilds existed in most central African tribes wher-
ever there was elephant country: initiation rituals,
secret languages and freemasonry-type rules of
brotherhood were usual features. Within such a
context, the fetish would have been implored to
favour a successful outcome to an elephant hunt, and
offerings would be made to it, whether in the form
of an iron arrowhead, a brass nail or palm oil, which
last has darkened the ivory with a reddish tinge and
caused verdigris to form on the brass. Since a suspen-
sion hole is pierced below the head, the whole might
have been hung up in a hut.

It could well be that this figure is unique. There
can be no doubt of its aura of authenticity and power,
wherever its origin: the nails suggest somewhere not
too far from the Songye, such as the Tetela, who live
to the north of them.

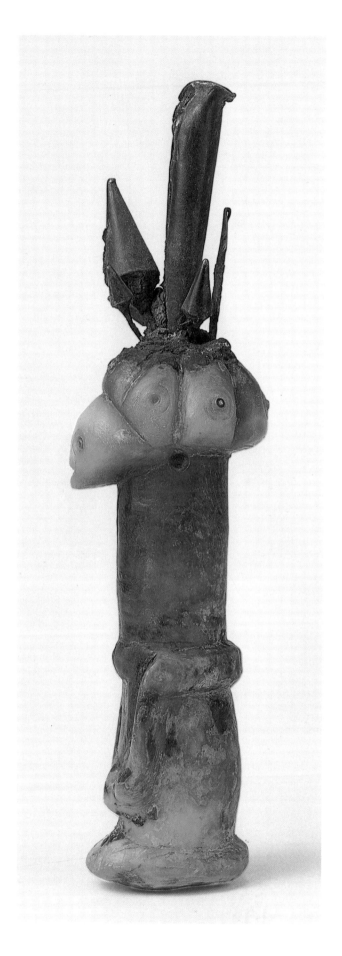

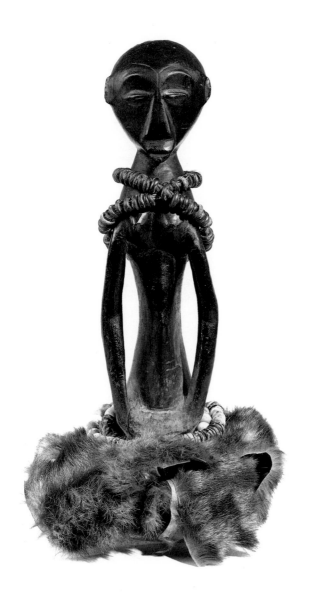

170 (*opposite*)

Zaire: Tetela (?)

Standing female figure
Late 19th/20th century
Wood
h. 23 in (58.4 cm)
Acquired 1973 UEA 529

While in many ways this figure shows all the hall-marks of a female ancestor, the bun-shaped lump of 'medicine' secured on top of the head with wooden pins and with a hole as if for a small horn links it to fetish figures such as occur among the Songye.

In the present state of knowledge of Zairean art styles it is difficult to locate this carving with any degree of confidence. The hair is a little reminiscent of the 'cascade' coiffure of the Luba-Shankadi; some Songye figures are carved with heavy buttocks and short legs; the abdominal scarification incision can be paralleled in eastern Zaire and western Zambia. If a balance were to be struck among all these, an origin among the Tetela, who are known for masks rather than figures, is a possibility.

Something about the carving suggests that it was made by an individual, perhaps self-taught, who developed his own style; this could account for the difficulty of placing it within a tribal context.

169

Zaire: Kusu (?)

Female half-figure
Late 19th/early 20th century
Wood, animal skin
h. 14½ in (36.8 cm)
Acquired 1973 UEA 532

Living to the north of the Songye, around the Lomami river, the Kusu are a group comprising the Tetela, Nkutshu and other tribes whose sculpture is relatively rare and shows affinities with Luba art.

This figure was probably made to surmount a fetish gourd filled with magic substances; examples of such guardian figures certainly occur among the Luba-Hemba and the Songye. This figure has a cavity in the crown, surely for reinforcing magic in the form of a 'medicine' horn, which is consistent with Songye and Luba-Hemba parallels. The coiffure has affinities with the 'cascade' style of the Luba-Shankadi, yet the torso, unlike most Luba female sculptures, shows no tribal scarifications. Ritual anointments with palm oil, designed to strengthen the magical powers, have left the figure black and sticky.

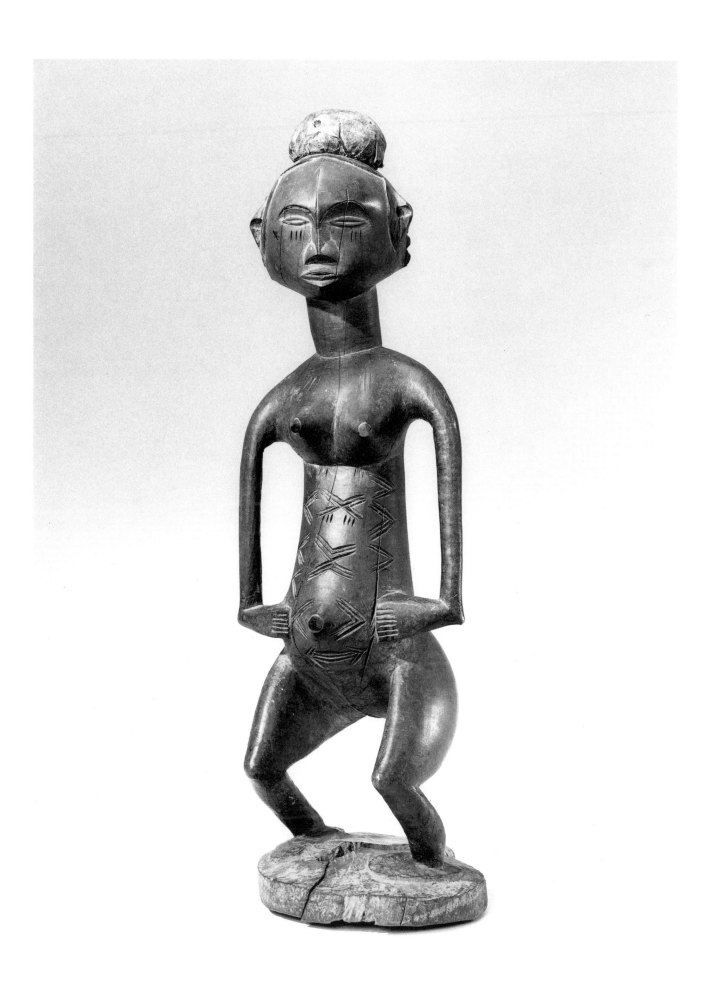

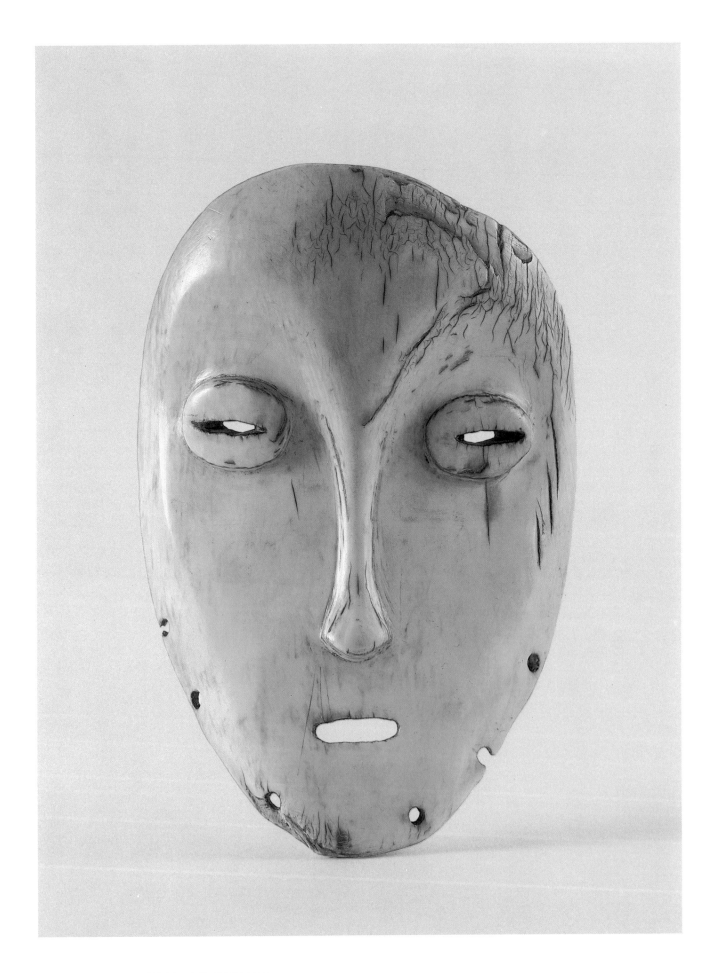

Zaire: Lega

Mask
Early 20th century (?)
Elephant ivory
h. 6¾ in (17.1 cm)
Acquired 1953 UEA 269

The Lega (also known as the Warega or Rega, the less correct Swahili form of the tribal name) live in eastern Zaire. They carve miniature masks and figures in ivory, bone and wood for use in the rites of the Bwami secret society to which nearly all adult Lega belong: Bwami *is* Lega society. The hierarchy, structure and rules that govern Bwami and define each of its members also govern Lega society. Bwami and Lega are indivisible. Women as well as men may be initiates, unlike the normal secret society which is restricted to men. Bwami was proscribed by the Government in 1948, but allowed to resume after the country gained independence.

Different masks, figures, carvings and other objects, singly or in combination, are appropriate to various grades within Bwami. They may be insignia, and may also embody some principle of good conduct within the group. Ivory masks, called *lukungu* (skull), represent 'the skull of my father' and symbolise the continuity linking the son with his father or other ancestors and kinsmen through Bwami. Such masks are used in the initiation of the highest grade, *kindi*. They may be handed down within a lineage over four or more generations. As part of the final stage of initiation (*lutumbo lwa kindi*) ivory masks are displayed on a small fence: proverbs embodying obligations and rules of conduct binding upon the initiates are associated with the display and its accompanying rites (Biebuyck, 1973: pls. 38-9).

Ivory and elephant bone are the usual materials for *lukungu* masks (*ibid*: pls. 56-8). This mask is rather larger than the average for such masks and would have come from a tusk at least 7 inches in diameter. The curves of the mask at the top left of the brow and on the chin show some irregularity which may be due to a flaw in the tusk, lack of skill in the carver, or damage in later handling. Most masks have no fibre beard such as this one seems to have had.

The colour is exceptionally pale: *lukungu* masks that have had tribal use acquire a distinctive warm orange-brown patina from *ibonga* (ceremonial oiling) in the rites consecrating them. Traces of patination are visible on both sides of the mask, which seems to have been 'cleaned up' by a non-Lega: there are also signs of some polishing compound in the cracks. While unauthentic Lega masks of this type undoubtedly exist, the signs of patina removal suggest that this mask is not among their number.

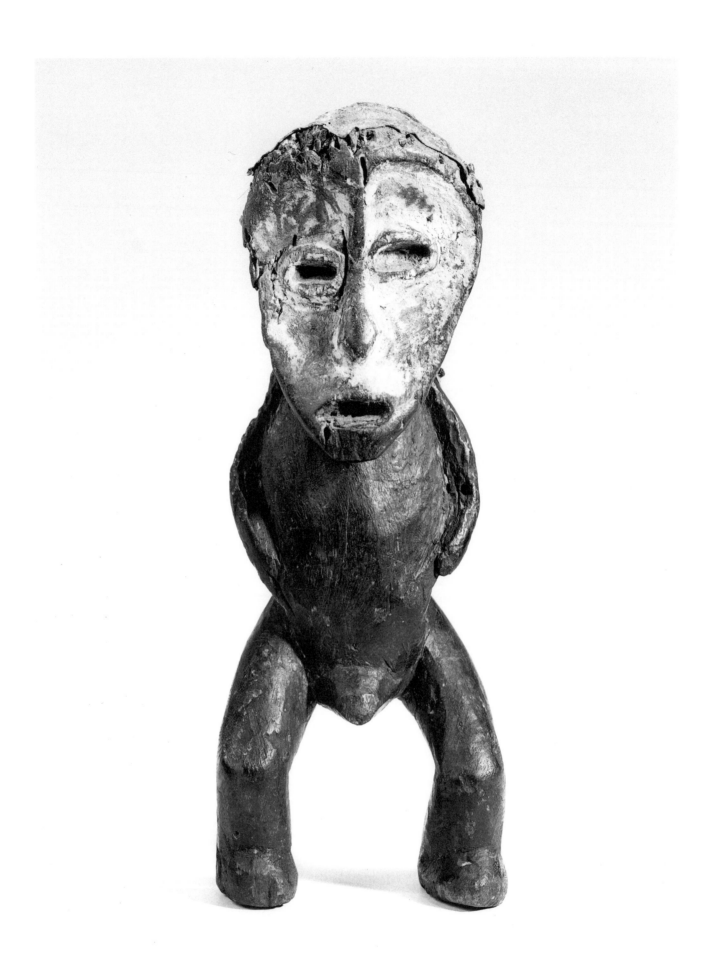

Zaire: Lega

Figure
20th century
Wood, monkey skin
h. $10\frac{3}{4}$ in (27.3 cm)
Acquired 1975 UEA 603

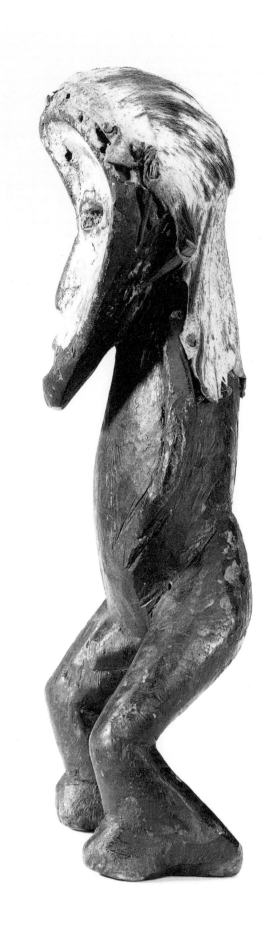

Professor Daniel Biebuyck, a naturalised MuLega
and acknowledged authority on Lega culture, lists
58 different principal characters portrayed in Lega
figurines (1973: 218-20). These express virtues and
failings, values and non-values, whether singly or in
combination with other figures or objects. Figures,
like the masks, are valued for their association with
high social rank, which in its turn depends on the
owner's grade within Bwami.

This figure appears to be that of Kakulu ka Mpito –
'The Great-Old-One with the black hat of monkey
hide who died a bad death because of his pregnant
adulterous wife or because of his lack of circum-
spection' (Biebuyck, 1973: 218, pl. 69). Kakulu ka
Mpito features in the *mutulwa* rite, towards the end
of *lutumbo lwa kindi*, the final stages of initiation into
the highest grade of Bwami. Nine proverbs and their
interpretations develop out of the contents of a
basket holding among others a figure of Mukobania,
a thoughtless agitator who invited a number of
people he did not know to a beer-drinking, where
there was a quarrel and Kakulu was killed. The lesson
is that a senior *mwame* (member of Bwami) should be
prudent and should not do anything without first
thinking matters through. Another figure in the
basket is Wayinda, the wife of Kakulu, who is guilty
of ritual pollution because of her adultery during
pregnancy, and thus magically she kills her husband.
This adulterous pollution is called *mpeto*; the
monkey whose skin furnishes Kakulu's skull-cap is
mpito, a typically punning allusion. The meaning of
this figure is underlined by the accompanying figures
with songs, proverbs and word associations.

Kakulu ka Mpito is thus a symbol of great social
importance, an essential part of the collection of
things in the basket with a deep meaning for the
social framework of Bwami. Since the figure can be
transferred by inheritance it ensures genealogical and
ritual continuity of the lineage group which holds it.
Kakulu also serves as a concrete reminder of rules of
character and conduct binding on every senior
mwame. It is not valued as an art object nor is it a
cult object, ancestor figure or fetish.

173

Central African Republic: Zande

Standing figure
20th century
Wood
h. 5¾ in (14.6 cm)
Acquired 1963 UEA 248

The Zande, belonging to the Nile-Congo watershed group of tribes, live over a large area including south-west Sudan, north-east Zaire, and the southern part of the Central African Republic. Their wood-carvings fall into two groups, one of which includes realistic figures and bow harps with human heads. The other group, of which this is an example, are less elaborately carved and were made for the rites of the Mani secret society. The austere treatment of the human form is akin to that of Lega figures (*cf.* no. 172, UEA 603).

The Mani cult began about the end of the nineteenth century in western Zande country, perhaps as a reaction to colonisation. Mani was a sort of mutual aid society, with rituals to invoke protection, bring good fortune or avert bad luck. Adepts met at night in the forest; they made and used small figures, *yanda* (also meaning 'spirit' or 'force'), which were made out of clay or the wood of special sacred trees. A *yanda* figure needed to be properly inaugurated to nullify any negative forces and to imbue it with the right sort of spiritual power. The ceremony was carried out before the group leader, two witnesses and the future owner, who from then on had to look after it, feed it and give it presents. It lived in a hut with the other *yanda* figures. This asexual figure is called *Nazeze* ('with legs') and is illustrated by Burssens (1962: pl. x, fig. 102).

At certain Mani assemblies, a special gruel, *libele*, was decocted out of a mixture of roots, barks, seeds, oil, salt and water; this *libele* and a powder, *mbagu*, were used to anoint *yanda* figures as an offering and to reinforce their power. The crusty surface of this figure is the result. Mani adepts also rubbed *libele* on themselves because it was a very powerful magical remedy. *Yanda* figures helped towards success in hunting, promoted fruitfulness in mankind, animals and plants, brought about favourable results in lawsuits and averted ill-luck generally. On the negative side, *yanda* figures could be used as agents of sorcery to cause illness or even death, but since payment was required in the form of the victim's heart and liver, this may not have happened too often.

Mani, like many other secret societies, was not favourably regarded by the Government and became something of an underground movement. Mani cells tended to form wherever large enough migrant groups of Zande lived, even where far outside Zande country proper.

Provenance: Collected by Dr J. de Loose in the town of Bangui in 1954, though it was carved in Rafai district, Central African Republic, the heartland of the Mani cult. Dr de Loose was Medical Officer in the Lower Welle region in 1952-56, and was thus well placed to be one of Burssens' chief informants.

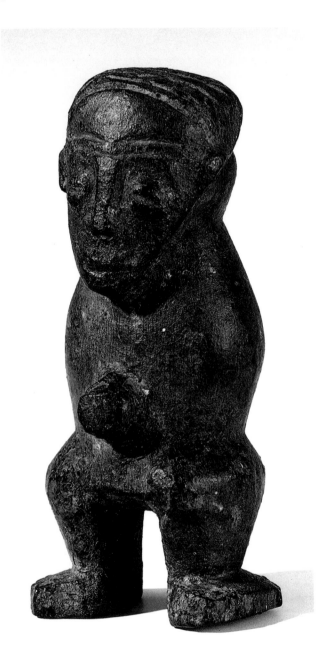

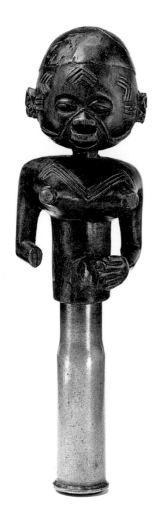
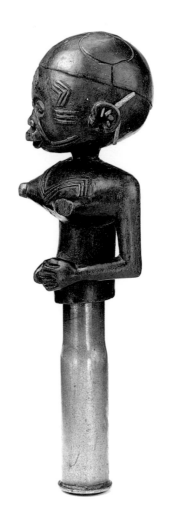

174

Mozambique/Tanzania: Makonde

Container for snuff or 'medicine'
Late 19th century
Wood, brass
h. 4¾ in (12.1 cm)
Acquired 1964 UEA 250

The Makonde group of peoples live on either side of the Ruvuma river which divides Mozambique from Tanzania. Tanzania was a German colony till after World War I, so it is not surprising that a German ethnographer should even today be one of our best sources of information on the Makonde. Karl Weule (1908: pls. 23-4) illustrates several pieces similar to this one, and describes them as boxes for snuff or medicine, worn attached to a belt. While the container was usually made from a piece of bamboo or reed, Weule (1908: 50) lists 'even a European

cartridge-case' among the materials used. The lid was normally of wood, ornamentally carved in different shapes including animals and human torsos.

The cartridge-case is an 11.5 mm centre-fire type of Austrian or German make. It bears the monogram of the manufacturer, the letters FAB and the date 1887. Ammunition of this type was used for the German Mauser rifles of the period (information courtesy of Dr Alan Borg).

The portrayal of face and body scarification by relief carving is surely on account of the small scale. On masks and larger figures, scarification is rendered in applied strips of black beeswax, subsequently by black paint, and later still by pyrogravure or incisions. Some Makonde carvings lack scarification but retain the lip-plug (*pelele*) which can be seen here in the protruding upper lip. The little female torso is beautifully carved with fine attention to detail, even to five perforations in each ear rim, some with the ear-pegs still in place.

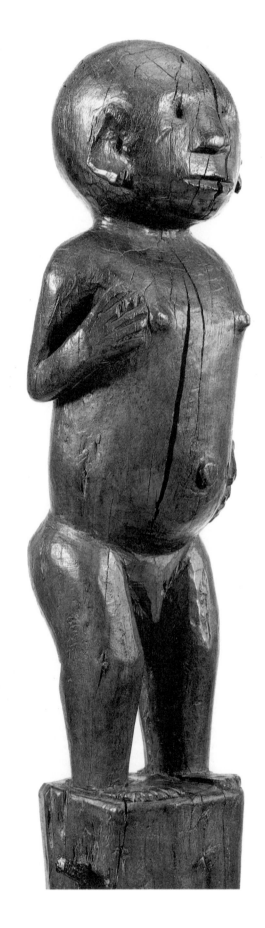

175

Tanzania: coastal Bantu (?)

Male figure on post
Early/mid 19th century
Wood
h. 46 in (116.8 cm); figure h. 15 in (38.1 cm)
Acquired 1962 UEA 187

This hardwood post figure remains an enigma.
Though clearly of considerable age it is without
collection data and neither its origin nor function is
known. In a preliminary catalogue of the collection
(Sainsbury, 1978) it was tentatively attributed to
Tonga on the basis of a pencil inscription to that effect
on the post in the hand of James Hooper. Since then
an Oceanic provenance has been discounted. Further
researches on East African sculpture have been
carried out (Hartwig, 1980) and an origin from that
region is now more probable.

However, more precise attribution remains
difficult. Comparable images come from the Bongo
of southern Sudan, while grave figures in post form
occur in Ethiopia and among the coastal Bantu of
East Africa. Nyamwezi carvings (which include those
formerly attributed to the Kerebe, inhabitants of an
island in Lake Victoria; see Hartwig, 1969: 85-102)
offer some similarities. In Kenya, the Giriama carved
anthropomorphic memorial planks deriving from
earlier Mijikenda memorial posts; the Zaramo of
Tanzania produced realistic articulated grave figures.
The form of the post, with octagonal-section top
tapering to an eroded base, and the transverse
grooves (which could be in imitation of lathe-turning)
may reflect Arab or Swahili-Arab influence, which
would make somewhere in the coastal Bantu area of
southern Tanzania a likely place of origin.

The two large iron nails driven into either side of
the upper part of the post, which may have served
to suspend offerings, are hand-made. Since machine-
made nails were first developed in the nineteenth
century the piece could date to that period, or even
earlier.

Provenance: Formerly in the collection of James
Hooper.

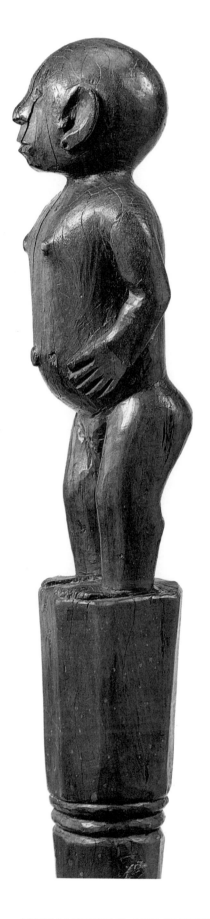

North America

North America

by Steven Hooper

Although there was never an intention on the part of the Sainsburys to form a North American 'collection', works of art from Alaska and the Northwest Coast are well represented in this section, together with a number of pieces from other areas, most notably from the Southeast. The emphasis is again on sculpture, for which, along with textiles, the indigenous peoples of North America are justly renowned. The author wishes to express his gratitude to Dorothy Jean Ray and Bill Holm, for their valuable comments on several of the Eskimo and Northwest Coast pieces respectively.

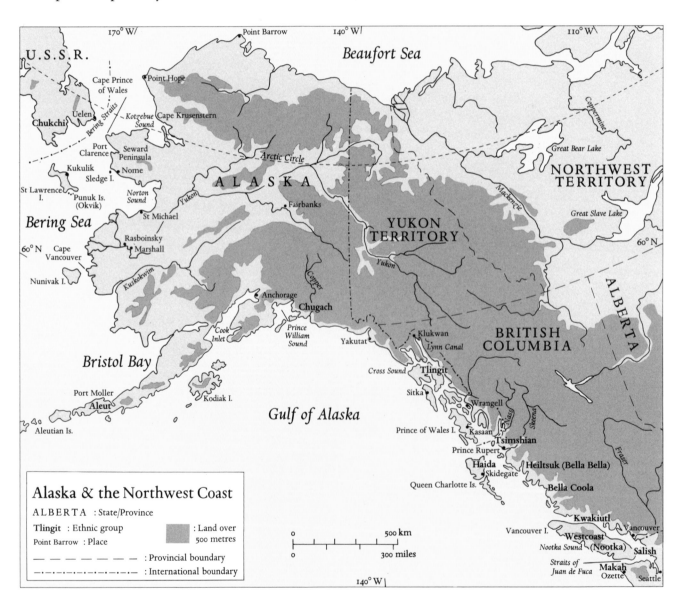

Alaska & the Northwest Coast

ALBERTA : State/Province

Tlingit : Ethnic group

Point Barrow : Place

: Land over 500 metres

— — — — — — : Provincial boundary

—·—·—·—·— : International boundary

Point Barrow

Yukon

Alaska

Mackenzie

Northwest Coast

Washington

Wishram Wasco

Columbia

Oregon

Pacific Ocean

Nevada

Utah

Colorado

California

30° N

Chumash

Santa Catalina

Arizona

Zuni

New Mexico

Kansas

Texas

Oklahoma

Spiro

Ark.

La.

Thule

GREENLAND

Arctic Circle

Ammassalik

Iglulik

Baffin I.

Cumberland Sound

Great Bear Lake

Southampton I.

Cape Dorset

Great Slave Lake

Hudson Bay

L. Athabasca

Labrador

C A N A D A

Cree

L. Winnipeg

Plains Ojibway

Red River Cree

Ojibway (Chippewa)

L. Superior

L. Huron

L. Michigan

L. Ontario

Iroquois

L. Erie

P l a i n s U. S. A.

Missouri

Missouri

Kentucky

Virginia

Tennessee

N. Carolina

Etowah

S. Carolina

Mississippi

Miss.

Moundville

Georgia

Alabama

Florida

Fort Centre

Atlantic Ocean

30° N

MEXICO

Gulf of Mexico

CUBA

North America

Alaska : State

Chumash : Ethnic group

Point Barrow : Place

: Land over 500 metres

—·—·—·—·—·—·— : International boundary

100° W

100° W

Prehistoric Eskimo

Archaeologists have developed a profusion of terms to designate various prehistoric Eskimo sites, styles, cultures and phases. The practice of naming a style (and then a culture and period) after the site where artefacts of that distinctive type have been discovered has often compounded the confusion. Thus, 'Okvik' material is named after a site on the Punuk Islands, just off St Lawrence Island, whereas 'Punuk' material is later and distinctly different, though also named because of its discovery at a site on the Punuk Islands. Further difficulty is caused by changes in nomenclature as a result of disagreement or continuing research. A brief historical résumé will therefore be given here.

The first datable evidence of occupation of the Bering Sea area is around 2500 BC, though human occupation doubtless goes back several millennia further. By about the beginning of the Christian era a number of distinct early Eskimo groups, with their ultimate ancestry in north-east Asia, had established themselves in the region. 'Old Bering Sea' and 'Ipiutak' (see Wardwell, 1986) are examples of these early Eskimo cultures (the designation of a culture being based on evidence provided by artefact types and art styles). They had developed the toggle harpoon, efficient for walrus and seal hunting, but they do not seem to have had knowledge of metal. Okvik is an alternative name for the first of the three phases of Old Bering Sea culture.

During the first millennium AD the artefact record changes, possibly as a result of local developments or of further migrations from north-east Asia, or a combination of both. These Punuk people (named after a site on the islets of that name) were expert whale hunters who had metal tools and more refined hunting equipment, though, as far as we can judge,

a less elaborate art tradition. After about AD 1000 there was a steady movement of people eastwards from Alaska as far as Angmassalik on the east coast of Greenland. The culture of these people has been called 'Thule', after the type-site in north-west Greenland. On their way through what is now arctic Canada they displaced the 'Dorset' Eskimo people (named after the type-site at Cape Dorset on Baffin Island), who are known to have inhabited the region since the middle of the first millennium BC. Thus, by the nineteenth century, these Thule people, sharing a common language (Inupiak), inhabited the Arctic from the Bering Straits to east Greenland. The Eskimo inhabitants of south-west Alaska, around the lower Yukon and Kuskokwim rivers, speak a different language (Yupik) from the Thule peoples, and are thought possibly to be descended from the Old Bering Sea peoples, with whom they share an elaborate curvilinear engraving style.

The dating and attribution of much prehistoric Eskimo material (i.e. predating the late eighteenth century, when European contact and trading became regular) presents many difficulties; collection or excavation data are usually absent, and stylistic comparisons with the limited amount of published material are hazardous. A body of documented material exists for the Old Bering Sea and Punuk periods, and is useful for comparative purposes, but documented prehistoric art from areas other than the Bering Sea region is limited. The dating of many objects in this section has for this reason been left imprecise. The term Eskimo derives originally from a Cree word meaning 'eaters of raw flesh'. It has been adopted by most 'Eskimos' except those from northern Canada, who prefer the Inupiak term Inuit, meaning people.

Bering Sea: Okvik style

Figure
Old Bering Sea I; *c.* 200 BC – AD 100
Walrus ivory
h. 5⅞ in (14.9 cm)
Acquired 1977 RLS I

During the course of this century a number of ancient walrus ivory sculptures from St Lawrence Island and adjacent islands in the Bering Sea have come to light, the result of both scientific and uncontrolled excavations. Pioneering research in the area by Collins (1929, 1939) has led to the identification of several phases in the prehistoric period, which are succinctly outlined and illustrated by Wardwell (1986).

Foremost among the distinctive and beautiful sculptures from the earliest phase (Old Bering Sea I, also known as Okvik) are walrus ivory figurines, of which this is a complete and fine example. A number of figures in this style were found at a site called Okvik on one of the Punuk islets, off the south-east coast of St Lawrence Island, a name which Rainey (1941: 46) translates as the 'place where many walrus haul up'. Okvik ivories are very often a rich brown or black colour, possibly the result of age and prolonged contact with organic material.

The pointed head, arching brows and long nose are characteristic Okvik style traits. Limbs are seldom represented. Collins distinguishes three substyles (A-C) within the general Okvik style; the present figure with its curvilinear engraving corresponds to substyle B (see Collins *et al.*, 1973: 3-5; Wardwell, 1986: nos. 31, 37). Neither the sex of the figure nor the meaning of the engraved designs is clear, though it is possible that the arms, legs and genitals of a female are represented on the front.

The significance and function of these prehistoric figurines is not known, though historic carvings of heads and torsos are usually interpreted as spirit images used in shamanic rituals, or as dolls with no specific ritual importance. The former attribution is more likely in the case of these figurines, since in this pre-metal culture considerable time and expertise

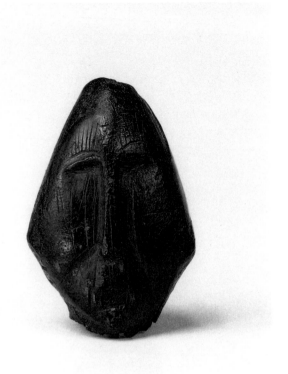

Bering Sea: Okvik style

Head
Old Bering Sea I; *c.* 200 BC – AD 100
Walrus ivory
h. 3 in (7.6 cm)
Acquired 1976 UEA 665

This deep brown walrus ivory head is almost certainly
from a figure similar to no. 176 (RLS 1), and the same
general remarks made about that piece also apply to
this one. This is more weathered and the features are
not so finely finished, but the eyebrows are clearly
marked. It was carved from the wide base of the tusk;
two pieces of the outer ivory have split away from
the tusk core and have been glued back by a former
owner.

would have been required to make them with flint
and slate tools.

The form follows the natural shape of the walrus
tusk from which it is carved. The walrus, with its
highly developed upper canines (present in both bulls
and cows), was of great importance to Old Bering
Sea peoples as a source of food, skin, ivory and bone.
Techniques for hunting whales, characteristic of
Punuk and later Thule peoples, had not been devel-
oped by the Old Bering Sea people. Walrus tusk can
readily be distinguished from ordinary walrus teeth,
sperm whale teeth, ancient mammoth tusk and other
mammal teeth by the darker 'bubbled' core which
runs down the centre.

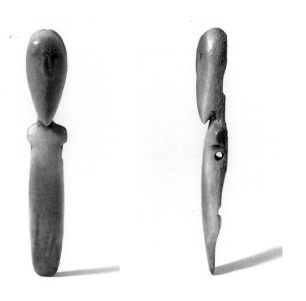

178

Bering Sea: Okvik style

Figurine
Old Bering Sea I; *c.* 200 BC – AD 100
Antler or bone
h. 2½ in (6.3 cm)
Acquired 1976 UEA 403

This small figure could have functioned as a cleat
on a boat or as a charm of the kind used later by the
Aleuts (see no. 226, UEA 666). It has two holes drilled
across the back of the body, the lower one now
broken. In simplicity of treatment it resembles a
figure illustrated by Collins *et al.* (1973: 4), having a
typically long Okvik face, though the nose is short.
The material, eroded and fibrous at the back, could
be caribou antler or bone.

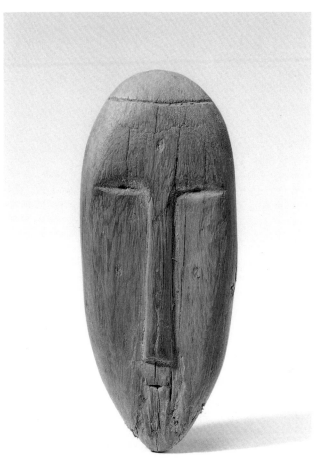

179

Bering Sea: Okvik style

Maskette
Old Bering Sea I; *c.* 200 BC – AD 100
Wood
h. 4¾ in (12.1 cm)
Acquired 1982 UEA 843

This maskette is given an Okvik attribution on
stylistic grounds, the long oval face, long nose and
diminutive mouth all being characteristic features.
The head is thin and the back flat, though it has
warped slightly. As there appears to be no break at
the neck it is probable that it was originally intended
to be attached to a costume or other artefact. Small
perforations at each side would have been for this
purpose. The holes for inlay on the forehead and
cheeks may represent tattoos.

Comparisons with the work of Modigliani are im-
mediately brought to mind when considering Okvik
heads, although there is no evidence to suggest that
the artist ever saw Okvik sculptures.

Bering Sea: Okvik style

Figure
Old Bering Sea I; *c.* 200 BC – AD 100
Wood
h. 11¼ in (28.6 cm)
Acquired 1984 UEA 879

Rainey (1941: fig. 28, 7) illustrates a comparable wood image which was excavated at the Okvik site on the Punuk Islands. The completely plain treatment of the body suggests that such figures were originally clothed, as were many nineteenth-century Alaskan images. The arched lines across the brow, possibly indicating age or tattoos, also appear on a mask found on St Lawrence Island in the 1880s (Fitzhugh and Kaplan, 1982: 228).

This example has been crushed and bent at the neck, and a vertical break down the centre has been repaired by a previous owner. Whether the curve in the figure is intentional (perhaps in imitation of walrus ivory images), or whether it is the result of having been crushed for a long period, is not clear.

Wooden items are currently rarer than ivory ones, though excavations, both controlled and otherwise, in frozen house foundations have uncovered many wood objects in a good state of preservation. Trees do not grow on the Bering Sea coast and islands, but logs of spruce, birch and poplar are carried down the main Alaskan rivers into the Bering Sea from the forested interior during the summer thaw. This driftwood provided the coastal and island Eskimo with valuable timber for boats, houses and ritual equipment such as masks and figures.

181

Bering Sea: Okvik style

Miniature mask
Old Bering Sea I; *c.* 200 BC – AD 100
Wood
h. 1¾ in (4.5 cm)
Acquired 1983 UEA 429

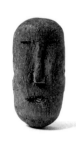

This tiny maskette is tentatively ascribed to the Okvik style. It is hollowed at the back and has a small hole at each side (now broken), perhaps for attachment to a costume or a doll.

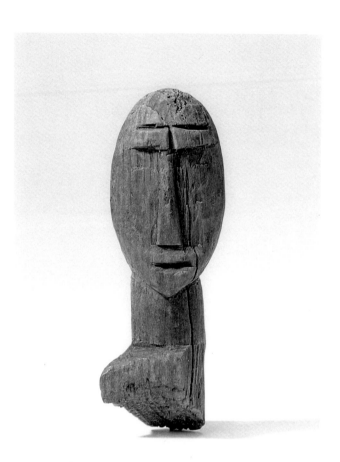

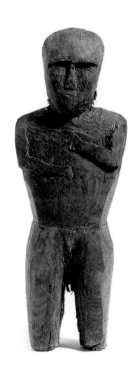

182

Bering Sea

Figure
(?) Old Bering Sea; *c.* 200 BC – AD 500
Wood
h. 3⅜ in (8.5 cm)
Acquired 1982 UEA 844

This figure is without provenance, but the arm position and head suggest that it dates back to Old Bering Sea times. The feet may have been cut off, although later figures from Greenland have this truncated leg form.

183

Bering Sea: Okvik style

Head
Old Bering Sea I; 200 BC – AD 100
Wood
h. 3⅝ in (9.2 cm)
Acquired 1983 UEA 863

This small head is also described as Okvik on stylistic grounds. Whether it was once part of a figure similar to no. 180 (UEA 879) is not clear, since the angled cut below the shoulder may be original, rather than later damage. The head has been crushed, resulting in a long vertical crack and loss of the left shoulder. The number A292 appears in black ink on a small white label on the back.

184

Bering Sea

Figure
Old Bering Sea II-III; *c.* AD 100 – 500
Walrus ivory
h. 6½ in (16.5 cm)
Acquired 1952 UEA 105

The chronological and stylistic attribution of this ancient ivory sculpture is uncertain, though the schematic face and positioning of the arms across the body are characteristic of ivory images ascribed by Wardwell (1986: nos. 58-61, 115) to the second or third Old Bering Sea phases. In these periods the full sculpting of the legs was more common than in the preceding Okvik phase.

The figure, of indeterminate sex, is weathered and pitted, probably as a result of frost-thaw action, and has acquired a rich mottled brown patina. The left leg is broken below the knee; the back is flat. Despite the weathering, or perhaps because of it, the face is particularly expressive. The number 1636 is painted in white on the back of the surviving leg.

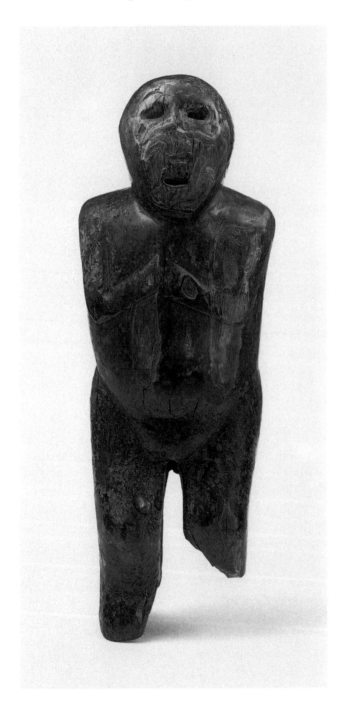

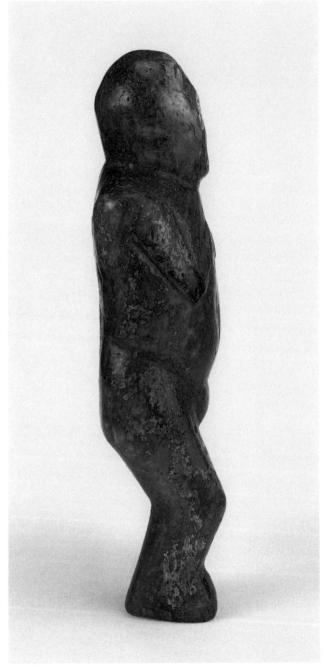

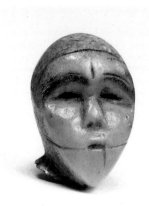

185

Bering Sea: Punuk Islands

Head
(?) Old Bering Sea II; *c.* AD 100 – 300
Walrus ivory
h. $1\frac{1}{2}$ in (3.8 cm)
Acquired 1979 UEA 721

This head is attributed to Old Bering Sea II, though it
could be slightly later (see Wardwell, 1986: nos. 58,
65, 67). It is almost certainly from a figure, as portions
of the shoulders remain above the break point. Tattoo
marks are indicated on the forehead and cheeks. The
colour is creamy brown, with traces of reddish stains
beneath the eyebrow lines.

Provenance: Reported by the vendor to have been
found on the Punuk Islands in 1979.

186

Bering Sea, St Lawrence Island, Kukulik

Handle with human head
Old Bering Sea II; *c.* AD 100 – 300
Walrus ivory
h. $6\frac{3}{8}$ in (16.2 cm)
Acquired 1979 UEA 720

This object, pitted and flaked by weathering, has been
ascribed to the Old Bering Sea II phase by Wardwell
(1986: no. 62). It may have been the handle for a drum,
ancestral to known nineteenth-century ivory handles
which were attached to tambourine-like drums of
wood and animal skin.
 The back of the head is flat, and the recess below
it is positioned opposite the rectangular aperture

beneath the chin. The circular hole at the end may
have been for ivory links or other ornamental attach-
ments. Three horizontal lines are engraved across
each cheek, probably representing tattoos. The colour
is a dark chocolate brown.

Provenance: Reported by the vendor to have been
found at Kukulik, St Lawrence Island, in 1979.

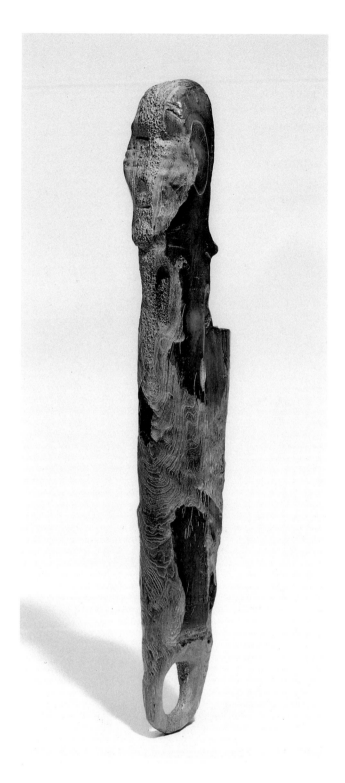

187

Bering Sea

Figure with head missing
Punuk; *c.* AD 500 – 1200
Walrus ivory
h. 7⅞ in (19.7 cm)
Acquired 1979 UEA 730

The shortened arms held at the sides suggest that this large figure is of Punuk origin. In its uprightness and simple, block-like treatment the sculptor has achieved a 'monumental' effect belied by the figure's actual size. Two small holes have been drilled at the navel and there is a further hole beneath each breast. The slightly swelling breasts and abdomen, with the genital cavity, indicate a female is represented.

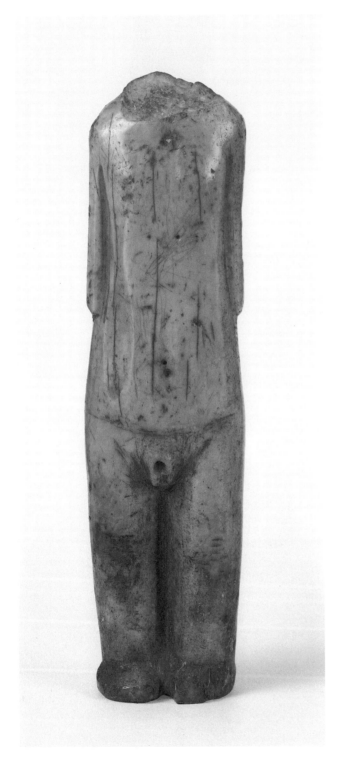
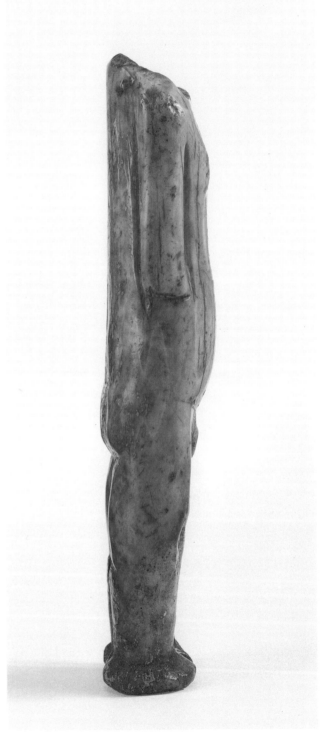

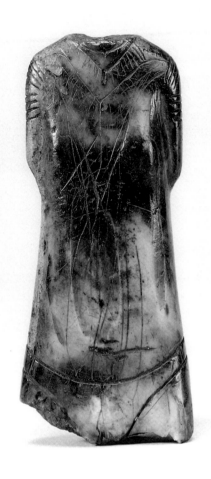

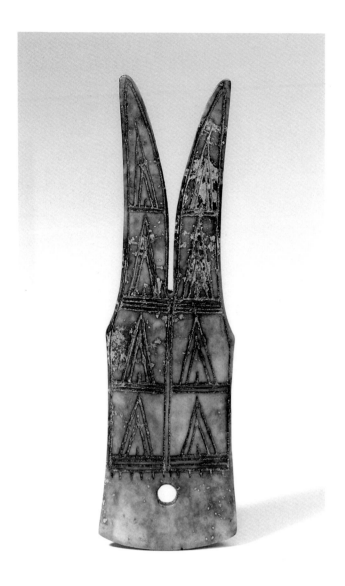

188

Bering Sea

Torso
Punuk; *c.* AD 500 – 1200
Walrus ivory
h. 4 in (10.2 cm)
Acquired 1983 UEA 877

This torso shows the shortened arms, close against
the body, typical of many Punuk images. The slightly
swelling abdomen suggests the figure is female. It is
engraved with a necklace and four bands across each
arm and shoulder. The head was certainly broken off
when the figure was still in use, since an ivory peg
set into the break and a repair hole at the back of the
neck show how the damaged head was once reattached.
There is a deep-drilled circular pit in the lower part
of the back, purpose unknown.

189

Bering Sea

Forked attachment
Punuk; *c.* AD 500 – 1200
Walrus ivory
h. 4¼ in (10.8 cm)
Acquired 1982 UEA 846

An enigmatic object with linear engraving on one side,
this flat ivory plaque may have been part of some
ritual object, since it is not suitable as the handle for
a tool, nor does it show any signs of use around the
points or in the central crevice. The shape calls to
mind a stylised walrus head, so it may have been used
in ritual connected with walrus hunting. Traces of red
pigmentation remain in the engraving. The 'walrus
tusk' motif also occurs on Punuk wrist guards (see
Wardwell, 1986: 105).

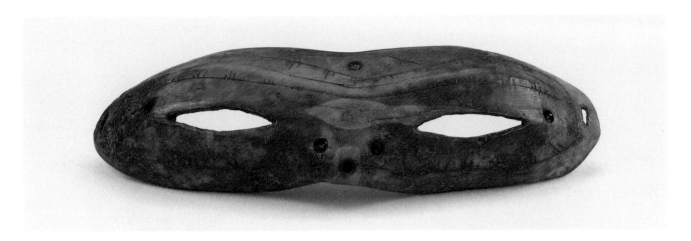

190

Bering Sea

Snow goggles
Punuk; *c*. AD 500 – 1200
Walrus ivory
l. 5⅛ in (13.1 cm)
Acquired 1982 UEA 830

Snow blindness, caused by excessive ultraviolet light, is a painful and debilitating condition, and in fine weather the combination of sun and ice produces a powerful glare against which the eyes of the Eskimo traveller or hunter have to be protected. Before the twentieth-century introduction of sunglasses, snow goggles with small slits provided remarkably good vision, especially on the horizontal plane, while deflecting much of the harmful glare. Engraved ivory examples are rare and this one is attributed by Wardwell (1986: no. 137) to the Punuk period. Most nineteenth-century examples are made of wood.

Six small holes around the eyes were for inlay of tiny pebbles; the three around the bridge of the nose have been interpreted as an animal face, possibly a fox. There is a rectangular hole at each end for attaching a headband.

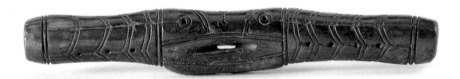

191

Bering Sea, Punuk Islands

Bag fastener (?)
Punuk; *c*. AD 500 – 1200
Walrus ivory
l. 4⅜ in (11.1 cm)
Acquired 1979 UEA 723

Although described as a needle case by Wardwell (1986: no. 145), this ivory cylinder is in fact solid and was most likely used as a fastener for a bag. Important sewing equipment was kept securely in a workbag or 'housewife'; nineteenth-century examples possess a large flap in which they were rolled, and then bound by a thong with a fastener of this kind at the end (see Fitzhugh and Kaplan, 1982: 132-3).

The engraving suggests two opposed animal heads, joined at the nose. The depth and precision of the engraving indicates the use of metal tools, which are known to have been available to Punuk craftsmen, since a number of iron-tipped engraving tools have been found at Punuk sites (Collins *et al.*, 1973: 30).

Provenance: Reported by the vendor to have been found on the Punuk Islands in 1979.

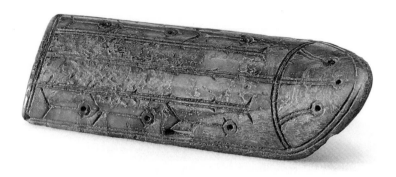

192

Bering Sea

Wrist guard
Punuk; *c.* AD 500 – 1200
Walrus ivory
l. 3⅝ in (9.2 cm)
Acquired 1982 UEA 832

During the Punuk period special wrist guards, or bracers, began to be used (possibly an introduction from north-east Asia; see Wardwell, 1986: 22) to protect the archer's wrist and the base of the thumb from the slap of the bow string when an arrow was released. This dark ivory example, deeply engraved with typical Punuk designs, has a concave inner surface which curves upwards to cover the base of the thumb. Rectangular holes on either side are for the wristband, now lost, and there are two tiny holes at each corner, possibly for an additional sinew wrist cord (see Collins *et al.*, 1973: 32, for related examples).

After the harpoon, the bow was the Eskimo's most important hunting weapon, especially for caribou. Bows were of driftwood, sometimes combined with bone and ivory; arrows were of wood, with feather flights and stone, bone or antler points.

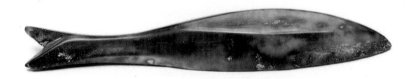

193

Bering Sea

Fish or whale ornament
Punuk; *c.* AD 500 – 1200
Walrus ivory
l. 4¾ in (11.1 cm)
Acquired 1979 UEA 735

The underside of the body of this fish or whale image is plain and slightly concave, with two pairs of holes forming attachment points for thongs. They do not seem sufficiently robust to withstand heavy pressure, so the piece probably served an ornamental rather than a directly practical function. The tail, more fish-like than whale-like, is carved in the round and may have projected from the object to which the fish was originally attached. 'Punuk' has been written in pencil beneath the head by a previous owner.

194

Bering Sea

Handle (?)
Punuk; *c.* AD 500 – 1200
Walrus ivory
h. 6⅛ in (15.6 cm)
Acquired 1982 UEA 845

A number of objects of this kind have come to light, but as yet their function has not been determined. This spear-head shaped implement has a plain, slightly concave back and may have been a handle for a tool, or possibly even a tool itself. Wardwell (1986: 103) refers to it as a handle; it could also have been a decorative attachment for a ritual object. The ivory is blackened and the engraving crisp and deep.

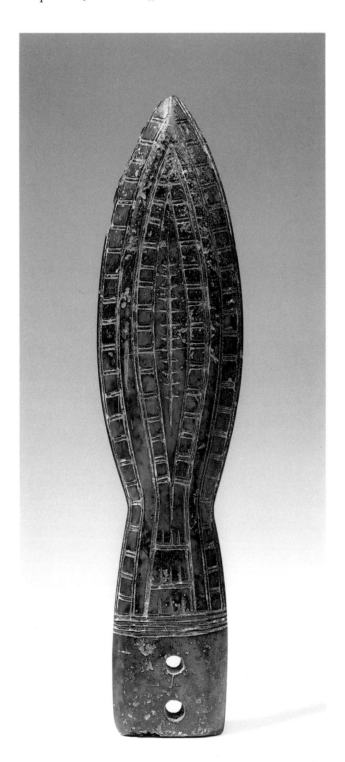

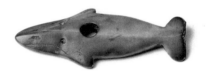

195

Alaska, Cape Prince of Wales

Miniature whale
Punuk; *c.* AD 500 – 1200
Walrus ivory
l. 1¾ in (4.5 cm)
Acquired 1979 UEA 722

Bowhead whales, which this miniature appears to represent, have been important quarry since Punuk times around the Bering Straits and along the north Alaskan coast. A Punuk attribution is suggested here. The details of eyes, mouth and double blow-hole are carefully rendered; the underside is plain.

Animals, important in myths and as a source of food and raw materials, have always been favoured subjects for Eskimo artists; carvings were attached to hunting equipment or ritual objects. Our knowledge of prehistoric ritual activity is very limited, though in the nineteenth century many rituals were directed at placating animal spirits for past catches and assuring a plentiful supply of game in the future.

Provenance: Reported by the vendor to have been found at Cape Prince of Wales, Bering Strait, in 1979.

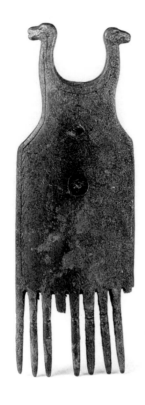

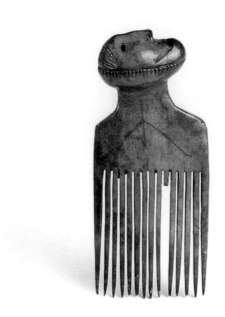

196

Alaska

Comb with two animal heads
18th century or earlier
Antler
h. $3\frac{5}{8}$ in (9.2 cm)
Acquired 1980 UEA 717

This comb has a pair of animal heads surmounting
the handle; the species is not identifiable. The shallow
engraving appears on one side only and the two
recesses were almost certainly for large beads, now
lost. It is comparable to a comb collected by Nelson
on Sledge Island, off the coast of western Alaska (see
Fitzhugh and Kaplan, 1982: 145). However, although
Nelson collected his material between 1877 and 1881,
a number of the objects, probably including the comb,
were archaeological material predating the nineteenth
century, which the local Eskimo had found in pre-
historic house foundations.

197

Alaska (?)

Comb with human head
18th century or earlier
Antler
h. $2\frac{5}{8}$ in (6.7 cm)
Acquired 1980 UEA 734

The expressive head on the handle of this comb has
engraved hair, cheek tattoos and a notched line round
the face which may represent the edge of a parka
hood. The eyes, nostrils and mouth are deeply drilled
and the squared spaces between the tines suggest
that a metal saw blade was used to cut them. The
engraving on the handle appears on one side only.
Metal tools were obtained by the Eskimo from Asian
sources long before the arrival of Europeans in the
Arctic, though use of a saw blade in the manufacture
of this comb suggests that it was made later in the
prehistoric period.

198

Alaska (?)

Comb with caribou image
18th century or earlier
Walrus ivory
h. 3 in (7.6 cm)
Acquired 1980 UEA 733

The top of this weathered ivory comb appears to
represent a young caribou without antlers. It has a
slightly concave back and a simple engraved design
on both sides. The small eyes are deeply drilled; four
of the twelve tines are missing. Although its age is
not known, it is likely to be of considerable antiquity.

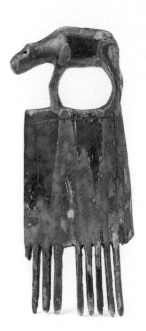

199

Alaska (?)

Handle for cord drill (?)
18th century or earlier
Walrus ivory
l. 4⅝ in (11.7 cm)
Acquired 1980 UEA 738

This carving could possibly be the handle for a seal
drag (a thong for dragging the dead animal across the
ice), but is more likely one of the handles for a cord
drill. Related examples are illustrated by Murdoch

(1892: fig. 158). The cord drill, an alternative to the
bow drill (see no. 219, UEA 661), was used south of
the Yukon river. A cord was looped round the drill
shaft and pulled backwards and forwards by means
of handles of this kind, thus rotating the shaft at high
speed. Downward pressure on the shaft was achieved
by a mouthpiece, gripped between the teeth.

The animal heads may represent caribou without
antlers, or bears. The eyes are inlaid with wood plugs;
the central aperture is broken at the back. Although
the simple engraving has some Punuk characteristics,
the piece is probably from later in the prehistoric
period.

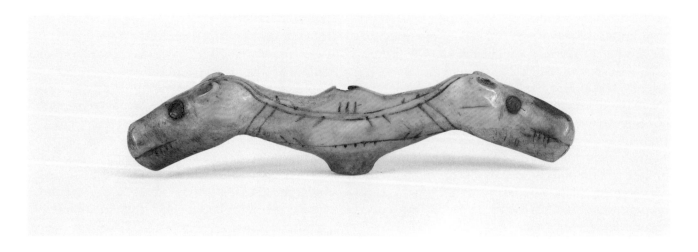

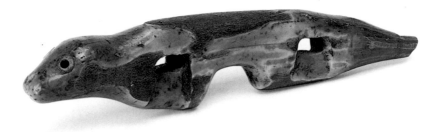

200

Alaska

Seal attachment
18th century or earlier
Walrus ivory
l. 4¼ in (10.9 cm)
Acquired 1980 UEA 739

The purpose of this attachment is not known, though it was clearly meant to be bound and fitted to a larger object, possibly a kayak. The rich brown ivory has glossy and matt surfaces, the matt area on the seal's back being carved in the shape of a baby seal riding on its back. The baby's tiny eyes are deeply drilled. The eyes of the main seal are inlaid with ivory rings, the pupils of which are missing.

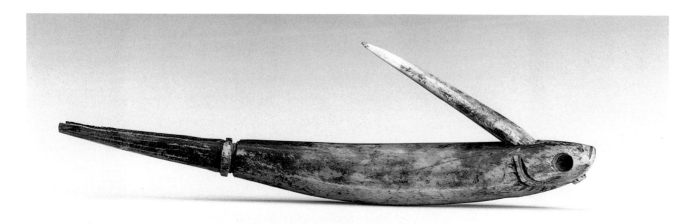

201

Western Alaska

Fish hook
13th/14th century
Walrus ivory
l. 5¾ in (14.6 cm)
Acquired 1980 UEA 736

The shank of this lure hook represents the body of a fish with small mouth and prominent gills. The tail is grooved longitudinally to receive the snood binding for the line; the holes for eyes and point are straight drilled. This example closely resembles an antler hook illustrated by Giddings (1968: pl. 31), which was found at Cape Krusenstern in Kotzebue Sound and is dated to *c.* AD 1300. Lure hooks were used for autumn and winter fishing through holes in the ice. The point seems of more recent manufacture than the shank, and may be a replacement.

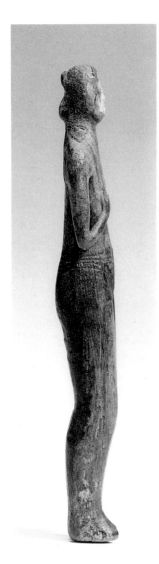 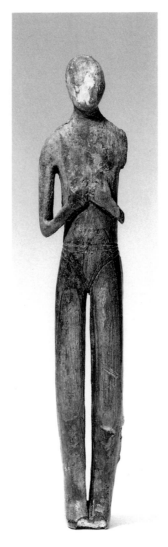 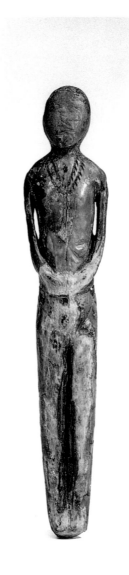 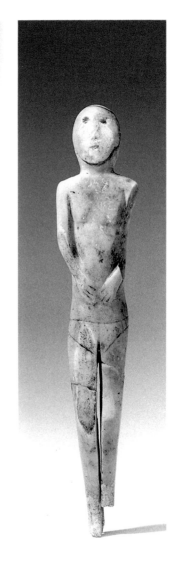

202

Alaska

Standing figure
18th century or earlier
Walrus ivory
h. 5 in (12.7 cm)
Acquired 1974 UEA 591A

This figure has a grey-brown patina and is severely
weathered about the face. It is finely engraved with a
double necklace (with small triangular pendants) and
double lines around the hips; a double chignon is
visible at the back of the head. The massive solidity
of the legs can be seen in the profile view. Despite an
appearance of great antiquity, the squared groove
between the legs seems to be the work of a metal
saw blade, placing the figure later in the prehistoric
period.

203-204

Alaska

Two standing figures
18th century or earlier
Walrus ivory
h. 4¾ in (12.1 cm); 4½ in (11.4 cm)
Acquired 1980, 1974 UEA 724, 591B

These figures are stylistically related, though no. 203
is weathered and probably older. Both have a groove
around the face, suggesting they were originally
clothed as dolls with a parka hood tied round the
head. No. 204 has a small double chignon at the back
of the head, similar to no. 202 (UEA 591A), and the legs
have been broken and repaired.

Provenance: No. 203 was reported by the vendor to
have been found on the Seward Peninsula in 1979.

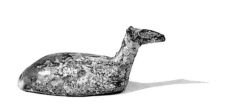

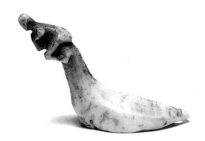

205-206

205-206

Arctic region

Gaming pieces
18th century or earlier
Mammal tooth
l. 1½ in (3.8 cm); 1⅞ in (4.8 cm)
Acquired 1983, 1960 UEA 433, 118

Images of swimming birds, some with human faces, have been found from the Bering Sea to Greenland, and date from prehistoric times to the nineteenth century. They are reported to have been used as toys, shamanic amulets and gaming dice. Referring to examples from northern Canada, Boas (1888: 567) noted: 'A game similar to dice, called tingmiujang – i.e. images of birds – is frequently played. A set of about fifteen figures . . . belongs to this game; some representing birds, others men and women . . . the figures are shaken in the hand and thrown upward. On falling, some stand upright, others lie flat on the

back or on the side. Those standing upright belong to that player whom they face . . . The players throw by turns until the last figure is taken up, the one getting the greatest number of figures being the winner.'

These specimens are carved from mammal teeth, possibly walrus (not tusk), and are pierced at the back. Bandi (1977: pls. 56-7) illustrates numerous birds similar to no. 205 from St Lawrence Island. No. 206 is a rare form in which the head of the bird becomes a human carrying a child on its back.

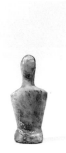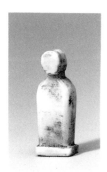

208-210 (*above*)

Bering Sea

Three miniature effigies
18th century or earlier
Walrus ivory, mammal tooth
h. 1⅞ in (4.7 cm); 1 in (2.5 cm); 1⅜ in (3.5 cm)
Acquired 1986, 1980, 1970 UEA 430, 431, 404

Numbers of these miniature figurines have been found in prehistoric sites on St Lawrence Island and neighbouring areas (see Bandi, 1977: pls. 54-5, who attributes them to later in the prehistoric era). Their former use is not known. No. 208 is of walrus ivory and is female; it has a small depression bored in the base. No. 209 is carved from a mammal tooth, possibly walrus or beluga (white whale), and no. 210, also of mammal tooth, is so well preserved that it may not have the same age as the others.

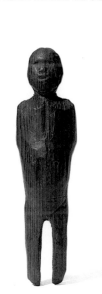

207

Alaska (?)

Standing figure
18th century or earlier
Wood
h. 3 in (7.6 cm)
Acquired 1980 UEA 718

The origin and age of this figure are not known; a groove around the head was probably for a parka.

Historic Eskimo

The distinction between prehistoric and historic Eskimo material is an arbitrary and imprecise one, created by Europeans to facilitate description and classification. Historic cultures are those about which some written records exist – which have a recorded history in the European sense. Thus the terms roughly correspond to pre-contact and post-contact (again imprecise terms), contact being a process which in Alaska is considered to have taken place during the second half of the eighteenth century, when Asian and European ships began regularly to visit the Alaskan coast.

The historic material in this section is mostly nineteenth century, deriving from Eskimo peoples about whom we have information as a result of the reports of explorers, traders, officials and academic researchers. Some material may be older, and this is noted in the caption.

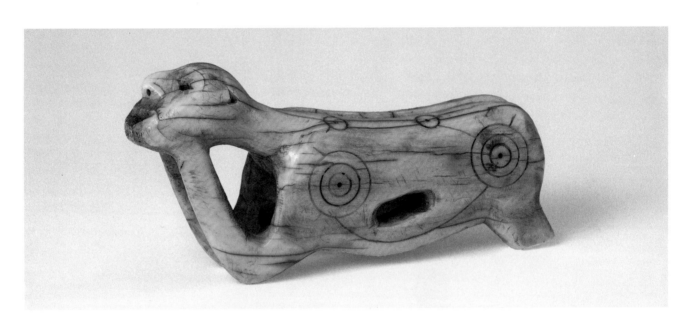

211

Alaska

Crouching figure
19th century
Walrus ivory
l. 4⅝ in (11.7 cm)
Acquired 1961 UEA 106

The linked ring-and-dot engraving and the form of the face place the origin of this piece somewhere in the Yukon-Kuskokwim delta area, perhaps Nunivak Island, where a belt ornament with similar features was collected by Nelson (Fitzhugh and Kaplan, 1982:

fig. 241). The function of this object is less easy to determine. The body has been hollowed, and the spaces between the limbs cleared, by a series of wide-gauge drill holes. Transverse perforations, not aligned, pierce the sides of the body. They were doubtless for bindings, and the comfortable way in which the figure fits the grip of a small hand suggests that it is the handle of a large knife or other implement, though the form is atypical.

Part human, part animal (caribou?), the figure could represent a transformed shaman or an *inua* spirit (*ibid.*: 14). The mouth is pierced and there are drill holes for ears and nostrils. The engraved designs are the same on both sides.

212

Alaska, Point Hope (?)

Scraper handle
19th century
Mammoth ivory
l. 4⅜ in (11.1 cm)
Acquired 1985 UEA 918

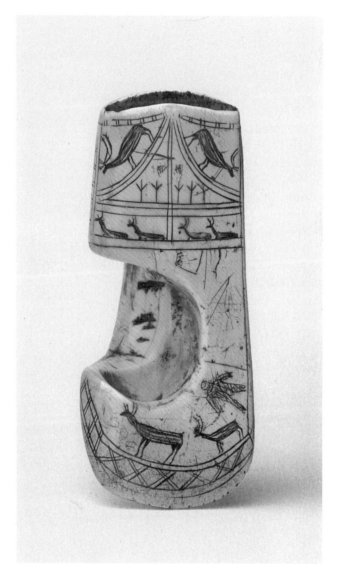

The proper preparation of animal skins was essential
to the effectiveness of clothing and boats in the Arctic.
Women were responsible for this work, and around
the Bering Strait and along the north Alaskan coast
they used special scrapers whose handles were shaped
to fit the fingers of their working hand. A stone blade,
missing here, was set into the recess. Most scraper
handles are of wood, but this example, for a right-
handed woman, is carved from mammoth ivory.
Even more rare is the engraving depicting caribou
and a figure; caribou are appropriate since they
provided skins for the best clothing.

Mammoth ivory, sometimes referred to as fossil
ivory (though it was not strictly fossilised, just pre-
served in the Arctic permafrost), can be identified by
its resemblance to contemporary elephant ivory,
having a criss-cross appearance in section, quite
different from walrus ivory with its 'bubbled' core.
The remains of woolly mammoths dating from the
last Ice Age were found in eroded river banks. Their
tusks, far greater in diameter than those of the
walrus, were especially suitable for scraper handles
and ladles (see Fitzhugh and Kaplan, 1982: 41, 131-2).

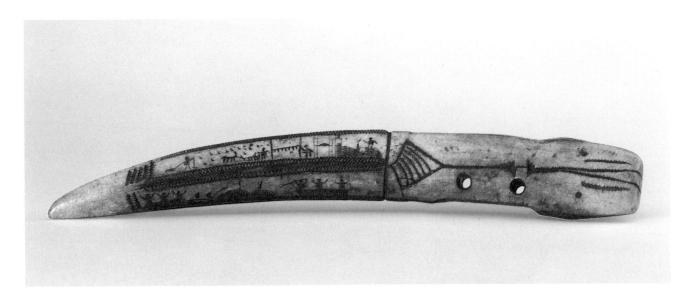

213

Alaska

Pick head
19th century
Walrus ivory, wood
l. $11\frac{7}{8}$ in (30.2 cm)
Acquired 1977 UEA 660

This walrus tusk pick was formerly bound to a wood handle with hide thongs through the two holes near the butt (see Nelson, 1899: pl. xxxv for complete examples). Picks were used for ice clearance around houses and for digging for roots in frozen soil.

This example, much darker on one side than the other, probably originates from the coastal region around the Bering Straits, as one of the four panels of engraving depicts a successful conclusion to a whale hunt. Whales are also cleverly incorporated into the design of the butt, where two complete bowhead whales are shown, their flukes ending where the panels of engraving begin. The depiction of whales was most common among the Eskimo around the Bering Straits and along the north Alaskan coast, where whaling predominated over other hunting.

The four panels of engraving, each separated by a notched groove, show animated hunting scenes with whale, walrus and bear, as well as domestic activities around a house, with fish drying on a rack and a dog pulling a sledge. Houses in coastal Alaska were permanent constructions of wood and turf, not the ice-block igloo, which was restricted to the Eskimo of the Canadian Arctic.

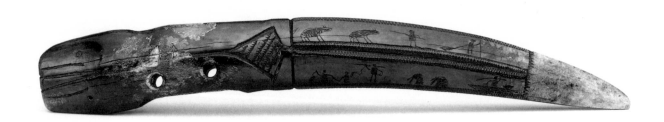

214

Alaska

Toggling harpoon head
19th century
Walrus ivory, antler, skin, wood, sinew
l. 13½ in (34.3 cm); socketpiece l. 8⅞ in (22.5 cm)
Acquired 1977 UEA 664

This is a complete assembly for a toggling harpoon,
lacking only the point. It is composed of a long walrus
ivory socketpiece into which is socketed a plain antler
foreshaft, which in turn is fitted into a barbed antler
head (lacking the metal or slate point).

The toggling harpoon was a sophisticated weapon
developed by the Eskimo for sea mammal hunting.
The socketpiece (formerly fixed to a wooden shaft)
lent weight to the impact of the harpoon, while the
slim foreshaft (secured to the line by a thong through
its central aperture) assisted deep penetration into
the seal, walrus or beluga (white whale). Once struck,
the animal's throes disengaged the harpoon and fore-
shaft from the barbed head, which remained firm in
the wound. The head was attached by a strong line to
an inflated sealskin float, which tired the animal

when it attempted to dive and escape. Toggling
harpoons of this kind were used for spring hunting
from kayaks in the offshore broken ice. A throwing
board was employed to provide extra impetus,
acting like an extension to the hunter's arm. In the
shallower waters off south-west Alaska smaller
mammals like seal and walrus were more important
than whales, which kept out to sea and were taken
more frequently around the Bering Straits and along
the north Alaskan shore (see Fitzhugh and Kaplan,
1982: 67-84 for further details).

The animal socketpiece on this example is very
similar to an example collected by Nelson on the
lower Kuskokwim river between 1877 and 1881 (1899:
pl. LIV, 8), which he describes as the conventionalised
form of a wolf. Wolves occur frequently in the myth-
ology and iconography of the Kuskokwim area, and
Fitzhugh and Kaplan (1982: 69) observe that 'socket-
pieces often display land or sea predators whose
cunningness is engaged spiritually to enhance the
hunter's success.'

Small wood plugs are set into the wolf's eyes,
nostrils, shoulders and hips. A tiny ivory disc remains
in the right eye. A former owner has glued the fore-
shaft into the head, no doubt to prevent its loss.

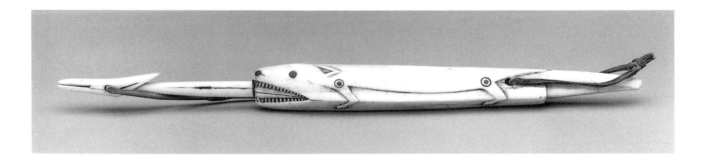

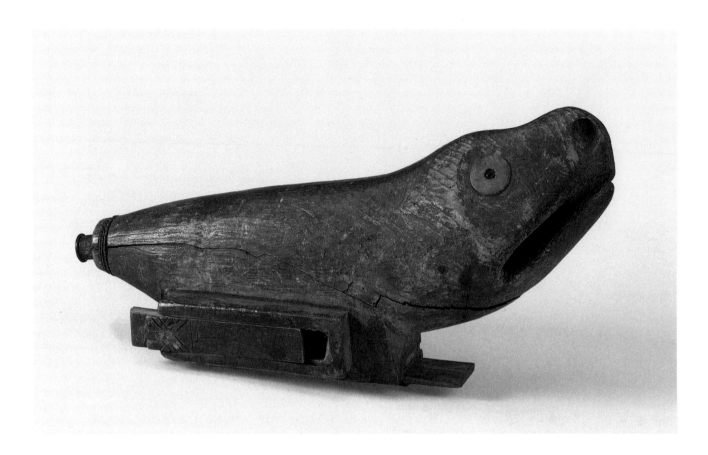

215

Alaska

Powder flask
19th century
Wood, metal, shell, bead, sinew
l. $11\frac{1}{2}$ in (29.2 cm)
Acquired 1985 UEA 916

Firearms were introduced to Alaska from Asia during the early nine-teenth century, and in due course the percussion mechanism superseded the flintlock. The Eskimo developed their own accessories in the form of powder flasks, percussion cap cases, bullet moulds, etc. (see Fitzhugh and Kaplan, 1982: 167).

Nelson collected a fine powder flask from Cape Vancouver in the form of a puffin's head, but this example surpasses even that in sculptural expression, suggesting as it does the dying throes of a stricken animal, probably a seal. The eyes are shell discs with bead pupils, and the flask is plugged with a cartridge case from a rifle bullet, which has traces of gunpowder inside and was used as a measure. Two small boxes with sliding lids (shown slightly open in the illustration) are incorporated into the block beneath the sculpture; these were for storing percussion caps or bullets (see VanStone, 1976: pls. 10, 25 for similar equipment). Traces of red paint remain around the animal's deeply chiselled mouth and the neck of the flask.

216 (*opposite*)

Alaska

Bowl as a seal
19th century
Wood, beads, fur
l. $11\frac{7}{8}$ in (30.2 cm)
Acquired 1984 UEA 893

This simple dish represents a seal, and has four pegs in its muzzle with traces of fur 'whiskers', and further pegs in the ears. The eyes are of blue beads and there is a shallow groove around the inside and outside of the rim. The base of the bowl is impregnated with oil, possibly from the seal, which was a major food resource for Eskimos south of the Bering Straits. The bowl probably originates from the same region as no. 217 (UEA 741), around Port Clarence, though it has affinities with seal bowls collected from southern Alaska (see King, 1981: 45).

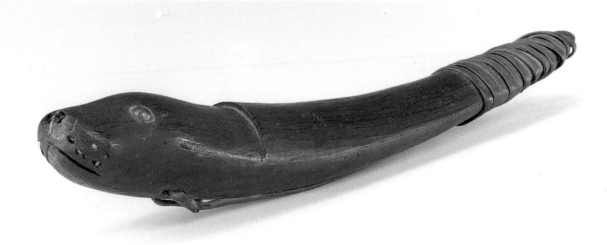

217

Alaska

Wound plug as a seal
19th century
Wood, bead, bone, fur, hide
l. 14⅛ in (35.9 cm)
Acquired 1979 UEA 741

Nelson (1899: 130-31) describes the use of wound plugs such as this in the following manner: 'During the winter and late in the fall seals are usually fat enough to float when killed in the water, but in spring, and sometimes at other seasons, they are so thin that they sink and the hunter loses them. To ensure their floating while being towed, it is a common practice to make slits in the skin at various points and, with a long pointed instrument of deerhorn, to loosen the blubber from the muscle for a space of a foot or more in diameter. Then, by use of a hollow tube, made from the wing-bone of a bird or from other material, air is blown in and the place inflated; wooden plugs are then inserted in the slits and driven in tightly to prevent the air from escaping. By the aid of several such inflated spots the seal is floated and the danger of losing it is avoided.' A very similar example was collected by Bruce in 1892/3 at Port Clarence (VanStone, 1976: 75), with a set of four smaller plain plugs hanging from the thong. This example has five holes on each cheek with remains of fur 'whiskers'. The eyes are blue beads set in bone surrounds.

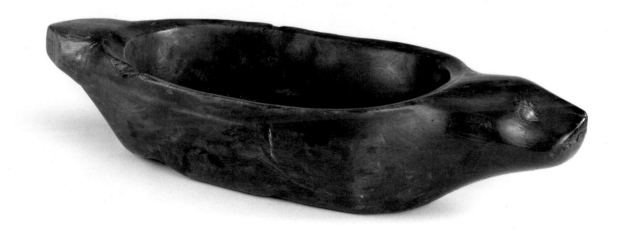

218

Alaska, Point Hope (?)

Head from a drum handle
19th century
Walrus ivory, beads
h. 1¼ in (3.2 cm)
Acquired 1957 UEA 109

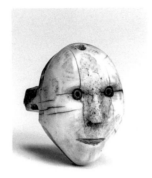

This head, broken off from an extension at the back, is almost certainly the end of a handle for a drum. The circular frame of the drum would have been fixed into the recess behind the head so that the face showed just inside the rim (see Murdoch, 1892: figs. 384-5; Nelson, 1899: 351). There is a double hole in the top of the head, possibly for bead pendants; small blue beads are set into the eyes.

Drums were used during dancing on ceremonial occasions and at shamanic rituals. They were beaten with a wood or ivory beater.

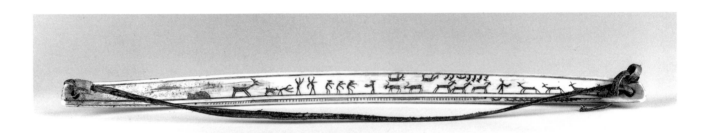

219

Alaska

Drill bow
19th century
Walrus ivory, hide
l. 13½ in (34.3 cm)
Acquired 1977 UEA 661

Drill bows were a favoured surface for pictographic engraving, and numerous examples have been collected since the late eighteenth century (see King, 1981: pl. 6; Bockstoce, 1977; Choris, 1822; Nelson, 1899). Eskimo engraving is usually filled with black or dark red pigment (as here), and often depicts scenes connected with hunting or ritual. Caribou are the principal subject on this example, shown resting, browsing and running towards a fence where hunters are waiting, one with a gun held to the shoulder. Caribou are related to the European reindeer, but were never domesticated by the Eskimo, who hunted them for their meat and skins, which made excellent clothing. One panel of engraving also depicts costumed dancers with antlers and goat-like animals with short backward-curving horns.

The drill was an important part of an Eskimo craftsman's tool kit. Two types were used in historic times, the bow drill and the cord drill, the former used from the Yukon northwards. To operate the bow drill the hide thong, present on this example, was looped round the drill shaft and the bow moved to and fro so as to rotate the drill shaft at high speed. The drill was steadied by a special holder slotted on to the butt and gripped between the craftsman's teeth. One advantage of the bow drill was that it left one hand free to manipulate the object being drilled.

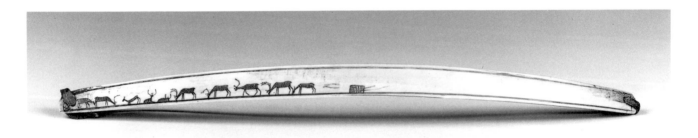

220

Alaska, Nunivak Island

Pendant with wolf head
19th/early 20th century
Walrus ivory
l. 1¼ in (3.2 cm)
Acquired 1985 RLS 2

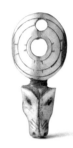

221 (*below*)

Alaska

Figure with 'crown'
18th/19th century
Walrus ivory
h. 2¼ in (5.7 cm)
Acquired 1985 UEA 919

The 'crown' on this figure is highly unusual. Nine
holes, in three groups of three, are drilled into the
base, and it is likely that three further holes were
present at the back, now broken away. The holes
were probably originally inlaid, since the male
labret holes have red pigment still in place. The
surface of the ivory is curiously eroded, as if it had
been covered in lichen for a long period. The legs of
the figure appear to have been sawn off and a hole
has been drilled into the base. This could be the
legacy of a previous owner tidying up a jagged break
for mounting purposes, leaving an impression of a
medieval chess piece. From the angle of the thighs it
is likely that the legs were originally flexed.

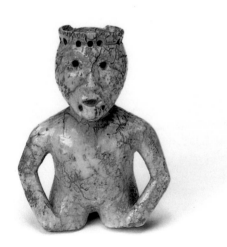

This small pendant was possibly part of an ear
ornament. It was originally suspended by the two
holes on the disc, and also appears to have had a
further pendant string round the neck of the wolf,
passing out through a tiny aperture at the mouth (now
broken, giving the appearance of two canines). The
number 2231.32 is painted in white on the plain back.

Provenance: Formerly in the collection of Charles
Ratton. Collected on Nunivak Island in 1936 or 1937
(illustrated in Himmelheber, 1938: pl. 31).

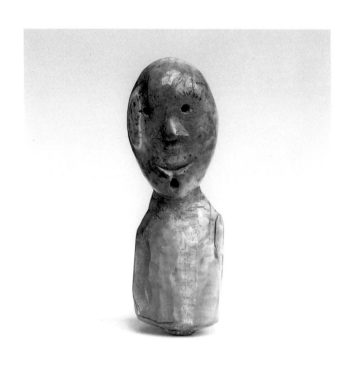

222 (*above*)

Alaska

Doll with plain body
19th century or earlier
Walrus ivory
h. 3⅛ in (7.9 cm)
Acquired 1979 UEA 737

This figure may be a doll, though, as Fitzhugh and
Kaplan explain (1982: fig. 190), such images were also
used for other purposes. Eskimo dolls often have only
a head and body, the arms and legs of the costume
supplying the limbs. The mouth and moustache
markings suggest a male is represented, though the
single hole in the lower lip does not correspond to the
usual male twin labret form. The eyes and nostrils
are drilled; the nose septum is broken.

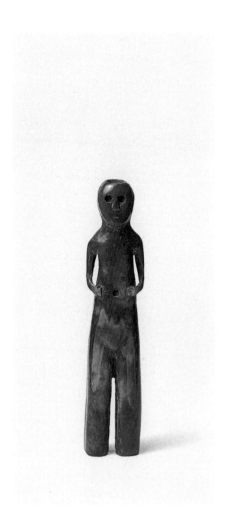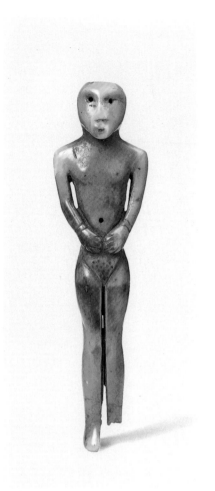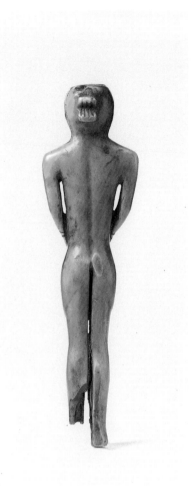

223-224

Alaska

Two needle cases as human figures
19th century or earlier
Walrus ivory
h. 2¾ in (7.0 cm); 3¾ in (9.5 cm)
Acquired 1977, 1985 UEA 686, 428

Sewing equipment was important to every Eskimo woman and special
tubular cases were used to keep the bone and ivory needles safe. Needle
cases in human form are rare.

No. 224, a female figure, is an exceptional example of miniature
sculpture – smooth, much used, with carefully observed detail like the
thigh muscles. Down the centre of the figure is the tubular cavity within
which the needles were kept on a hide thong. The hair is shown dressed
in a double chignon at the back. Comparable examples are illustrated by
Nelson (1899: pl. XLIV, collected on the Lower Yukon) and Mathiassen
(1927: II: fig. 3, from Point Hope).

No. 223 differs in that the tubular body cavity divides down each leg.
Evidence of metal sawing between the legs suggests that the artist used
an ancient piece of ivory. The eyes and navel are drilled, but not through
to the cavity. The number 31 765 is written in black ink on the back.

225

Alaska, Kodiak Island (?)

Figure
19th century or earlier
Walrus or whale ivory
h. 3¾ in (9.5 cm)
Acquired 1986 UEA 931

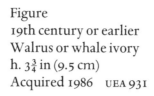

This small figure with a pointed head is probably from Kodiak Island or the neighbouring Alaskan mainland. There is a groove down the spine and shallow engraving on the face, chest, and kneecaps.

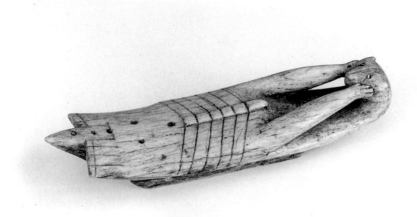

226

Alaska, Aleutian Islands

Sea otter image
19th century
Bone, pebbles
l. 3¾ in (9.5 cm)
Acquired 1976 UEA 666

The Aleuts fixed attachments of this kind to the inside of their canoes as hunting charms and fasteners (see Liupanova, 1967: pl. 1, in Ray, 1981: 106). They are usually made of walrus ivory or bone and depict the sea otter in its characteristic feeding posture, lying on its back in the water. A raised rectangular panel down the back has two transverse holes pierced through it, by which the image was attached to the canoe.

Sea otter pelts were in great demand in the Far East in the eighteenth and nineteenth centuries, and a busy trade developed between traders and local people along the western seaboard of north America. The Aleuts are distantly related to the Eskimo of the adjacent Alaskan mainland, with whom they shared many culture traits and a similar way of life.

Provenance: Formerly in the collection of Kenneth Webster.

227

Alaska, Lower Yukon

Mask
Late 19th century
Wood
h. 10¼ in (26.0 cm)
Acquired 1983 UEA 862

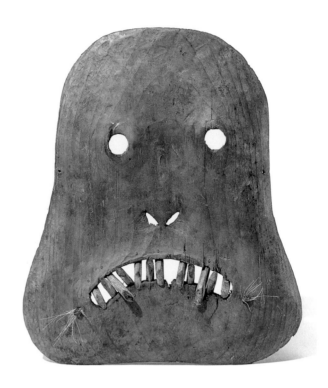

This striking mask is carved with concentric ridges and grooves around a central aperture and has two slits for eyes. The inside is concave and smooth, except where the aperture is encircled by a single shallow groove. Two holes are pierced on each side for a head-strap; there are three further holes around the top for feathers, now lost.

Fitzhugh and Kaplan observe (1982: 201-2) that circular grooves, hoops and feather attachments frequently appear on Alaskan Eskimo masks and other objects (see no. 216, UEA 893). They cite iconographic parallels with circular constructions erected in the ceremonial house, symbolic of the heavens, and they also suggest a relationship between circular devices and the encircling of the human face by the parka hood, defining its special identity and its relationship to the surrounding world.

Two similar examples of this rare form of mask, complete with feathers, were collected by Nelson at Rasboinsky on the Lower Yukon in 1879 (Collins *et al.*, 1973: 110; Fitzhugh and Kaplan, 1982: fig. 258). Nelson stated that they represented a *tunghâk*, a powerful spirit and mythical 'keeper of the game' who controlled the supply of game. These were probably shamans' masks, worn during winter festivals in the ceremonial house. When in use it is likely that fur strips or tassels hung from the central 'mouth'.

Provenance: Reported by the vendor to have been collected in the 1960s by Lawrence Irving, an Arctic biologist, at Pilot village, Takshak area. Pilot village is a few miles west of Marshall on the Lower Yukon river, the vicinity of the Rasboinsky settlement of Nelson's time.

228

Alaska, Norton Sound

Walrus mask
Late 19th century
Wood, whiskers
h. 8⅜ in (21.3 cm)
Acquired 1977 UEA 685

This thin mask has pegged teeth common to masks from the St Michael area of Norton Sound. The two longer teeth from the upper jaw, with the slanting nostrils, suggests a walrus is intended, although the two pegs holding the whiskers are positioned below the corners of the mouth, the usual place for men's lip plugs (labrets), thus emphasising the dual human and animal identity of many Alaskan masks.

The mask may have been used in dances during the Bladder Festival, which was 'celebrated to ensure success in hunting [and was a] memorial service for all food animals that had been killed the previous year' (Ray, 1967: 37). Animal bladders, considered to be the location of the soul, were inflated for use in rituals at the festival. Masks worn in the St Michael festivals 'displayed not only the spirit of a bird or animal represented in the dance, but also the likeness of a dancer's guardian spirit' (*ibid.*: 38).

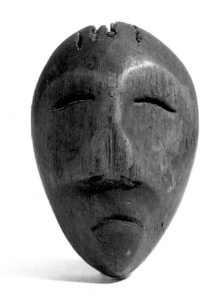

229

Alaska, Point Hope (?)

Maskette
19th century
Wood
h. 3 in (7.6 cm)
Acquired 1979 UEA 732

Four peg holes at the top suggest that this flat-backed maskette was formerly attached to another object. The nose is damaged, but when complete may have resembled the flukes of a whale's tail (Ray, 1967: pl. 54, shows a mask from Point Hope with a whale fluke nose which was used in whaling ritual).

230

Alaska, Point Hope (?)

Male head
19th century or earlier
Wood
h. 4⅛ in (10.5 cm)
Acquired 1953 UEA 114

VanStone (1968/9) illustrates a marionette head of similar form from Point Hope, which is probably nineteenth century. However, this damaged head with forehead and cheek tattoo marks could be considerably older, possibly even Punuk. A groove around the face may have been to secure a parka-type

231 (*opposite*)

Alaska, Point Hope

Mask
Late 19th century
Wood
h. 8¾ in (22.2 cm)
Acquired 1962 UEA 110

In 1939, Rainey and Larsen obtained a cache of some fifty masks during their archaeological research at Point Hope (Rainey, 1959: 11). These had been discovered by an old woman under the floor of a dancing house which was estimated to date from the late nineteenth century. Several of those masks are similar to this example (see Meldgaard, 1960: pl. 35), which almost certainly comes from the same region.

The eyes, nostrils and mouth are pierced and the eyebrows are grooved. There is a hole made by a nail through the chin. The mask is thin and light, and the irregular features give an animated, even humorous, appearance, a quality often desired in masks for winter festivals.

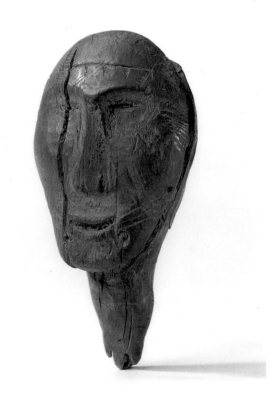

costume; wooden labrets are pegged in at the corners of the mouth. Marionettes were used in winter rituals to dramatise dances and myth re-enactments.

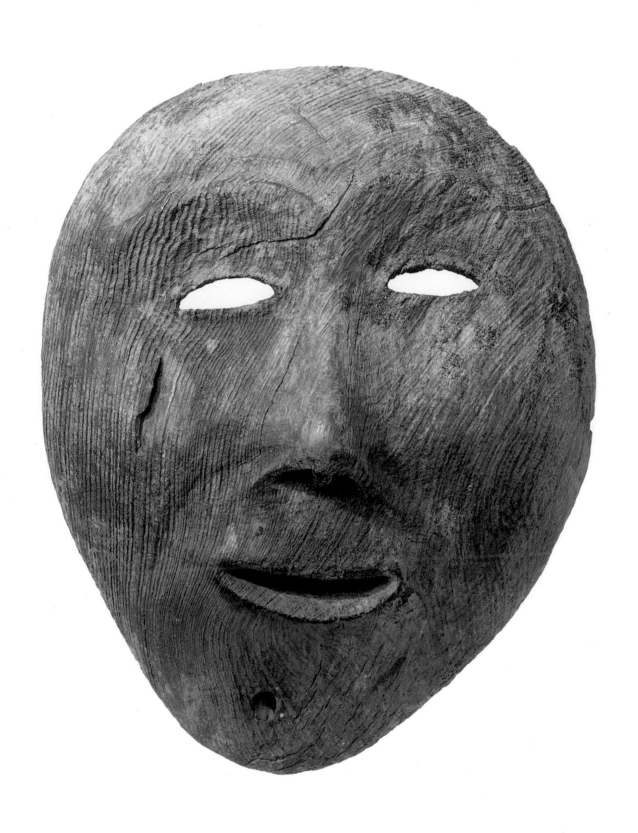

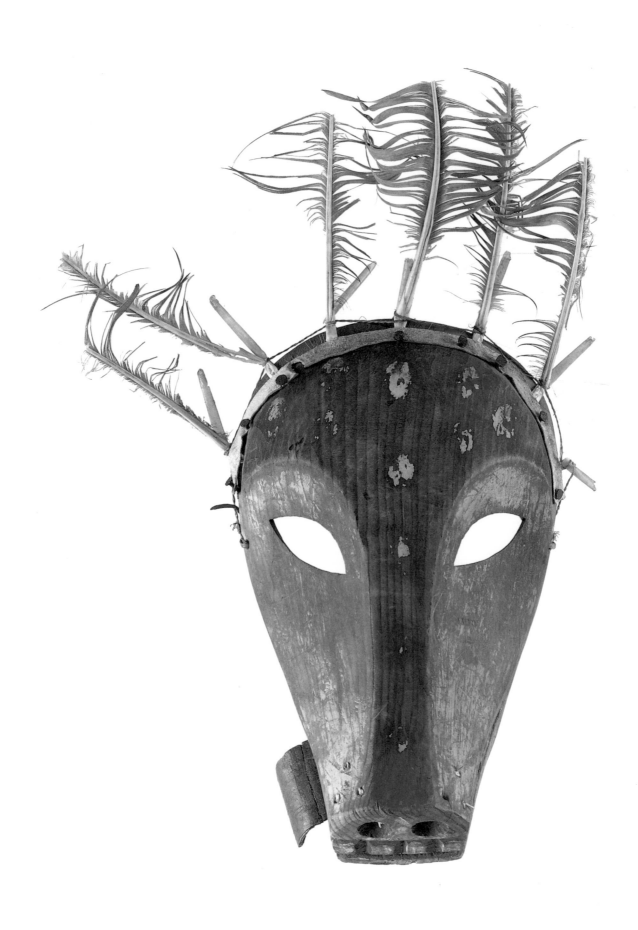

254 NORTH AMERICA: HISTORIC ESKIMO

232

Alaska, Norton Sound

Wolf mask
Late 19th century
Wood, feathers, leather, nails, bark
h. 9¾ in (24.8 cm) without feathers
Acquired 1974 UEA 502

This mask is virtually identical to one collected by
Bruce in the Port Clarence area in 1892-3 (VanStone,
1976: pl. 42), except that the birchbark tongue is
placed on the opposite side of the mouth. Ray, who
illustrates a related example, considers that the type
comes from St Michael and was used in dances for the
Messenger Feast, a festival which 'integrated homage
to game animals, entertainment, feasting, trade,
and romance' (1967: pl. 14; 35). The wolf and eagle
received greatest homage in the Messenger Feast and
masked dancers re-enacted myths concerning the
transformation of birds into wolves (*ibid.*: 190-91).
The presence of white feathers (goose or gull) on this
example suggests its use in such dances.

The mask is thin and light in weight. The face is
painted black and white, now faded, and there are
traces of red on the mouth, tongue and around the
top of the head. Remains of three quill 'whiskers' are
set in the muzzle above each nostril.

234

Alaska

Miniature head
19th century
Walrus ivory
h. 1⅛ in (2.9 cm)
Acquired 1972 UEA 117

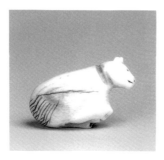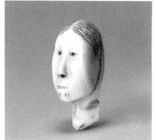

This miniature carving is an example of the visual
punning of which Alaskan Eskimo artists were par-
ticularly fond (see Nelson, 1899: 61; Fitzhugh and
Kaplan, 1982: fig. 56). One view reveals a female head
with hair parted and typical chin tattoos; turned over,
the neck becomes the shoulders and head of a wolf-
like creature. The neck is grooved for binding. Nelson
collected a related example of a head/bird from Cape
Vancouver (Collins *et al.*, 1973: fig. 94).

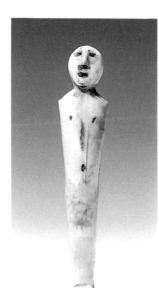

233

Alaska

Figurine
19th century or earlier
Walrus ivory
h. 2¾ in (7.0 cm)
Acquired 1974 UEA 591 C

This small figurine was acquired with nos. 202 and
204, but does not appear to be related to them. It is
probably a doll and was originally clothed. There is a
groove for attachment round the base.

235

Alaska (?)

Striding figure
19th century
Walrus ivory
h. 1¾ in (4.4 cm)
Acquired 1971 UEA 115

Animated carvings of this kind were made in many
Eskimo areas in the nineteenth century, for trade as
well as indigenous use. This accomplished example
has flat feet, which allow it to stand upright.

Alaska

Souvenir mug
Late 19th century
Whalebone
h. 5⅝ in (14.3 cm)
Acquired 1985 UEA 917

Europeans began to visit and settle in Alaska in increasing numbers
during the second half of the nineteenth century, until by the late 1890s,
at the height of the gold rush, some thirty thousand settlers were based
in the vicinity of Nome on Norton Sound. The local Eskimo, after first
parting with much of their indigenous material (Nelson collected
thousands of items between 1877 and 1881), began to make objects for
trade with the settlers. Popular items were ivory pipes, engraved tusks
and ivory cribbage boards. Basketry also blossomed at this time.

 This mug falls within the souvenir category, though it is possibly
unique, and the engraving style would date it to the 1870s or 1880s,
since the bird-carrying-whale motif appears on a harpoon rest which was
collected by Nelson (Fitzhugh and Kaplan, 1982: 19, 193), and the
style is much more animated and less naturalistic than later engraving
(see Ray, 1977: 214-41; Smith, 1980: 96-117, for further details). The mug
shows no signs of use and the back is plain.

237

Arctic

Seal
Late 19th century
Walrus ivory, wood
l. 3½ in (8.9 cm)
Acquired 1957 UEA 119

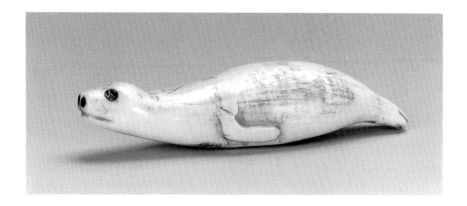

This is a well observed carving of a swimming seal, thrusting its body through the water in an undulating curve. It has no means for attachment and no discernible function, so was possibly made for the European market. The eyes and nostrils are inlaid with wood, or possibly baleen.

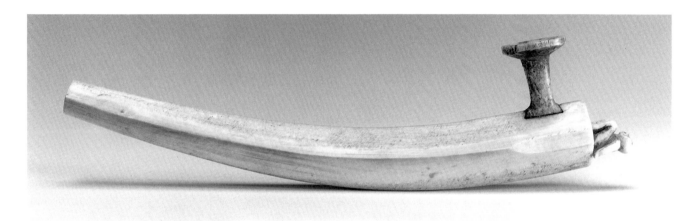

238

Alaska

Souvenir pipe
Late 19th century
Walrus ivory
l. 9½ in (24.1 cm); figure h. ⅝ in (1.6 cm)
Acquired 1976 UEA 662

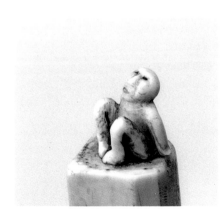

Smoking was introduced to the Alaskan Eskimo from north-east Asia at some time in the seventeenth or eighteenth century. Wooden pipes, similar to those used by the Siberian Chukchi, were used by the Eskimo, who also chewed tobacco with the nicotine which collected in the pipe stem.

 Walrus ivory pipes of this kind, which imitate the form of the Siberian pipe, were not smoked but were a development of the late nineteenth century to supply the growing demand for curios by visiting Europeans. Many have pictographic engraving, though this example seems to be unfinished. The small seated figure, acting as a plug to the stem cavity, is an unusual and expressive sculpture.

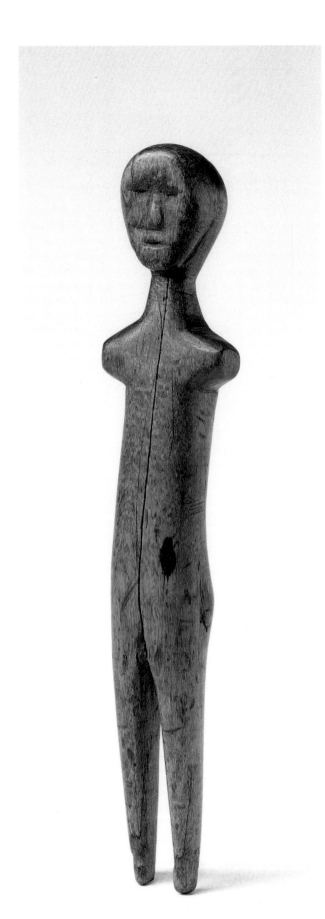

239

Northern Canada

Doll
19th century
Wood, metal
h. 7⅞ in (20.0 cm)
Acquired 1979 UEA 731

The precise origin of this doll is not known. The schematic features and stumpy arms suggest a central Eskimo attribution, and it probably formerly had a full fur costume, as shown in Turner (1894: 258; see also examples from Cumberland Sound in Boas, 1888: 571). A split up the body has been arrested by a large iron nail through the hips.

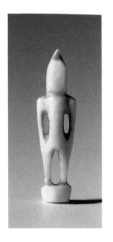 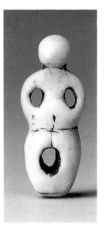 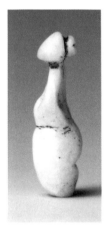

240-241

Northern Canada

Two figurine pendants
19th century or earlier
Walrus ivory
h. 1½ in (3.8 cm); 1⅝ in (4.1 cm)
Acquired 1959, 1977 UEA 116, 663

These miniature sculptures show two interpretations of the same basic subject, a figure worn as a pendant suspended through the hole between the legs (see Taylor *et al.*, 1971: figs. 39, 59-60 for further examples). No. 240 is slender and angular, with a pointed hood, whereas no. 241 is rounded, with massive legs and a double chignon at the back of the head. It resembles a figure from Southampton Island, at present in the Pitt-Rivers Museum, Oxford.

242

Greenland

Female figure
19th century or earlier
Walrus ivory
h. 3⅞ in (9.8 cm)
Acquired 1957 UEA 107

This distinctive T-shape hairstyle is characteristic
of women from the coastal regions of Greenland,
notably Ammassalik in the east; their long hair is tied
up with a band so as to project above and behind the
head (see Holm, 1888: pl. III). Numerous wooden and,
more rarely, walrus ivory figures have been collected
from Greenland, most of them recognisably female
because of the hairstyle. Those from Ammassalik
have the topknot directly above the head (Holm,
1888: pls. XXVII-XXVIII; Thalbitzer, 1914: fig. 366),
but an ivory figure from north-western Greenland,

dated to the prehistoric period, has it placed further
back (Fitzhugh, 1984: 534). The present figure may
also come from that area.

The Greenlanders are the easternmost Eskimo
group, descendants of the Thule Eskimo who moved
eastwards from northern Alaska early in the second
millennium AD. In this pale ivory sculpture the artist
has achieved a beautiful rendering of female fecun-
dity by the use of flowing, rounded forms. The three-
quarter view shows that the arms are present, but are
stylised into a curve on the abdomen.

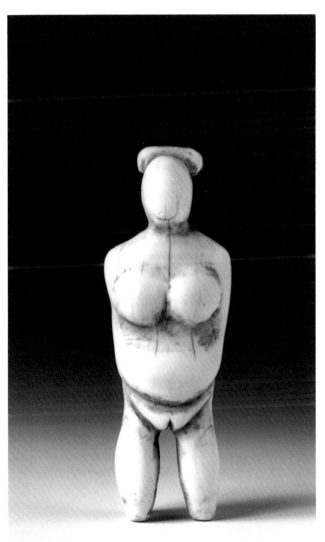
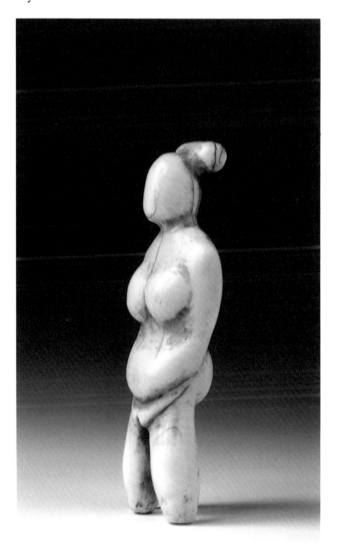

Northwest Coast

The art of the peoples of the Northwest Coast is notable for its dramatic use of animal forms. Birds, bears, beavers, wolves and other creatures lend their shape to many objects, or are incorporated as an integral part or as a surface design. These animals often have human characteristics, a feature which is connected with beliefs about the ability of animal spirits to transform themselves into human form and interact with humans. Much of a shaman's equipment involved transformational imagery, through which animal spirit powers were controlled for human use. In addition, animal images were used as heraldic crests. Clans and other groups were associated with particular animals, which were depicted on mortuary posts, head-dresses and other possessions. The right to display these crests was a privilege which required periodic reaffirmation at public gatherings, notably potlatches, where energetic leaders vied with one another, using food and fine artworks to proclaim their heritage, resources and achievements.

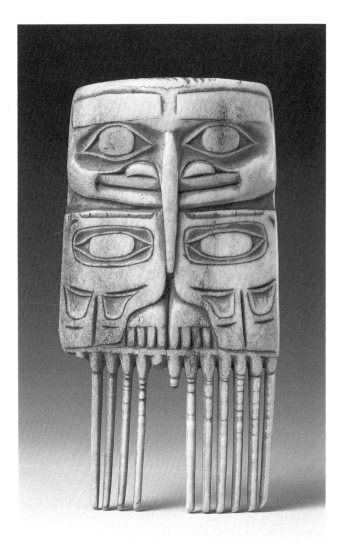

243

Tlingit, Cross Sound

Comb
Late 18th century
Caribou antler
h. $4\frac{1}{4}$ in (10.8 cm)
Acquired 1983 UEA 875

The Vancouver voyage provenance of this fine comb makes it one of the earliest documented pieces to have been collected among the Tlingit. It is well-preserved and the carving is noteworthy in that it exhibits the 'formline' design arrangement which is familiar from later nineteenth-century material. The term 'formline', coined by Holm in his analysis of the principles and techniques of Northwest Coast design (1965), refers to the broad uncarved band which here delineates the form of the wings, enclosing 'eyes' and other shapes which stand for joints and feathers.

The handle appears to represent a long-beaked bird, but the 'beak' has a proboscis-like quality usually associated with the representation of insects (suggestion courtesy of Carol Mayer). In addition, the face has humanoid features, so this is not a depiction of an ordinary bird, but a special one, possibly the mythical raven, famous throughout the coast, who was capable of transforming himself into many guises and whose exploits are recounted in numerous myths (see no. 258). According to myth, all creatures

originally had a human form, before they donned skins and became animals. This comb could be interpreted as a depiction of raven in this transformational aspect, wearing his wings as if they were a cloak.

Combs were used as hair ornaments and carvings for display. They have also been found in shaman's kits with masks and other ritual items (Jonaitis, 1986: pl. 66). A further possible use for combs is suggested by the grooves across the base of the tines, which resemble friction marks. These also occur on wooden combs (Collins *et al.*, 1973: 226) and may have been caused by combing some rough material like the wool or cedar bark used in weaving.

Any outward extension of the 'beak' has apparently been prevented by the flatness of the antler, which for that reason cannot be elk, and is almost certainly caribou. Caribou do not occur in Tlingit territory and their antler and skins, excellent for clothing, were obtained by trade with the Athapaskan peoples of the interior (see Krause, 1956: 127).

Provenance: Collected in 1794 during Vancouver's voyage. The comb was acquired following an auction at Sotheby's, London (27 June 1983; lot 61), when an export licence was withheld. Its collection history was not known, but subsequent research led to the discovery by a relative of the vendor of a handwritten list of ethnographic material bearing the name Captain Dobson. On this list, under the heading 'Cross Sound', is the entry '1 Bone Carved Comb'. The items on this list were grouped under places which correspond precisely to those visited by Captain George Vancouver during his voyage in the Pacific in H.M.S. *Discovery* (1791-5). In addition, a Lieutenant Thomas James Dobson was serving aboard the *Discovery* at that time (information courtesy of Jonathan King), and comparison with Dobson's log (ADM 51/4534) at the Public Record Office showed that the list of ethnographic material was written in Dobson's own hand. The association between Dobson's list and this comb is confirmed by the fact that companion pieces sold at auction (lots 52-64, 147-9) can also readily be identified on the list.

The *Discovery* visited Cross Sound between 7 and 29 July 1794, and frequent encounters with local people are reported in Vancouver's journal (Lamb, 1984: 1319, 1341-2). Dobson's own log gives only a few tantalisingly brief entries, such as 'sev'ral canoes alongside'. The comb later passed from Dobson into the possession of the collector John Gent (died *c*. 1815) of Devizes, Wiltshire, and thence by descent to the vendor in 1983.

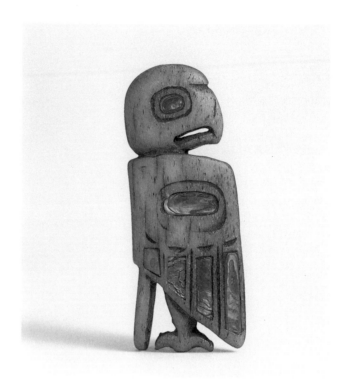

244

Tlingit

Bird pendant
Early 19th century
Whalebone, abalone shell
h. $3\frac{1}{4}$ in (8.3 cm)
Acquired 1979 UEA 729

This carving of a bird of prey, an eagle or owl, is flattened oval in section and is pierced through the neck and the base of the tail with straight-drilled holes. It probably served as a neck pendant of the kind worn by shamans during healing and other rituals. A shaman's initiation involved a vision quest, a period of fasting in the wilderness during which he would experience encounters with animal spirits (*yek*) who would help him in his subsequent work. A shaman's paraphernalia, his pendants, rattles, masks and other equipment, depicted such creatures, whose powers might be invoked during a ritual performance (see de Laguna, 1972: 670-725).

This pendant is smooth from much handling, and the abalone shell inlay contrasts pleasingly with the whalebone. Both materials are exotic, in the sense that neither occurs locally, and they had to be obtained by trade. Thus, this object's significance lies not only in the bird it represents, but also in the materials from which it is made, which signify access to and control over valuable outside resources.

245

Tsimshian or Tlingit

Club
Early/mid 19th century
Caribou antler, abalone shell
l. 17½ in (44.5 cm)
Acquired 1957 UEA 120

Antler clubs of this kind, of which about ten are known, are often referred to as 'slave killers', though no evidence exists to confirm that this was indeed their primary function. It is more likely that they were used as a kind of sceptre, the possession of which enhanced the prestige and splendid appearance of the owner on formal occasions. They are usually attributed to the Tsimshian, but this fine example could also be Tlingit.

All are carved with animal features. This one has the head of a bear with tongue protruding, while the surface of the club is engraved with a complex of designs, more clearly visible in the diagram, depicting the body of the bear and another creature. On the bear the oval shoulder and hip joints, linked by a three-section backbone, connect to long curling claws. Although bears are typically depicted with claws, this design has certain seal characteristics, making our animal no ordinary bear, but probably a creature which featured in a myth associated with the family or ancestors of the owner. One such mythic creature is called the sea bear, which has both bear and killer whale attributes.

Below the 'bear', and facing away from it, is a wide-mouthed creature, possibly a killer whale. This may be the work of a different hand, since the engraving is not so crisp and the ovals which form the eyes are not carved in the same style as the joints of the main 'bear'. The designs on the projecting leg of the club do not seem to be part of the main animal, and may be decorative filler. The slit in the projection is square-cut and is unlikely to have been for a blade; no example with an original blade exists, and it is likely that the split had symbolic significance. The butt and the top of the bear's head are pierced, possibly for feather attachments.

This club has no collection data associated with it and none of the others have collection information which predates 1860. However, this form of club or baton has great antiquity in the region; MacDonald (1983: 112) illustrates a miniature antler club with an animal head and bifurcated projection which dates to about AD 100.

Comparison of this example with specimens of elk, caribou and moose antler shows this to be caribou. The top of the bear's head was the base of the antler and his nose was the base of the first tine. A further tine once emerged above the handgrip (visible on a fine club in Philadelphia; Maurer, 1977: 306) but this has been cut away. Antler is a hard material, but its surface can be softened for carving by immersion in water. As with many other carvings, this prestigious object is made from highly valued foreign materials, antler from the interior and abalone shell from the south (ultimately California). It is likely to have been made for a chief who had the right to display this 'bear' crest, though a smaller example of the type once belonged to a nineteenth-century Tsimshian shaman (Phelps, 1976: pl. 181).

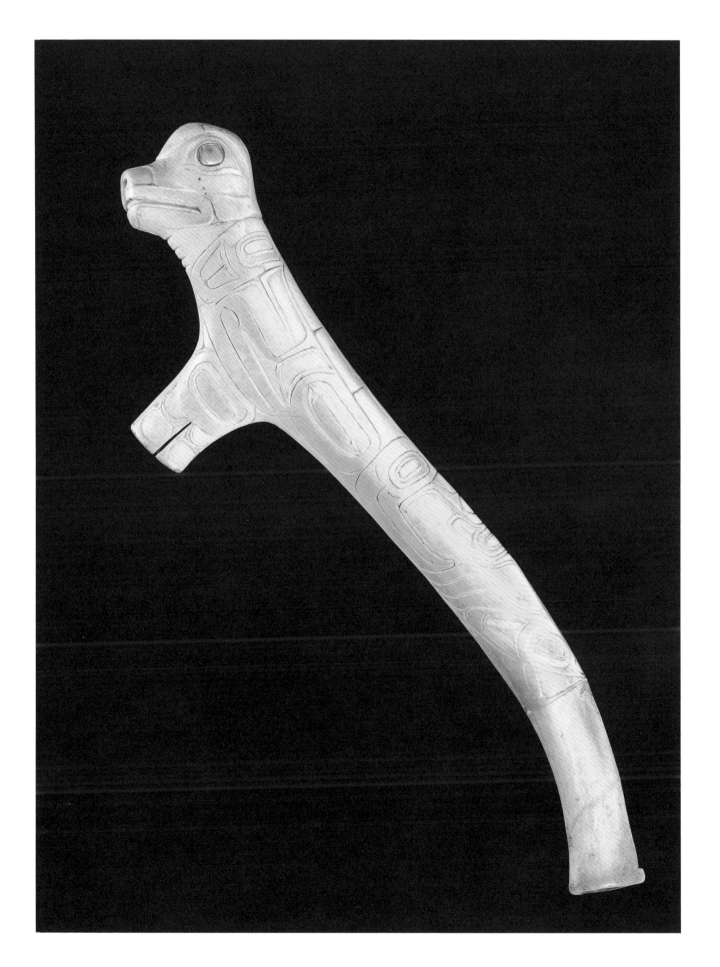

Tlingit

Bowl in beaver form
Late 18th/early 19th century
Wood
l. 9 in (22.9 cm)
Acquired 1966 UEA 123

Although this fine bowl has no surface engraving, the eyes, ears and
general form suggest a northern Northwest Coast attribution. Bill Holm
(personal communication, 1985) considers it to be Tlingit and early
nineteenth century at the latest. The naturalism is unusual, but beavers
were more often depicted naturalistically than other species. Here, the
large incisors, forepaws gripping the stick, and the broad, thick tail show
beaver in a typical pose.

 The wood (probably alder) is completely blackened and saturated
with oil, suggesting a long period of use. Such bowls were used at feasts
to serve fish oil or seal oil, which was eaten with dried salmon and
other delicacies. Fish oil was extracted, by boiling, from the candlefish
or olachen (see Krause, 1956: 122, 130) and preserved in wooden chests.
Large quantities of oil were accumulated, and then either consumed
or distributed at potlatch feasts. One of the main routes to eminence in
northern Northwest Coast societies was through public demonstrations
of abundance and control over valued resources. Food and crest artworks
were material manifestations of such abundance, and the potlatch was
the occasion when this wealth was displayed, consumed or given away

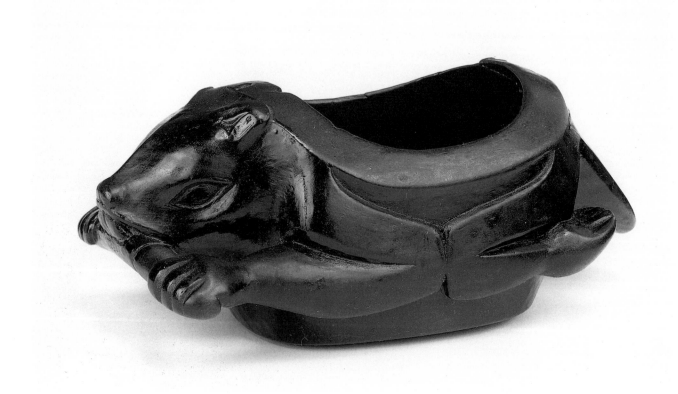

(see Rosman and Rubel, 1971; de Laguna, 1972: 606-51, and Jonaitis, 1986: 42-50, for an assessment of the potlatch, a large-scale gathering linked to mortuary rites which involved feasting, singing, dance entertainment and distributions of food and property). A man could gain great prestige by hosting a potlatch and demonstrating publicly his ability to mobilise large quantities of food and goods. By doing so he honoured the dead in an appropriate manner, repaid groups who had contributed to earlier funeral rites, and also validated the status of his family or clan. Such munificence did not lead to impoverishment, for a donor would soon be a recipient on another occasion.

Some of the finest sculptures from the Northwest Coast are bowls in which the body of a human or animal becomes the vessel. Sturtevant *et al.* (1974) illustrate many fine examples in the Smithsonian Institution. The animal crests with which they are decorated relate to the original owner for whom they were carved, although bowls could themselves be distributed as valuables. The walls of this bowl are thin and there are two holes in the flat rim, probably for a suspension cord. There is an old paper label on the base with the number 845 in black ink.

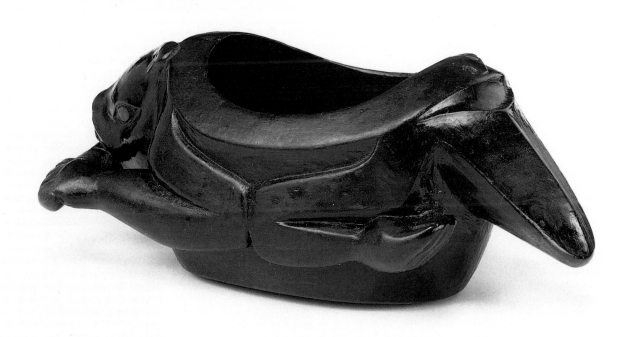

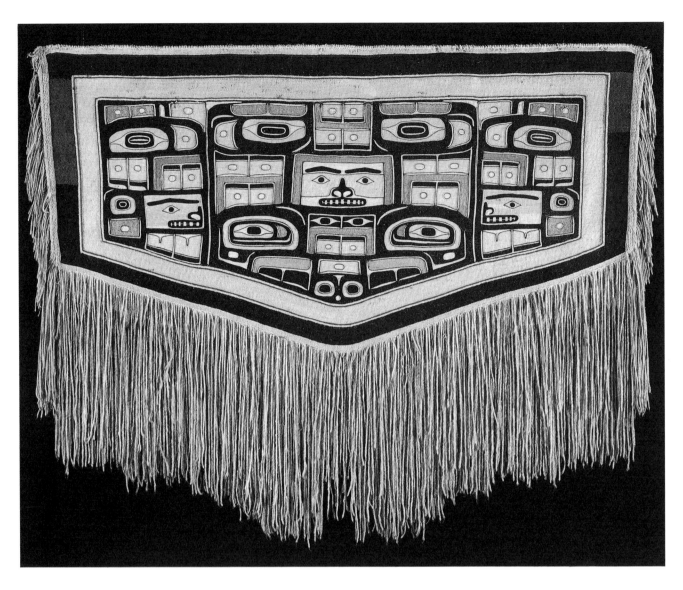

247

Tlingit, Chilkat

'Chilkat' blanket
Late 19th century
Mountain-goat wool, yellow cedar bark
w. 68 in (172.7 cm)
Acquired 1977 UEA 667

This is a well-preserved example of a type of cere-monial robe which became popular throughout the northern Northwest Coast during the course of the nineteenth century. They are widely referred to as 'Chilkat blankets' because the women of the Chilkat Tlingit of the Lynn Canal area were the prin-cipal weavers, although they were also made in other places, and oral history relates that the form had its origin among the Tsimshian to the south. Samuel (1982) has made a detailed study of these blankets,

especially of the technical aspects of production, which involved highly sophisticated twining and finger-weaving techniques.

Chilkat blanket designs were copied from a wood pattern board which had the design painted upon it. Thus many blankets share the same general design, and two which correspond to this one are illustrated in Boas (1907: fig. 564a) and Holm (1983: no. 84). The central design panel on these blankets has been called the 'diving whale' pattern, based on an interpretation by Emmons. The 'whale' is viewed from above; the lower part of the design is said to be the whale's head with large eyes, the central face stands for its body, and the two upper eye forms and associated smaller elements are the flukes of the tail. The symmetrical side panels are difficult to interpret, and as no first-hand indigenous information seems to have been recorded in the nineteenth century, such design interpretations remain speculative.

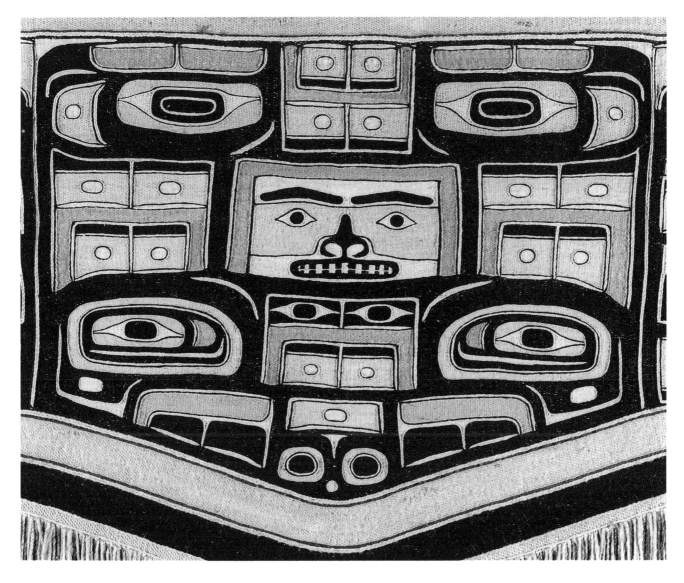

The warp is of the twisted inner bark of the yellow cedar and the weft and fringes are of mountain-goat wool, which is white in its natural state. The colours were originally obtained from local dyes. When foreign dyes became available during the second half of the nineteenth century a pale blue/green (present here) was introduced into the colour scheme. The black areas on this blanket have sections which are dark brown and dark green, showing that local, as well as commercial, dyes have been used to produce the 'black'. The colours on the front are duller than those on the back, the result of exposure to light.

Samuel (1982: 25) estimates that six months of regular work was involved in the manufacture of a single blanket, and this was one factor which set this type of garment above and apart from trade blankets and other costumes. Chilkat blankets were regarded as great valuables and were not only worn by those of high status (men and women), but were also given as gifts to participants in ceremonial exchanges, notably potlatches. They were also used as funeral shrouds and decorations on grave houses – their destruction being an act of respect for the deceased and a sign of plentiful resources on the part of the owner.

When worn, the blanket was draped over the shoulders, and in dancing the arms were spread to achieve maximum impact for the design. During the second half of the nineteenth century, a full ceremonial costume for an eminent person on the northern Northwest Coast consisted of a Chilkat blanket, an apron, a crest hat or head-dress (no. 263) and a raven rattle (no. 260). The potlatch was the usual occasion for such elaborate attire. Dances were performed by hosts and visitors and there was often a strong competitive element in these encounters between kin. A splendid appearance, with many crests displayed, was one way to establish prestige and a high reputation.

248

Northern Tlingit (?)

Male figure
19th century
Whale or walrus ivory
h. 5⅝ in (14.5 cm)
Acquired 1977 UEA 658

This figure is not easily classifiable, though certain features suggest a northern Northwest Coast origin. Genitals were sometimes carved on male figures (Duff *et al.*, 1967: no. 186; Wardwell, 1978: 90; Holm and Reid, 1975: no. 63), and the pointed head-dress could correspond to a shaman's goat-horn crown, indicating that this was perhaps a shaman's charm pendant. The two holes in the face may be nostrils, or even a representation of Eskimo labrets. The armpits are cut square and the back is plain. The material resembles whale ivory rather than walrus tusk.

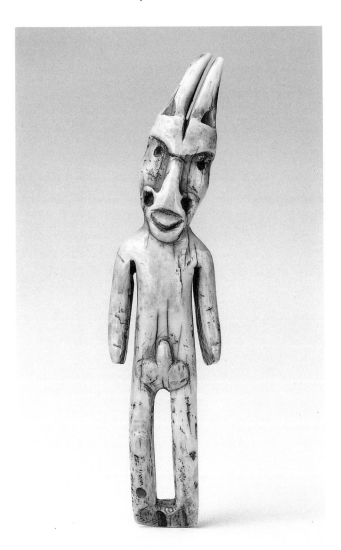

249

Tsimshian

Head with spike
Mid 19th century
Walrus ivory
h. 3⅞ in (10.0 cm)
Acquired 1977 UEA 659

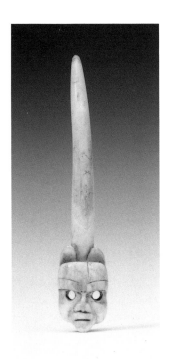

This carving seems to imitate the form of the spikes on a shaman's goat-horn head-dress, where a face was sometimes carved at the base (see de Laguna, 1972: 693, pl. 175, for a Tlingit example). The face here has human features but large, bear-like ears; the bear spirit, if encountered during a shaman's vision quest, was among the most important of his helpers. This is too small to be part of a head-dress, but it may have been a shaman's pendant or attachment of some kind. A clue to its former function is provided by a similar ivory in the Peabody Museum, Harvard (69-30-10/1922), which serves as a toggle on the end of a strap which ties a pouch of gambling sticks. The Skeena River provenance makes it likely to have originated among the Tsimshian.

Provenance: Formerly in the collection of Harry Beasley, no. 12-4-32: 'Northwest Coast, Skeena R. Collection of Reverend E. J. Peck, L.M.S., 1875-80.'

250

Tsimshian or Tlingit

Shaman's charm
19th century
Walrus or whale ivory
l. 1¼ in (3.2 cm)
Acquired 1964 UEA 132

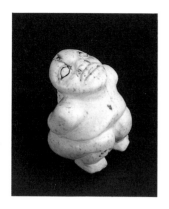
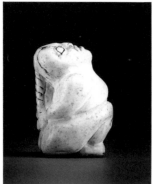

251

Tlingit

Miniature captive 'witch'
19th century
Stone
h. 1¼ in (3.2 cm)
Acquired 1973 UEA 501

The image of the bound captive appears on a variety
of Tlingit sculptures (Harner and Elsasser, 1965: 92;
Collins *et al.*, 1973: 269-70, 277; Jonaitis, 1986: plates
51, 60), and is usually interpreted as the figure of a
witch. More properly, the term should be sorcerer,
the distinction being that a witch has intrinsic evil
powers, whereas a sorcerer uses certain materials
and rituals to bring about evil or illness. Swanton
(1908: 467) and de Laguna (1972: 736) discuss 'witches'
and the procedure by which a shaman first identified
a witch by divination, and then forced a confession
by binding and torture.

 This compact stone sculpture, in which the captive's
long hair is twisted into a cord that binds the wrists,
vividly expresses the anguish of the victim. 'Witch'
imagery is usually associated with shaman's equip-
ment, and this carving was possibly a charm used in
the diagnosis of sorcery. The figure has no labret
and so probably represents a man.

In this miniature sculpture (opposite), the carver has
achieved an illusion of completeness, despite the fact
that only the head and forelegs of the animal, perhaps
a bear, are present. It was probably a shaman's pen-
dant and has a hole through the lug at the back.

Provenance: Formerly in the collection of William
Oldman.

252 *(below)*

Northern Tlingit (?)

Captive 'witch'
19th century
Whalebone
h. 4⅝ in (11.8 cm)
Acquired 1950 UEA 122

This bound captive image differs in treatment from
no. 251 (UEA 501) in that, although the subject matter
is recognisably Tlingit, the facial features are not.
The rib-cage is, however, often depicted on Tlingit
images in death or distress, and since shaman's
charms also sometimes have an idiosyncratic quality,
it is likely that this piece originated from the Tlingit,
perhaps from the north, near Prince William Sound.

 The captive's wrists are shown tied at the back
with a twisted cord, though no hair is shown. There
is a depression on each side of the neck.

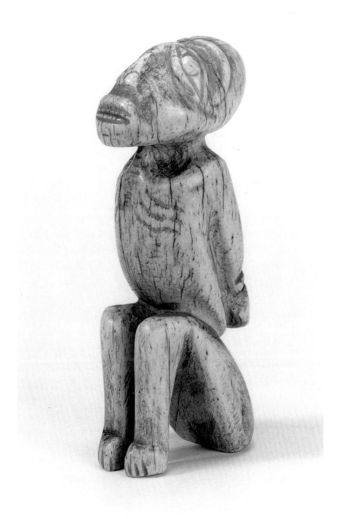

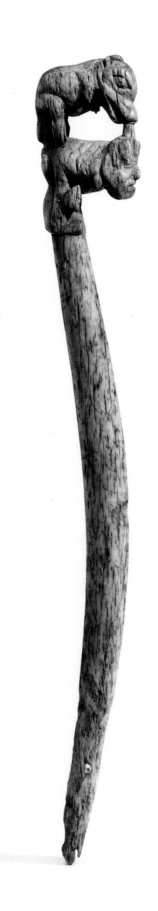

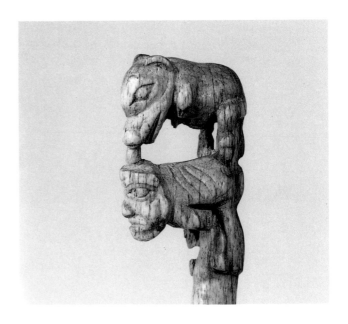

253

Tlingit

Trap stick
18th/early 19th century
Whalebone
l. $10\frac{1}{2}$ in (26.7 cm); h. of carving $2\frac{1}{8}$ in (5.4 cm)
Acquired 1979 UEA 726

Although these implements are referred to widely as 'trap sticks', their exact function is not known. Some examples in the American Museum of Natural History in New York have marmot snares attached to them, but, as Holm (1983: 90) observes in his description of a comparable piece, their 'very specific and uniform shape implies a much more complex function than a tethering pin'. In many examples the lower part shows signs of abrasion or chewing, which suggests their role as part of a trap mechanism.

The carved finials on trap sticks frequently depict an animal on the back of a human figure, an arrangement which probably has sexual connotations and is also found in other contexts (see Maurer, 1977: 290). This imagery may also be seen as the reverse of the usual hunting procedure, and was possibly connected with a mythic episode, reference to which made the trap more effective, since, in hunting as in all things, mere technical efficiency would not alone guarantee success. Here the human figure, with prominent rib-cage, has slender folded legs. The animal resembles a bear, though it has a long tail. The piece has the appearance of great antiquity, consistent with the fact that metal traps quickly superseded local methods in the early nineteenth century.

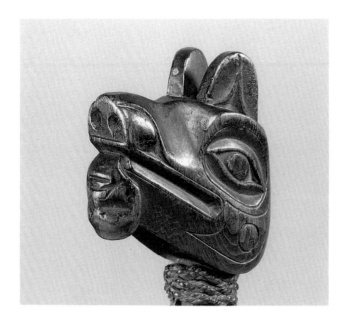

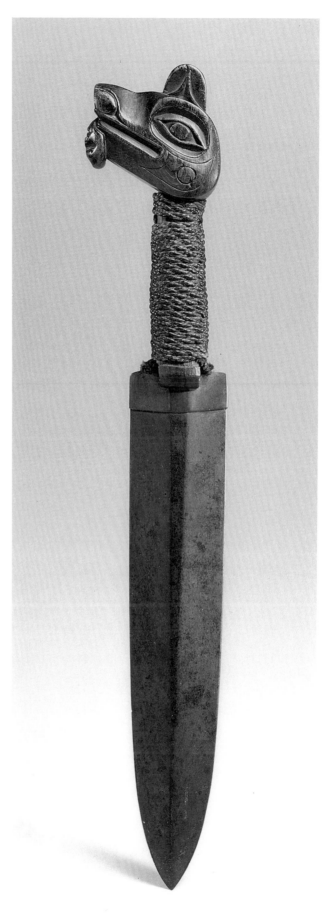

254

Tlingit, Wrangell

Dagger with bear head pommel
Early/mid 19th century
Wood, iron, brass, cedar bark
l. 15¾ in (40.0 cm)
Acquired 1961 UEA 127

The pommel of this dagger is carved as a bear, with
rounded ears and a protruding tongue which is shaped
as the head of a tiny figure. This last feature refers
to two themes common in Northwest Coast art, the
tongue, which is characteristic of bear carvings and
which Jonaitis (1986: 135-6) discusses in relation to a
shaman's vision quest, and the imagery of devouring,
which has sexual connotations.

A dagger closely resembling this one is illustrated
by Holm (1983: 99), where he identifies the wood as
walnut. Walnut, frequently used for pipes and dagger
handles, was not local but was obtained from old
musket stocks. The brass-mounted blade is also of
foreign origin, and both this example and the next
(no. 255) show how the Tlingit were able to adapt
introduced materials to make objects which were in
essence 'traditional'. Indeed, part of the nature of the
Tlingit dagger seems to have been that it should be
made of exotic materials, implying control over
wealth and external resources. The cord which binds
the handle is of twisted cedar bark.

Provenance: Formerly in the Museum of the American
Indian, New York (no. 11/5413, acquired 1922).
Collected by G. T. Emmons at Wrangell after 1882.

255

Tlingit, Klukwan

Dagger with bird head pommel
Late 19th century
Copper, musk-ox horn, abalone
shell, leather
l. 22 in (55.9 cm)
Acquired 1963 UEA 126

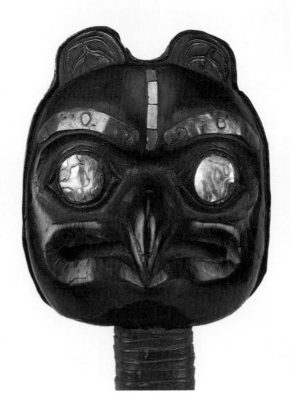

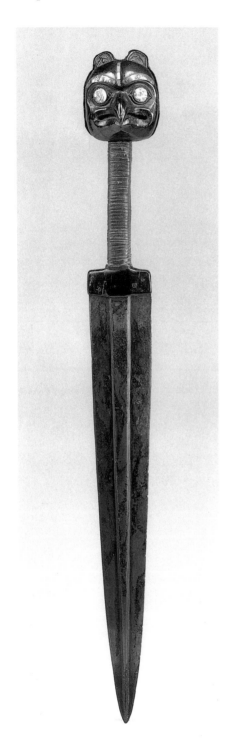

This dagger is one of a corpus of about fifteen examples in this style
which appear to be the work of a single workshop, probably located
at Klukwan around the end of the nineteenth century. Four daggers in
the University Museum of Pennsylvania were collected by the director,
Gordon, in Klukwan in 1905; none of the others have collection data
which predate 1900 (see Collins *et al.*, 1973: 260; Maurer, 1977: 309).

These daggers demonstrate considerable technical sophistication.
A rib of copper is applied to the top of the trapezoid-section blade and is
set with tiny rivets and commercial solder. Witthoft and Eyman (1969:
14) observed that this workmanship meets 'the standards of an expert
modern mechanic', and it is probable that a small group of skilled Tlingit
craftsmen produced a series of daggers for local ceremonial use, though
several were soon acquired by museum collectors such as Gordon and
Emmons, who were scouring the area at the time (see Cole, 1985).

Witthoft and Eyman also analysed several examples and found that
the horn used for the handle and pommel was musk-ox, and that the
copper for the blade was very pure but did not come from the expected
sources on the Copper River of Alaska or the Coppermine River of
northern Canada. It seems likely that these materials were obtained
from Europeans, and not via the traditional trade routes.

The pommels are mostly of horn with copper backing and applied
copper strips (as here), though some are of copper only. The animals
represented also vary, possibly because particular crests were required
by different clients. This example has the head of an owl or hawk, others
have the head of a bear, wolf or eagle. It is unlikely that these daggers
were ever used in combat, rather they were part of the impressive cos-
tume worn by eminent people on formal occasions such as potlatches.

256

Tlingit (?)

Bowl with wolf head
18th/early 19th century
Mountain-sheep horn
l. 8½ in (21.6 cm)
Acquired 1979 UEA 728

Krause (1956: 125) reported that Tlingit hunters went up into the interior to catch mountain sheep and goats, the horns of which were then made into bowls and spoons. Undecorated horn ladles were also made by the interior peoples and traded to the coast, but Holm (personal communication, 1985) considers this bowl 'is probably Tlingit, and I believe that it was entirely made by a coastal artist rather than imported already worked from the interior.' Horn, when soaked and boiled, will form translucent sheets, and when very hot it can be pressed and moulded into shape (Hodges, 1964: 155).

The head is likely to be that of a snarling wolf, one of the principal crests of the Tlingit. The double lines behind the large nostrils vividly convey the appearance of a wolf's muzzle when the upper lips are drawn back over the teeth. The outer rim has well-worn hatched engraving of the kind that Holm (1983: 74) has interpreted as a skeuomorph, a decorative feature which has its origin in a functional feature of a similar object made from a different material (in this case the overlapping sewn border of a birchbark container).

The dynamic upward thrust of the head and the broad flare to the sides of the bowl make this an especially appealing sculpture. The warm honey colour of the translucent horn adds to the pleasing effect. Its appearance gives the impression of great age; a comparable piece in the Smithsonian Institution, with inward facing head, was accessioned by them in 1862 (Sturtevant et al., 1974: no. 46). There are no deposits of oil in this bowl, so it was probably used to serve dried food or berries.

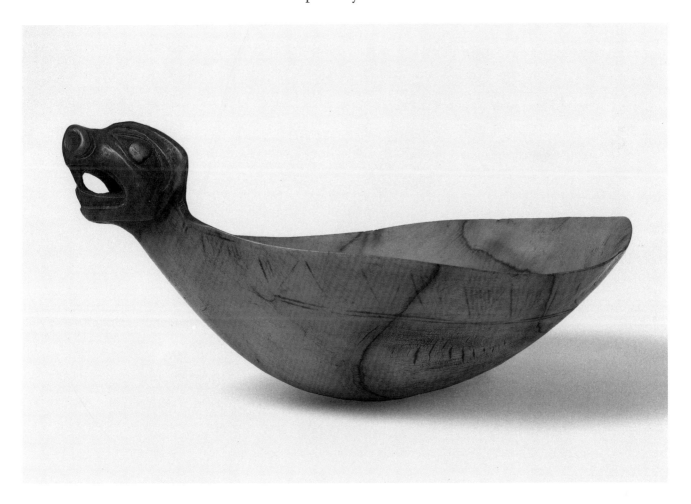

257

Tlingit or Haida (?)

Ladle
Mid 19th century
Mountain-sheep horn, walrus ivory,
abalone shell, copper
l. 11⅜ in (28.9 cm)
Acquired 1958 UEA 121

This ladle is an accomplished and ambitious work by an artist who was clearly intent on achieving dramatic visual impact. The deeply-sculpted ivory handle is enlivened by abalone shell inlay, and is expertly fitted with copper rivets to an elegant horn bowl. Ivory is an unusual material for the handle of a composite ladle, but steel tools have allowed the artist to carve deeply and produce a miniature version of a memorial column. Two small figures (perhaps representing the same person) sit below a hawk and a raven respectively. They both wear conical hats with horizontal bands, representing a local type of chief's basketry hat with cylinders on top. These are popularly known as 'potlatch rings', denoting the number of potlatches given by the owner, but there is no conclusive evidence for this. Nevertheless, it indicates that the figures have chiefly status and are associated with raven and hawk crests. The raven has

a cylindrical head-dress which echoes the form of the hats and is also found on many full-scale memorial columns.

Decorated ladles, spoons and bowls were provided for use at potlatch feasts, at which the hosts wished to impress their guests with crest carvings of high quality. The walrus ivory would have been obtained from the north or from traders; the mountain sheep horn bowl may have been imported from the interior in finished form, or made on the coast. It is pale and translucent showing that it has been steamed or boiled prior to being pressed and shaped in a wood mould. A precise attribution is not possible, but it is most likely to be of Tlingit or Haida origin.

When found by the vendor, the entire ladle was covered with a thick black varnish. This was cleaned off, which accounts for the pristine appearance of the carving on the handle.

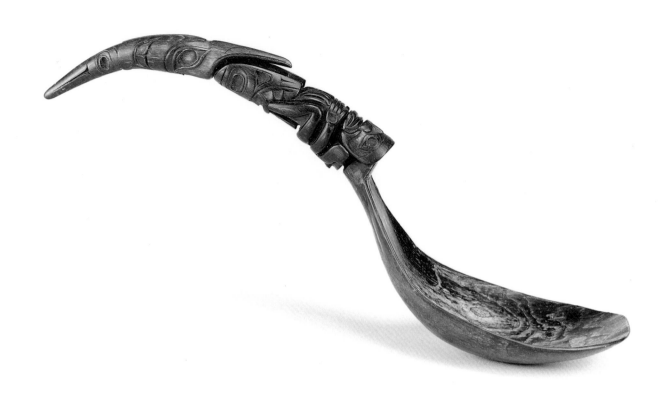

258

Tlingit or Haida (?)

Spoon
Early/mid 19th century
Mountain-goat horn, iron
l. 9 in (22.9 cm)
Acquired 1983 UEA 869

Horn spoons of this general type are not uncommon, but this example is exceptional for the quality of the carving on the handle, where an inverted human figure crouches beneath a raven-like bird. The figure is deeply cut and has a rhythmic quality, particularly apparent in the arrangement of the arms and legs. There is an extensive body of myth concerning the activities of raven and early humans, and the design here may refer to a particular mythic episode (see Swanton, 1909; Boas, 1916; de Laguna, 1972).

The crispness of the carving recalls the work of the best Haida argillite pipe carvers, but certain stylistic features, such as the broad eyebrows of the figure, point to a Tlingit origin for this spoon. Local trading practices make attributions difficult, for, as Boas observed (1916: 57), the 'products of different parts of the country and of different tribes were so varied, that a lively trade existed all along the coast. The Tsimshian sold to the Haida, in exchange for canoes, particularly boxes of olachen oil, carved spoons of mountain-goat horn . . . and bighorn-sheep horn, wool and woolen (*sic*) blankets.' The bowl of the spoon is plugged into the handle and secured with an iron rivet. Cavities in the eyes, wrists and wings were almost certainly once inlaid with abalone shell.

259

Tlingit or Haida (?)

Bird rattle
19th century
Wood, pebbles
l. 12½ in (31.8 cm)
Acquired 1966 UEA 130

This rattle depicts a long-beaked bird, possibly an oyster-catcher or kingfisher, with a further bird mask on its breast and a human face carved on the tail. It is constructed of two hollowed parts, pinned at the handle and tied at the sides, the bird's body forming a globular cavity for the small pebble rattles.

 Rattles were used throughout the Northwest Coast to provide rhythmical accompaniment to speeches, songs and dances performed on public occasions. They were also used during shamanic rituals, when their sound was associated with the presence of spirits. The original function of this rattle is not known, nor its precise tribal attribution. It is painted black, red and pale turquoise, these colours now faded.

Provenance: Formerly in the Pitt Rivers Museum, Farnham, Dorset.

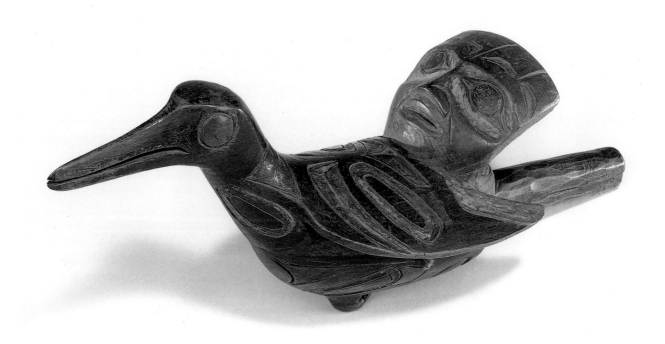

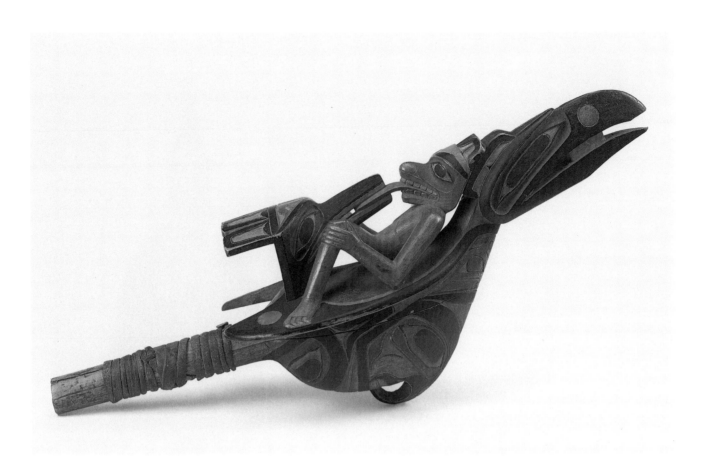

260

Haida or Tlingit (?)

Raven rattle
Mid 19th century
Wood, leather, pebbles
l. 12½ in (31.8 cm)
Acquired 1982 UEA 831

Rattles in the form of birds were used throughout the Northwest Coast. Some were collected during Cook's visit to the Nootka in 1778 (King, 1981: pls. 49-51), and an example similar to this one was collected among the Tlingit in 1805 by Lisiansky (1814: pl. Ie; Siebert and Forman, 1967: 59, 60). The bird most frequently depicted is the raven, as here, with a 'hawk' mask carved on its breast and a reclining figure on its back. This figure has its tongue extending into the beak of another bird, whose head forms the tail of the raven. The extended tongue occurs often in Northwest Coast art. In some cases it has sexual significance, but here it is likely to be connected with concepts of the tongue as the locus of life force; the acquisition of animal tongues and their associated spiritual power was a crucial part of a shaman's vision quest (see de Laguna, 1972: 676-80).

Raven rattles are popularly classified as chief's rattles, in contrast to shaman's rattles, which depict other kinds of bird. However, raven rattles have been found in shaman's graves (de Laguna, 1972: pls. 176, 187; Wardwell, 1978: no. 52), and reliable first-hand evidence for a firm classification is lacking, as indeed is information about the symbolic significance of the scenes carved on the backs of rattles. In the second half of the nineteenth century, raven rattles were part of the standard ceremonial accoutrements of chiefs throughout the northern coast, along with Chilkat blankets and dance head-dresses. However, this may reflect a change of emphasis, where the rattle's significance as a marker of high status superseded a former, shamanic, importance, about which we have little information.

This rattle is well preserved, and the figure, with its bear-like head and claws, is larger and more sculpturally accomplished than many other examples. Besides the Lisiansky rattle, which also retains its strong colours, this one is similar to an example collected among the Haida (probably in the 1870s) which is illustrated by Niblack (1888: pls. LIII-IV).

Provenance: Formerly in the collection of James Hooper, no. 1455 (Phelps, 1976: pl. 179).

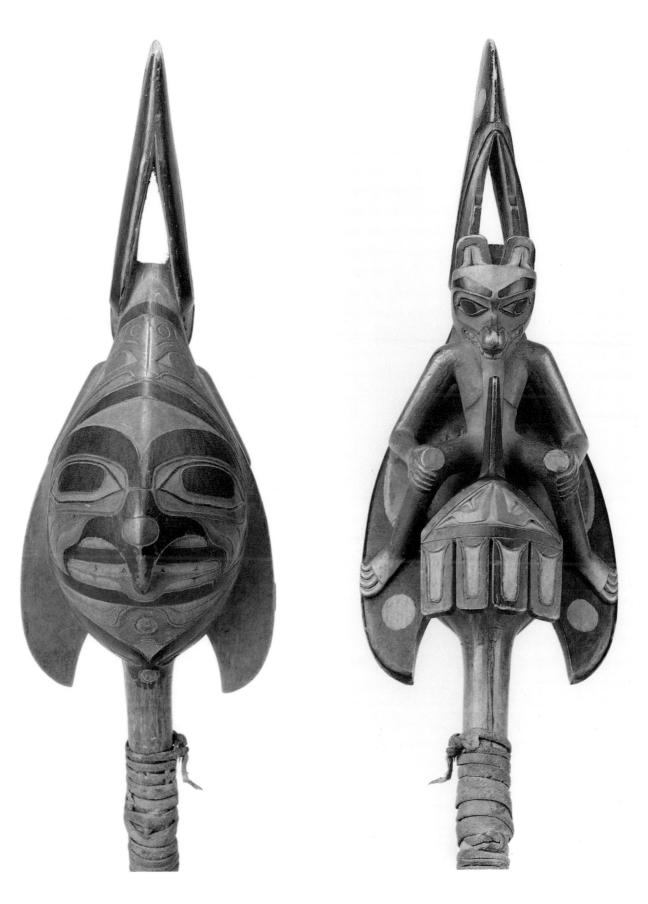

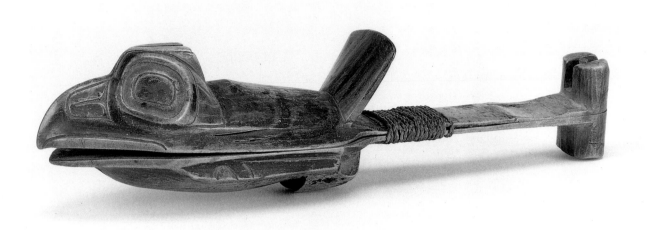

261

Tlingit

Bird clapper
Early 19th century
Wood, cord
l. 9 in (22.9 cm)
Acquired 1986 UEA 930

Clappers, or snappers, are much rarer instruments
than rattles and were mostly used in the northern
part of the Northwest Coast. They performed the
same functions as the rattles used by dancers and
orators on public occasions, but the sound they
produce is a sharp clap, which is more precise than
that produced by a conventional rattle. Clappers
were held horizontally in the hand, and by a quick
upward and downward motion the upper section was
caused to swing up and snap back against the lower
half. The flexible arm of the upper section of this
example has been broken and is glued and tied with
cord, possibly of cedar bark. A wooden peg through
the handle holds the two parts together.

 Clappers, as with rattles, are very often in the form
of a bird. This one seems to portray a fledgeling, with
broad immature beak, large eyes and chubby appear-
ance. The shape of the beak suggests this is young
raven, an identification which is also proposed by
Holm (1983: no. 21), who detects humour in the
image, appropriate to the trickster aspect of raven's
mythological character.

 There is a certain torpedo-like energy to the young
bird. The two feet are tucked back under the tail,
giving an impression of forward thrust. Stubby wings

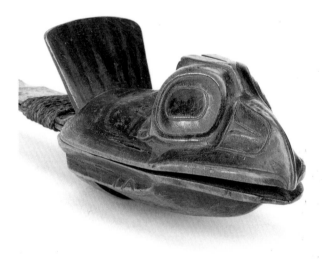

project on either side, but both are broken, and
formerly would have extended to at least twice their
current width. The two halves are both extremely
thin and have suffered cracking; black and red
painted designs on the back and breast are faded.

Provenance: Formerly in the collection of James
Hooper and John Hauberg (JH 54).

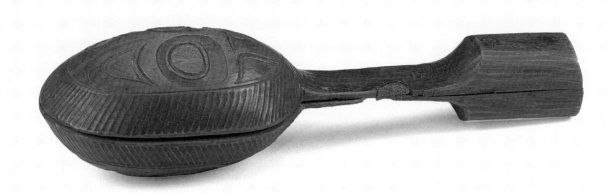

262

Haida or Tlingit

Clapper
Mid 19th century
Wood
l. 6¼ in (15.9 cm)
Acquired 1979 UEA 727

This small clapper is a simple, finely carved example
of this rare form of musical instrument. Both sides
of the globular sound box are carved with formline
designs, resembling faces, which are encircled by a
panel of fluted carving. This fluting is often associated
with the depiction of the cockle shell or other kinds
of shell fish, such as the chiton (see Holm and Reid,
1975 : 202), and this may have been the carver's
intention here.

Beasley's label attribution to the Haida does not
seem to be based on collection information, and as
the pale turquoise colour is often found on Tlingit
material, this clapper may be from farther north.
The two halves are fixed together by two wooden
pegs through the handle; one of the arms has been
broken and glued.

Provenance : Formerly in the collection of Harry
Beasley. Catalogue entry for 1931. 'A small clapper
carved with two conventionalised faces and partly
coloured. Bought from Sir Harry Verney, Bart.,
Steeple Claydon, Bucks. Collected by Capt. Edmund
Hope Verney, H.M.S. *Grappler*, in the Pacific, 1864.'
Verney became commander of H.M.S. *Grappler* on
25 February 1862.

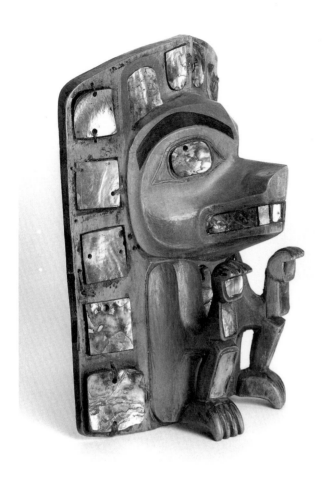

263

Kaigani Haida (?)

Head-dress frontlet
Mid/late 19th century
Wood, abalone shell, sinew
h. $7\frac{1}{2}$ in (19.1 cm)
Acquired 1974 UEA 590

Among the most dramatic examples of crest art on the northern Northwest Coast was the chief's dancing head-dress. This consisted of a carved wooden frontlet of the kind shown here, which was attached to the front of a cylindrical framework of baleen strips. The framework, which enclosed a skin cap, was decorated with ermine pelts hanging at the sides and back and had a 'coronet' of sea lion whiskers and flicker feathers (see Holm, 1983: 18-24). These head-dresses considerably increased the stature of the wearer, male or female, and were worn on formal occasions, notably at potlatch gatherings, where all participants wished to emphasise their status and abundant resources. Ceremonies of welcome involved dances, and Niblack (1888: 264) reports how costumed performers danced a welcome to their guests, and in doing so showered them in white eagle's down which had been placed for the purpose inside the framework of their head-dresses.

Besides the imposing impression created by these head-dresses, they were also significant because of the particular crest with which the frontlet part was carved. The creature portrayed here has many bear characteristics – curving claws, regular teeth and large, rounded ears. The original owner would have had the right to display the bear crest on his or her costume, for the display of crests was not random, but was linked to the clan to which an individual belonged and was justified by a mythical or historical event. Crests were intimately linked to status, and their display was a privilege. If an individual displayed crests to which he had no right, he was criticised, with resulting loss of prestige. The most eminent people had the right to display many crests, and these privileges were publicly validated at large-scale gatherings at which they acted as hosts.

This fine frontlet, probably carved from maple, is very thin and light in weight. Some of the abalone shell plates are glued-in replacements. The surviving original ones are tied on with sinew and appear to be old pendants which have been adapted for use as inlay. The left forepaw is a replacement.

Provenance: Reported by the vendor to have belonged to Son-i-hat, a chief of Kasaan, Prince of Wales Island, towards the end of the nineteenth century.

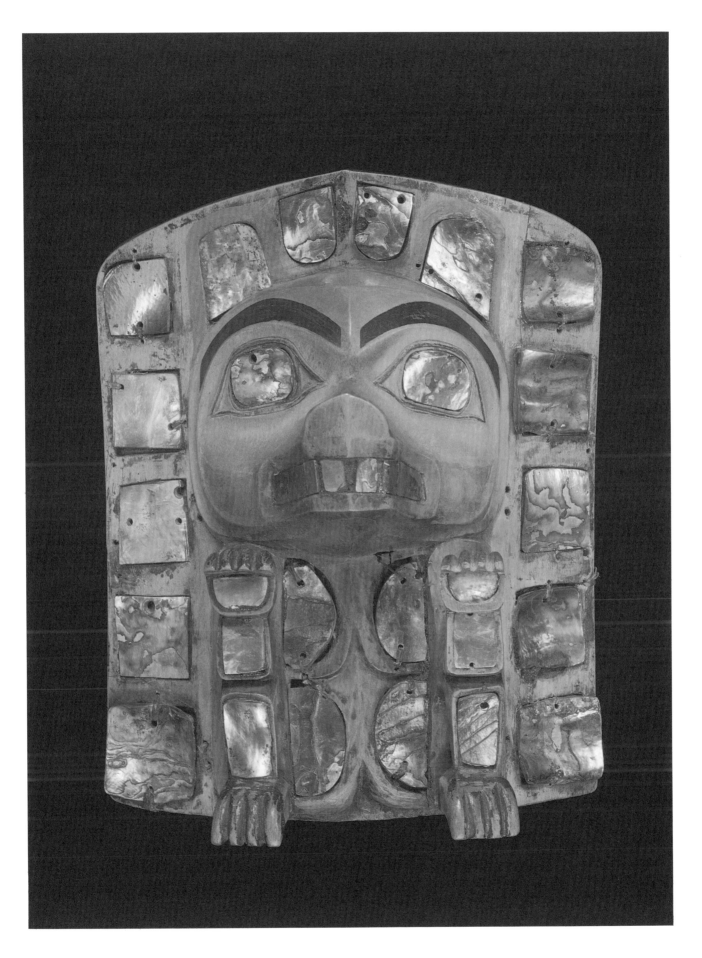

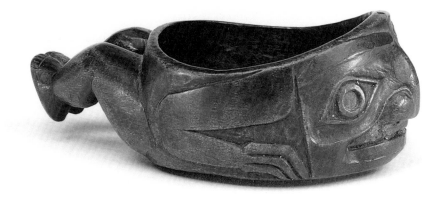

264

Haida (?)

Bowl with legs
Early 19th century
Mountain-sheep horn
l. 4¼ in (10.8 cm)
Acquired 1972 UEA 124

This delightful bowl is a good example of the imaginative use of form and proportion which distinguishes many of the best Northwest Coast sculptures. It is as if what interested the artist were the formal properties of a sculpture, and proportion and anatomical arrangement were modified to suit the general form of the object, whether it was a mask, mortuary post or bowl. The legs on this bowl are clearly human, but the arms and face have frog characteristics. Frogs, or, more properly, toads, appear frequently on carvings and in myths (see Jonaitis, 1986: 76).

Comparable material is scarce. The Haida of the Queen Charlotte Islands were expert horn carvers and the famous Haida anthropomorphic wood bowl in the British Museum, collected by Dixon (King, 1981: no. 49), has some features in common, but a precise attribution is not possible. The material is dark and has the general appearance of wood, but exposure to bright light shows it to be translucent and therefore made of horn. It may have served as a cup or dipper; there are deposits of oil. Two holes in the rim were for suspension cords and the eyes were probably once inlaid with abalone shell.

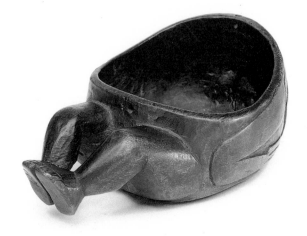

265

Northern Wakashan, Heiltsuk (?)

Head-dress frontlet
Late 18th/early 19th century
Wood, quills
h. 6⅛ in (15.5 cm)
Acquired 1975 UEA 627

This is a small and delicate frontlet in light wood which may date to the eighteenth century. It has no surrounding panels of abalone inlay, and relies for visual impact on paint (black, red and pale green, now faded) and on the boldly projecting beak of the bird.

This is identifiably a depiction of raven, who is often portrayed carrying a red object in his beak, standing for fire, or the box of daylight, that in a famous myth he is held to have introduced to mankind. There are numerous myths recounting the adventures of raven, a trickster who had the ability to transform himself into human and other forms. In this sculpture we have a reference to this human/bird

quality in the hands which rest on the knees, giving the wings the appearance of a cloak, an image which occurs in Tsimshian myths about raven (Boas, 1916: 60). Raven's body is carved as the face of another creature with a broad, toothed mouth. This is one of the conventions of Northwest Coast design, where a face can stand for a body, and eye forms can stand for the joints of wings or limbs.

This frontlet was once fixed at the base, neck and forehead to a head-dress framework (described for no. 263, UEA 590), but only a few feather quills remain of its former embellishments. It has been broken and repaired at the neck.

266

Makah or Westcoast (Nootka)

Baton/club
Late 18th century
Wood
l. 21½ in (54.6 cm)
Acquired 1967 UEA 129

Two very similar batons, now in the British Museum, were collected in 1778 during Captain Cook's third voyage (King, 1981: 67, pls. 5, 45). They have the same distinctive terminal, which has a V-shaped notch on either side, and differ only in the carving of the finial. Here a bird, possibly an owl, perches on a quadruped, its talons gripping the animal's eyes. This is an unusual feature which can be found on an early Nootkan mother and child sculpture, where the child has a finger in its mother's eye (*ibid.*: pl. 57).

The precise function of these batons is not known. They may have had some connection with fishing, the bulbous head being used to stun the fish, while the V-shaped lower part may have served as a device for removing a hook from the fish's mouth without endangering the fingers. The form is of some antiquity, for similar objects have been recovered from the Ozette site on the north Washington coast, dating to *c.* AD 1500 (see Kirk and Daugherty, 1978: 57; Daugherty and Friedman, 1983). Whether this club is Nootka or Makah in origin is not clear. The Ozette people were ancestral to the Makah, but the two British Museum examples have 'Nootka Sound' written on them. Tests carried out on them showed the wood to be yew (*Taxus* sp.).

Provenance: Formerly in the collection of Lord Lonsdale, Lowther Castle.

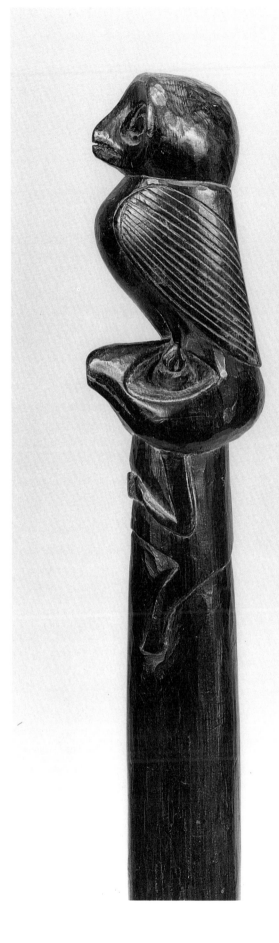

267

British Columbia/Washington/Oregon

Pendant in the form of a head
18th century or earlier
Stone
h. 1⅜ in (3.5 cm)
Acquired 1982 UEA 839

There is a long tradition of expert stone sculpture from the Northwest Coast and the area inland and to the south (see Duff, 1975). Dating this material is problematic, since some examples are at least three thousand years old (Borden, 1983), while others were collected by European visitors in the late eighteenth century (King, 1981 : pl. 41). This small pendant has no provenance, except a suggestion from the vendor that it comes from the Dalles area on the Columbia River. No precisely comparable carving has been found in the available literature, but it is likely to be from this area and to be many centuries old.

The back is slightly concave and the eyes, brows and nose are smooth and polished. The aperture for the suspension cord has a figure-of-eight form with two holes, both drilled from the front. Such precise drilling must have been difficult, but two suspension holes allow a pendant to lie flat, and this functional and aesthetic requirement probably prompted the extra work. This stone is harder than steatite, the stone most frequently used for sculpture in this area.

North America: General

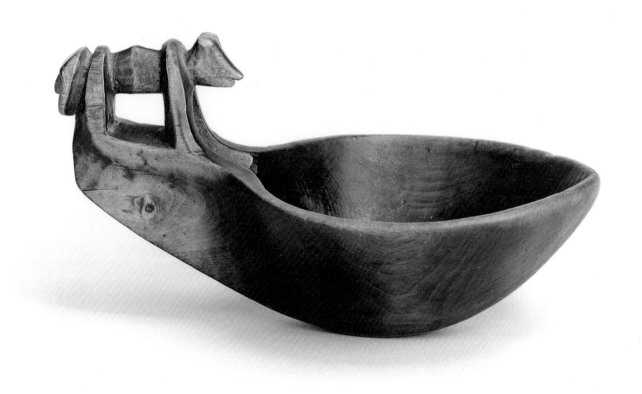

268

Washington/Oregon: Wishram or Wasco

Ladle with animal handle
19th century
Wood
l. 6⅝ in (16.8 cm)
Acquired 1975 UEA 634

This is a rare type of ladle from the Wishram or Wasco people of the
Columbia River region, which has a wolf-like quadruped forming
the top of the handle (see another in Conn, 1979: no. 347). In addition,
this one is carved with a small human head facing in the opposite
direction, visible in the detail. A deep groove runs along the underside
of the bowl, coming to a point at the lip. The wood is darkened and
saturated with oil, probably fish oil, suggesting a long period of use.

269

Washington/Oregon: Wasco

Basket
Late 19th/early 20th century
Hemp, corn husk, cloth, leather
h. 10½ in (26.7 cm)
Acquired 1976 UEA 637

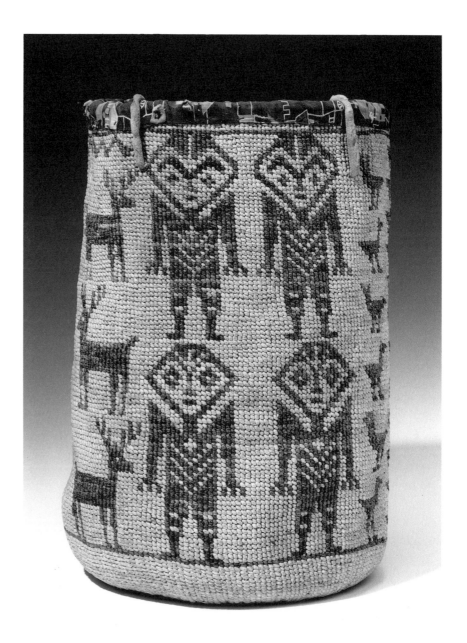

Wasco twined baskets of this kind are popularly called sally bags and
were used as carrying baskets – remains of two leather straps can be
seen near the rim. Mason (1904: 439) noted that they were 'made in
plain twined weaving over warp of rushes, the patterns being effected
by overlaying the twine of hemp with strips of fiber that in structure
resemble corn husks'.

 This example is in good condition, with patterns in the shape of four
human figures, six deer with antlers, seven geese (?), twenty-eight fish
and six birds with spread wings. The human figures are of two types,
differing in details of the face, which may mean that both sexes are
represented. The rim of the basket, as in many examples, is sewn with
a border of European cotton cloth. The central section of the base is
darker brown in colour.

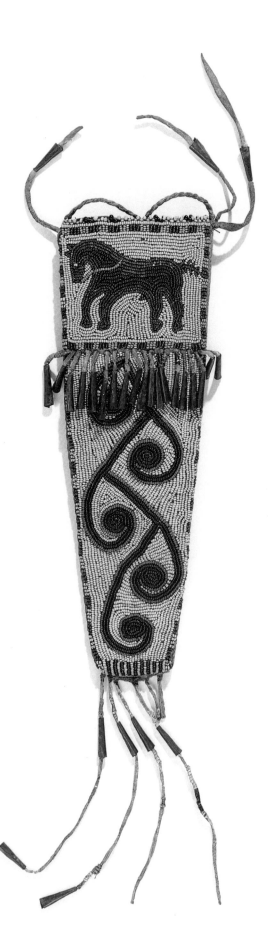

Northern Plains: Plains Ojibway (?)

Knife sheath
Late 19th century
Skin, beads, quills, tin
l. 9 in (22.9 cm) excluding tassels
Acquired 1979 UEA 703

The form of this knife sheath, with an upper panel
and tin-cone pendants, points to a northern Plains
origin, possibly Plains Ojibway. The rounded form of
the horse and the scrolling fronds indicate a Wood-
lands design influence, which is often present in late
nineteenth-century beadwork from this area.

The horse and fronds are in dark and pale blue glass
beads on a pink/mauve ground. Green, red, black and
yellow beads form the borders to the main designs,
and red, black and white quills are bound round the
tassels; the back is plain. European glass beads had all
but replaced local shell beads in most areas of North
America by the mid nineteenth century.

Provenance: Formerly in the collection of Josef
Mueller (Christie's, 1979: lot 4).

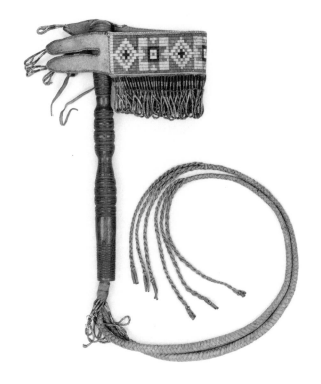

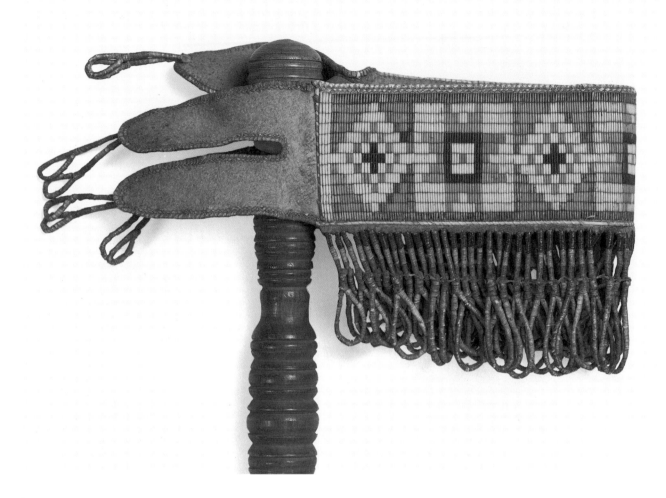

271 (*opposite and above*)

Northern Plains: Red River Cree

Quirt with quillwork wristlet
Early/mid 19th century
Wood, leather, quills
l. (handle) 11½ in (29.2 cm)
Acquired 1978 UEA 687

The form of this quirt is typical for the northern Plains, but the fine quillwork panel which decorates the wristlet is recognisably Cree work. Colin Taylor (personal communication, 1988), who dates the panel to the 1820s, suggests that it originates from the Red River Cree, who lived on the margins of the Plains, west of the Great Lakes (see also Coe, 1976: nos. 392, 394). Quillwork from the northern Plains is usually sewn directly into the buckskin, but the Cree and other peoples of the western Woodlands and forests perfected a loom-weaving technique, resulting in finely detailed panels of the kind shown here (see Orchard, 1971: 54-8).

The completed quill panel is sewn to the wristlet, which is tied to the wood handle through a hole near the top. The handle has been turned, and may once have been part of a chair or other piece of furniture. A cavity has been bored in the end, where the whip thongs are fixed by a single wooden pin. The looped quillets on the wristlet and the base of the handle show that all the parts are contemporary and belong together. Porcupine quills, which were traded widely, were split and dyed prior to use.

Provenance: Formerly in the collection of Harry Beasley.

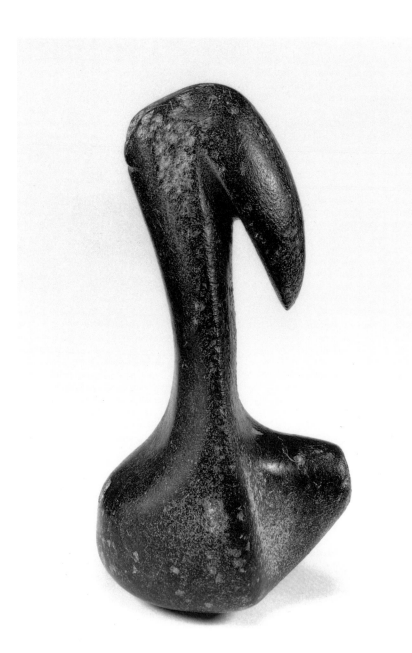

Southern California: Chumash

'Pelican stone' image
18th century or earlier
Steatite, asphaltum
h. 5⅜ in (13.6 cm)
Acquired 1971 UEA 133

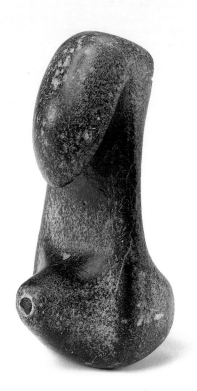

Objects of this kind have been found at many sites in southern California and on the offshore islands, but very little is known of their former use, nor have they been precisely dated, though the area has been occupied for many centuries. They have been called 'pelican stones' because the hook projection resembles the beak of the pelican, which is an expert fisher. Hudson and Blackburn (1986: 174) suggest that they may have been used as fishing talismans. The Chumash subsisted by hunting and fishing; they did not practise agriculture.

Steatite, a soft stone quarried on Santa Catalina Island, was used by the Chumash for a variety of items, including pipes and zoomorphic images (see Burnett, 1944). Many of these are decorated with shell discs set in asphaltum, which occurs naturally in seeping pools. A disc, now lost, was formerly set into the asphaltum plug in the 'navel' of this image. There is an engraved line across the back of the head. The number 19/30 is written in black ink on the base.

273

Southern California: Chumash

Bird image
18th century or earlier
Steatite, asphaltum, shell
l. 3⅛ in (7.9 cm)
Acquired 1962 UEA 134

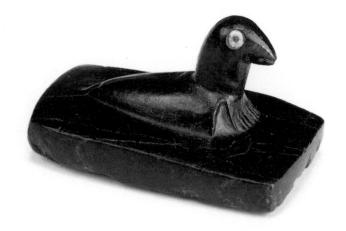

The materials from which this object is made suggest immediately
that it is of Chumash origin, but nothing comparable has been found in
the literature. It is carved as a swimming (?) bird on a flat rectangular
tablet, smooth on all surfaces. It could have served as a polisher or as a
warming stone used in medical treatment (see Hudson and Blackburn,
1986: 276). The eyes are inlaid with shell discs set in asphaltum.

Provenance: Formerly in the Montrose Museum, Scotland.

274

Southwest (?)

Head of a ram
19th century (?)
Bone
w. 3 in (7.6 cm)
Acquired 1973 UEA 504

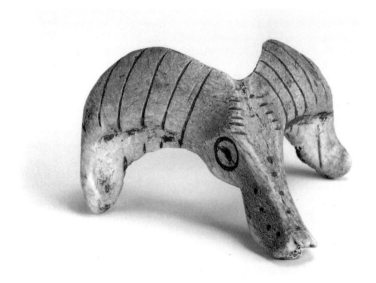

The origin and function of this small ram's head is uncertain. However,
Dockstader (1978: no. 291) tentatively attributed it to the Zuni, and ram
carvings in stone from this area are illustrated by Maurer (1977: nos.
293, 322). The bone has been shaped, and has been identified by Dr
Adrian Friday, of the Cambridge University Museum of Zoology, as the
occipital condyles and base of the brain case of an ungulate, probably a
small horse. The eyes, lines and dots are marked in dark pigment.

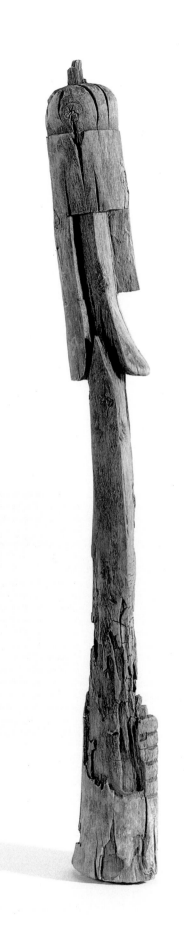
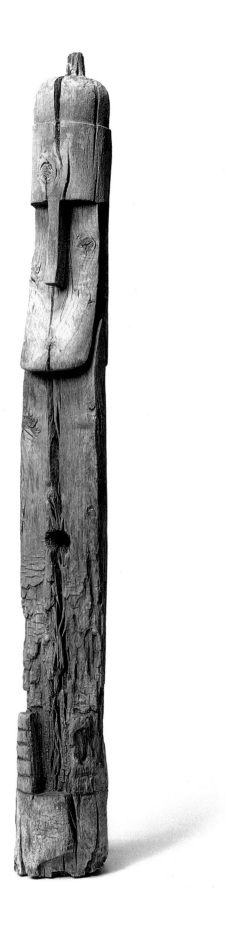

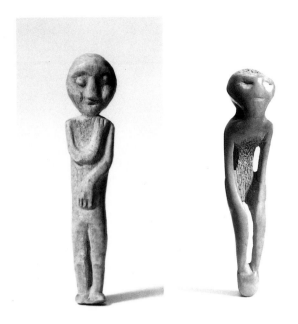

Eastern Great Lakes: Iroquois (?)

Three pendant figures
16th/17th century
Antler or bone
h. $2\frac{3}{8}$ in (6.0 cm); $2\frac{5}{8}$ in (6.7 cm); $4\frac{1}{2}$ in (11.4 cm)
Acquired 1986 UEA 932 A-C

These rare pendants, each pierced through the neck, have no provenance, but are comparable to antler figurines which were excavated from Dutch Hollow, a Seneca site in northwest New York State, dating to about AD 1600 (Mason, 1981: 381). The Seneca were the westernmost of the Iroquois confederation, living to the south of Lake Ontario. The distinctive arm position of no. 277 can also be found on a pendant from Ontario (Boyle, 1895: fig. 206).

275 (*opposite*)

New Mexico: Zuni

War god image
Late 19th/early 20th century
Wood
h. $30\frac{1}{4}$ in (76.8 cm)
Acquired 1970 UEA 135

Images of this kind, representing the elder and younger brother war gods, played an important role in two major rituals of the Zuni, the winter solstice ceremonial and the scalp ceremonial (see Stevenson, 1904: 113 ff., 578 ff. and Parsons, 1939). Images were carved from cottonwood for the annual winter solstice ceremony, then painted and bound with bundles of feather prayer sticks. After receiving offerings the figures were placed in a shrine outside the village, where they were left to decay. Stevenson stated that the 'Gods of War are thus honoured that they may intercede with the rain-makers for rains to fructify the earth' (1904: 116; pl. XXII). Similar offerings of feather prayer sticks and food were made to the war gods during the scalp ceremonial. On these occasions the figures were made from lightning-struck pine.

This figure, which is probably pine, has lost all its paint, except for some red traces around the 'fingers' on the base. It has also decayed around the body where the offering bundles were attached. The hole in the body once held a wood projection, which early accounts identify as the navel, but which Parsons (1918: 396) suggests has phallic significance.

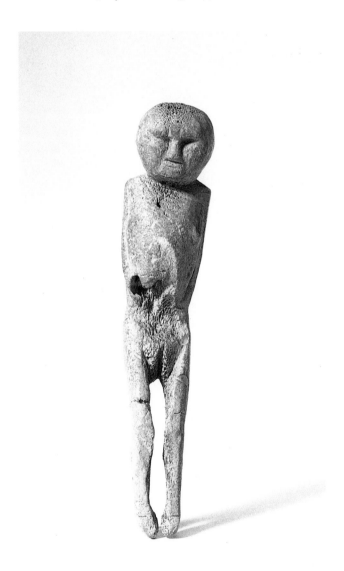

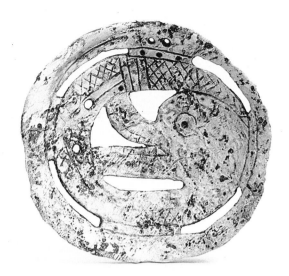

279

Southeast, Mississippi

Rattlesnake gorget
Mississippian; *c.* AD 1300-1600
Marine shell
w. 3¾ in (9.5 cm)
Acquired 1982 UEA 840

Shell gorgets of this kind have been found in many
parts of the southeast. They represent a rattlesnake
with large head, gaping jaws and short body ending
in a hatched design representing the rattle. Holmes
(1883: 290) noted that it is very rare for the snake to
be facing the viewer's left – as in this example (see
also one from Georgia in Moore, 1897: fig. 19). The
serpent occurs frequently in the iconography of the
southeast, and Penney (1985: 189-92) discusses its
symbolic association with death and the underworld.
When found in controlled excavations these gorgets
are usually associated with burials. Similar examples
have been found in mounds in Tennessee (Holmes,
1883: pl. LXII, 2; Kneberg, 1959: nos. 39-44; Dickens,
1982: no. 44).
 The shell is probably a section of the outer whorl
of *Busycon perversum*, the concave inner surface of the
shell being used for the engraving. This has been con-
siderably eroded, and a former owner has attempted
to emphasise with graphite the markings of the eye,
teeth, tail and other features. The gorget was worn
suspended from the two small holes at the top.

Provenance: Formerly in the collection of Ralph Olson,
Deerfield, Illinois. Reported to have been found in
De Soto County, northwest Mississippi.

280

Southeast, Alabama

'Forked-eye' mask
Mississippian; *c.* AD 1400-1600
Marine shell
h. 5⅝ in (14.3 cm)
Acquired 1983 UEA 842

The Mississippian period (*c.* AD 1000-1600) designates
an era when the southeast was inhabited by peoples
practising agriculture who lived in numerous settle-
ments around major political/ritual centres such as
Spiro, Moundville and Etowah. Information about
these chiefdoms is available from archaeological
excavations and from the reports of early European
visitors, notably De Soto, who travelled in the region
in 1539. It is clear that these peoples had extensive
long-range trade networks, especially in high-value
ritual materials, such as marine shells from the
Atlantic and Gulf coasts, and copper from sources
near Lake Superior (Brown, 1975: 26). Marine shells,
notably *Busycon perversum*, the left-handed whelk (so
called because the direction of the whorl is sinistral
and opposite to that of other whelks and related
shells), were associated with the elites of Mississippian
societies. Large numbers of shell cups, gorgets, beads
and, later in the period, masks, have been found in
elite burials at the major sites. Masks are usually
found with males or infants (Kneberg, 1959: 27).
 This well-preserved mask is cut from the outer
whorl of the *Busycon* and, in common with others, is
plain on the back and shows no signs of having been
worn. It is distinguished by an engraved 'forked-eye',
a design associated with the eye markings of the
peregrine falcon, a raptor famous for its speed and
spectacular aerial attacks. Brown (1975: 22) considers
'the essential element of the falcon is represented
by the forked-eye motif, which is one of the more
distinctive and widespread motifs in late Prehistoric
North America . . . The falcon emerges as a major
symbol of aggressive warfare, and is indeed appro-
priate to employ as a symbol of fierceness and
boldness.' The forked-eye design seems to have been
connected with an elite warrior status, termed by
Brown (1985: 114-23) the 'falcon-impersonator',
members of which are often depicted with weapons
and a feathered cape.

Provenance: Formerly in the collection of Ralph Olson,
Deerfield, Illinois. Reported to have been found on a
farm at Bridgeport, northeast Alabama.

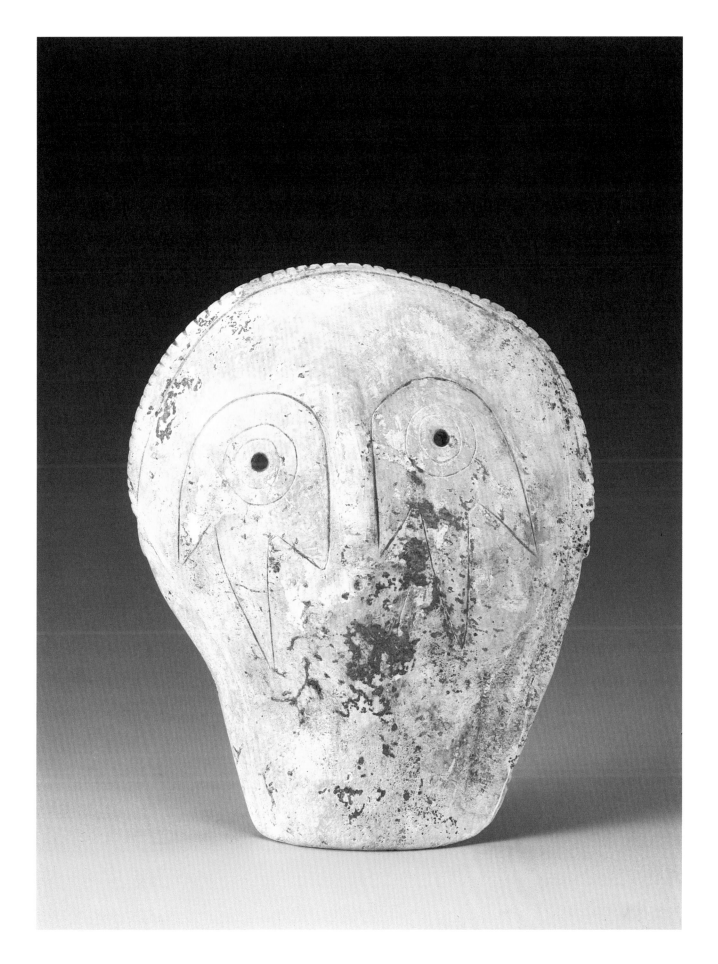

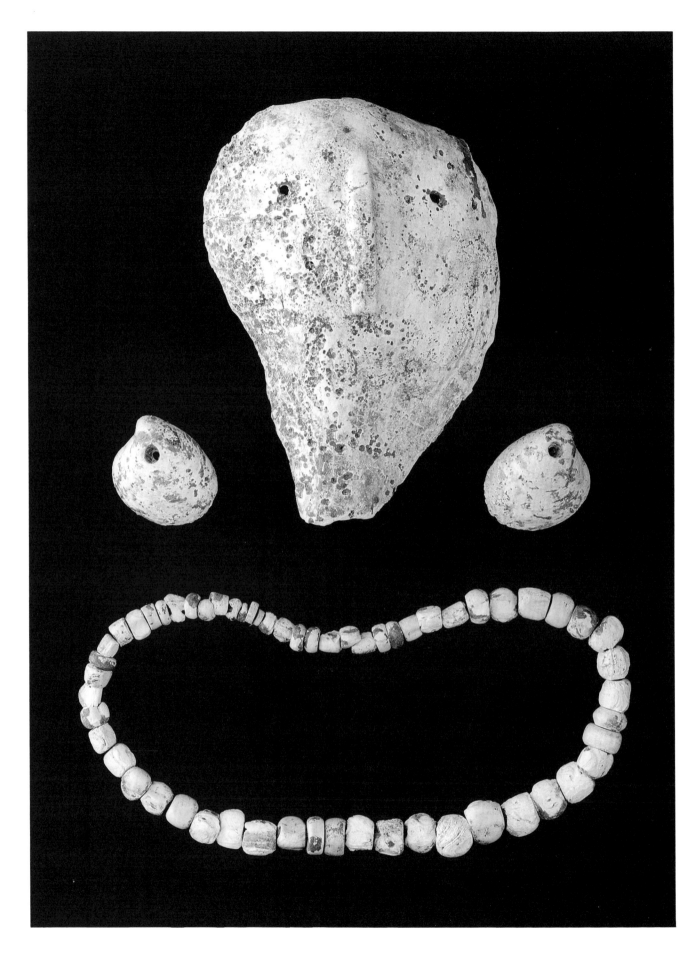

281

Southeast, Tennessee

Mask, beads and pendants
Mississippian; *c.* AD 1300-1600
Marine shell
h. (mask) 8 in (20.3 cm)
Acquired 1981 UEA 791

This mask is a simpler form of the 'forked-eye'
mask (no. 280, UEA 842) but is probably contemporary
with it. There is no engraving or mouth, but the nose
is shown as a long flat ridge. Shell masks appear in
burial contexts late in the Mississippian period, but
beads have been found in a wide number of sites
spanning the entire period. These beads are probably
a selection from the 551 which were found with the
mask (see below). Like the mask, they are made from
the shell of the *Busycon perversum* (see previous entry),
but from the central columella of the shell. To make
beads the columella was cut into short sections, each
of which was then drilled, a laborious process in the
absence of metal tools (see Fundaburk and Foreman,
1957: pl. 155). Beads were worn as necklaces, bracelets
and anklets, and were also suitable for use as offer-
ings. Turner (1985: 206), referring to John Smith's
account of 1607-9, notes how copper and shell beads,
both exotic materials acquired over long distances,
were used as offerings to the gods and ancestors in
Virginia.

 The two bivalve shells (probably freshwater mussel)
have a slight iridescent quality and are pierced from
the convex side. They appear to have been ear pen-
dants, but are atypical, since ear pins were the usual
ear ornament during the Mississippian period.

Provenance: Removed in 1968 from a burial at the
Holliston Mills site, Hawkins County, northeast
Tennessee, by Elmer Austin of the Tennessee
Archaeological Society (information courtesy Dr
Jefferson Chapman, Frank H. McClung Museum,
University of Tennessee, who writes, 'the site is
essentially late Mississippian, *c.* AD 1300-1600. It was
excavated by various members of the Kingsport
Chapter of the T.A.S., beginning in the late 1960s.
Unfortunately, the work was done entirely by ama-
teurs with no professional supervision'). A burial
record by Austin states that the shell 'gorget' was
found above the skull of a child, with 551 shell beads,
some around the head, others scattered. There is no
mention of mussel shell pendants, so these may not
be from the same site.

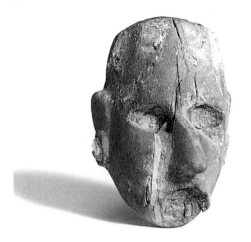

282

Oklahoma, Spiro

Head
Mississippian; *c.* AD 1200-1350
Red cedar, shell
h. $2\frac{1}{4}$ in (5.7 cm)
Acquired 1986 UEA 933

Although this small head has no provenance, it is
very similar to about forty others which are known to
have come from the Craig Mound at the Spiro site in
Le Flore County, eastern Oklahoma (Burnett, 1945:
pl. LXXVIII; Brown and Hamilton, 1965: 52). These
heads are of red cedar with shell inlay in the eyes, ears
and mouth. Many have green deposits on them, as
here, indicating their burial association with copper
objects, fine repoussé examples of which have been
found at Spiro (see Brose *et al.*, 1985: pl. 101). The back
of this head has a large oval recess, with small holes
drilled through above and below each ear, suggesting
that it may once have been attached to a body or
some other object. It has been crushed, and the right
cheek repaired with pale wood.

 The Spiro site was one of the main ceremonial
centres during the Mississippian period. Mounds with
numerous wood, shell, copper and stone burial goods
have been found there (see Brown, 1975, for a discus-
sion of Spiro art and mortuary practices). This head
was almost certainly obtained there during the mid
1930s, when commercial diggers removed large quan-
tities of material before controlled excavations were
undertaken (see Clements, 1945: 48-68).

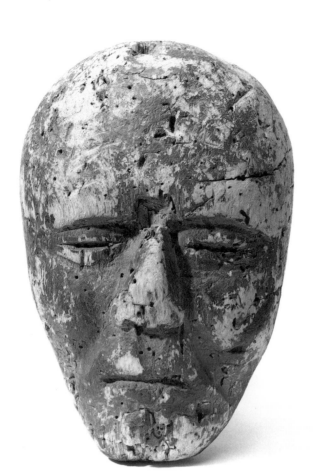

Southeast, Florida (?)

Head
(?) Late Woodland period;
c. AD 500-1000
Wood
h. 8¾ in (22.2 cm)
Acquired 1981 UEA 790

This life-size head has a circular recess in the neck, and was therefore
probably originally fitted to a wood body or post. It has no collection
data, nor have comparable heads been found in the available literature,
so any observations as to its age or origin remain speculative. A test by
the U.S. Department of Agriculture found the wood to be a species of
Erythrina, possibly *E. herbacea*, which is native to the southeast region.
The wood has suffered abrasion, insect damage and cracking, the last
consistent with having dried out after saturation. Animal images from
the Fort Centre site in Florida, dating to the late Woodland period, were
preserved by immersion in the swamp (Sears, 1982: 38 ff.), and this head
may have had a similar history.

 Wooden images, some of them large, were made in the southeast
(Fundaburk and Foreman, 1957: pl. 141), and Brown (1985: 104) suggests
that they represented the founding ancestor of the group to whom they
belonged. This head has traces of brown paint, especially on the face.
There are also three black lines on the left cheek, radiating from the
temple, and a broad black line from the right eye to the corner of the
mouth. Three wood pegs remain in the top of the head, and there are
holes for others, indicating that hair may once have been attached.

Provenance: Formerly in the collection of J.C. Leff, Pennsylvania.

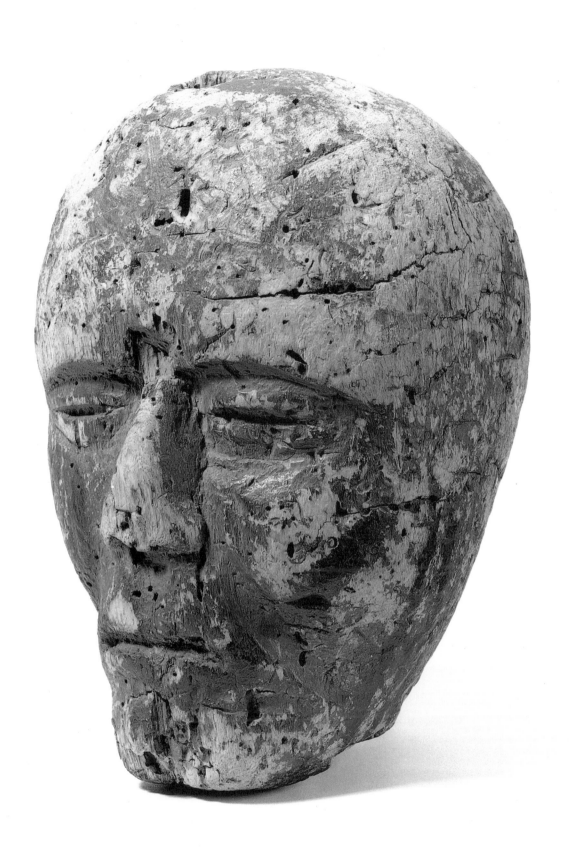

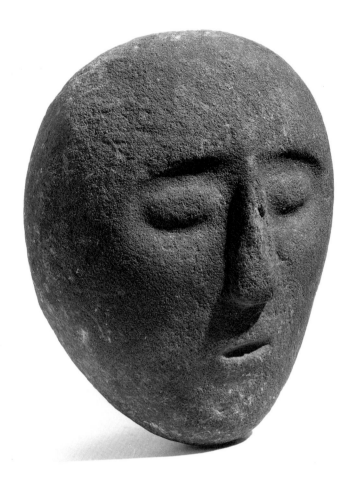

Southeast, Kentucky

Head
Mississippian; *c.* AD 1200-1500
or earlier
Sandstone
h. 6½ in (16.5 cm)
Acquired 1981 UEA 810

This head shows no signs of having been attached to a body, although
it is similar in size to heads of sandstone figures from mounds in Georgia
and Tennessee which date to the Mississippian period (see Brose *et al.*,
1985: pls. 139-40; Fundaburk and Foreman, 1957: pl. 97). It is flattened
in shape and the back is slightly dished, with a shallow depression in
the centre. The stone is darker in some areas than others, and the nose,
formerly more prominent, has been damaged. The mound context in
which it was found (see below) suggests it accompanied a burial, and it
may have been a memorial head connected with the ancestor cult of the
Mississippian period.

Provenance: Formerly in the Matatuk Museum, Naugatuck, Connecticut.
An inscription in white ink on the back states, 'Greenapsburg Co. From a
mound, Kentucky. Cast of this in National Museum, Washington, D.C.'
Dr Adrienne Kaeppler has kindly supplied the information that a cast of
this head was indeed made by the Smithsonian Institution in 1877, when
the head belonged to R. W. Mercer, a dealer of Cincinnati, Ohio. Mercer
wrote in a letter to the museum (May 26th, 1877), 'The face was taken
from a mound in Greenup Co., Kentucky years ago. The label was so
near gone I could only see *Mound Greenup Co. Ky.*' Greenup County (not
Greenapsburg) is in the extreme northeast of Kentucky.

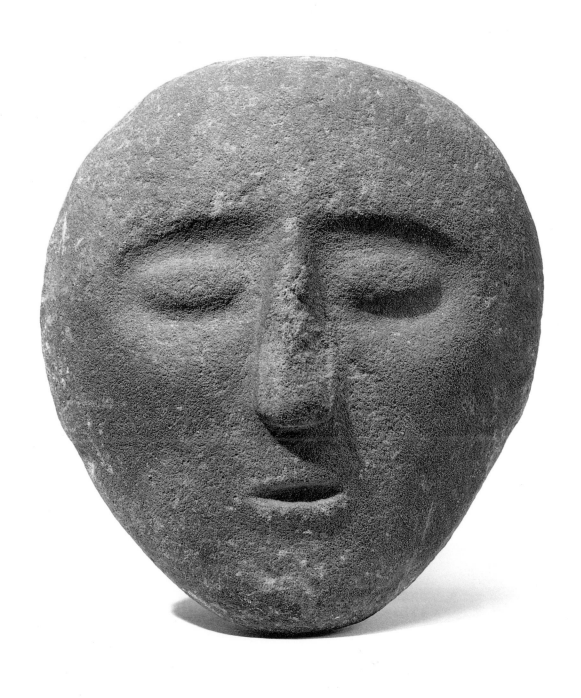

Appendix

The George Brown Sculptures from New Ireland

The six works of art which appear on the following pages were part of the large ethnographical collection formed by the Reverend George Brown (1835-1917) during his residence in the Pacific as a Methodist missionary. He served in Samoa (1860-74) and the Bismarck Archipelago (1875-80), followed by a long period in administrative positions, based in Sydney, until his retirement in 1908. During his career he also visited Fiji, Tonga and other parts of the western Pacific. Further information may be found in his autobiography (Brown, 1908) and in Ryan (1972: 124-7). His papers are in the Mitchell Library, Sydney.

Although firm evidence has not yet come to light, it is most probable that these sculptures were obtained by George Brown during his period in the Bismarck Archipelago. One likely occasion was during his only personal visit to northern New Ireland. On Tuesday, 28 October 1880, on the northwest coast near to Sandwich Island (Dyaul), he wrote, 'The natives in this part brought off great numbers of most grotesque-looking wooden masks, and also some rather elaborate wood-carvings, some of them being representations of the hornbill (Buceros ruficollis), and others representing iguanas eating snakes, etc. These they readily sold for hoop iron' (Brown, 1881: 217). Technical and iconographic details support an 1880 date. European cloth and woollen yarns, not present here, began to be used later in the nineteenth century; red and black chequer designs and marine sponge, present here, appear on pieces in Berlin which are known to have been collected in 1875 (see Helfrich, 1973: nos. 7, 63, 74-5, 116).

Some of the George Brown material was acquired by the Australian Museum in Sydney, while the rest was sold in 1920 to Bowes Museum in County Durham, near where he was born. In 1954 this collection was acquired by King's College, Newcastle (later Newcastle University), who, in controversial circumstances, sold it in 1986 to the National Museum of Ethnology in Osaka, Japan (see Benthall, 1986; Powell, 1986). Export licences were withheld for a number of items, which gave the University of East Anglia the opportunity to acquire some of them.

New Ireland

The peoples of northern New Ireland, New Hanover and the Tabar group are justly famous for the sculptures and masks which are associated with the complex ceremonial cycle known as *malagan*. This term (also spelt *malangan* or *malanggan* to stress the hard G) is used both for the cycle of ceremonies and for the elaborate sculptures which were produced for display at the climax of the cycle. Masks, although worn in dances which were performed during the later stages of *malagan*, are not usually included under this general term.

The *malagan* cycle of the nineteenth century took the form of a series of ceremonies and feasts which involved the whole community, and covered all those fields of activity which in western societies would be separated out under the headings religion, economics and politics. In the same way as the annual cycle of the Christian calendar was once the focus of the lives of rural people in Britain, so was *malagan* the focus of the lives of the people of New Ireland. Through *malagan* the dead were honoured, political leadership was exercised, kinship was strengthened, youths were initiated into manhood, and transactions in valuables and food were greatly stimulated. The system of *malagan*, with its associated carvings, is locally considered to have originated on the Tabar Islands, whence it spread to central and northern New Ireland and New Hanover (Lavongai).

The ostensible purpose of *malagan* was to honour the ancestors, in particular the recently deceased. They were thus memorial rituals on a grand scale. However, the actual process of *malagan* in all its complexity, spanning many months or even years, involved the production, presentation and distribution of large quantities of food – pigs and root vegetables in particular – as well as numerous transactions connected with rights to commission carvings, and the actual carving of them by specialist craftsmen. Although there were nominal 'chiefs', political power and influence resided to a large extent with those capable of co-ordinating successful *malagan* ceremonies and feasts. The sponsoring of a *malagan* sequence by a relative of the deceased was a way in which a man could increase his prestige and influence in the community. Superior qualities of leadership were required to carry off such major enterprises, and the sponsor, or host, and his numerous helpers, who prepared and distributed large amounts of food and shell valuables, derived great renown from their liberality. The recipients of this liberality, temporarily enriched, acquired the means by which to initiate their own cycle of ceremonies and thereby improve their own status.

Crucial to the climax of the memorial ceremonies was the display of elaborate carvings, brightly painted and animated with opercula eyes. Any sponsor of *malagan*, to be considered successful, needed to have carvings made for display, and he could not commission carvings to be

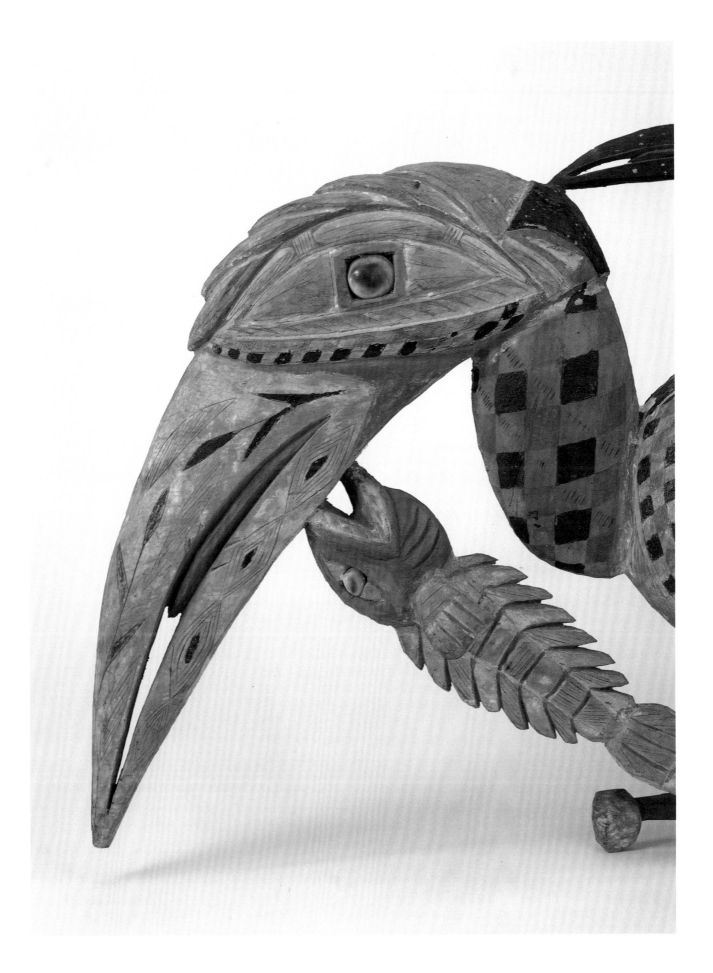

made for this purpose without owning the right to do so. Owners of the 'copyright' to particular types could be persuaded to transfer this copyright in exchange for feast foods and shell valuables. Once rights to particular *malagan* designs were acquired in this way, the sponsor could then commission a skilled carver to reproduce them – a transaction again involving food and shell valuables.

Completed carvings, which had hitherto been kept hidden from women and uninitiated males, were displayed in a special enclosure at the climax of the memorial ceremonies. This enclosure took the form of an open-sided house or tall, leaf-covered back-drop to which carvings could be fixed. Afterwards the carvings were discarded, or sold to visiting Europeans, since it was the right to reproduce the carving, not the carving itself, which was of enduring value. The right to the design remained with the sponsor – who could commission new carvings for a subsequent *malagan*, or 'sell' the copyright to another man who was marshalling resources for a different *malagan* cycle.

Various types of sculpture were appropriate to *malagan* displays – figures, friezes, panels and posts – most of which are characterised by openwork carving depicting humans, birds, snakes and fish. No full explanation of this imagery has been made, or is indeed now possible, although ancestral and mythical episodes are no doubt relevant to any analysis, as well as the cosmological domains of sky, earth and sea. The wood used for most *malagan* carvings is *Alstonia*, which is relatively soft and light and lends itself to intricate designs, especially when metal tools are used. Metal knives and axes were among the first items obtained from Europeans, and after the mid nineteenth century they were generally available to New Ireland carvers, so it is most probable that these sculptures were made with metal tools.

Excellence in carving and painting was clearly admired in *malagan* objects, as these and other early examples show, but the aim was to achieve maximum dramatic impact during temporary ritual display, not a permanent work of art. A musical analogy may perhaps help explain the New Irelanders' view. It is as if an orchestra had the exclusive right to perform a particular work. This they did from time to time, giving considerable pleasure to a live audience by the excellence of their performance. This re-creation of the work of art was, however, transitory, and after the performance nothing remained except the right to perform it again and the knowledge of how to perform it well.

The apparent lack of regard for carvings and masks, once they had fulfilled their ritual purpose, in part explains why so many were collected by German and other expeditions in the late nineteenth and early twentieth centuries. There was also an increase in local production at this period, both as a response to European demand and as a means of obtaining shell currency and cash. Extensive changes took place in New Ireland society during the second half of the nineteenth century, the result of contact with European traders and missionaries, 'blackbirding' (enforced labour recruitment) and German Colonial administration (1885-1914). Further changes have continued to take place during the twentieth century, though *malagan* persists, albeit in modified form. Lincoln (1987), Lewis (1969, 1973, 1979), Wilkinson (1978), Groves (1934-5, 1935-6, 1936-7) and Powdermaker (1933) provide accounts of New Ireland society in general and of *malagan* in particular.

285

Northern New Ireland

Hornbill carving
Late 19th century (*c.* 1880)
Wood, shell, opercula
l. 32 in (81.3 cm)
Acquired 1986 UEA 942

This is an exceptional sculpture of the Papuan hornbill (*Aceros plicatus*), a large, noisy, fruit-eating bird, with distinctive behaviour (see Rand and Gilliard, 1967: 302-3), which inhabits the forest canopy of New Ireland and neighbouring islands. Hornbill sculptures are rare; comparable examples are in Hamburg and Berlin (Krämer, 1925: pls. 71-2), and Sydney. The Hamburg hornbill was acquired in 1886 from the Godeffroy Museum, which had ceased to function after the company of the same name became bankrupt in 1879. It is described as being part of a *Totenboot* (mortuary or death boat; Führer, 1984: no. 247), an assembly of human and animal carvings mounted in a canoe which was displayed at the climax of *malagan* rites. This example has a hole pierced through the body of the human figure, but whether this was for mounting on a canoe is not known.

Interpretation of the symbolic significance of this and other *malagan* sculptures is problematic. The relationship between the hornbill, frigate bird (on the back), two skeletal fish and prone human figure may have been interpretable in the original context of display, but no longer. Small carvings of hornbill heads are known to have been held in the teeth by dancers, whose movements imitated those of the bird (Lincoln, 1987: nos. 20, 43).

The eyes of both birds are set with the opercula of the *Turbo petholatus*, a hemispherical valve which seals the entrance to the shell when the animal is alive. The eyes of the figure are small chips of shell with a banded pattern. The broken right leg of the figure and right tail feather of the frigate bird are old breaks, visible in the earliest published photograph (Brown, 1908: 200). The piece is likely to have been collected by George Brown in 1880 (see quotation above on page 305).

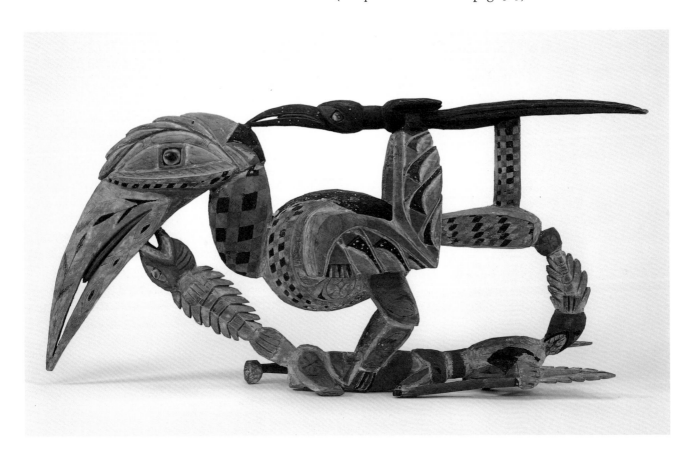

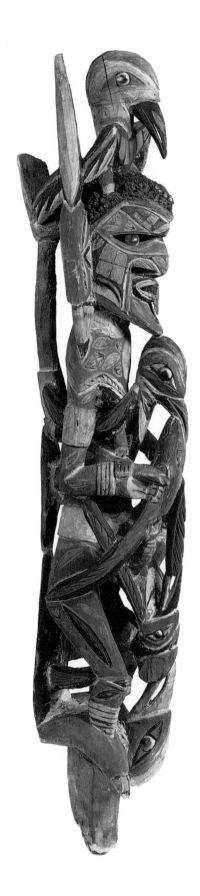

286

Northern New Ireland

Figure
Late 19th century (*c.* 1880)
Wood, fibre, opercula
h. 36½ in (92.7 cm)
Acquired 1986 UEA 944

Complex figures of this kind were made to be set up
in a special enclosure and put on public display at the
climax of *malagan* ceremonies. Once the 'copyright'
to a particular design had been obtained by the spon-
sor of a *malagan*, a specialist was commissioned to
complete the work of carving and painting. This was
done in a private enclosure, lest women or the unini-
tiated saw the carvings before their display. The form
of the carving followed a verbal description of the
design, as previous examples were not available to
copy. Sculptural forms were thus subject to a process
of continuing reinterpretation, based on memory,
the stylistic and other implications of which have
been discussed by Kuechler (1987).

Tibor Bodrogi (1987: 21-27) summarises the role
of sculptures in *malagan* mortuary displays. He states
that figures can represent particular people who have
died, the ancestors generally, or mythical characters.
Spirits were present in the images during the ritual
display, but afterwards they departed, allowing the
images to be discarded or otherwise disposed of.

This example consists of a single standing figure
with a bird perched on its head. A second bird (its tail
turned up behind) seems to emerge from and enclose
the chest of the figure, while a third bird, upside
down, emerges from the figure's waist. The head of
a fourth bird rises from between the feet of the figure
and grips the head of the third bird, which in turn is
connected to the figure's penis. The two central birds
clasp a flying fish in their beaks, and up the back are
further fish-like carvings. The figure has a hollowed
head and enlarged forefingers. White ankle, wrist,
arm and breast ornaments are indicated. The left ear
projection is broken, as is something which was once
held in the figure's mouth, possibly a representation
of a dance mouthpiece (also missing in the earliest
published photograph, in Brown, 1908: 192).

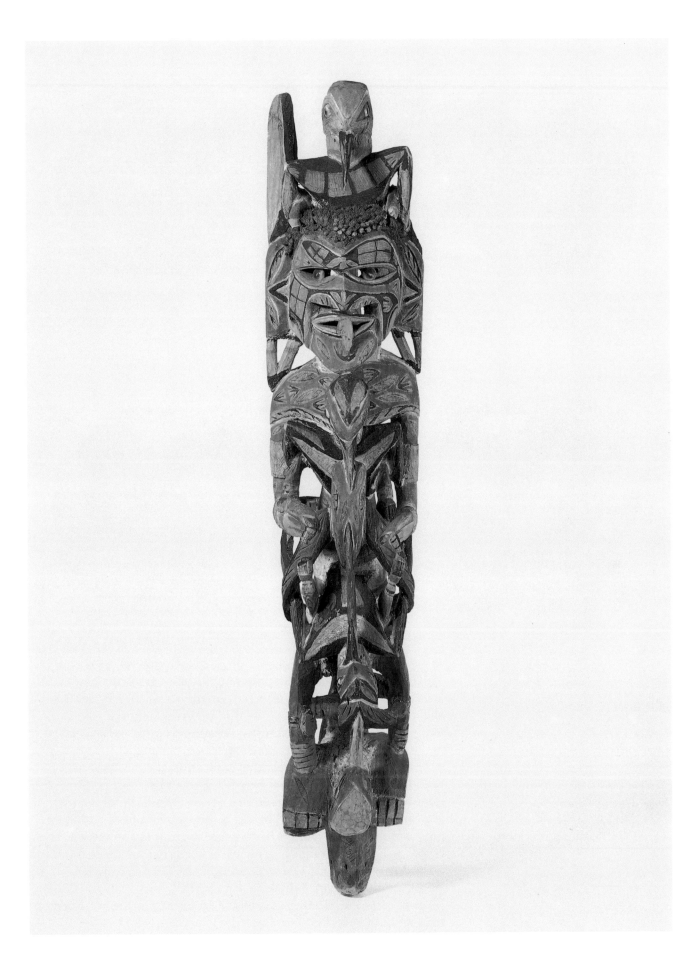

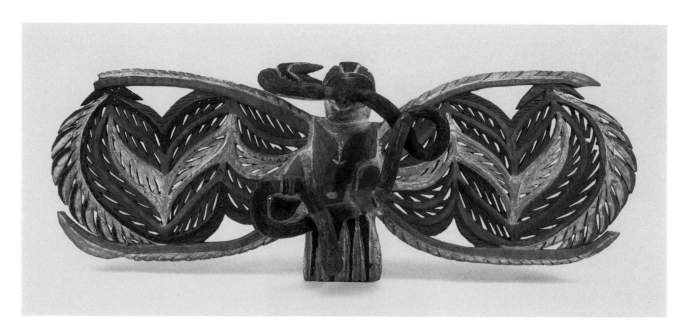

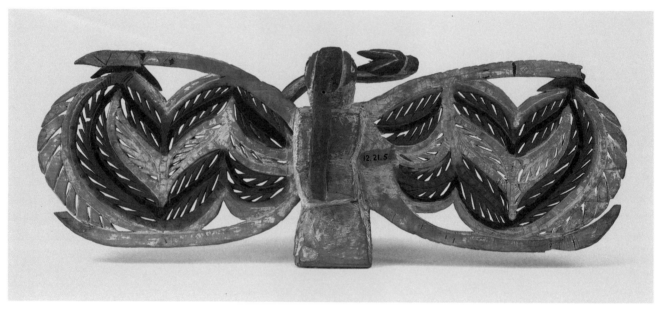

287

Northern New Ireland

Frieze
Late 19th century (*c.* 1880)
Wood, opercula
w. 33 in (83.8 cm)
Acquired 1986 UEA 943

This frieze depicts a bird with elaborate spread wings, gripping a snake in its beak and talons. The snake's tail emerges from that of the bird, and it appears to be about to strike the bird in the right eye. The 'bird-struggling-with-snake' is a common theme in New Ireland art, indeed in the art of the Indo-Pacific region (see UEA 872, no. 74).

The purpose of friezes of this kind is not entirely clear. They have been referred to as dance paraphernalia, since most have a perforated ridge down the back which could function as a handle (Bodrogi, 1987: 28). However, it seems more likely that they were for fixed display on a post of some kind, so that the back of the wings could also be seen. The ridge down the back of the bird on this example has two holes, but these do not form a hand-grip and were probably for binding to a post.

At least three friezes of this kind were in the George Brown collection (Brown, 1908: 200) and they may be the 'iguanas eating snakes' referred to in the quotation cited above on page 305.

288

Northern New Ireland

Mask with crest
Late 19th century (*c.* 1880)
Wood, cane, coconut husk, fibre,
seeds, leaf, opercula
l. 15 in (38.1 cm)
Acquired 1986 UEA 939

This type of mask is generally known as *tatanua*, a name which, like *kapkap*, comes from one of the New Ireland languages, but which has now attained general usage. *Tatanua* were worn when costumed male dancers from one village or clan performed for the assembled company as part of the climax of *malagan* rites. Clay (1987) gives an account of *tatanua* masking and of its contemporary form in the Mandak area.

The crest is well preserved, inside and out. It is constructed from a cap made from the split husk of a mature coconut, which is fixed to the top of the wood face. A cane framework extends over and back from this, covered in bark cloth and concentric bands of orange-yellow fibre. The left side has a central area of seeds, painted red and white; the right side has red and black designs on a white ground, painted in clay-like pigments which are now much crumbled. The mouth form is unusual for *tatanua* masks; the ears are separate and tied on.

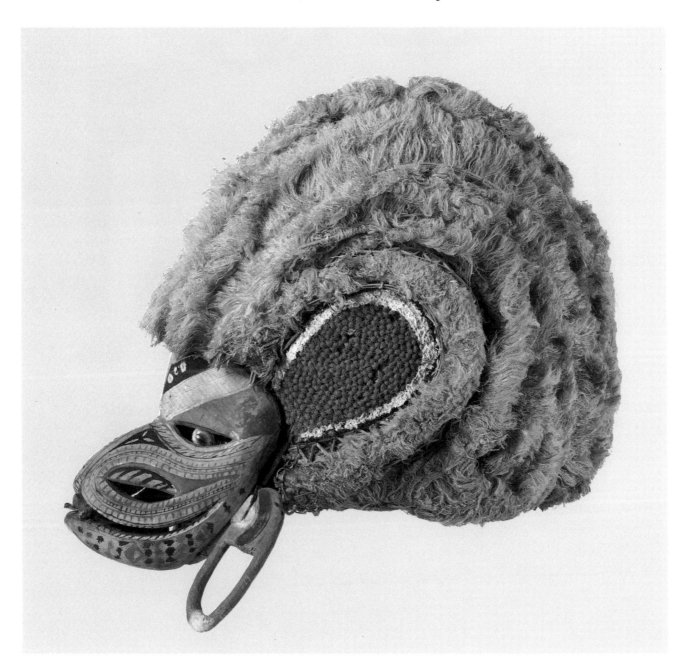

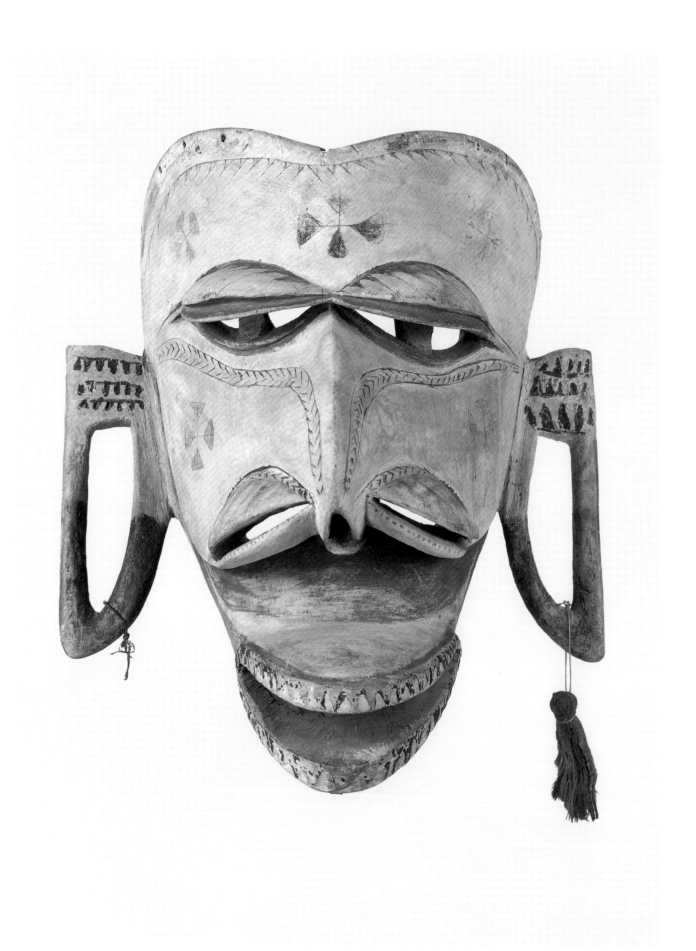

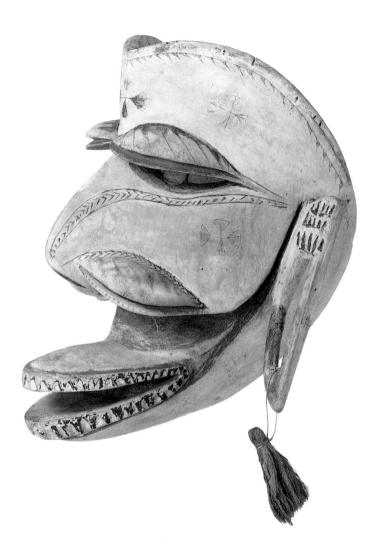

289

Northern New Ireland

Mask
Late 19th century (c. 1880)
Wood, fibre
h. 10¼ in (26.0 cm)
Acquired 1986 UEA 941

This mask is both sculpturally exceptional and unique in form. The nose
has five apertures – two in the flaring nostrils (echoing the prominent
eyelids), two at the base of the nose and one, vertical, at the tip. Small
holes around the upper rim of the mask show that it was once attached
to a crest or cap, of which nothing now remains. The pierced eyes have
circular mounts for opercula, but these are missing. Similar masks have
not been found in the literature; perhaps the closest parallel in style is a
mask in Berlin, collected in 1875, which has similar long lips and engr-
aved designs (Helfrich, 1973: no. 4).

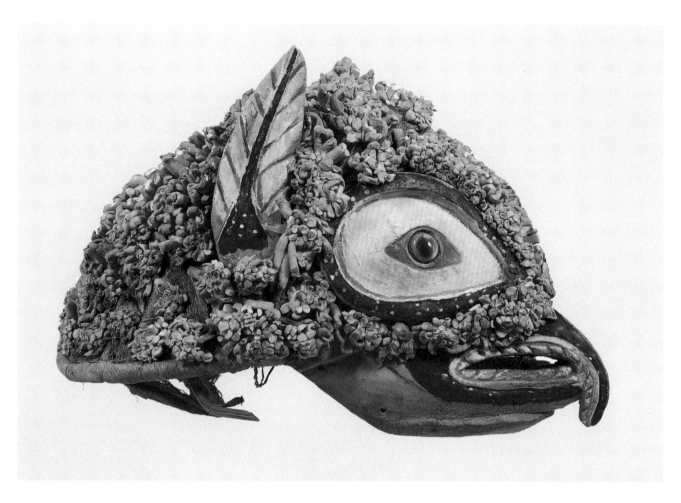

290

Northern New Ireland

Owl mask
Late 19th century (*c.* 1880)
Wood, marine sponge, cane, bark cloth, fibre, opercula
l. 13¼ in (33.7 cm)
Acquired 1986 UEA 940

Owl masks are rarer than the *tatanua* type (UEA 939, no. 288), though
they appear to have been used on similar occasions during dances at the
climax of a *malagan* cycle. Powdermaker (1933: 126) witnessed such a
dance in 1929, when she wrote, 'the men . . . have masks very cleverly
representing owl heads (*dudul*). The entire body of each dancer is covered
with leaves. The dance is in two-line formation, and one line is supposed
to represent men and the other their ghosts. It was taught . . . by a man
from the Kockopo district of New Hanover'.

 This example is well preserved. It consists of a wood face and ears tied
to a cane framework which is covered in bark cloth. Clusters of marine
sponge are tied through holes in the wood and bark cloth to form tightly
packed rosettes, some of which are now missing. Formerly a fibre beard
was tied under the beak (Helfrich, 1973: nos. 112-13). Marine sponge is
not common as a mask material, but it does appear on some examples
dating to the 1870s (*ibid.*: nos. 6, 74-5).

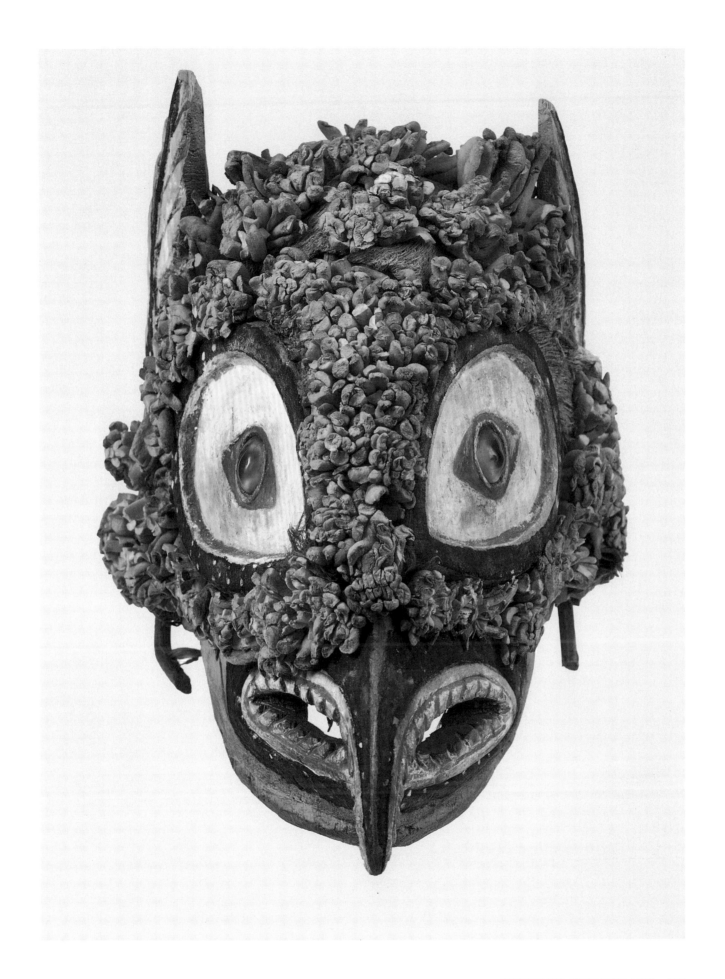

Bibliography

The bibliography has been arranged according to the three main sections of the catalogue. Because the texts for this volume were the first to be written, typeset and printed, a supplementary bibliography is given at the end to signal relevant recent publications not cited in the catalogue.

The Pacific

Andersen, J. C.
 1934 *Maori Music with its Polynesian Background*. New Plymouth (Memoirs of the Polynesian Society; 10).
Anton, F. *et al.*
 1979 *Primitive Art*. New York.
Avé, J. B.
 1981 The Dayak of Borneo. *In*: Stöhr, 1981, pp. 93-117.
Avé, J. B. and V. T. King
 1986 *People of the Weeping Forest: tradition and change in Borneo.* Leiden.
Badner, M.
 1979 Admiralty Island 'Ancestor' Figures? *In*: Mead, 1979, pp. 227-37.
Bamler, G.
 1911 Tami. *In*: Neuhauss, R., *Deutsch Neu-Guinea*, 3 vols., Berlin, 3, pp. 489-566.
Barbier, J. P.
 1983 *Tobaland, the Shreds of Tradition*. Geneva.
 1984 *Indonesian Primitive Art from the Collection of the Barbier-Müller Museum, Geneva*. Dallas.
Barrow, T. T.
 1959 Free-standing Maori Images. *In*: Freeman, J. D. and W. R. Geddes (eds.), *Anthropology in the South Seas*, New Plymouth, pp. 111-20.
 1959a Maori Godsticks Collected by the Rev. Richard Taylor. *Dominion Museum Records in Ethnology*, 1(5), pp. 183-211.
 1961 Maori Godsticks in Various Collections. *Dominion Museum Records in Ethnology*, 1(6), pp. 213-41.
 1969 *Maori Wood Sculpture of New Zealand*. Wellington.
 1979 *The Art of Tahiti and the neighbouring Society, Austral and Cook Islands*. London.
Basler, A.
 1929 *L'Art chez les Peuples Primitifs*. Paris.
Beaglehole, J. C. (ed.)
 1955, 1961, 1967, 1974 *The Journals of Captain James Cook on his Voyages of Discovery*. 4 vols. in 5 & portfolio, Cambridge (Hakluyt Society, Extra Series, 34-7).
Beasley, H. G.
 1922 A Fijian Oil Dish. *Man*, 22(76), pp. 132-3.
 1939 The Tamar of Santa Cruz. *Ethnologia Cranmorensis*, 4, Chislehurst, pp. 27-30.

Bellwood, P.
 1978 *Man's Conquest of the Pacific: the Prehistory of Southeast Asia and Oceania*. Auckland.
Benthall, J.
 1986 The George Brown Collection. *Anthropology Today*, 2(4), pp. 1-3.
Berndt, R. M.
 1974 *Australian Aboriginal Religion*. 4 fascicules, Leiden.
Berndt, R. M. and C. H. Berndt
 1964 *The World of the First Australians: an introduction to the traditional life of the Australian aborigines*. London.
Berndt, R. M. and J. E. Swanton
 1980 *Australian Aboriginal Art in the Anthropology Museum of the University of Western Australia*. Perth.
Best, E.
 1925 *Maori Agriculture*. Wellington (Dominion Museum; Bulletin 9).
Birket-Smith, K.
 1956 *An Ethnological Sketch of Rennell Island: a Polynesian outlier in Melanesia*. Copenhagen.
Bodrogi, T.
 1961 *Art in North-east New Guinea*. Budapest.
 1987 New Ireland Art in Cultural Context. *In*: Lincoln, 1987, pp. 17-32.
Brigham, W.
 1911 *Ka Hana Kapa: the making of bark cloth in Hawaii*. Honolulu (Bernice P. Bishop Museum; Memoir 3).
Brown, G.
 1881 A Journey along the Coasts of New Ireland and neighbouring Islands. *Proceedings of the Royal Geographical Society* (London), 3, pp. 213-20.
 1908 *George Brown D. D., Pioneer-Missionary and Explorer: an autobiography*. London.
 1910 *Melanesians and Polynesians: their life-histories described and compared*. London.
Buck, P. H. (Te Rangi Hiroa)
 1944 *Arts and Crafts of the Cook Islands*. Honolulu (Bernice P. Bishop Museum; Bulletin 179).
Bühler, A.
 1935 Versuch einer Bevölkerungs und Kulturanalyse auf den Admiralitätsinseln. *Zeitschrift für Ethnologie*, 67, pp. 1-32.
Cameron, E. L.
 1985 Ancestor Motifs of the Paiwan. *In*: Feldman, 1985, pp. 161-70.
Campbell, D. T.
 1904 Notes on Dancing Boards. *Journal of the Natural History and Science Society of Western Australia*, 3(2).
Choris, L.
 1822 *Voyage Pittoresque autour du Monde*. Paris.

Clay, B.
 1987 A Line of Tatanua. *In*: Lincoln, 1987, pp. 63-73.
Clunie, F. G. A. U.
 1977 *Fijian Weapons and Warfare*. Suva (Fiji Museum; Bulletin 2).
 1986 *Yalo i Viti: Shades of Viti, a Fiji Museum Catalogue*. Suva.
Corbin, G. A.
 1979 The Art of the Baining: New Britain. *In*: Mead, 1979, pp. 159-79.
Cox, J. H. and W. H. Davenport
 1974 *Hawaiian Sculpture*. Honolulu.
Crystal, E.
 1985 The Soul that is Seen: the Tau Tau as shadow of death, reflection of life in Toraja tradition. *In*: Feldman, 1985, pp. 129-46.
Davenport, W. H.
 1962 Red-feather Money. *Scientific American*, 206, pp. 94-104.
 1981 Male Initiation in Aoriki: man and the spirits in the eastern Solomon Islands. *Expedition*, 23(2), pp. 4-19.
 1985 *A Miniature Figure from Santa Cruz Island*. Geneva (Musée Barbier-Mueller; Bulletin 28).
Davidson, D. S.
 1937 *A Preliminary consideration of Australian Aboriginal decorative art*. Philadelphia (Memoirs of the American Philosophical Society; 9).
De Hoog, J.
 1981 The Lesser Sunda Islands and the Moluccas. *In*: Stöhr, 1981, pp. 121-7.
De Menil
 1984 *La Rime et la Raison: les collections Ménil (Houston – New York)*. Grand Palais, Paris.
Deacon, A. B.
 1934 *Malekula: a vanishing people in the New Hebrides*. London (edited by C. H. Wedgwood).
Dr. O.
 1929 Art Primitif et Psychoanalyse d'après Eckart von Sydow. *Cahiers d'Art*, 4(2-3), pp. 65-72.
Duff, R.
 1950 *The Moa-hunter Period of Maori Culture*. Wellington.
Edge-Partington, J.
 1890, 1895, 1898 *An Album of the Weapons, Tools, Ornaments, Articles of Dress, etc., of the Natives of the Pacific Islands*. 3 vols., Manchester (reprinted in 2 vols., 1969).
Eichhorn, A.
 1929 L'Art chez les Habitants du Fleuve Sepik (Nouvelle Guinée). *Cahiers d'Art*, 4(2-3), pp. 73-8.
Erskine, J. E.
 1853 *Journal of a Cruise among the Islands of the Western Pacific … in H.M.S. 'Havannah'*. London.
Ewins, R.
 1982 *Fijian Artefacts: the Tasmanian Museum and Art Gallery Collection*. Hobart.
Feldman, J. (ed.)
 1985 *The Eloquent Dead: ancestral sculpture of Indonesia and Southeast Asia*. Los Angeles.
Force, R. and M. Force
 1968 *Art and Artifacts of the 18th century: objects in the Leverian Museum as painted by Sarah Stone*. Honolulu.
Forge, A.
 1962 Paint – A Magical Substance. *Palette*, 9, pp. 9-16.
 1973 (ed.) *Primitive Art and Society*. London.

Fox, C. E.
 1925 *The Threshold of the Pacific: an account of the social organization, magic and religion of the people of San Cristoval in the Solomon Islands*. New York.
Fraser, D. F.
 1955 Mundugamor Sculpture: comments on the art of a New Guinea tribe. *Man*, 55, pp. 17-20.
Freeman, J. D.
 1960 A Note on the Gawai Kenyalang, or Hornbill Ritual of the Iban of Sarawak. *In*: Smythies, 1960, pp. 99-102.
Führer
 1984 *Führer Durch die Sammlungen*. Hamburgisches Museum für Völkerkunde. Munich.
Fundaburk, E. L. and M. D. F. Foreman (eds.)
 1957 *Sun Circles and Human Hands: the southeastern Indians, art and industries*. Luverne.
Gathercole, P., A. L. Kaeppler and D. Newton
 1979 *The Art of the Pacific Islands*. Washington.
Graebner, F.
 1909 Völkerkunde der Santa-Cruz-Inseln. *Ethnologica* (Cologne), 1, pp. 71-184.
Groves, W. C.
 1934-5 Tabar To-day: a Study of a Melanesian community in contact with alien non-primitive cultural forces. *Oceania*, 5(2), pp. 224-40; 5(3), pp. 346-60.
 1935-6 Tabar To-day: Present day conditions in Tautau Village. *Oceania*, 6(2), pp. 147-57.
 1936-7 Secret Beliefs and Practices in New Ireland. *Oceania*, 7(2), pp. 220-45.
Güell, E. S. and A. F. Rusiñol
 1976 *Arte de Papua y Nueva Guinea*. Barcelona.
Haddon, A. C. (ed.)
 1912 *Reports of the Cambridge Anthropological Expedition to Torres Straits*, vol. 4: *Arts and Crafts*. Cambridge.
Hamilton, A.
 1896 *Maori Art*. Wellington.
Handy, E. S. C.
 1923 *The Native Culture in the Marquesas*. Honolulu (Bernice P. Bishop Museum; Bulletin 9).
Harding, T.
 1967 *Voyagers of the Vitiaz Strait: a study of a New Guinea trading system*. Seattle (American Ethnological Society; Monograph 44).
Harrisson, T.
 1960 Birds and Men in Borneo. *In*: Smythies, 1960, pp. 20-61.
 1965 Humans and Hornbills in Borneo. *Sarawak Museum Journal*, 12, pp. 400-13.
Hauser-Schäublin, B.
 1976/7 Mai-masken der Iatmul, Papua New Guinea (part 1). *Verhandlungen der Naturforschenden Gesellschaft in Basel*, 87/88, pp. 119-45.
 1981 Mai-masken der Iatmul, Papua New Guinea (part 2). *Verhandlungen der Naturforschenden Gesellschaft in Basel*, 92, pp. 47-54.
Helfrich, K.
 1973 *Malanggan I: Bildwerke von Neuirland*. Berlin.
Hose, C. and W. McDougall
 1912 *The Pagan Tribes of Borneo*. 2 vols., London.
Idiens, D.
 1982 *Pacific Art in the Royal Scottish Museum*. Edinburgh.

Ivens, W. G.
 1927 *Melanesians of the South-east Solomon Islands*. London.
Juynboll, H. H.
 1909-10 *Borneo*. Rijksmuseum voor Völkenkunde, Leiden.
 Katalog des ethnographischen Reichsmuseums,
 vols. 1 & 2.
Kaeppler, A. L.
 1978 *'Artificial Curiosities': being an exposition of native manu-
 factures collected on the three Pacific voyages of Captain
 James Cook, R.N.* Bernice P. Bishop Museum, Honolulu.
Kaufmann, C.
 1980 *Ozeanische Kunst: Meisterwerke aus dem Museum für
 Völkerkunde, Basel.* Basel.
Kelm, H.
 1966 *Kunst vom Sepik.* 3 vols., Berlin.
Koch, G.
 1971 *Materielle Kultur der Santa Cruz-Inseln.* Berlin.
Kooijman, S.
 1959 *The Art of Lake Sentani.* The Museum of Primitive Art,
 New York.
 1972 *Tapa in Polynesia.* Honolulu (Bernice P. Bishop
 Museum; Bulletin 234).
Krämer, A.
 1925 *Die Malanggane von Tombara.* Munich.
Küchler, S.
 1987 Malangan: art and memory in a Melanesian society.
 Man, n.s. 22(2), pp. 238-55.
Larsson, K. E.
 1960 *Fijian Studies.* Göteborg (Etnologiska Studier; 25).
Leach, E.
 1973 Levels of Communication and Problems of Taboo.
 In: Forge, 1973, pp. 221-34.
Lewis, P. H.
 1969 *The Social Context of Art in northern New Ireland.* Chicago
 (Fieldiana, Anthropology; 58).
 1972 Malanggan. *In*: Ryan, 1972, pp. 675-9.
 1973 Changing Memorial Ceremonies in northern New
 Ireland. *Journal of the Polynesian Society*, 82(2), pp. 141-53.
 1979 Art in Changing New Ireland. *In*: Mead, 1979, pp. 378-91.
Lincoln, L. (ed.)
 1987 *Assemblage of Spirits: idea and image in New Ireland.* New
 York.
Malinowski, B.
 1922 *Argonauts of the Western Pacific.* London.
McCarthy, F. D.
 1951 The Human Sculptures of the Solomon Islands.
 Australian Museum Magazine, 10(6), pp. 139-43, 182-5.
McLean, M. E.
 1968 An Investigation of the open tube Maori flute or
 kooauau. *Journal of the Polynesian Society*, 77, pp. 213-41.
Mead, M.
 1935 The River-Dwelling Mundugumor. *In*: Mead, M., *Sex
 and Temperament in Three Primitive Societies*, London,
 pp. 163-233.
Mead, S. M. (ed.)
 1979 *Exploring the Visual Art of Oceania: Australia, Melanesia,
 Micronesia and Polynesia.* Honolulu.
 1984 *Te Maori: Maori Art from New Zealand Collections.* New
 York.
Mead, S. M. and B. Kernot (eds.)
 1983 *Art and Artists of Oceania.* Palmerston North.

Muensterberger, W.
 1955 *La Sculpture des Primitifs.* Paris.
Müller, C. C.
 1980 *Wittelsbach und Bayern: 400 Jahre Sammeln und Reisen.*
 Munich.
Nevermann, H.
 1934 *Admiralitäts-Inseln.* Ergebnisse der Südsee-Expedition,
 1908-10, vol. 11(A, 3). Hamburg.
Newton, D.
 1961 *Art Styles of the Papuan Gulf.* New York.
Newton *et al.*,
 1979 see Gathercole, Kaeppler and Newton, 1979.
Nieuwenhuis, A. W.
 1904-7 *Quer Durch Borneo: Ergebnisse seiner Reisen in den Jahren
 1894, 1896-7 und 1898-1900.* 2 vols., Leiden.
Oldman, W. O.
 1938 *The Oldman Collection of Maori Artefacts.* New Plymouth
 (Memoirs of the Polynesian Society; 14).
 1943 *Polynesian Artefacts: the Oldman Collection.* Wellington
 (Memoirs of the Polynesian Society; 15).
Paulding, H.
 1831 *Journal of the Cruise of the United States Schooner 'Dolphin'
 among the islands of the Pacific.* New York.
Phelps, S. J.
 1976 *Art and Artefacts of the Pacific, Africa, and the Americas: the
 James Hooper Collection.* London.
Porter, D.
 1822 *A Voyage in the South Seas ... in the frigate 'Essex', 1812-14.*
 New York.
Powdermaker, H.
 1933 *Life in Lesu: the study of a Melanesian society in New
 Ireland.* London.
Powell, H. A.
 1986 The George Brown Collection. *Anthropology Today*,
 2(5), p. 18.
Rand, A. L. and E. T. Gilliard
 1967 *Handbook of New Guinea Birds.* London.
Reichard, G.
 1933 *Melanesian Design.* 2 vols., New York.
Richman, R.
 1980 Decorative Household Objects in Indonesia. *Arts of Asia*,
 10(5), pp. 129-35.
Rose, R.
 1979 On the Origin and Diversity of 'Tahitian' janiform fly
 whisks. *In*: Mead, 1979, pp. 202-13.
 1980 *Hawai'i: the Royal Isles.* Honolulu (Bernice P. Bishop
 Museum; special publication 67).
Roth, H. L. (ed.)
 1891 *Crozet's Voyage to Tasmania, New Zealand ... 1771-72.*
 London.
 1896 *The Natives of Sarawak and British North Borneo.* 2 vols.,
 London.
Roth, J. F. V. and S. J. P. Hooper (eds.)
 1989 *The Fiji Journals of Baron Anatole von Hügel, 1875-77.* Suva
 (dated 1990).
Rubin, W. (ed.)
 1984 *'Primitivism' in Twentieth Century Art.* Museum of
 Modern Art, New York.
Ryan, P. (ed.)
 1972 *Encyclopaedia of Papua and New Guinea.* 3 vols.,
 Melbourne.

Sarasin, F.
 1929 *Ethnologie der Neu-Caledonier und Loyalty-Insulaner.*
 2 vols., Munich.
Schärer, H.
 1963 *Ngaju Religion: the conception of God among a South Borneo
 people.* The Hague.
Schoffel, A.
 1981 *Art Primitif de l'Asie de Sud-Est.* Meudon.
Scott, J. G.
 1961 A Maori Carved Wooden Figure. *Scottish Arts Review,*
 VIII(I).
Sillitoe, P.
 1980 The Art of War: Wola shield designs. *Man,* n.s. 15(3),
 pp. 483-501.
Simmons, D.
 1983 Moko. *In:* Mead and Kernot, 1983, pp. 226-43.
 1983a Whakapakoko Rakau: Godsticks. *Records of the
 Auckland Institute and Museum, 20,* pp. 123-45.
Smythies, B. E.
 1960 *The Birds of Borneo.* Edinburgh.
Somerville, B. T.
 1897 Ethnological notes in New Georgia, Solomon Islands.
 Journal of the Royal Anthropological Institute, 26,
 pp. 357-412.
Sotheby's
 1978 *Catalogue of the George Ortiz Collection of African and
 Oceanic works of art, Thursday 29th June.* Sotheby, Parke
 Bernet, London.
 1983 *Prince Sadruddin Aga Khan Collection of African art,
 Monday 27th June.* Sotheby, Parke Bernet, London.
Speiser, F.
 1923 *Ethnographische Materialen aus den Neuen Hebriden und
 den Banks-Inseln.* Berlin.
Starzecka, D. and B. A. L. Cranstone
 1974 *The Solomon Islanders.* The British Museum, London.
Stöhr, W. (ed.)
 1981 *Art of the Archaic Indonesians.* Geneva.
Sumnik-Dekovich, E.
 1985 The Significance of Ancestors in the Arts of the Dayak
 of Borneo. *In:* Feldman, 1985, pp. 101-28.
Taylor, R.
 1855 *Te Ika a Maui: or New Zealand and its inhabitants.*
 London.
 1870 *Te Ika a Maui: or New Zealand and its inhabitants.* 2nd ed.,
 London.
Tobing, P. O. L.
 1956 *The Structure of the Toba-Batak Belief in the High God.*
 Amsterdam.
Tuzin, D. F.
 1980 *The Voice of the Tambaran: truth and illusion in Ilahita
 Arapesh religion.* Berkeley.
von den Steinen, K.
 1925-28 *Die Marquesaner und ihre Kunst.* 3 vols., Berlin.
Waite, D.
 1983a *Art of the Solomon Islands: from the collection of the Barbier-
 Müller Museum.* Geneva.
 1983b Shell-inlaid shields from the Solomon Islands. *In:* Mead
 and Kernot, 1983, pp. 114-36.
 1984 The Decorated Canoe of the Western Solomon Islands:
 art object and social metaphor. Paper delivered at
 Pacific Arts Association Symposium, New York,

September, 1984. Published as '*Mon* Canoes of the
 Western Solomon Islands', in Hanson and Hanson,
 1990, pp. 44-66 [see bibliography supplement on p. 326].
Wardwell, A.
 1967 *The Sculpture of Polynesia.* Chicago.
Webster, K. A.
 1948 *The Armytage Collection of Maori Jade.* London.
Wilkinson, N.
 1978 Carving a Social Message: the Malanggans of Tabar.
 In: Greenhalgh, M. and V. Megaw (eds.), *Art in Society,*
 London, pp. 227-41.
Williams, F. E.
 1936 *Papuans of the Trans-Fly.* Oxford.
 1940 *Drama of Orokolo: the social and ceremonial life of the
 Elema.* London.
Williams, J.
 1837 *A Narrative of Missionary Enterprises in the South Sea
 Islands.* London.
Williams, T.
 1858 *Fiji and the Fijians.* 1: *The Islands and their Inhabitants*
 (edited by G. S. Rowe). London (reprinted by Fiji
 Museum, 1982).
Wirz, P.
 1950 *Der Ersatz für die Kopfjägerei und die
 Trophäenimitation.* In: Beitrage zur Gesellungs-
 und Völkerwissenschaft (Festschrift von Prof. R.
 Thurnwald), Berlin, pp. 411-34.
Woodford, C. M.
 1926 Notes on the Solomon Islands. *Journal of the Royal
 Geographical Society, 68,* pp. 481-7.
Zimmer, H.
 1960 *The Art of Indian Asia: its mythology and transformations.*
 2 vols., Princeton (completed and edited by Joseph
 Campbell).

Africa

Ajayi, J. F. A. and M. Crowder (eds.)
 1971 *History of West Africa I.* London.
 1974 *History of West Africa II.* London.
Bascom, W.
 1969 *Ifa Divination: communication between gods and men in
 western Africa.* Bloomington.
Bassani, E.
 1978 Una Bottega di Grandi Artisti Bambara. *Critica d'Arte*
 (Florence), nos. 157-9, 160-62.
Bastin, M.-L.
 1961 *Art Décoratif Tshokwe.* 2 vols., Lisbon (Publicações
 Culturais, Diamang, Museu do Dundo; 55).
Bedaux, R.
 1977 *Tellem.* Berg en Dal.
Beier, U.
 1957 *The Story of Sacred Wood Carvings from One Small Yoruba
 Town.* Lagos.
Ben-Amos, P.
 1980 *The Art of Benin.* London.
Biebuyck, D.
 1953 Signification d'une Statuette Lega. *La Revue Coloniale
 Belge, 195.*
 1973 *Lega Culture.* London.

Bourgeois, A. P.
 1984 *Art of the Yaka and Suku*. Meudon.
Burssens, H.
 1962 *Yanda-Beelden en Mani-Sekte bij de Azande*. Tervueren
 (Musée Royale de l'Afrique Centrale; Annales, n.s. 4).
Christie's
 1984 *Art and Ethnography from Africa, the Americas and the*
 Pacific, Monday, 25th June. Christie, Manson and Woods,
 London.
Cole, H. M. and D. H. Ross
 1977 *The Arts of Ghana*. Los Angeles.
Cornet, J.
 1978 *A Survey of Zairian Art: the Bronson Collection*. Raleigh.
 1982 *Art Royal Kuba*. Milan.
Dalton, O. M. and C. H. Read
 1899 See Read and Dalton, 1899.
Dark, P. J. C.
 1973 *An Introduction to Benin Art and Technology*. Oxford.
d'Azevedo, W. L. (ed.)
 1973 *The Traditional Artist in African Societies*. Bloomington.
de Oliveira, E. V.
 1968 *Escultura Africana: no Museu de Etnologia do Ultramar*.
 Lisbon.
de Sousberghe, L.
 1958 *L'Art Pende*. Académie Royale de Belgique, Beaux-Arts
 ix, 2, Brussels.
Fagg, W. B.
 1959 *Afro-Portuguese Ivories*. London.
 1963 *Nigerian Images*. London.
 1965 *Tribes and Forms in African Art*. London.
 1970 *Divine Kingship in Africa*. London.
Fagg, W. B. and J. Pemberton
 1982 *Yoruba Sculpture of West Africa*. London.
Fischer, E. and H. Himmelheber
 1984 *The Arts of the Dan in West Africa*. Zurich.
Fischer, E. and L. Homberger
 1985 *Die Kunst der Guro, Elfenbeinküste*. Zurich.
Fisher, A.
 1984 *Africa Adorned*. London.
Flam, J. D.
 1982 Signs and Symbols in Traditional Metal Art of the
 Western Sudan. *In*: Brincard, M. T. (ed.), *The Art of*
 Metal in Africa. New York, pp. 19-30.
Garrard, T. F.
 1980 *Akan Weights and the Gold Trade*. London.
Gebauer, P.
 1979 *Art of the Cameroon*. Portland.
Griaule, M.
 1965 *Conversations with Ogotemmeli: an introduction to Dogon*
 religious ideas. Oxford.
Hartwig, G.
 1969 A Historical Perspective of Kerebe
 Sculpturing…Tanzania. *Tribus*, 18, pp. 85-102.
 1980 Sculpture in East Africa. *African Arts*, 11(4), pp. 62-5, 96.
Heslop, T. A.
 1987 Art History Students and African Objects. *Museum*
 Ethnographers Group Newsletter, 21, pp. 6-18.
Holas, B.
 1969 *Masques Ivoiriens*. (Abidjan).
Krieger, K.
 1965-69 *Westafrikanische Plastik*. 3 vols., Berlin.

Kup, A. P.
 1961 *A History of Sierra Leone, 1400-1787*. Cambridge.
Lamb, V.
 1975 *West African Weaving*. London.
Leiris, M. and J. Delange
 1968 *African Art*. London.
Leuzinger, E.
 1972 *The Art of Black Africa*. London.
Ling Roth, H.
 1903 see Roth, H. L., 1903.
Maesen, A.
 n.d. *Umbangu: art du Congo au Musée Royale de l'Afrique*
 Centrale. (Tervuren, *c*. 1960).
Malraux, A.
 1952 *Le Musée Imaginaire de la Sculpture Mondiale*. Paris.
McLeod, M. D.
 1981 *The Asante*. London.
Meauzé, P.
 1968 *African Art*. London.
Menzel, B.
 1968 *Goldgewichte aus Ghana*. Berlin.
Messenger, J. C.
 1973 The Role of the Carver in Anang Society. *In*: d'Azevedo,
 1973, pp. 101-27.
Meyer, P.
 1981 *Kunst und Religion der Lobi*. Zurich (Publikations-
 stiftung für das Museum Rietberg; 3).
Murdock, G. P.
 1959 *Africa: its people and their cultural history*. London.
Nesmith, F. H.
 1979 Dogon Bronzes. *African Arts*, 12(2), pp. 20-26, 90.
Neyt, F. and A. Désirant
 1985 *The Arts of the Benue: the roots of tradition*. (s.l.).
Perrois, L.
 1979 *Arts du Gabon: les arts plastiques du Bassin de l'Ogowe*.
 Paris.
Pitt Rivers, A. L. F.
 1900 *Antique Works of Art from Benin*. (s.l.).
Portier, A. and F. Poncetton
 1936 *Les Arts Sauvages: Afrique*. Paris.
Rasmussen, R.
 1951 *Art Nègre*. Paris.
Read, C. H. and O. M. Dalton
 1899 *Antiquities from the City of Benin and from other parts of*
 West Africa. British Museum, London.
Roth, H. L.
 1903 *Great Benin: its customs, art and horrors*. Halifax.
Roy, C. D.
 1981 Mossi Dolls. *African Arts*, 14(4), pp. 47-50, 88.
 1983 *The Dogon of Mali and Upper Volta*. Munich.
Sainsbury, R. J. (ed.)
 1978 *Robert and Lisa Sainsbury Collection: exhibition for the*
 opening of the Centre, April 1978. Norwich.
Salmons, J.
 1985 Martial Arts of the Annang. *African Arts*, 19(1),
 pp. 57-62, 87.
Sieber, R.
 1980 *African Furniture and Household Objects*. Bloomington.
Tagliaferri, A. and A. Hammacher
 1974 *Fabulous Ancestors: stone carvings from Sierra Leone and*
 Guinea. New York.

Thompson, R. F.
 1971 *Black Gods and Kings: Yoruba art at UCLA*. Los Angeles.
 1973 Yoruba Artistic Criticism. *In*: d'Azevedo, 1973, pp. 19-61.
Underwood, L.
 1948 *Masks of West Africa*. London.
 1949 *Bronzes of West Africa*. London.
Visonà, M. B.
 1987 Carved Posts of the Lagoon Region, Ivory Coast. *African Arts*, 20(2), pp. 60-64, 83.
Vogel, S. (ed.)
 1981 *For Spirits and Kings: African Art from the Tishman Collection*. New York.
von Luschan, F.
 1919 *Altertümer von Benin*. 3 vols., Berlin.
Wardwell, A.
 1966 Some Notes on a Substyle of the Bambara. *Museum Studies*, Chicago, I, pp. 112-28.
Weule, K.
 1908 *Ethnographischen Forschungsreise in den sudösten Deutsch-Ostafrikas*. Berlin.
Willett, F.
 1971 *African Art*. London.

North America

Bandi, H. G.
 1977 *Die Kunst der Eskimos auf der St.-Lorenz-Insel in Alaska*. Bern.
Benson, E. P. (ed.)
 1975 *Death and the Afterlife in Pre-Columbian America*. Washington.
Boas, F.
 1888 The Central Eskimo. *In: Sixth Annual Report of the Bureau of Ethnology to the Secretary of the Smithsonian Institution. 1884-85*, Washington, pp. 399-669.
 1907 Notes on the Blanket Designs. *In*: Emmons, 1907.
 1916 Tsimshian Mythology. *In: Thirty-first Annual Report of the Bureau of American Ethnology to the Secretary of the Smithsonian Institution, 1909-10*, Washington, pp. 43-1037.
Bockstoce, J. R.
 1977 *Eskimos of Northwest Alaska in the early Nineteenth Century: based on the Beechey and Belcher collections . . . 1826 and 1827*. Pitt Rivers Museum, Oxford.
Borden, C. E.
 1983 Prehistoric Art of the Lower Frazer Region. *In*: Carlson, 1983, pp. 131-65.
Boyle, D.
 1895 *Notes on Primitive Man in Ontario*. Toronto.
Brose, D. S., J. A. Brown and D. W. Penney
 1985 *Ancient Art of the American Woodland Indians*. New York.
Brown, J. A.
 1975 Spiro Art and its Mortuary Contexts. *In*: Benson, 1975, pp. 1-32.
 1985 The Mississippian Period. *In*: Brose *et al.*, 1985, pp. 93-145.
Brown, J. A. and H. W. Hamilton
 1965 *Spiro and Mississippian Antiquities: the McDannald Collection*. Museum of Fine Arts, Houston.
Burnett, E. K.
 1944 *Inlaid Stone and Bone Artefacts from Southern California*.

New York (Contributions from the Museum of the American Indian, Heye Foundation; 13).
 1945 *The Spiro Mound Collection in the Museum*. New York (Contributions from the Museum of the American Indian, Heye Foundation; 14).
Carlson, R. L. (ed.)
 1983 *Indian Art Traditions of the Northwest Coast*. Burnaby.
Choris, L.
 1822 *Voyage Pittoresque autour du Monde*. Paris.
Christie's
 1979 *Tribal Art from the Collection of the late Josef Mueller (part 2), Tuesday, 20th March*. Christie, Manson and Woods, London.
Clements, F. E.
 1945 *Historical Sketch of the Spiro Mound*. New York (Contributions from the Museum of the American Indian, Heye Foundation; 14).
Coe, R. T. (ed.)
 1976 *Sacred Circles: two thousand years of North American Indian art*. London.
Cole, D.
 1985 *Captured Heritage: the scramble for Northwest Coast artifacts*. Seattle.
Collins, H. B.
 1929 *Prehistoric Art of the Alaskan Eskimo*. Washington (Smithsonian Miscellaneous Collections; 81 (4)).
 1937 *Archaeology of St. Lawrence Island, Alaska*. Washington (Smithsonian Miscellaneous Collections; 96).
Collins, H. B., F. de Laguna, E. Carpenter and P. Stone
 1973 *The Far North: 2000 years of American Eskimo and Indian Art*. Washington.
Conn, R.
 1979 *Native American Art in the Denver Art Museum*. Denver.
Daugherty, R. and J. Friedman
 1983 An Introduction to Ozette Art. *In*: Carlson, 1983, pp. 183-95.
de Laguna, F.
 1972 *Under Mount Saint Elias: the history and culture of the Yakutat Tlingit*. 3 vols., Washington (Smithsonian Contributions to Anthropology; 7).
Dickens, R. S.
 1982 *Of Sky and Earth: art of the early Southeastern Indians*. Atlanta.
Dockstader, F. J.
 1978 North American Indian and Eskimo Art. *In*: Sainsbury, 1978, pp. 165-93.
Duff, W.
 1967 *Arts of the Raven: masterworks by the Northwest Coast Indian*. Vancouver Art Gallery, Vancouver.
 1975 *Images Stone B.C.: thirty centuries of Northwest Coast Indian Sculpture*. Saanichton.
Emmons, G. T.
 1907 The Chilkat Blanket. *Memoirs of the American Museum of Natural History, 3*(4), pp. 329-401.
Fitzhugh, W. W.
 1984 Paleo-Eskimo Cultures of Greenland. *In*: D. Damas (ed.), *Handbook of North American Indians. 5: the Arctic*. Washington, pp. 528-39.
Fitzhugh, W. W. and S. A. Kaplan
 1982 *Inua: spirit world of the Bering Sea Eskimo*. Washington.

Giddings, J. L.
 1967 *Ancient Men of the Arctic*. New York.

Harner, M. J. and A. B. Elsasser
 1965 *Art of the Northwest Coast: an exhibition at the Robert H. Lowie Museum of Anthropology of the University of California*. Berkeley.

Himmelheber, F.
 1938 *Eskimokünstler*. Stuttgart.

Hodges, H.
 1964 *Artifacts: an introduction to early materials and technology*. London.

Holm, G. F.
 1888-9 *Den Ostgronlandske Expedition, udfort i Aarene 1883-5*. Copenhagen (Meddelelser om Gronland, 9-10).

Holm, W.
 1965 *Northwest Coast Indian Art: an analysis of form*. Seattle.
 1983 *The Box of Daylight: Northwest Coast Indian art*. Seattle.

Holm, W. and W. Reid
 1975 *Form and Freedom: a dialogue on Northwest Coast Indian art*. Houston.

Holmes, W. H.
 1883 Art in Shell of the Ancient Americans. *In: Second Annual Report of the Bureau of Ethnology to the Secretary of the Smithsonian Institution, 1880-81*, Washington, pp. 174-305.

Hudson, T. and T. C. Blackburn
 1982-7 *The Material Culture of the Chumash Interaction Sphere*. 5 vols., Los Altos (vol. 4, 1986).

Jonaitis, A.
 1986 *Art of the Northern Tlingit*. Seattle.

King, J.
 1981 *Artificial Curiosities from the Northwest Coast of America*. London.

Kirk, R. and R. D. Daugherty
 1978 *Exploring Washington Archaeology*. Seattle.

Kneberg, M.
 1959 Engraved Shell Gorgets and their Associations. *Tennessee Archaeologist, 15*, pp. 1-39.

Krause, A.
 1956 *The Tlingit Indians: results of a trip to the Northwest Coast of America and the Bering Straits*. Seattle (American Ethnological Society; Monograph 26).

Lamb, W. K. (ed.)
 1985 *The Voyage of George Vancouver, 1791-95*. 4 vols., London. (Hakluyt Society, Second Series; 147).

Laude, J.
 1973 *African Art of the Dogon*. New York.

Lisiansky, U.
 1814 *A Voyage round the World in the years 1802-6…in the ship 'Neva'*. London.

MacDonald, G.
 1983 Prehistoric Art of the northern Northwest Coast. *In: Carlson, 1983*, pp. 99-120.

Mason, O. T.
 1904 Aboriginal American Basketry. *In: Annual Report of the Board of Regents of the Smithsonian Institution, 1902. Report of the U.S. National Museum*. Washington, pp. 17-548.

Mason, R. J.
 1981 *Great Lakes Archaeology*. New York.

Mathiassen, T.
 1927 *Archaeology of the Central Eskimo*. 2 vols., Copenhagen (Report of the Fifth Thule Expedition 1921-4; 4; 1-2).

Maurer, E. A. (ed.)
 1977 *The Native American Heritage*. Chicago.

Meldgaard, J.
 1960 *Eskimo Sculpture*. London.

Moore, C. B.
 1897 Certain Aboriginal Mounds of the Georgia Coast. *Journal of the Academy of Sciences of Philadelphia, XI(1)*, pp. 5-138.

Murdoch, J.
 1892 Ethnological Results of the Point Barrow Expedition. *In: Ninth Annual Report of the Bureau of Ethnology to the Secretary of the Smithsonian Institution, 1887-88*, Washington, pp. 3-441.

Nelson, E. W.
 1899 The Eskimo about Bering Strait. *In: Eighteenth Annual Report of the Bureau of American Ethnology to the Secretary of the Smithsonian Institution, 1896-97*, part 1, Washington, pp. 3-518.

Niblack, A. P.
 1890 The Coast Indians of Southern Alaska and Northern British Columbia. *In: Smithsonian Institution. Report of the U.S. National Museum, 1888*, Washington, pp. 225-386.

Orchard, W. C.
 1971 *The Technique of Porcupine Quill Decoration among the North American Indians*. 2 ed., New York (Contributions from the Museum of the American Indian, Heye Foundation; 4(1)).

Parsons, E.
 1916 The Zuñi a'Doshle and Suuke. *American Anthropologist, 18(3)*, pp. 338-47.
 1939 *Pueblo Indian Religion*. 2 vols., Chicago.

Penney, D. W.
 1985 Continuities of Imagery and Symbolism in the Art of the Woodlands. *In: Brose at al., 1985*, pp. 147-98.

Rainey, F.
 1941 Eskimo Prehistory: the Okvik site on Punuk Islands. *Anthropological Papers of the American Museum of Natural History, 37(4)*, pp. 453-569.
 1959 The Vanishing Art of the Arctic. *Expedition, 1(2)*, pp. 3-13.

Ray, D. J.
 1967 *Eskimo Masks: art and ceremony*. Seattle.
 1977 *Eskimo Art: tradition and innovation in North Alaska*. Seattle.
 1981 *Aleut and Eskimo Art: tradition and innovation in South Alaska*. Seattle.

Rosman, A. and P. G. Rubel
 1971 *Feasting with Mine Enemy: rank and exchange among Northwest Coast societies*. New York.

Rubin, W. (ed.)
 1984 *'Primitivism' in Twentieth Century Art*. The Museum of Modern Art, New York.

Samuel, C.
 1982 *The Chilkat Dancing Blanket*. Seattle.

Sears, W. H.
 1982 *Fort Center: an archaeological site in the Lake Okeechobee Basin*. Gainsville.

Siebert, E. and W. Forman
 1967 *North American Indian Art: masks, amulets, wood carvings and ceremonial dress from the North-West Coast*. London.

Smith, J. G. E.
 1980 *Arctic Art: Eskimo ivory*. Museum of the American
 Indian, New York.
Sotheby's
 1978 *Catalogue of the George Ortiz Collection of African and
 Oceanic works of art, Thursday 29th June*. Sotheby, Parke
 Bernet, London.
Stevenson, M. C.
 1904 The Zuñi Indians: their mythology, esoteric frater-
 nities, and ceremonies. *In: Twenty-third Annual Report
 of the Bureau of American Ethnology to the Secretary of the
 Smithsonian Institution, 1901-02*, Washington, pp. 3-634.
Sturtevant, W. C. *et al.*
 1974 *Boxes and Bowls: decorated containers by nineteenth-century
 Haida, Tlingit, Bella Bella and Tsimshian Indian artists.*
 Washington.
Swanton, J. R.
 1908 Social Conditions, Beliefs, and Linguistic Relationships
 of the Tlingit Indians. *In: Twenty-sixth Annual Report of
 the Bureau of American Ethnology to the Secretary of the
 Smithsonian Institution, 1904-05*, Washington, pp. 391-485.
 1909 *Tlingit Myths and Texts*. Washington (Bureau of
 American Ethnology; Bulletin 39).
Taylor, W. E. *et al.*
 1971 *Sculpture/Inuit*. Toronto.

Thalbitzer, W.
 1914 *Ethnological Collections from East Greenland*. Copenhagen
 (Meddelelser om Gronland; 39).
Turner, E. R.
 1985 Socio-Political Organization within the Powhatan
 Chiefdom and the Effects of European Contact,
 AD 1607-46. *In*: Fitzhugh, W. W. (ed.), *Cultures in Contact*,
 Washington, pp. 193-224.
Turner, L. M.
 1894 Ethnology of the Ungava District. *In: Eleventh Annual
 Report of the Bureau of Ethnology to the Secretary of the
 Smithsonian Institution, 1889-90*, Washington, pp. 159-350.
VanStone, J. W.
 1968/69 Masks of the Point Hope Eskimo. *Anthropos, 63/64*,
 pp. 828-40.
 1976 *The Bruce Collection of Eskimo Material Culture from Port
 Clarence, Alaska*. Chicago (Fieldiana, Anthropology; 67).
Wardwell, A.
 1978 *Objects of Bright Pride: Northwest Coast Indian art from the
 American Museum of Natural History*. New York.
 1986 *Ancient Eskimo Ivories of the Bering Strait*. New York.
Witthoft, J. and F. Eyman
 1969 Metallurgy of the Tlingit, Dene and Eskimo. *Expedition,
 11*(3), pp. 12-23.

Bibliography supplement

These selected works were either not referenced in the text or
have been published since this volume was typeset and printed.
They are signalled to the reader as useful for further study.

The Pacific

Dark, P. J. C. and R. G. Rose (eds.)
 1993 *Artistic Heritage in a Changing Pacific*. Honolulu.
Hanson, A. and L. Hanson (eds.)
 1990 *Art and Identity in Oceania*. Honolulu.
Kaeppler, A. L., C. Kaufmann and D. Newton
 1993 *L'Art Océanien*. Paris.
Küchler, S.
 1992 Making Skins: Malangan and the idiom of kinship in
 northern New Ireland. *In*: Coote, J. & A. Shelton (eds.),
 Anthropology, Art and Aesthetics, Oxford, pp. 94-112.
Thomas, N.
 1995 *Oceanic Art*. London and New York.

Africa

African Arts
 1988 Several articles on Dogon art in issue XXI(4).
Beumers, E. and H. J. Koloss (eds.)
 1992 *Kings of Africa: art and authority in Central Africa.*
 Maastricht.
Biebuyck, D.
 1986a *The Arts of Zaire. I: Southwestern Zaire*. Berkeley.
 1986b *The Arts of Zaire. II: Eastern Zaire*. Berkeley.
Drewal, H. J., J. Pemberton III and R. Abiodun
 1989 *Yoruba: nine centuries of African art & thought*. New York.

Mack, J.
 1991 *Emile Torday and the Art of the Congo, 1900-1909*. British
 Museum, London.
Phillips, T. (ed.)
 1995 *Africa: the art of a continent*. London.
Schmalenbach, W. (ed.)
 1988 *African Art from the Barbier-Mueller Collection, Geneva.*
 Munich.
Verswijver G., *et al.* (eds.)
 1995 *Treasures from the Africa-Museum Tervuren*. Royal
 Museum for Central Africa, Tervuren.

North America

Emmons, G. T.
 1991 *The Tlingit Indians* (edited and with additions by
 Frederica de Laguna). Seattle (Anthropological Papers
 of the American Museum of Natural History; 70).
Fitzhugh, W. W. and A. Crowell (eds.)
 1988 *Crossroads of Continents: cultures of Siberia and Alaska.*
 Washington and London.
Galloway, P. (ed.)
 1989 *The Southeastern Ceremonial Complex: artifacts and
 analysis*. Lincoln, Nebraska and London.
Jonaitis, A.
 1988 *From the Land of the Totem Poles: the Northwest Coast
 Indian art collection at the American Museum of Natural
 History*. New York and Seattle.
Suttles, W. (ed.)
 1990 *Handbook of North American Indians. 7: Northwest Coast.*
 Smithsonian Institution, Washington.

Index

Hawk, depictions of, 272, 274-5, 278
Hawkins County, 299
Head-dresses:
 NW Coast, 267-8, 278, 285
 Santa Cruz, 74
Head-hunting, 56, 71
Headrests, Zaire, 189
Heitiki, 15
Hemba, the, 200-3
Hewett, John, 35, 53
Hivaoa Island, 25
Hobday, A. E., 35
Hogon, 107-9
Holliston Mills, 299
Holm, Bill, 264
Hooper, James, 217, 278, 280
Hooper Collection, 17, 67, 155, 217, 278, 280
Hope, Point, 241, 246, 248, 252
Horn, 268, 273, 275-6, 284
Hornbill, 86-7, 116, 305, 307-9
Horns (musical), African, 103, 165-7, 181
Hornung, H., 64
Horses and riders:
 Benin, 148-9
 Ivory Coast, 135
 Mali, 109
Housepost figures, New Guinea, 40-1
Human:
 bone, 28-9, 54, 77
 depictions of (*see also* Figure sculpture), 289
 hair, 22-3, 29-31
Hunterian Museum, 5
Huon Gulf, 61

Iatmul, the, 44, 49-55
Iban, the, 91
Ibibio, the, 117, 163
Ibibio-speaking peoples, 160
Idoma, the, 117, 163
Ifa, 143
Ife, 152
Igbomina, 143
Igloo, 242
Iguanas, 305, 312
Ikot Ekpene, 163
Illness, depictions of, 117
Ilobu, 140
Inagaki, 125
Indigo, 140, 146-7
Indonesia, 2, 82-93
Initiation rituals:
 Australia, 81
 New Guinea, 46-7, 50
 Solomon Is., 73
Inua spirit, 240
Inuit, 222
Inupiak language, 222
Ipiutak, 222
Irian Jaya, 43
Ironwood, 16-17, 26
Iroquois, the, 295
Irving, Lawrence, 251
Ivory: *see* Elephant ivory; Fossil ivory;
 Mammoth ivory; Walrus ivory
Ivory Coast, 114-37

Jasper, 153
Jenne, the, 109
Joest, Wilhelm, 74
Jokwe, the, 192-5
Jonzen, Basil, 102

Kaarta, 111
Kaeppler, Adrienne, 302
Kahn, Alphonse, 13
Kaigani Haida, 282-3
Kakulu ka Mpito, 213
Kalimantan, 86-7, 89, 91
Kambire, Sikire, 113
Kaolin, 122-3, 125, 175-7
Kapkap, 65, 313
Kasaan, 282
Kasai, province, 195, 197, 205
Katundu chiefdom, 191
Kayan, the, 88-91
Keggie, James, 114
Kentucky, 302-3
Kenya, 101, 217
Kenyah, the, 88-91
Kerebe, the, 217
Kifwebe society, 205
Kimberleys region, 80-1
King, Jonathan, 261
King, Victor, 86
Kingfisher, 277
Kiphuth, David, 22
Klee, Paul, 81
Klukwan, 272
Knife sheaths, Plains, 290
Kodiak Island, 249
Kola nuts, 182
Kongo, the, 182-6
Kongoti village, 134
Konodimini, 110
Koranic charms, 126
Kotzebue Sound, 237
Koudougou: *see* Zimwomdya
Kru, the, 102
Krusenstern, Cape, 237
Kuba, the, 195-8
Kukulik, 229
Kuskokwim River, 222, 240, 243
Kusu, the, 208
Kwele, the, 176

La Rochelle, 176
Labouret, Henri, 113
Ladles, 64, 273-5, 288
Lavongai: *see* New Hanover
Lazard Collection, 105
Le Flore County, 299
Leblond, Ary, 182
Leeds Philosophical and Literary
 Society, 25
Leff, J. C., 300
Lega, the, 210-14
Leipzig, 61
Lele, the, 197
Leopards, 157
Liberia, 102, 114-23
Ligbi, the, 127, 135
Lime containers, 52
Lime spatulae, 62

Limesticks, 72
Linden Museum, Stuttgart, 64, 163
Lisbon, 134, 188
Lobi, the, 112-13
Loeb, Pierre, 13, 41, 43-4, 47, 56, 123
Lomami River, 205, 208
Lombok, 92
London Missionary Society, 18
Long Apari, 91
Lonsdale, Lord (Lowther Castle), 72, 286
Lou Island, 64
Lower Sepik River, 42-4, 48
Lower Welle region, 214
Lower Yukon River, 248, 251
Lualaba River, 203
Luba, the, 198, 200-5, 208
Luba-Hemba, the, 200-3, 208
Luba-Shankadi, the, 208
Lulua River, 198
Luluwa, the, 198-9
Lumbo, the, 173-4
Lunda kingdom, 193
Lynn Canal area, 266

McLeod, Malcolm, 136
Mahakam river, 91
Mahen yafe, 99
Makah, the, 286
Makonde, the, 215
Maku and Toibo (carvers), 140
Malagan, 306-10, 313, 316
Malaita, 67, 73
Malangan: see: Malagan
Malekula, 76-7
Mali, 104-11
Malraux, André, 125
Mammoth ivory, 241
Mammoths, 241
Mangonui, 15
Mani, 214
Maniet, 79
Manus, the, 63
Manutuke, 7
Maori, 4-15, 31
Maprik, 79
Marine sponge, 316
Marionettes, 252
Marquesas Islands, 23-8, 36
Marshall, 251
Maru, 9
Maskettes: *see* Masks
Masks, maskettes:
 Akan, 136
 Baining, 66
 Bambara, 111
 Bamileke, 165
 Baule, 113, 128-9
 Benin, 151, 153, 156-7
 Dan, 114-9
 Ejagham, 162-3
 Eskimo, 225-7, 250-5
 Fang, 174-5
 Guro and Yaure, 124-6
 Ibibio, 160-1
 Idoma, 163
 Jokwe, 192-5
 Kuba, 195, 197-8